Expect Great Things!

∽

ALSO BY VANDA KREFFT

The Man Who Made the Movies:
The Meteoric Rise and Tragic Fall of William Fox

Expect Great Things!

∾c∽

HOW *the* KATHARINE GIBBS SCHOOL REVOLUTIONIZED *the* AMERICAN WORKPLACE *for* WOMEN

c∾∽

VANDA KREFFT

ALGONQUIN BOOKS OF CHAPEL HILL 2025

Published by
ALGONQUIN BOOKS OF CHAPEL HILL
an imprint of Little, Brown and Company
a division of Hachette Book Group, Inc.
1290 Avenue of the Americas
New York, NY 10104

The Algonquin Books of Chapel Hill name and logo are registered trademarks of Hachette Book Group, Inc.

Printed in the United States of America.
Design by Steve Godwin.

The Hachette Speakers Bureau provides a wide range of authors for speaking events. To find out more, go to hachettespeakersbureau.com or email hachettespeakers@hbgusa.com.

Little, Brown and Company books may be purchased in bulk for business, educational, or promotional use. For information, please contact your local bookseller or the Hachette Book Group Special Markets Department at special.markets@hbgusa.com.
The publisher is not responsible for websites (or their content) that are not owned by the publisher.

Cataloging-in-Publication Data is available from the Library of Congress.

ISBN 978-1-64375-317-1 (hardcover), ISBN 978-1-64375-748-3 (ebook)

Printing 1, 2024
First Edition
LSC-C

CONTENTS

Expect Great Things!

Manhattan, Mid-1950s

∽ొౖ

AS SHE STOOD ON THE SIDEWALK amid the glistening steel towers of 1950s Manhattan — buses whooshing by, newspaper vendors hawking the latest headlines, construction workers jackhammering in the street — she adjusted her spotless white gloves, tipped her hat a fraction of an inch back into position, and straightened the jacket of her tailored business suit. Then she raised her hand to hail one of the yellow Checker Cabs beetling down the street. It was a strong, commanding gesture. She knew where she was going, in more ways than one.

Who was she? She might have been the daughter of a Brooklyn sign-painter or a Wall Street stockbroker or an Illinois farmer. She might have a degree from Smith or Vassar or Cornell, or maybe only a high school diploma because her family couldn't afford to send her college. But now, as she headed to her first job interview, the most important fact anyone needed to know about her was that she was a graduate of the exclusive Katharine Gibbs School on Park Avenue.

But any casual passerby would have known that right away. It was the look, almost a uniform: the neutral-colored suit that hit just the right note of fashion-meets-business with its "New Look" rounded shoulders, nipped waist, and straight skirt; the string of pearls and small matching earrings; the white gloves; the soft shades of lipstick and nail polish, and her neatly styled hair, no longer than collar length. And, of course,

the hat. Not one of those flamboyant, lampshade styles as wide as an umbrella, but a demure, close-fitting crescent shape or a quiet little pill-box or a face-framing cloche. Class.

If any doubts remained, her demeanor dispelled them. She was calm, confident, friendly, and polite. No pushing ahead of anyone, and if a briefcase-carrying man leaped in front to claim the taxi that had just pulled to the curb for her — well, another one would come along soon. She'd built in extra time for this sort of thing. Definitely a "Gibbs girl."

Some people — mostly men — thought Katharine Gibbs was merely a secretarial school. While Gibbs did require students to master typing and stenography at breakneck speed before graduating, these skills merely opened the door to the halls of power. Once inside, young women should aim for the sky. "Expect great things!" founder Katharine Gibbs told them. Her school would give women the courage and vision to do just that. It would teach them how to walk, talk, dress, and behave so they belonged among the swells. No special connections or "right background" needed. The rules of this game could be learned.

Graduates who started their careers as assistants in executive suites would use those jobs as launching pads into leadership positions in business, the arts, education, the military, and government. They might work for a retailer, a manufacturer, an art dealer, a publishing company, a college, or a movie studio. They'd make big decisions, travel the world, and have their own secretaries. They wouldn't need to marry for financial security or bask in their husband's reflected glory. They could wait for love, and if love never came, they'd still have gotten a square deal. They'd have lived life on their own terms.

As the young woman on that Manhattan street stepped into her cab and gave the driver her destination, she knew she'd get this job. Actually, what she knew was that she'd get the job *offer*. Whether or not she accepted it was another matter. Gibbs teachers had hammered in the importance of career planning, especially in the first five years. What could she learn here? Could she move up in the organization? Would she make useful contacts? Because while this man — and it was always a man — would get the best

secretary he ever had — someone who'd fix his grammar, stay late without complaining, and charm clients and colleagues when he kept them waiting — she was going places. She might not know where yet, but it would be Somewhere Important.

Today, the Katharine Gibbs School has disappeared and is all but forgotten. Yet in its glory days, the early to mid-twentieth century, it was a quiet revolutionary force in the working world.

At a time when the nation's professional schools accepted women in no more than minuscule numbers, blocking them from high-paying, prestigious careers in law, medicine, and business — a time when women were supposed to marry quickly or busy themselves beforehand as teachers, nurses, and librarians — Katharine Gibbs opened the door to a much wider range of choices. It showed women how to get in, get ahead, and get to the top.

Equipped and encouraged, many Gibbs graduates soared. This is their story — a story about the imagination, courage, and triumphs of a remarkable, white-gloved army of women who typed their way out of the shadows of history, forever changing the face of power in America and setting the stage for gender equality in the twenty-first century workplace.

April 4, 1909, Cranston, Rhode Island

∽◦⌒◦

IT WAS A QUIET SUNDAY AFTERNOON, with a brisk spring breeze ruffling the air off Narragansett Bay. Onshore at the Edgewood Yacht Club, William Gibbs, a popular member who'd been elected vice commodore some years before, was preparing his yawl for the upcoming racing season. He loved sailing and took great pride in his boat, a sprightly little two-mast craft considered one of the finest of its class in the area. This year, it was especially important to make a good show. The previous April, the red-roofed, shingle-style Edgewood clubhouse had inexplicably burst into flames, sending sheets of fire into the night sky and burning fiercely until all that remained was "a mass of smoldering ruins lying on the beach."

Miraculously, within a year, the club's hardy New England membership, about five hundred strong, had rebuilt the structure back to its original design, complete with a second-floor ballroom and long, leisurely front porches facing the bay. The least William could do in appreciation was to apply a fresh coat of paint to his yawl, named *Katharine*.

A few blocks away, the original Katharine, William's forty-six-year-old wife, was at their home at 110 Albert Avenue. A petite, soft-spoken woman, she was content in her role as a supportive wife and a devoted mother to their two sons, now nine and eleven. Her husband made the decisions. She followed. Because it was his passion, whether she'd wanted to or not, she learned to sail and dutifully served on William's crew. It seemed a fair bargain. He was a good man, with a respectable job as a watchmaker at Tilden-Thurber,

an upscale jewelry and home furnishings store in nearby Providence that sold items like Patek Philippe watches, Oriental rugs, oil paintings, and Gorham silver tea sets. William's earnings had brought them to this leafy neighborhood of comfortably sized homes — nothing ostentatious, that wasn't the way here — and his outgoing personality had ensured a warm welcome into the Yacht Club's social whirl of fortnightly dances, whist tournaments, charity fundraisers, and, of course, friendly competitions out on the bay. Altogether, the family enjoyed a safe, predictable, peaceful life. That was how Katharine expected to spend the rest of her days.

Fate had other plans. Shortly after 1:00 p.m. on April 9, 1909, William ascended in the boatswain's chair to scrape the mainmast before painting it. Suddenly, the thirty-foot pole snapped at its base and sent him hurtling downward, smashing his head against the wooden deck and whacking him across the chest.

Friends who'd been helping William paint the boat carried his limp body home. Surely his injuries weren't serious, they consoled Katharine. A few days' rest in bed and he'd recover completely. But the doctor who arrived a short time later took one look at William and immediately ordered him to the hospital. He died there sixteen days later of a brain hemorrhage and internal injuries. He was fifty-three.

Being suddenly widowed with two young children was bad enough, but Katharine was in for another big shock. Her loving husband left her nearly broke. He had no life insurance or significant savings, and their house was rented rather than owned. To make matters worse, because he had failed to make a will, all their assets — which according to the law were *his* assets — fell under the jurisdiction of the probate court. That meant that a judge would decide how to distribute their possessions, while imposing taxes and fees that were much greater than they would have been had William executed a will.

Nothing except her clothes remained to Katharine, not even a chair to sit in or a plate on which to serve her children dinner. Treated more or less as an interloper in her own family, she had to ask the court for permission to keep her household furniture, for a six-month family support allowance of $700 (a modest $4,000 a month today), and even for money to pay her late husband's hospital bill. After those and miscellaneous other deductions,

the estate was valued at $6,104 (about $211,000 today), mostly in shares of stock. The court divided that amount in thirds among Katharine and her two sons. When all the dust settled, she ended up facing the rest of her life with about $540 in cash (about $18,700 today). The government was no help. Social Security, with life-saving benefits for women like Katharine, wouldn't arrive until 1935.

Worst of all, Katharine discovered she might lose custody of her children. In Rhode Island at the time, if one spouse failed to make a will appointing the other as the guardian of their children under fourteen, the state took over. Katharine had to petition the court for guardianship of her sons and she was especially at risk because she had no income. Her boys might be torn from her and sent to some faraway relative they barely knew, or worse, end up in a grim state-run orphanage that could send them out to earn their keep as household servants or indentured laborers.

It took more than a year, but in late September 1910, likely with the help of her lawyer brother John, Katharine dodged that heartbreak and officially became her boys' guardian. However, the state didn't totally trust her. To make sure she didn't abscond with money meant for her children's care, she had to sign a bond of $6,000 to her sister. As a further insult, the court appointed three men to assess the boys' inheritance.

Once legal matters were settled, Katharine faced the big black void of her future. Middle-aged, with two children to support on her own, she had never worked outside the home a day in her life. She had no marketable skills and only a high school education.

How in the world was she going to survive? And how could she make sure that she never again ended up so vulnerable?

The answers that Katharine Gibbs found to these questions would ultimately transform the lives of generations of American women. But first, Katharine had to transform herself. She had to throw away the attitudes and assumptions about a woman's place in the world that had beguiled her for forty-six years but that, under pressure, had turned treacherous and catastrophic.

Catherine/Katharine

∾ So

KATHARINE GIBBS NEVER MEANT to be a feminist. Born Catherine Ryan on January 10, 1863, in Galena, Illinois, she grew up pampered, protected, and provided for in a man's world. That suited her. Her parents were wealthy and well-connected, and with their ambitions focused on the five boys in the family, Katharine (she would change the spelling of her name as a teenager) and her two sisters could do as they pleased without a thought for the future.

A small town perched on the northwestern tip of the state on the edge of the Wild West, Galena had been built by manly brawn. The area's rugged hills were rich in lead—*galena* means *lead* in Latin—and around 1820, hordes of prospectors with get-rich-quick dreams swooped in. At the time, lead was even more valuable than gold. Essential for rifles and ammunition, it was "the metal of the frontier." Galena was especially inviting because although lead is usually hidden far underground, making mining difficult and expensive, here rich deposits lay close to the surface. Another natural advantage was the town's location near the Mississippi River. All steamboats traveling north or south stopped there, so by 1845 Galena had become the most important commercial port north of St. Louis. With a population of 15,000, it was even larger than Chicago.

A few years later, after the easily accessed lead deposits had been exhausted, the 1849 Gold Rush lured a stampede of miners away to

California. Then the arrival of the railroads in the mid-1850s sharply reduced the shipping trade. Galena's population cratered, falling to only 7,019 by 1870. Some glory had been restored during the Civil War by Ulysses S. Grant, whom Galena claimed as its own even though he'd lived there only since 1860 when, after resigning from the army in 1854 due to repeated drunkenness, he'd arrived to join his family's tannery business.

During Katharine's childhood in the postwar era, her father helped lead the local economy's revitalization. The son of Irish immigrant adventurers who'd roamed Virginia, Kentucky, Ohio, and Missouri before opening a grocery store on Galena's Main Street, James M. Ryan took the family business a step further. A stocky bearded character with an unruly thatch of hair and a piercing gaze, he started a packing house in a grimy, four-story brick box near the railroad tracks. "Packing house" was a euphemism for slaughterhouse. Ryan killed farm animals. Mostly hogs. Lots of them. On opening day of the season in October 1870, his employees killed 800 hogs, two per minute, their blood running in "little rivers." During the next decade, he slaughtered an average of 1,200 hogs daily, with as many as ten carloads of the unfortunate animals arriving by train per day. Nothing went to waste. Ryan shipped the hams to eastern markets, sent bacon and dried salt meat to the South, and dried the offal for sale as fertilizer. It was a brutal, bloody, foul-smelling business, but he built it into the largest pork packing plant in the state outside of Chicago and amassed a fortune.

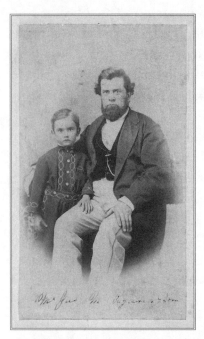

Katharine's father, James M. Ryan, with her younger brother, James W. Ryan, circa 1869

EDWARD W. PEIRCE, COURTESY
OF GALENA PUBLIC LIBRARY DISTRICT

Wealth placed Ryan within elite circles and brought opportunities to make

even more money. He became a major stockholder and director of the local Merchants National Bank and president of the Galena and Southern Wisconsin Railroad. He married well. Katharine's mother, Catharine McNulty, came from one of the oldest and richest lead mining families in the area. Active in local politics, Ryan developed a close friendship with General Grant who, even after he was elected president, stopped in at the Ryan home when in town. To keep Grant anchored in Galena, local leaders bought him a fully furnished home, and Ryan chaired a fundraising committee to build Grant a monument.

In this scheme of things, upper-class wives and daughters were mostly decorative, meant to smooth the rough edges off a burly patriarch who had wrested wealth from the earth and to escort him into genteel society. Katharine's mother, Catharine, appears to have been a model of such propriety. She bore Ryan ten children, but lost two in infancy; their first child, William, died in May 1858 at two and a half, and Alice in February 1874 at four months. Catharine's only significant mention in the local paper occurred when she hosted an evening party for two hundred at the packing house. With an orchestra imported from Dubuque and decorations that

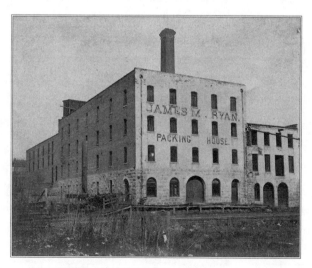

James M. Ryan Packing House, Galena, IL, circa 1890
COURTESY OF GALENA PUBLIC LIBRARY DISTRICT

included a profusion of flowers and tri-color bunting, she had transformed the space into a huge stage for dancing, roller-skating, and a lavish banquet. The local paper pronounced the event, which lasted till 2:00 a.m., "a scene of brilliancy never before witnessed in this city."

The family's fourth-born child, Katharine, spent her early childhood in a house in town where, until 1871, hogs were allowed to run wild in the street. When she was thirteen, the family moved into a splendid new home. Miles from the slaughterhouse, on an estate he expanded into 640 acres of rolling green land, Ryan built a 9,000-square-foot, 24-room redbrick mansion, complete with a white-colonnaded porch, ruby red Czechoslovakian stained-glass windows, twelve fireplaces, and a third-floor ballroom. Katharine and her siblings basked in luxury. Servants cooked and cleaned and waited on them.

A taciturn man devoted to his family, Ryan recognized education as a cornerstone of social status — but it had to be the right education. No local public schools for his children. Galena was still a frontier town that raised its young to be miners, shopkeepers, and factory hands. After being tutored locally by "two highly educated New England women," Katharine and her older sister, Mary, were shipped out for high school to New York's Academy of the Sacred Heart (now Manhattanville University), an elite Christian boarding school for girls, located then at 128th Street and St. Nicholas Avenue.

Katharine's four years at the Academy of the Sacred Heart affected her profoundly. Dropped into the deep end of the pool of East Coast aristocratic culture, she found herself alongside the daughters of Wall Street barons, oil industry millionaires, politicians, real estate magnates, and bankers — a milieu traditionally populated by girls with last names like Mellon, Schuyler, Livingston, Bouvier, and Drexel, and girls descended from signers of the Constitution and the Declaration of Independence. Their family's money gave the Ryan sisters a boost upward. Although there were only about twenty-five private rooms for a student body of two hundred, Katharine and Mary each got one. Their classmates with less influence slept in dormitories, their beds curtained off into alcoves.

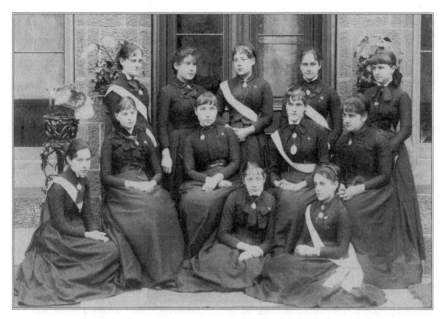

Katharine Gibbs, then Katharine Ryan, middle row, far right, 1882 class picture
at the Academy of the Sacred Heart, New York
COURTESY OF MANHATTANVILLE UNIVERSITY SPECIAL COLLECTIONS

Katharine adapted quickly. Fortunately, her midwestern fashion sense didn't have a chance to stamp her as a hayseed. All students had to wear the same uniform — a long, black, high-necked cashmere dress "daintily made in a simple prevailing style," with no jewelry or other accessories allowed. With one-upmanship thus banned from personal adornment, Katharine set about erasing other markers of her unsophisticated background. It was here that she changed the spelling of her name. No longer willing to be a dime-a-dozen "Catherine," she became a patrician "Katharine," with the second "a" adding a particularly tasteful touch. She also had extensive dental work, resulting in a bill of $73 (about $2,300 today) at a time when five months' board and tuition at this upper crust school cost $200, plus an extra $50 for her private room.

Although the school's express purpose was to teach "young ladies of the higher class . . . to pursue all the useful and ornamental branches becoming their sex," the curriculum was by no means frivolous. Required classes

included Latin, with readings from Cicero and Virgil; three years of philosophy comprising logic, psychology, and metaphysics; mathematics; physics; civics; and with "great stress," English grammar, composition, literature, and essay writing. However, these studies aimed to prepare young women not for professional life but to take their place as genteel, high-society ladies who could "carry on a sensible conversation or…write a letter worth reading." Decades later, Mary Ryan admitted that — even though no one ever guessed it — her sister Katharine had based the Gibbs training on "the spirit of the Sacred Heart." She just turned it to face the working world instead of the home.

While their brothers attended college, with one continuing on to Harvard Law School, Katharine and Mary ended their education after high school. That was the usual pattern. For one thing, parents had few places to send an aspiring female scholar. While men's colleges had been around in the United States since 1636 when Harvard opened its doors, women had to wait until 1833 when Oberlin began as the nation's first co-ed college. Opportunities increased in the late nineteenth century, especially at newly launched Midwest and Western co-ed state colleges as well as the elite all-women Seven Sisters in the Northeast. Still, widespread public opinion frowned. It just wasn't natural to give a girl too much classroom learning.

In his 1873 book *Sex in Education; or, A Fair Chance for the Girls*, Harvard Medical School professor Edward H. Clarke spelled out the reasons. Mainly, he argued, women were intellectually inferior to men. If they insisted on a rigorous college education with the same standards that applied to men, he wrote, females risked disasters such as a nervous breakdown or sterility or — horrors — a lack of marriage prospects. In the latter case, they might "[drift] into the hermaphroditic condition that sometimes accompanies spinsterism." The book was so popular it sold out in a week. A second edition was immediately printed.

Point taken. Between 1833 and 1885, only a few thousand women attended a college or university in any one year.

As with higher education, so with a career. Katharine, like most of her

peers, wasn't interested. In 1890, only 19 percent of women over sixteen worked outside the home, compared to 90.5 percent of men in the same age group, and almost all of them toiled out of necessity in low-paid, low-status jobs. They were factory laborers, domestic workers, and schoolteachers, and their employment outside the home cast shadows of shame and pity. If there were a man in the house, the message was loud and clear: he couldn't provide properly for his dependents. If the man had died or run off, perhaps these women hadn't taken proper care of him and so they deserved their fate.

To want more, to yearn for a challenging, lucrative, influential career — that was bad form. Unfeminine. No less an authority than the US Supreme Court said so. Women had a "natural and proper timidity and delicacy," wrote US Supreme Court Justice Joseph P. Bradley in a concurring opinion to an 1873 decision that rejected a woman's application for an Illinois law license (*Bradwell v. Illinois*, 1873). "The paramount destiny and mission of woman are to fulfill the noble and benign offices

Ryan mansion, Galena, IL
PHOTOGRAPHS IN THE CAROL M. HIGHSMITH ARCHIVE, LIBRARY OF CONGRESS, PRINTS AND PHOTOGRAPHS DIVISION

of wife and mother. This is the law of the Creator." Only one justice dissented.Katharine was no firebrand, not yet. Following society's rules had given her an easy, enjoyable life. Returning home to Galena at nineteen, she floated along like a leaf on a light summer breeze, visiting friends and relatives in Iowa, Minnesota, Wisconsin, and Montana with her older sister Mary as her constant companion. At the family mansion, the sisters, known as Katie and Minnie, gave lavish parties. For one evening fête, they decorated the front lawn with double rows of Chinese lanterns, served a "sumptuous repast," and offered dancing with music by the Germania Band of Dubuque. At another gathering, deemed by the local paper "one of the most brilliant social events of the season," they set up the grounds for lawn tennis, archery, and croquet.

Outgoing and sociable, Katharine joined several theatrical groups. In the 1886 debut performance of the local dramatic club, she starred as an impoverished ballet dancer in the English play *Caste* at a three-hundred-seat theater, winning praise from the *Galena Daily Gazette* as "the favorite of the evening." With the Galena Amateur Opera Company in 1892, she directed the three-act comic opera *Erminie* at the thousand-seat Turner Hall. She also organized and produced children's plays, and both sisters won ladies' tournaments of the card game euchre.

As much as she hewed to conventional notions of femininity, in one respect Katharine resisted conformity. She showed no interest in finding a husband. In 1890, when she turned twenty-seven, the median age for a woman to marry for the first time was twenty-two, and brides as young as fifteen or sixteen were not unusual. Only about 10 percent of American women in the late nineteenth century would never marry. Katharine certainly would have been an attractive catch. None of her brothers wanted to take over their father's lucrative business, so an ambitious son-in-law could have positioned himself as the heir apparent and landed in a luxurious life.

But Katharine didn't need to marry for financial security. Lacking that motive, her shrewd frontier intelligence sensed a threat on the landscape. Although by the 1861 Married Woman's Act, Illinois had struck

down the concept of "disability of coverture" — by which married women had to give their husbands absolute authority over all their assets, including their clothes — many complications soon arose and cluttered up the courts for decades. A single woman, though, clearly controlled her own money. Equally off-putting, under the law Katharine would have had to submit to her husband's will and follow his instructions. As for the possible attraction of running a household, since their mother's death in 1888, Katharine and her sister Mary had been in charge of the family mansion without having to answer to any bossy or pompous husband.

KATHARINE'S LIFE AS A social butterfly ended abruptly on October 9, 1892, when she was twenty-nine. That evening, after boarding a streetcar in Dubuque, Iowa, and depositing his fare in the box, her father slumped into a seat, fell unconscious, and died of heart failure. Alas, sixty-five-year-old James M. Ryan hadn't made a will.

This careless oversight turned his daughters' lives upside down. Days

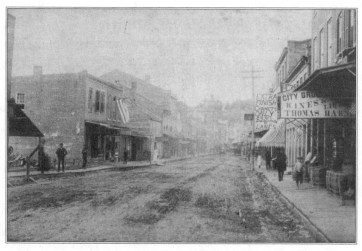

North Main Street, Galena, 1891
WILLIAM H. LANE, COURTESY OF GALENA PUBLIC LIBRARY DISTRICT

after their father's death, the two oldest sons, Charles L. Ryan, five years older than Katharine, and James W. Ryan, three years younger, became administrators of the estate, with power over all the assets. Within a month, they'd closed down the highly profitable Ryan meat packing plant, put it up for sale, and declared that if no buyers stepped forward, they would simply abandon it. The place would remain shuttered and unsold for years, delivering a severe blow to the local economy. Charles, James, and another brother also took over the family farm, comprising some of the best and most valuable land in Illinois, and kept the profits for themselves. The sisters got nothing.

For the time being, Katharine, twenty-nine, and Mary, thirty-two, were allowed to stay in the mansion, while youngest sister Cecelia was off at boarding school. Their position was precarious. They now depended entirely on the good will of their brothers, which was highly uncertain because Charles was in financial trouble. A Montana mining company where he was a partner was failing and in 1893, he defaulted on a stock purchase assessment, resulting in his shares being put up for sale. Another warning bell rang when their brother James married on New Year's Day, 1895, in Galena in a lavish church ceremony with five hundred invited guests. Although Katharine served as maid of honor, family solidarity promptly collapsed. By early May, when the sisters returned to Galena from Chicago where they'd spent the winter, the newlyweds had taken over the family mansion. Rumors circulated that Charles and James planned to sell the place.

Once mistresses of the mansion, Katharine and Mary had become charity boarders, subject to eviction at any moment.

Now Katharine needed to find a husband. Fast.

The successful candidate was William Gibbs, a Massachusetts native whom she'd probably met in Helena, Montana, during visits to her brother Charles, who'd lived there since at least the late 1880s. Nothing is known about the couple's meeting or courtship, likely because by the time anyone was interested enough to ask for the public record — if, indeed, anyone

ever did — William had already died and the marriage belonged to a closed chapter of Katharine's life.

The wedding was quick and quiet. Telling her neighbors in Galena only that she and Mary were heading east for the winter, Katharine eloped to New York City. There, on December 20, 1896, at the then-"old-maid" age of thirty-three, she married Gibbs at her alma mater, the Academy of the Sacred Heart. Mary and their younger brother John, who was sympathetic to his sisters, were the only guests.

She landed safely just in time. Nine months later, on September 29, 1897, her brothers sold the family homestead for $83,000 (about $3.1 million today). Within weeks, they'd completely dismantled the house.

These sobering events knocked the frivolity out of Katharine. Going forward, there would be no more parties with Chinese lanterns on the lawn and archery and croquet games, no gallivanting from town to town on social calls, no amateur theatricals that sparked gushing praise in the local paper. She had been lucky to find a reliable, good-natured man like William Gibbs to marry. But a middle-class husband was not an indulgent, rich father. From now on, she'd have to pull her weight.

The newlyweds settled in Rhode Island, where William Gibbs landed his job as a watchmaker at the upmarket Tilden-Thurber store in Providence. Demonstrating the adaptability that would mark her career years later, Katharine became what the situation called for — in this case, a happy homemaker. Children arrived quickly. William Howard Gibbs was born on October 8, 1897, when she was thirty-four, and James Gordon followed on January 17, 1900. Friends described Katharine as a loving, attentive mother and a soft-spoken, contented, deferential wife. Accompanying her husband to yacht club events and to church on Sundays, she stayed in the background and kept quiet when the conversation turned to public affairs. An all-around delightful member of the community, people said.

It was a huge change from Katharine's past. She had gone from a small midwestern town to a bustling, modern eastern metropolis, from people and customs she had known all her days to strangers with unfamiliar histories

and traditions, from a freewheeling existence as a wealthy single woman to managing a middle-class household and raising children. Once her activities had dotted the social chatter columns of the *Galena Daily Gazette*; now her life shrank within the four walls of home. Yet, there was no point in being anything but happy about it. The one steady tie to her past was her older sister Mary who, having nowhere else to go after the sale of the family mansion, came to live with the Gibbses in Rhode Island. To his credit, easygoing William accepted his sister-in-law as a member of the family.

From time to time, other siblings visited, stirring up unresolved family drama. Their eldest brother, Charles L. Ryan, had never given five of them their fair share of their father's estate, which at the time of his death had an estimated value of $500,000 to $1 million ($17.3 million to $34.6 million today). In 1904, after twelve years of fruitless pleading, it was time to act. The previous year, for an undisclosed amount, Charles had sold the long-idle Ryan slaughterhouse to investors who turned it into the Galena Iron Works, which manufactured mining equipment. That had put more money under Charles's control.

The five empty-handed Ryan children — all three daughters and two of the five sons — agreed to settle with Charles for a total of $45,784.64, in the form of thirteen mortgage loans Charles had made on real estate. It was a shockingly paltry amount, less than one-tenth of the lowest estimated value of their father's estate. Evidently, that was all the money the five siblings could hope to get. The fate of the rest of the family fortune is a mystery. Perhaps, over the years, it had gone down the drain in the various unsuccessful companies Charles formed. Some may also have gone to, or been lost by, two other brothers who had been in business with Charles and who did not join in the settlement action.

Before the court could approve the settlement, a preliminary step was necessary. A conservator had to be appointed for Cecelia, the youngest Ryan daughter, who was mentally impaired. In years ahead, this process would drive home further to Katharine the dire vulnerability of women to male decision-making. While their father was alive, Cecelia had been well cared for. She even had some high school education, acquired at three

boarding schools in as many years, although it appears she never graduated. But after James M. Ryan's death in 1892 and the sale of the mansion five years later, Cecelia was banished to the home of a former household servant and her husband, a coachman. This was another consequence of James M. Ryan's failure to execute a will. He hadn't named a guardian or allocated money for Cecelia's care.

Now, a conservator would manage Cecelia's finances, keep a detailed accounting of all transactions, and file regular reports with a county judge. At the hearing on July 26, 1904, in Galena, five witnesses — including Katharine's sister Mary, her youngest brother, Albert, and an aunt — all testified that thirty-one-year-old Cecelia had been "feeble minded" for as long as they'd known her and was incompetent to manage herself and her property. Court records contain no descriptions of specific behavior, and "feeble minded" was such a vague diagnosis that it's impossible to know what it meant in this case. According to one expert of the day, the term encompassed "all grades of idiocy and imbecility, from the child that is merely dull...to the gelatinous mass that simply eats and lives" and was even more difficult to define than insanity. A jury of six men agreed with the witnesses, and the court appointed a local lawyer as Cecelia's conservator.

With that done, a judge approved the $45,784.64 settlement between Charles and his five siblings. Katharine and her two sisters were awarded amounts varying from about $11,000 to $12,000; the two brothers got several thousand less. But because the money was tied up in mortgage loans, they would receive it in installments over a number of years rather than as a lump sum. Paid out like that, the inheritance wasn't enough for Katharine to buy a house or to build up savings. Likely, she simply spent it on small family expenses.

She let the matter go. That was the way of the world. Men controlled money. Women had to accept the fact. Besides, she was secure in her new life. Her husband was surely going to live a long time and provide well for her and the children.

Except that he wasn't and he didn't. After that awful day in April 1909 when William Gibbs fell thirty feet from the mast of his yawl and suffered

fatal injuries, Katharine's illusions shattered. Three times the men who were supposed to protect and provide for her had failed. First her father died without a will, leaving his children to fight over his estate. Then several of her brothers either appropriated or mismanaged most of the money. And finally, her loving husband, knowing of these crises, had repeated their triggering error. He, too, failed to make a will and left her shipwrecked.

And then the courts told her she was a nobody, with no presumed right to anything in her household, because she was just a housewife. She'd even had to ask permission to raise her own children.

This pile-up of events made Katharine good and mad. Not banner-carrying, manifesto-writing, angry-shouting mad. But simmering, steely-determined, and not-having-it-anymore mad. Never again would she place her fate in the hands of a man. Even the best of them — like her father and her husband — could make disastrous mistakes.

It had taken her forty-six years to learn the lesson, but Katharine knew it now. The only way for a woman to be secure was to have her own money. And the only way a woman could be sure to keep her money was to earn it herself.

A brand-new Katharine Gibbs was about to emerge.

A New Idea in Education

∽ᴐᴄᴐ

NOBODY, KATHARINE KNEW, WAS going to hire a middle-aged woman with no job experience, no marketable skills, and only a high school education. So, summoning the entrepreneurial spirit of their forebears — their hog-slaughtering father, his grocery-store-owning parents, and the lead mining McNultys of Shullsburg, Wisconsin, on their mother's side — she and her sister Mary started a dressmaking and clothing design business. The idea made sense, sort of. In high school at the Academy of the Sacred Heart, the two had taken required courses in dressmaking and embroidery, and as a single woman in the Midwest, Katharine had spent hours in museums studying antique needlepoint stitches and copying designs. Unfortunately, clueless about marketing and sales, Katharine and Mary saw their business quickly unravel for want of customers.

Yet, neither resorted to the fallback strategy of the day, marriage. They might easily have found husbands. A sympathetic soul at the Edgewood Yacht Club, site of Katharine's husband's freak accident, surely could have rustled up a bachelor brother or an eligible coworker or a lonely, well-to-do widower. Neither sister was interested. The harsh lesson they'd learned could not be unlearned. With the welfare of Katharine's two young sons at stake, the risks were too great to take a chance on depending on a man again.

Fortified by a lively sense of humor and an attitude she later described as

"Take sides and get mad at things," Mary, in her late forties, marched off to enroll in typing and stenography classes at a small, down-at-the-heels secretarial school in a scruffy area of Providence. The other students were probably less than half her age, yet Mary matched them in youthful energy, breezing through the work. Among her classmates, Mary stood out sufficiently that when she finished the course, the school's owner hired her as a teacher.

Of the two sisters, Katharine had always been the leader, the go-getter, the big thinker, and the problem solver. It was she — upending the social convention as old as the Bible that Leah should marry before her younger sister Rachel — who had lassoed a husband and provided a home for both of them when their brothers sold the Ryan mansion out from underneath them. Now, she was determined to engineer another rescue. In 1911, when Mary's employer put the school up for sale, Katharine jumped at the chance.

It was a preposterous idea. She was still scraping by financially, she had no clerical skills, she had never taught anyone anything, she had failed at dressmaking…the reasons against the purchase went on and on. No matter. Katharine sold her jewelry, borrowed $1,000 (about $33,000 today) from rich friends, and bought the place.

So nondescript that its name has been lost to the mists of time, the school consisted of two rooms on the second floor of a commercial building one block from Providence's Chinatown. It was hardly a glamorous location. The exoticism of the area — a bustling collection of boarding houses, Chinese fancy goods shops, restaurants, and laundries — stoked fears in the larger community of opium dens, gambling parlors, and "young girls who foolishly frequent" second-story Chop Suey houses, prey to the attention of lascivious men. The reputation wasn't entirely untrue. Providence police described the area as "a constant source of anxiety" and the "central depot" of an illegal drug trade extending throughout New England.

Inside the place, Katharine didn't get much for her money, only a desk, a filing cabinet, a typewriter, a stack of dusty, outdated textbooks, and one lone student. With no funds left to hire staff, she appointed herself the school's manager while Mary doubled as treasurer and teacher. "Do the best you can, at whatever you are asked to do, and do it with a

good grace," became Katharine's motto, one she would drill into her students. "Never be afraid to undertake new projects or branch out in new directions. You may make mistakes, but if you learn from them, they are part of your higher education."

For the next two years, the school limped along with low enrollment and shaky finances. Finally, in the summer of 1913, Katharine faced the fact that — unlike her sister, who'd attended and taught at the school under its previous owner — she didn't know what she was doing. To remedy that, she enrolled in a six-week Secretarial Studies course at Simmons College in Boston, where she boned up on the basics — typing, shorthand, bookkeeping, commercial law, business practices — and learned how to teach those subjects. More important, she entered an environment of big ideas about woman's place and potential in American society.

Founded in 1902 by a bequest from John Simmons, a wealthy Boston clothing manufacturer, Simmons College had forged a new path for women's colleges. While the others modeled themselves after liberal arts men's colleges and focused on instilling good taste and cultural discernment, Simmons blended real world vocational training with ivory tower academics. Its graduates would be more than just "good," explained Dean Sarah Louise Arnold. They'd be "good for something." In other words, they'd have the skills, knowledge, and sophistication to contribute to society while earning an independent living. No more mincing, subservient, cloistered females — the Simmons graduate would be a "ten-talent woman" with "the power to modify circumstances, to improve conditions, to direct enterprises, to assume executive control." That idea would become central to Katharine's vision. Simmons College also added other options to the standard one-size-fits-all, four-year education plan by offering a technical course for college graduates and shorter courses for women pressed for time. Katharine would appropriate that model, too, for her own playbook.

Following her stint at Simmons, enrollment picked up enough to put Katharine's business, renamed the Providence School for Secretaries in 1916, steadily in the black. Still, there was nothing special about the place, nothing to distinguish it from the smattering of other clerical schools in the area,

most of which were pokey little enterprises offering four- to six-week courses, some sponsored by office equipment manufacturers. In fact, Katharine wasn't even offering much more than the public high schools, which increasingly provided typing and stenography classes to students for free.

∽

MEANWHILE, SEISMIC SHIFTS WERE rumbling under the foundation of American women's lives. The women's suffrage movement, which brought about the Nineteenth Amendment in 1920 and guaranteed the right to vote nationwide, was just one part of it. More and more women were enrolling in college. Between 1900 and 1920, the number of female students skyrocketed 1,000 percent in public colleges and 482 percent in private colleges.

On the home front, a rising standard of living, along with snazzy new labor-saving appliances like vacuum cleaners, electric washing machines, irons, refrigerators, and sewing machines, freed women from household drudgery and sparked thoughts of entering the workforce. Urbanization brought people closer to offices and factories — by 1920, for the first time in history, more Americans would live in cities and towns than in rural areas — and automobiles and public transportation made it easier to get back and forth.

And then there were the movies, which exploded in popularity during the mid-1910s. Up on the big screen, larger than life, they splashed daring new possibilities for women. The low-budget 1915 movie *A Fool There Was* became the first feature film to earn $1 million in profits, thanks to the previously unknown actress Theda Bara, who vamped her way through scenes as a sultry, scantily clad vixen delightedly ruining men with sex. Within a year, after a spate of similar roles, Bara ranked as one of the nation's most popular movie stars, rivaling Charlie Chaplin and "America's Sweetheart" Mary Pickford.

While these trends prompted a lot of media chatter about a liberated, tradition-flouting "New Woman," they did very little to advance one of the truest measures of freedom, financial prosperity. Other than marriage and

inheritance, the major roads toward money posted large "Do Not Enter" signs for women. The gatekeepers were the nation's professional schools, which provided a bridge for college graduates into the upper echelons of employment as doctors, lawyers, and captains of industry. Male college graduates, that is. Especially at elite universities, women's applications were routinely tossed into the trash.

In theory, most US medical schools admitted female students without prejudice. By 1920, the nation had 85 medical schools, of which 64, or 75 percent, were coed, while one, the Women's Medical College of Pennsylvania, admitted only women. However, in the opening decades of the twentieth century, women accounted for only about 5 percent of medical school admissions, and that figure that would crawl at a snail's pace up to a mere 11 percent in 1970. The standard-bearer of the field, Harvard Medical School, clung tightly to its men-only policy until 1945, resisting even the lure of a large cash donation. In 1882, a group of female physicians offered $50,000 (about $1.5 million today) if the school would agree to admit women. No dice. The outraged medical school faculty threatened to resign en masse, so the Harvard Corporation turned down the deal.

Prospects were equally dim at US law and business schools. In 1910, only fifty-two women received degrees from US law schools, and as of the late 1910s, women accounted for less than 1 percent of US lawyers. Not until 1918 were women admitted to the American Bar Association. Harvard Law School, the nation's most prestigious and most selective law school, would remain staunchly opposed to admitting women until 1950 — but had welcomed all kinds of men. By the late nineteenth century, the school had admitted Jews, East Asians, African Americans, Native Americans, and a blind man who could learn only by hearing; it also waived tuition fees for indigent male students. Yale Law School did admit a woman in 1885, but that was by mistake. Alice Rufie Blake Jordan had used only her initials on her application. After she graduated, Yale Law barred female students until 1919. Many lower-tier law schools did accept women, but often with quotas as low as 5 or 6 percent.

Information about the history of women in business schools is scant,

but a few facts probably tell the story well enough. The world's first MBA program, Harvard's Graduate School of Business Administration, was launched in 1908 and accepted only men until 1963 — when it enrolled eight women alongside 676 men. The world's first undergraduate business school, Wharton at the University of Pennsylvania, began in 1881 with the express purpose of preparing students to become "pillars of the State, whether in private or in public life." Again, men only. The school didn't accept women till 1954, and then only fifteen of them. Wharton's prestigious MBA program began in 1921 and graduated a lone female student ten years later.

Government, which should have been fairer, wasn't. In the late 1910s, women were barred from 60 percent of all civil service examinations, including 64 percent of those for scientific and professional positions and 87 percent of those for mechanical and manufacturing positions. The federal Bureau of Animal Industry prohibited women from studying animal parasites because, according to an official, any job that dealt so much with breeding was no place for a proper lady. The US Forest Service wouldn't hire women to study the physical and mechanical properties of wood and the National Museum forbade women to work with reptiles.

The message was unmistakable. Interesting, challenging, and, especially, highly paid jobs required tough-minded manliness and were entirely unsuitable for delicate, overly emotional, scatterbrained females. In society's eyes, the purpose of higher education for women was to create gracious wives who could boost their husband's careers and raise cultured children. If educated women really wanted, or needed, to work, they could become teachers, nurses, librarians, or social workers. Then, after enough experience with low pay and dead-end prospects, they might well view marriage in a more alluring light.

☙

WHEN THE US ENTERED World War I on April 6, 1917, Katharine suddenly saw her opportunity. At the time, almost all executive secretaries were male

because the jobs were considered a springboard into management. Now, those young men would be leaving their desks for foxholes in France. Unless they wanted to type their own letters, bosses would have to consider the previously unthinkable option of hiring a female assistant. Ready to step in, Katharine realized, were all those bright, eager young women whose ambitions had been bottlenecked by the existing system. They'd simply need a bit of polishing.

Like many great ideas, her master plan was magnificently simple. She'd give employers women who were better than the men — speedier typists, flawless stenographers, tidy organizers, and what's more, well-groomed, nicely dressed, gracious hostesses who could serve afternoon tea to office guests. No one would ever want a male secretary again.

Meanwhile, under cover of docility and unfailing cheerful cooperation, "Gibbs girls" would stealthily learn all about the organization, observe leadership, gain new skills, make important contacts, and earn a decent living. If their own company wasn't smart enough to promote them, another one would. Failing that, they'd know enough to strike out on their own. It would be a modern-day Trojan horse campaign. Male executives who were about to get replaced or pushed aside for promotion wouldn't know what was happening until it was done.

"I felt certain that I had a new idea in schools," Katharine later commented. "Besides the necessity of earning money, I felt the urge to create something new, and I chose to put into an actual school my ideal in education."

She knew she needed to expand. And at age fifty-four, with the war's duration uncertain, she knew she had to act quickly. After getting permission in August 1917 from the Cranston, Rhode Island, Probate Court, Katharine sold shares of railroad stock from her late husband's estate. Combining those proceeds with profits from the Providence school, she plowed the money into two new schools in chic, strategic locations.

"Accomplishment comes only as the result of two important things — knowing definitely what you want and setting out to get it," she said.

Katharine wanted the best, and only the best. This would be another

key theme that Gibbs training constantly hammered home — do not settle. Success depended on "the ability to distinguish between those things which are best and those which are second best, and the power to choose and hold fast to the best." Make whatever sacrifices are necessary, Katharine would tell her students. The effort, expense, and temporary hardship would pay off.

For the new schools, the right addresses were crucial. Scanning the territory, Katharine saw that Boston could catch graduates of four of the Seven Sisters colleges. Radcliffe was in the city's backyard in Cambridge, and Smith, Wellesley, and Mount Holyoke were relatively nearby in western Massachusetts. In September 1917, she opened her second school in suite 301 of the Nottingham Chambers building at 25 Huntington Avenue, on Copley Square in the highbrow Back Bay neighborhood. It was a place to inspire dreams of belonging to — or retaining one's place in — America's genteel elite. From the windows of the third floor, students could look out on the massive Romanesque façade of Trinity Church, completed in 1877, or glance sideways at the Renaissance Beaux-Arts Boston Public Library, dubbed by its high-society architect Charles Follen McKim as a "palace for the people." At lunchtime, they could stroll over to the fifty-acre Boston Common, the nation's oldest park, where in season they might picnic or ride on a Swan Boat around the lagoon.

Next stop, New York, which was poised to become the most exciting, sophisticated, and culturally vibrant city in the world. And the wealthiest. World War I had shifted the center of the global banking industry from London to New York, inviting all enterprising eyes to focus on Manhattan.

One street name in particular connoted class: Park Avenue. So, in mid-1918 that's where Katharine landed, at 101 Park, on the corner of 40th Street, in the Architects Building, home to some of the best names in the trade. McKim, Meade & White, which had renovated the White House and designed the Boston Public Library, had offices there. Katharine couldn't afford much, only an office and two classrooms. But sprawling space wasn't the point. Prestige was — whatever the cost, whatever the risk. Katharine

Copley Square, viewed from third floor of 25 Huntington Avenue, Boston, late 1950s
PHOTO BY NISHAN BICHAJIAN. COURTESY OF MIT

summoned her courage and put down her money. As she later explained, "Believe you can accomplish things and half the battle is over. Then you must have faith in the enterprise into which you throw your mind and your strength."

Now she put herself out front, renaming all three locations the Katharine Gibbs School of Secretarial and Executive Training for Educated Women. Her sister Mary was her cofounder and an important decision maker — it was she who had pushed for the New York school as their flagship location. But Katharine held a trump card, the one valuable asset that the Rhode Island probate court hadn't been able to challenge or change: her late husband's patrician-sounding last name. "Katharine Gibbs," combined with the tony Park Avenue and Back Bay addresses, would conjure up the image of a high-society lady, perhaps the daughter of a banker or a university president, ready to dispense the secrets of her caste. "Mary Ryan," though, might have been a ruddy-cheeked parlor maid. Easygoing Mary accepted

her place in the background. A supportive personality, she was happy to cheer on her imaginative, energetic sister.

Driven by her new vision, Katharine overhauled the curriculum. Out the window went the old come-one, come-all admissions policy. From now on, she would accept only well-educated women. At first that meant college graduates, but Katharine quickly realized there were a great many intelligent, ambitious young women whose families either couldn't afford four years of college or who believed that higher education was wasted on a woman. By 1920, she had created three plans of study. High school graduates could choose either a speedy one-year course or a two-year course that essentially packed four years of college into half the time, with instruction "stripped of non-essentials" to avoid a "waste of time, money, or energy." College graduates could enroll in a six-month (later eight-month) "Executive Training Course."

The two-year course added a heavy dose of cultural studies to basic office skills training. Courses included art and music appreciation, English literature and composition, psychology, economics, and world government, as well as instruction in personal grooming, elocution, and fashion sense. But all of it was geared toward practical application in the working world, toward the goal of shaping "a delightful human being in business."

Decades before Pierre Bourdieu put a name to it, Katharine understood the idea of "cultural capital." That is, while productive skills and knowledge could pry open the door to social and economic advancement, the wind that blew a person over the threshold and punched the button of the penthouse elevator was the

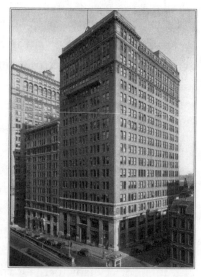

Architects Building, 101 Park Avenue, circa 1924, first site of Katharine Gibbs's New York school

seemingly mysterious quality of good taste. Knowing what was done and what wasn't. Good breeding, some called it. Nonsense. Katharine knew that while upper class children absorbed this information by osmosis from their social milieu, it could also be taught. She had learned it in high school at the Academy of the Sacred Heart and, during her marriage, among the pooh-bahs at the Edgewood Yacht Club.

Lest anyone raise an eyebrow about the quality of instruction at a secretarial school, Katharine assembled a first-class faculty, reeling in a good many moonlighters from Ivy League and Ivy-equivalent universities as well as distinguished guest lecturers. Over the next decade, instructors came from Harvard, Columbia, Brown, MIT, and Wellesley, as well as top perches in industry. It was quite an achievement for a woman who, in her mid-fifties, had had only moderate success in Providence, was pitching an untested concept, and hadn't managed to rustle up any rich or influential backers. But she did it, proving — another lesson for students — the power of personality.

"She was irresistible," recalled Dr. John C. Dunning, a political science professor at Brown University, who was immediately charmed by Katharine's lively humor, common sense, enthusiasm, sincerity, and "tenacity of purpose." The two met when Katharine, unknown to Dunning and without an appointment, quietly slipped into his office at Brown's John Hay Library and appeared at his desk with her hand shyly extended. A verbal faux pas broke the ice. When Katharine explained that a mutual acquaintance, a lawyer, had recommended Dunning "as one who would hold my girls," both instantly caught the double entendre and "burst into a hearty laugh."

"Then we sat down. She told me who she was; she stated the object of her call; she unfolded her dreams to 'invade' Boston and New York; she set forth her ideals; and much more," Dunning said. She exuded such "endearing and inspiring qualities of leadership" that he signed on immediately. Dunning would teach for decades at the Providence and Boston schools.

Staking everything on a big win, Katharine bought a snowstorm of ads in publications like *Vogue, Harper's Bazaar,* the *New York Times,* women's

rights magazines, and various college alumnae publications. They were usually small, plain, unillustrated ads lumped into the classified ad section on a back page under "Vocational." In these early years, she couldn't afford splashier displays, but broad reach was critical.

With messianic zeal, Katharine believed that all women needed the "protection against the future" that her schools offered. Even women who didn't know it yet, women who thought they'd be safe with family money or a high-earning husband. Even if they enrolled only because their parents made them or because they wanted an adventure before settling into marriage — and she was right, many did come for those reasons — still she'd prepare them for what she knew might lie ahead: life's unexpected blows. As she put it, "Fortunes rise and fall, taxation makes increasing inroads upon wealth, and the buying power of money has been growing less and less." Not to mention careless fathers, greedy siblings, and/or careless husbands. There was only one true source of security, she insisted. "To know that one is equipped for effective work in agreeable and profitable fields gives one a sense of up-standing independence that nothing else can give — a capital that panics and reversals cannot touch."

She was every woman, Katharine realized. What had happened to her could happen to anyone. And while she couldn't change her own past, she could change the future for others. Her school would arm young women to win in a world made by and for men. Finally, women would have what their fathers and brothers and boyfriends could usually take for granted, someone to show them the ropes.

FOUR

"Expect Great Things!"

∽∾ℰ∾

NO CYMBALS' CLASH WELCOME greeted Katharine's "new idea in education." The Boston school opened in September 1917 with only a handful of students, and on its first day the following year, the New York location had more typewriters than students — a mere ten young women signed up for classes. Katharine forged ahead, keeping up her blizzard of ads, sending recruiters to colleges, and reinvesting what little money she had in the business. As she later advised students, "I can wish nothing better for you than that you learn to think in terms of possibilities rather than difficulties and so make all achievement easier for yourselves." Press coverage didn't help because there was none. Not until the late 1920s would any magazine or newspaper editor notice Katharine or her school.

Even when money mostly flowed outward, she didn't fret. She simply went "calmly and confidently" about her work. "There was a grand quality of courage about her," commented Erwin H. Schell, an MIT professor of business management who met Katharine in 1919 and went on to teach at the Gibbs school in Boston. "A decision made, she would move forward with vigor and certainty. . . . Fearlessness was quite natural with her."

Katharine's courage came from clear vision. She saw through the myth of the "New Woman." As much as popular history points to the 1920s as a time of liberated Gatsby-esque flappers with bobbed hair knocking back cocktails all night in speakeasies and shuffling through romantic

partners like a pack of cards, the decade also produced a strong backlash that tried to pull women back into traditional roles. Mass-market magazines ran articles with titles like "Equality of Woman with Man, a Myth," "The Problem of the Educated Woman," "Evils of Woman's Revolt Against the Old Standards," and "Woman's Encroachment on Man's Domain." In 1929, *Ladies' Home Journal* touted the life of a wife as "an adventure — an education in color, in mechanics, in chemistry, in economics," while *McCall's* ballyhooed that homemaking had "an even more profound influence over human destiny than the heroism of war."

In fact, the independent "New Woman" was largely a myth created by movies, magazines, and advertisers. In pay-the-bills life, it was bankrupt. The 1920s produced no substantial increase in good jobs, and in some fields, women's position regressed. A US Department of Labor report revealed that while the 1920s saw "an unexpectedly large increase" in the number of women working for pay, only a very small proportion had nontraditional jobs. Most of them held broomsticks and irons. The most frequent female job was "servant," and between 1920 and 1930, that category increased from 1 million to 1.6 million out of a total of nearly 11 million working women. Servants included chambermaids, cooks, ladies' maids, nursemaids, and general servants in homes, hotels, restaurants, and boarding houses. Schoolteachers accounted for the next largest group of working women (850,000), followed by stenographers and typists (775,000). Others were store sales clerks, farm laborers, bookkeepers, cashiers, laundresses, nurses, telephone operators, waitresses, and factory workers.

Among "professional" women, by 1930 four out of five were either schoolteachers or nurses. Elsewhere, women showed up in novelty numbers — 379 architects, 11 veterinary surgeons, 4 mining engineers (an improvement over zero ten years earlier), 60 CPAs, 151 female dentists — or stashed into jobs that men didn't want. At US colleges and universities, a full 60 percent of women faculty members were in the home economics department. Men still held on tight to high-paid, high-prestige occupations. As of 1930, women lawyers had made almost no progress. They still represented less than 3 percent of the profession, up from about 1 percent

twenty years earlier. And female physicians, surgeons, and osteopaths actually lost ground during the 1920s, their numbers falling from 8,882 to 8,388. That situation wasn't going to change soon. Law and medical schools opened their doors no wider for the "New Woman" than they had for her old-fashioned sisters of previous decades.

Of course, there had always been gatecrashing women who refused to take no for an answer, regardless of the derision heaped on them for going where they weren't wanted. In 1849 Elizabeth Blackwell became the first woman to graduate from a US medical school, finishing first in her class at Geneva Medical College in upstate New York. In 1870, ignoring advice to seek work instead as a cook, a laundress, or a floor scrubber, Ada Kepley became the first woman in the US to earn a law degree, graduating from the Union College of Law, later part of Northwestern University. And Madam C. J. Walker, founder of a company that made cosmetics and hair care products for Black women, barreled through both race and gender barriers to take her place in history as the nation's first female self-made millionaire.

Yet across America, there was also a secret army ready to be mobilized: countless smart, ambitious young women who didn't want to put on boxing gloves to achieve their dreams. They wanted to stay closer to the center, probably get married and have children, yet still use their intelligence and talents in public life. Katharine Gibbs spoke directly to them.

"Expect great things!" she declared in a large ad that ran with her byline in the November 1922 *Harper's Bazaar*. "For great opportunities are ahead; greater than any that have come before…. A wise man has said, 'Know

1920s Katharine Gibbs students
"85 YEARS OF EXCELLENCE,"
KATHARINE GIBBS SCHOOL BROCHURE, BROWN UNIVERSITY

where you are going and the world will step aside.'" A 1920 Gibbs ad promised that college women could earn a starting annual salary of $1,500 and high school graduates $1,200. By contrast, US schoolteachers earned an average of $631 a year, less than housemaids, brick carriers, blacksmiths, and window washers.

No one else was offering this message to young women: believe in yourself, invest in yourself, reach for the sky.

Katharine's first crop of students during the late 1910s and early 1920s were restless, renegade adventurers. Many of their names and stories have been lost. Enrollment records from these early years haven't survived, and the school didn't begin issuing yearbooks until the mid-1930s. Still, family archives, personal papers, and late-in-life recognition open a window into the lives, dreams, and struggles of some of these pioneering young women who were determined to trade the "separate sphere" for the excitement of the wider world.

Some came from wealth and privilege and might easily have stayed there. Others were recent college graduates who slammed into the "Stop right there!" hand of the working world. A few weren't so different from Katharine Gibbs herself — fallout from families gone wrong. Every young woman had her own story and her own reasons for signing up. What they shared was the determination to rescue themselves, and a Katharine Gibbs education threw them a life preserver.

Natalie Corona Stark was one of the rich girls. Born on October 30, 1898, the youngest of three daughters of a wealthy real estate developer in Dorchester, Massachusetts, she grew up in a close-knit family in a redbrick mansion staffed by three servants and surrounded by gardens dotted with cherry blossom trees. As she matured into a pretty young

Young Natalie Corona Stark
COURTESY OF THE CROUTER
FAMILY/ SCHLESINGER LIBRARY

woman with a radiant smile, suitors came calling. One of them, successful children's book author and illustrator Harold Gaze, wrote to her that she "stirred and intoxicated" him. He'd have done well enough as a husband.

But Natalie couldn't accept a safe, cosseted life. She knew what it was like to be different. Born prematurely and with rickets, she'd struggled to survive and at age nine became critically ill with meningitis and polio. While other children were playing outdoor games, going to school, and making friends, she spent three years recuperating at home. Too weak even to walk, she had to be wheeled in a wagon by her mother to catch the streetcar into Boston for physical therapy. That experience left her with a mildly crippled right leg — and a keen sense of empathy for life's unfortunates. Early on, to the dismay of her beaux, she began attending lectures about social justice issues, everything from world disarmament to prison reform to social breakdown in Germany to starvation among West Virginia miners.

One cause in particular riveted her — the defense of Nicola Sacco and Bartolomeo Vanzetti, working-class Italian immigrant anarchists who were accused of murdering two employees during the April 1920 armed robbery of the Slater and Morrill Shoe Company in Braintree, Massachusetts. When their trial began in May 1921 in the Boston suburb of Dedham, Natalie attended regularly and was horrified by the prosecution's contradictory testimony. It seemed "all part of a time of witch hunting." She gave money to the defense fund, but after Sacco and Vanzetti were convicted in July 1921, she wanted to do more, only to realize she had no skills or knowledge to offer. She was, she thought, "a commonplace little me." To change that, in October 1923, a few weeks before her twenty-fifth birthday, she began the one-year course at Katharine Gibbs in Boston.

Across the country, Katherine A. Towle faced a different dilemma. Raised in northern California, descended from a cofounder of the logging town of Towle, she had primed herself for a center-stage working life. A political science major at the University of California, Berkeley, in the late 1910s, she was "busy as a bird dog" with campus activities. In addition to wartime volunteer work with the Red Cross, she wrote for

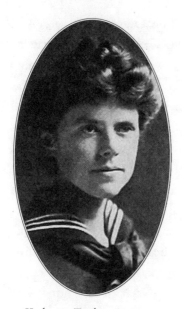

Katherine Towle as a teenager

BERKELEY HIGH SCHOOL 1915 YEARBOOK

the *Daily Californian*; served on the Student Affairs Committee; edited *The Dill Pickle*, an irreverent women's humor magazine; and during her senior year was elected president of both the Prytanean Women's Honor Society and her sorority. But when she graduated in 1920, all her energy suddenly had nowhere to go.

She'd considered law school, then thought better of it. Understandably so. Although by 1920 every US state admitted women to the bar, employment prospects were dismal. Routinely shunned by corporations and prestigious firms, female lawyers often had to practice with a male relative or in a lower-paid "protected sector" such as government. To stay on campus, Katherine took low-level jobs with a history professor and later with the Examiner's Office, forerunner of the Admission's Office. Then something—possibly a broken romance—"suddenly changed the future pattern of my life entirely." She had to get away, far away. In the fall of 1922, she joined a college friend and the friend's mother who were moving to New York, found her own small apartment in Greenwich Village, and—because "it sounded interesting"—enrolled at Katharine Gibbs.

Likewise frustrated by the practical value of her prestigious degree, Clara D. Davies signed up at Gibbs in Boston. A 1914 graduate of the New England Conservatory of Music and an accomplished pianist, she'd found that the best she could do with her education was to give private music lessons—earning so little that she evidently had to live with her parents in the servants' quarters of the Brookline, Massachusetts, estate where her father worked as a chauffeur.

Katharine Brand had not only a college degree of dubious usefulness, but

also a splintered and reconfigured family. Her childhood had been miserable, full of "scenes of raw suffering" between her parents who, "if both of them had taken a year off and searched the world . . . could not have done worse, matrimonially speaking, than they did." Her father, a Congregationalist minister turned Oregon fruit farmer and part-time journalist, spent her mother's money while haranguing her with "cutting sarcasm." He also repeatedly flirted with other women and pulverized his only child's hopes of becoming a writer herself by expecting perfection. As Katharine would later observe, "nothing so paralyses the pen (or, if one is seven years old, the pencil) as the knowledge that One sits below, awaiting a deathless masterpiece." Singing sad hymns in church, she fought back tears because "sad things hurt, terribly."

Katharine Brand as a young teen
KATHARINE E. BRAND PAPERS, SMITH COLLEGE

But Charles A. Brand had a beguiling charm. Katharine's mother, Phebe, stayed with him until he drove her into a hospitalized mental breakdown, after which, when Katharine was ten, she divorced him. Between various moves within the marriage and rearrangements after both parents remarried, Katharine was shuttled back and forth across the country, with stops in the Midwest to live with relatives. By the time she finished high school, she'd attended eight different schools. Her four years as an English major at Smith College in Northampton were the most stable period of her life. "I love Smith so," she wrote in her diary after her freshman year. Upon graduation in 1921, she was terrified. She had no idea what to do and "had the feeling that I might be going to die."

Still under her father's spell, she gave him one last try. Hoping he would help her with her resurrected dream of a writing career, she went to live with Charles and his second wife in Oregon. The answer was no. She should

Mary Sutton Ramsdell, 1915
SAN FRANCISCO CHRONICLE

have known. In college, she'd mailed him one of her short, "sweet and sentimental" poems. "Here," she wrote, "is a 'pome' you might like to see." He sent it back with one piercing comment: "A pome is an apple." After a year, Katharine returned to the New England home of her mother and stepfather. She loved them, but knew she'd be a third wheel there. In September 1922, she enrolled at the Gibbs school in Boston.

Mary Sutton Ramsdell followed a few years later. She was older than most Gibbs students, in her mid-thirties, the survivor of two family smashups. Her paternal ancestors, the Suttons, had once been fabulously wealthy. In the early 1800s, Mary's great-great-grandfather owned two textile mills in North Andover, Massachusetts, and increased his wealth through shrewd investments in banking, other businesses, and railroads. Mary's grandfather, Eben Sutton, tapped to run the mills in the mid-nineteenth century, bought one of the finest estates in northern Massachusetts, Hillcrest. A local hero, he was known as a kindly employer, a generous contributor to charities, and a civic patron who helped establish the local fire company.

It was all downhill from there. Mary's father, John Hasbrouck Sutton, took over the mills upon Eben's death in 1890, but six years later, following a labor strike over wages, he resigned and his sister became president of the business. While Mary's father struggled in his new job selling mill supplies, her mother spent money like there was no tomorrow, and her older brother, Richard, ruined the family's reputation through constant run-ins with the law. Once a popular MIT student, Richard dropped out

around 1905 to begin a crime streak. Over the next few years, he forged about $1,000 worth of checks in his Sutton grandmother's name, stole her silverware, and led police on a high-speed car chase with two vagrants aboard. An eighteen-month stint at the Concord Reformatory appeared to straighten him out. He married, had a daughter, got a job making shoes in a local factory — and then, yet another heartbreak for the family, died in March 1913 at age thirty of acute appendicitis.

Mary escaped the turmoil about six weeks later by marrying Leland Stanford Ramsdell, manager of Bullock & Jones, a San Francisco luxury haberdasher, whom she probably met during one of his East Coast buying trips. At least, she thought she'd escaped. Very little about Ramsdell was as it seemed. He wasn't, as he claimed, a nephew of Stanford University founder and former California governor Leland Stanford, and he wasn't even precisely a Ramsdell. He'd been born Leland Stanford Gould in San Francisco, the son of a railroad office clerk. (His parents weren't alone in appropriating the famous name. In the late nineteenth century, many others did the same, resulting in countless young Leland Stanfords nationwide with different last names.) After Leland's father died, his mother married Harry V. Ramsdell, owner of Bullock & Jones, and Leland legally changed his last name. Neither was Ramsdell only twenty-eight, as he stated at the time of their marriage — he was thirty-three, ten years older than Mary.

These concealments paled next to the most important fact that Ramsdell withheld from his bride. He was homosexual. Soon after Mary moved into her husband's house in Burlingame, so did another resident, Francis Davis Jr., a high school student whom Ramsdell presented as his "ward." Subsequent events indicated that Davis was far more than that. On June 15, 1916, shortly after her third anniversary, Mary fled her sham marriage and returned to her parents' home in North Andover. The couple divorced in February 1918.

For the next few years, Mary wandered, doing missionary work with the Episcopal Church among the Ute Indians in Utah and teaching at the Rowland Hall girls' boarding school in Salt Lake City. Then there was nowhere to go except back again to North Andover, where her once

high-society father now worked as a steam engineer for the state. After he died in 1926, with her family's share of the Sutton fortune all gone, Mary had no one but herself to depend on. She signed up at Gibbs school in Boston.

One young woman who almost certainly didn't attend Gibbs in the 1920s, despite oft-repeated reports that she had, was Warner Brothers star Kay Francis. Notoriously deceptive about her early life, Francis evidently invented the story that she'd been a Gibbs student based on the slender coincidence that her birth name was Katharine Gibbs. However, born in Oklahoma into an itinerant and often impoverished show business family, she was no relation to the New England Gibbses and her timeline simply doesn't fit. In May 1921, at age sixteen, she dropped out after her junior year of high school and the following year, she claimed, she'd enrolled at Katharine Gibbs — highly unlikely because the school required at least a high school diploma, no exceptions. Neither was it plausible that she attended later. At age seventeen, in December 1922, Kay married wealthy playboy James Dwight Francis, and shortly after their April 1925 divorce, she launched her instantly successful acting career.

For all their range in geography, family background, and motives, Gibbs students weren't truly diverse. Although over the years the school would admit Asian, Hispanic, and Jewish women, there were no Black students in the 1920s, and for the next few decades, according to photos in extant school literature, there wouldn't be.

Probably few, if any, Black women applied. Cost was a significant barrier. In 1927, tuition for the day school in Boston was $350 per year ($6,400 today), while live-in students paid $1,400 per year for tuition and room and board. That would have been a stretch for many families, and Black workers were disproportionately crowded into lower-paid occupations. In 1930, only 2.1 percent of Black workers were professionals, compared to 6.5 percent of the white workforce, and an estimated 95 percent of Black workers were manual laborers.

For Black women whose families did have money, there was little chance that a Gibbs education would pay off. Black people were almost entirely

absent from management at US companies. As Swedish economist and sociologist Gunnar Myrdal noted in his classic 1944 study of race relations, *An American Dilemma: The Negro Problem and Modern Democracy*, "Many employers believe that Negroes are inferior as workers, except for dirty, heavy, hot or otherwise unattractive work." Customers, too, often refused to deal with a Black employee except in an obviously menial position. And if employers did hire or promote a qualified Black person, Myrdal wrote, they would likely create a stampede of minority job applicants, whom they would have to hire because white workers would shun the company. The net effect would be a loss of business, due to a widespread public perception of inferiority. Rare was the employer willing to risk that fate.

⚭

AS THE DESKS FILLED up at Katharine Gibbs, elbows jostled. In 1923, the New York flagship left its cramped space in the Architects Building to move a few blocks north to the splashy new Park Lexington Building at 247 Park Avenue, between 46th and 47th Streets. Built one year earlier for $2 million by real estate operator R. M. Catts, the twenty-story building featured an ostentatious lobby and was topped by Catts's private penthouse, which had a block-long rooftop garden dotted by marble statues and "groves of cedar and azalea."

In Boston, Katharine bought four large Back Bay homes and remodeled them as classrooms and student residences. One was the four-story townhouse at 90 Marlborough Street, located directly across the street from the former home of author and presidential descendant Henry

247 Park Avenue, first building on the right, where the Gibbs school relocated in 1923

KATHARINE GIBBS SCHOOL BROCHURE, 1927, WIDENER LIBRARY, HARVARD UNIVERSITY

*Reception room at Katharine Gibbs, 90
Marlborough Street, Boston, mid–1920s*
KATHARINE GIBBS SCHOOL BROCHURE, 1927.
WIDENER LIBRARY, HARVARD UNIVERSITY

Adams. She also bought the home next
door at 92 Marlborough and two more
nearby at 151 Commonwealth and 135
Commonwealth. The Providence school
moved twice, first from Chinatown-
adjacent Westminster Street to 14 Green
Street and then to Churchill House at 155
Angell Street, near Brown University. To
finance this expansion, Katharine didn't
hunt for investors or loans, but relied on
her schools' income.

Walking through the doors of a Gibbs
school, students entered an enchanted
world. This was no austere industrial trade
school, but a vision of elegance and refine-
ment. Reception rooms at all the schools were furnished like upper-class
drawing rooms, with comfortable armchairs, tasteful throw pillows, and
shaded lamps; students were encouraged to relax, read, and welcome guests
there. Beyond, bouquets of fresh flowers decorated the halls and lounges.
At daily social hours, students served one another from a silver tea set,

*Dining room, Katharine Gibbs, Boston,
mid-1920s*
KATHARINE GIBBS SCHOOL BROCHURE, 1927.
WIDENER LIBRARY, HARVARD UNIVERSITY

*Dorm room, Katharine Gibbs, Boston,
mid-1920s*
KATHARINE GIBBS SCHOOL BROCHURE, 1927.
WIDENER LIBRARY, HARVARD UNIVERSITY

Times Square, Manhattan, 1920
NEW YORK PUBLIC LIBRARY

and holidays and birthdays were celebrated with special dinners. "[S]ocial development should be as much a part of a young woman's education as classroom study," Katharine believed.

In Boston, spacious dorm rooms had high-quality furniture with graceful feminine accents like floral curtains and wallpaper and had either private or semi-private bathrooms. Just like home, it was supposed to be, although often it was better than home and certainly better than the average college campus. Students took their meals not in a clanking cafeteria with cheap cutlery and plastic trays, but in dining rooms that resembled an expensive restaurant or private club. At tables-for-four, with white tablecloths, silver-plated flatware, and fresh flowers in vases, waitresses served them. New York didn't yet have a student residence — that would come soon — but in the 1920s the city itself sparkled with excitement and glamor.

It was a glittering lure: the best of everything could be theirs for life. Wherever a young woman came from, however life had punched her around or bashed in her dreams, the world began anew here. Expect great things! Anything was possible for those willing to work hard.

Typewriting classroom, Katharine Gibbs, Boston, mid-1920s
KATHARINE GIBBS SCHOOL BROCHURE, 1927, WIDENER LIBRARY, HARVARD UNIVERSITY

Willing to work hard, that was the key. Well aware of the huge obstacles facing young women, Katharine designed her curriculum as a combination of skillset boot camp and C-suite finishing school. Hard-core, military-style training in office tasks — typing, stenography, filing, and the like — would not only open doors to upper-level secretarial jobs but also instill the discipline, perseverance, and excellence necessary to get out of those jobs and into leadership. Typing classrooms had all the warmth of an army barracks. At the Boston school, long narrow wooden tables were packed into tight rows; students sat in stiff-backed wooden chairs and faced a battalion of clunky metal typewriters with blank keys. A legend at the front of the room told where the letters were, so students had to sit up straight (posture!) rather than hunch over the machines. To keep the class on pace, teachers played music with an increasingly fast tempo. Stenography, with its arcane squiggles and curlicues, became a bête noire for many students.

According to standards that would remain unchanged for the next half-century, all work had to be perfect. A single typo, an ink smudge, or

even one letter in a document paler than the others because the key hadn't been hit hard enough, any such error would cause an assignment to boomerang back with instructions to redo. "And, of course, if the sentence ended with an exclamation mark and you only had a period — that was really a mistake!" recalled one student. To meet the breakneck speeds of typing and stenography required for certification, some took the tests over and over. Tears were shed.

Meeting these unforgiving, grueling demands bred strength into the bone. It showed young women who thought they couldn't that they could excel — and if at this task, then likely at any other on which they set their sights. "The first thing of importance is to have confidence in yourself, in your abilities," Katharine insisted.

Yet, no boss wanted a grim martinet glowering over her typewriter or barking at phone callers and office guests. Charm was required. Not the eyelash-batting kind, but genuine likeability, sophistication, and usefulness to others. "Every business office is a miniature world, full of all sorts of people," Katharine observed, and a young woman starting out needed to know "how to keep human relations, which are always delicate and difficult, on an even keel." That was thinking behind the other — the truly unique — part of the Gibbs coursework, which aimed to shape the raw clay of youth into intelligent, cultured, self-assured ladies at a time when the term "lady" commanded society's respect and honor.

Katharine's instincts were right on the money. A 1924 study by two University of Pittsburgh professors found that the qualities most valued by employers in a secretary included courtesy, good judgment, tact, personal pleasantness, and personal appearance. One said he decided

Social life at Katharine Gibbs in the 1920s

to hire an applicant just by the way she walked into the office. Most wanted, if not a college graduate, then someone with a "cultural background."

At Gibbs, all those classes in English, comparative literature, history, art, economics, sociology, government, and contemporary civilization served two purposes. In addition to providing the polish that higher-up bosses sought in a secretary, they instilled a wide base of knowledge about human behavior and world events that would mark a young woman as leadership material. "Nothing pleases an employer more," Katharine noted, than an employee "who knows more than is actually demanded of her and who reads and keeps up with what is going on."

This was first-class education, especially for the two-year students who got four-year college-level courses crunched down to the essentials and taught by distinguished scholars. For the New York school, Katharine poached heavily from Columbia University, reeling in as moonlighters during the 1920s English professors Raymond Weaver and John Angus Burrell; history professor John A. Krout; and Ordway Tead, from the Personnel Administration Department. In Boston, she recruited William

Academic classroom, Katharine Gibbs School, 90 Marlborough Street, Boston mid-1920s. Small group instruction was considered an important part of the "essential factor" of character development

KATHARINE GIBBS SCHOOL BROCHURE, 1927,
WIDENER LIBRARY, HARVARD UNIVERSITY

Chase Greene, a Harvard classics professor and Rhodes Scholar; Erwin H. Schell, an MIT business management professor; Oscar W. Haussermann, an MIT business law professor; and Wellesley economics professors Judith B. Williams and Lawrence Smith. Other razzle-dazzle instructors at that time included efficiency expert Lillian Gilbreth, who had a PhD in applied psychology from Brown and who would become known as the mother in *Cheaper by the Dozen*; leading Walt Whitman authority Clifton Furness; and Richard D. Currier, founder and president of New Jersey Law School.

Katharine knew how to land the big names. First, courage. Told that a special lecturer she wanted for the Boston school was unapproachable, she wrangled an appointment with him and gave such a forceful sales pitch that he agreed to deliver not one but an entire series of lectures. Second, money. She didn't quibble. In early 1928, Lillian Gilbreth, who had recently reorganized Macy's offices, wanted a total fee of $10,000 (equal to $184,000 today) to work four days per month for ten months teaching management classes and conducting an efficiency study for the school. Katharine agreed right away. She even offered to throw in travel expenses and to cover Gilbreth's meals and lodging costs.

She got good value. Academic courses plunged students into thoughtful, intelligent discussions of essential facts and contemporary issues. Government classes analyzed the US Constitution and its historical development, with special emphasis on "the opportunities and responsibilities of the citizenship of women." Literature classes reviewed important authors and trends of the past, then delved into an intensive study of modern poetry, drama, and fiction. Art Appreciation classes scrutinized design in fine arts, architecture, and various handicrafts in order to "form the taste, enrich the appreciation, and so far as possible to deal with living as an art." Beyond school hours, Katharine encouraged students to explore culture on their own — no man required — at museums, concerts, plays, lectures, and bookshops. "Read, study, think, and experiment," she urged. "You will find life generally more interesting, as you give more to it, and take more."

Katharine expected her students to look as good as they sounded.

Image of Katharine Gibbs circulated to newspapers in the early 1930s, but probably not an accurate representation

Long before anyone came up with "dress for success," she put the idea into action. Gibbs students had to show up for class ready to enter a corporation president's office. That meant simple, well-cut dresses and suits with no revealing lines or short sleeves and a discreet whisper of makeup. No rattling jewelry, no tottering heels, and for heaven's sake, no fire engine red lipstick or nail polish. In public — what would become the "Gibbs girl" trademark — students had to wear a ladylike hat and white gloves. The hat edict was borrowed from Radcliffe, where in the 1890s Dean Agnes Irwin began requiring students to wear a hat in Harvard Square; that rule would persist into the 1930s. Tasteful, demure outfits connoted good judgment and discretion — valuable assets for a boss who might not have them himself — and they kept the office wolves at bay.

While crackerjack skills, cultural polish, and a pleasing appearance were the Trojan horse exterior that would open the gates to coveted territory, an ambitious young woman also needed a strategic battle plan. No one was going to hand her an exceptional job, nor would she stumble over it accidentally. To get to the top, she needed long-range look-ahead and smart, step-by-step footwork. Katharine Gibbs had a game plan for that, too, and a hundred years later, much of it holds up as timeless good counsel.

The first step was to find the right field, even if it required frequent job-hopping. Katharine advised, "Make contacts with employment agencies, discuss your plans and ambitions with them, and let it be known you are looking for something better than you have. Jobs seldom come after you — you must make the overtures." Then do everything possible. Volunteer for

new tasks, fill in for an absent colleague, stay late till all work is finished. "[The] real secret of getting a good job for yourself is by assuming responsibilities rather than shunning them, and to guard against routine instead of courting it."

At a time when barriers to advancement seemed so high that some young women considered any tactic fair play, Katharine shook her head: no office vamping. "Many young girls, going into business, believe they can secure their jobs by playing up to and flirting with certain men in the office who have important positions. Without considering the ethics of this, it is good sense not to rely upon this method," she observed. "If you desire your employer to think you are serious about your work, and that is what he needs to think if he is going to advance you, don't let him get the impression you are out every night having a good time. He may tell you about all the gay times he has, but he will not relish hearing about yours."

Gibbs training also prepared young women to deal with workplace biases. In her Personal Efficiency course, Lillian Gilbreth asked students, "You apply for a promotion and are told, 'No woman has ever held that job.' What is your reply?" and "You apply for a job as a machine operator and are refused because 'you might hurt yourself or the machine.' What will you do?" On the race question, a hot potato during the 1920s as many Black people moved north in search of better jobs during the Great Migration, Gilbreth took a progressive stance and urged young women to become agents of change. "No race has essentially different mental processes," she taught. When she asked her class, "A group objects because you put in a colored worker. What will you do?" she assumed that they would judge on the basis of competence and that any resistance to the hiring was wrong.

In the early years, Katharine herself taught some classes. She entered a room like a flash of lightning, ablaze with energy and inspiration. "That so tiny a person could be possessed of so much force and ability seems almost incredible," said Elizabeth Whittemore, registrar of the Boston school during the 1920s. "And such keen perception and intuition, too. She seemed to be able to size up a person, or a situation, at a glance, and then to express herself on the subject in a word." Despite her sharp insights, her

Katharine Gibbs; a slightly different version of this photo appeared in the Brooklyn Daily Eagle *in 1928*

1930 KATHARINE GIBBS SCHOOL BROCHURE, HARVARD UNIVERSITY

words didn't wound. She spoke to students softly and kindly. They revered her. Mount Holyoke graduate Jean Drewes recalled falling under "the forceful spell of Katharine Gibbs," whom she described as "so sweet and motherly in contrast to the intensity of her personality."

Katharine loved her job. Hit by a Fifth Avenue bus and sent to the hospital with a broken leg, she brushed aside her doctor's order to stay home and instead hobbled to school on crutches. Always on the lookout for new ideas, she regularly updated the courses with new teaching methods, new textbooks, and the most modern equipment. Staff members described her as "an indefatigable worker" with "stupendous energy" and "soaring ideas," yet also as a warm and generous friend.

For so vibrant a personality, it's odd that a photo of Katharine rarely appeared in promotional literature during her lifetime and only three images of her remain today. One probably wasn't of her at all, although the caption said it was. A photo, circulated to newspapers in 1933 along with an article she wrote, showed a trim, youngish woman (Katharine was then seventy) in a smart dark-colored dress with white trim, alertly on the phone with a pen or pencil in hand. No doubt this went out with Katharine's approval — she micromanaged every detail — and represented the way she thought people wanted to see her. The other two images were undoubtedly factual. These were a photo published five years earlier alongside a different article she wrote and another head-and-shoulders portrait, each portraying a white-haired senior citizen in borderline-dowdy clothes and grandmotherly pince-nez glasses. These conflicting images, signposts of identity pointing in different directions, told their own truth. Katharine

had a "rare modesty," said her assistant in New York, Eunice Lilly. She wanted attention focused not on herself but on the school, which was her real self, "her dream, her own creation, and the embodiment of her thought and of her life."

Many found the Gibbs training tougher than expected. A 1923 graduate of the New York school commented, "Never in my college years did I work so hard." Some found it too tough and dropped out. But one of the school's foundational principles was that anyone — alive, breathing, and motivated — could make it through. That proved true. "School. Dazed by more new stuff. . . . Got C- in exam," Natalie Corona Stark noted

Katharine Gibbs, circa late 1920s/early 1930s

KATHARINE GIBBS SCHOOL RECORDS. BROWN UNIVERSITY

glumly in her diary shortly after starting at Gibbs. Persisting, she "studied till cramped!" and "Worked late on Eng. & shorthand. . . . Studied till 11." Then: "Typed page without error! . . . Test. Got A! . . . One of 4 in school to get A in English exam." She graduated in the spring of 1924.

An underground revolution was rumbling. One by one by one, the first generation of Gibbs graduates set out for the four corners of the working world to plant the flag of female competence.

Where Do All the Girls Come From?

∽⊙e⌒

BY THE END OF the 1920s, Katharine Gibbs was stunned by her own success. Enrollment across all three schools totaled nearly 1,000, and students came not only from big cities like New York and Boston, but also from whistle stops like Oil City, Pennsylvania; Howell, Michigan; St. Johnsbury, Vermont; and Okmulgee, Oklahoma. They were graduates of Radcliffe, Smith, Bryn Mawr, Mount Holyoke, Wellesley, Vassar, and Barnard as well as of top private high schools like Miss Porter's, Dana Hall, National Cathedral, Emma Willard, Rosemary Hall, and Miss Spence's. Their sheer numbers baffled Katharine. "I can't help wondering where all these girls come from," she mused to a faculty member.

The answer was simple. Her plan worked. Before Gibbs, many students saw few opportunities and were aimless or unsure of themselves. Afterward, they knew what they wanted and they knew how to pursue it. Other young women noticed, nodded, and followed. Katharine's first generation of graduates were her best advertising, and they laid the foundation for decades of the school's future success.

After finishing at Gibbs's Boston school in 1924, former "commonplace little me" Natalie Stark upgraded her style from tomboy casual to sleek, modern professional. And with first-class skills now to offer to the

Natalie Corona Stark
before Gibbs, 1922
COURTESY OF THE CROUTER
FAMILY/ SCHLESINGER LIBRARY

Natalie after Gibbs, Summer 1925,
at home in Dorchester, Massachusetts
COURTESY OF THE CROUTER
FAMILY/ SCHLESINGER LIBRARY

legal case that had riveted her attention, she volunteered as a secretary for the lawyers representing Sacco and Vanzetti. The two politically radical Italian immigrants had been convicted of murder three years earlier, and since then their defense team had been filing motions for a new trial. Watching up close as the judicial system refused to budge, Natalie saw that "smoothness and suavity scarcely veiled the clash of class and privilege versus attempts to change." That thought would stamp her future.

In early 1925, as defense efforts to secure a new trial lumbered toward doom (Sacco and Vanzetti would be executed on August 23, 1927), twenty-six-year-old Natalie left to join her father on a round-the-world trip. But only weeks after sailing to the Far East, her father became seriously ill. While he recuperated for five days in Manila, she planned their trip home

to Massachusetts — with the help of a handsome young American she met in their hotel lobby, thirty-one-year-old Jerry Crouter, who'd served as a first lieutenant in the US Army during World War I. Assigned to the Philippines, he'd fallen in love with the place and stayed. Employed now by the Hawaiian Sugar Planters Association as a labor recruiter, he had a gentle, easygoing manner, a tall and robust build, and a sharp mind honed at the Colorado University School of Law. As they discussed books and politics, Jerry, less radical than Natalie, defused sparks of conflict with his lively sense of humor. Perfect.

Arriving home, Natalie decided she wanted to marry Jerry. (Gibbs training didn't frown at marriage, only at depending totally on a man.) After her letter-writing campaign failed to produce signs of a commitment, she took stronger measures. Not for nothing had Natalie gone from a C- to an A student at Gibbs. On the ship back from Manila, she'd met a couple who invited her to visit them in Tientsin (now Tianjin), a large port city along China's northern coast. In October 1926 she set out alone for San Francisco, boarded the SS *President Pierce*, and sailed to China.

Natalie and Jerry Crouter in the Philippines, 1931
COURTESY OF THE CROUTER FAMILY/ SCHLESINGER LIBRARY

Travel to China in the 1920s was perilous, especially for a young woman on her own. The country was aflame with political turmoil. Since the 1911 Revolution that abolished imperial rule, a group of ruthless warlords had seized power and chopped up the country into their own private fiefdoms. Between 1916 and 1928, they fought an estimated 160 wars among themselves. In Tientsin in late December 1925, less than a year before Natalie arrived, one warlord had his troops pull a rival warlord off a train and shoot him in the back of the head. With the formation

in July 1925 of the National Government, which aimed to unite China and obliterate the warlords' power, anarchy loomed. As northern China's main trading center, Tientsin was especially vulnerable. Fearing for the safety of Americans, in the summer of 1925 US Marines arrived to bolster US Army forces stationed there.

Undeterred, Natalie arrived safely, settled in with her friends, and invited Jerry to visit. And that was that. He proposed, they married in Tientsin on February 3, 1927, and then sailed to Manila for Jerry's job. Although she took on the traditional role of wife and mother, giving birth to children June and Frederick and following Jerry through job moves that ended in the hilltop resort town of Baguio, inwardly Natalie hadn't changed. Her passion for social justice and her Gibbs-acquired commitment to action remained. She volunteered with the Red Cross, taught English to Filipino nurses, wrote for the *Baguio Bulletin*, and in the late 1930s became a leader of one of the most important, idealistic projects aimed at saving lives in destitute rural China: the Indusco system of labor cooperatives.

Through her wide network of friends — Gibbs training had emphasized the importance of social life — she'd met American writer Edgar Snow, who was now in Baguio recovering from an illness. Author of the best-selling book *Red Star over China*, about the Red Army's rise, Snow was one of the founders in 1938 of the Chinese Industrial Cooperative organization, called Indusco. As if China hadn't already had enough trouble, in the summer of 1937 Japan invaded China, igniting the Second Sino-Japanese War. Soon, the Japanese military either destroyed or took over all of China's modern industry and seized control of China's railways, coastal ports, and internal rivers in order to choke transportation of supplies inland. In vast agricultural areas, families and war refugees were starving. Snow, along with his wife, Helen, and New Zealander Rewi Alley, devised an idea to start small, decentralized industrial cooperatives to produce food and basic goods in these remote areas. While thwarting Japanese imperialism, they believed, the cooperatives would lay the economic foundation of a new democratic society in China. The problem was money. The Chinese

government promised a lot, but gave little, and banks, at best, made loans for terms too short to be useful.

Becoming fast friends with the Snows, Natalie chaired the Baguio branch of the 200-member Philippine Association for Industrial Cooperatives in China. She led fundraising efforts throughout the Philippines, which became a crucial source of foreign financial support; kept the local records; gave a radio speech promoting Indusco; and rallied several hundred leading American executives in the Philippines to petition President Roosevelt for loans to Indusco. She also raised money to benefit Chinese orphans through a program run by Madame Sun-Yet Sen, widow of the revered statesman who in 1912 had become the first president of the Republic of China; the two women would remain lifelong friends. In April 1941, Natalie wrote to a relative, "My picture has been in the Chinese papers twice recently, lost in a welter of Chinese characters!"

Although Chinese bureaucratic rivalry and runaway inflation killed Indusco in the mid-1940s, for a while it made a life-or-death difference. At its peak in 1940, there were 3,000 industrial cooperatives in eighteen Chinese provinces, and an estimated 250,000 Chinese depended on Indusco for a living. Her Gibbs education had shown Natalie the truth. She could make a difference in the world.

While Natalie was overhauling her life in Southeast Asia, UC Berkeley graduate Katherine Towle set about building an academic career. After finishing at the New York Gibbs in 1923, she received a telegram "right out of the blue" offering her a full-time job as an assistant in Berkeley's admissions department, where she'd previously worked part-time. Maybe that could be a launching pad. It wasn't. After three years of advising prospective students about admissions standards, she hadn't advanced an inch. Then, her Gibbs credential spun dross into gold.

Part of Katherine's job was to explain the university's requirements to high school teachers and principals, one of whom was Edith Bridges, cofounder and headmistress of Miss Ransom and Miss Bridges School, an elite girls' school in Piedmont, California. With Marion Ransom having retired due to poor health and Bridges in her mid-fifties, the school needed

new blood. Twenty-eight-year-old Katherine, with her Berkeley degree and her Gibbs poise and polish, was the perfect candidate for resident dean.

She'd think about it, Katherine said. What she really wanted was to be a university professor. So, she went off on a year-long trip to Europe, and after returning in May 1927, she consulted a political science professor at Berkeley. He set her straight. No, as a woman she would not be accepted into the PhD program, and no, she could not have a teaching assistant position. But she could return to her old entry-level job in the admissions department.

Gibbs training taught that the first five years of a woman's career were crucial, a direction-setting, goal-defining time. Katherine faced facts. The university had shown how little it thought of her. By contrast, upon contacting Edith Bridges at the Ransom and Bridges school, she learned that they'd held the job of resident dean open the entire year, hoping she'd accept. There was a lot to be said for going where she was wanted versus staying where she wasn't. She accepted the offer and in late summer 1927 moved to the school's campus in Piedmont, a prosperous hillside town overlooking the San Francisco Bay.

The job was magical. Overnight, Katherine had zoomed up the career ladder from an underling to an authority, with a luxury lifestyle tossed in as a bonus. The school's elegant Mediterranean-style buildings had been designed by Hearst Castle architect Julia Morgan and were surrounded by redwood trees, tennis courts, and beautifully kept grounds. "It was really a charming place," Katherine would recall. "Miss Ransom and Miss Bridges both had excellent taste and it was reflected in the whole school." Assigned a lovely apartment on campus, she supervised about fifty mostly high school age boarders among the school's three hundred students. At least once a week, she went horseback riding with her charges in the hills behind Piedmont.

Two years later, when Edith Bridges retired, the school's trustees promoted Katherine to headmistress. At thirty-one, she now led one of the most prestigious private schools on the West Coast. Given executive powers that were unheard-of for a woman her age, she pulled the school into

the modern age and reversed its financial troubles. Along with the school's academic head, Katherine started a successful preschool — a rarity in its time — relaxed old-fashioned stuffy rules that severely limited visitation, brought in outside speakers, and generally created a lively learning atmosphere. Even if she never became a university professor, Katherine realized, "working with young people . . . could really offer lifelong and rewarding enrichment and experience."

On the East Coast, Smith graduate Katharine Brand, whose warring parents had constantly shuttled her around the country and whose father had scoffed at her literary ambitions, got her own fresh start as secretary to famed muckraking journalist Ray Stannard Baker. A close friend of Woodrow Wilson who'd served as his press secretary at Versailles, fifty-five-year-old Baker had just been named the late president's official biographer. Katharine got the job because she pursued it aggressively — the first time she'd ever acted so boldly.

Katharine Brand, 1921

It had taken a while for the trademark Gibbs confidence to settle on her. For nearly two years after graduating, still loyal to her father, she'd slogged through miserably underpaid jobs with his former employer, the Congregationalist Church in Boston. Finally, no longer willing to get by on a doughnut for breakfast because that was all she could afford, she quit. Then, in early 1925, learning of Baker's appointment. Katherine wrote to him, told him he'd surely need a secretary, proposed herself for the job, and got it. Baker agreed to a comfortable salary and a month's paid vacation annually.

The position was a prize catch. Instead of a dreary impersonal office, she worked in a study off the dining room in Baker's home in Amherst,

Massachusetts, with a fireplace in the corner and rows of books behind her. Theirs was a huge task. Shortly after she started, on a spring day in 1925, a truck pulled up in front of Baker's house to deliver five tons of Wilson papers — a haphazard assortment of historical documents and every scrap of paper that Wilson's widow, Edith, had found. "Five tons of papers! What in the world am I to do with them?" Baker had moaned.

Not to worry: Katharine was soon doing far more than typing and filing. She offered to compile a chronology — yes, Baker agreed, that was a very good idea. Vacationing in Europe in the summer of 1926, she interviewed several Wilson acquaintances. Upon returning, she continued that work, meeting a colorful cast of characters who included "a poor old drunken wreck who used to be a newspaper editor," a "stout Irish mayor, who produced endless details of his own life and works but could not be brought to the point," a lawyer who propped his feet up on the desk while talking to her, and a "distinguished gentleman, a member of the Cabinet in fighting days, whose face lighted up as he reviewed the old battles." She read letters "signed by the great and the near-great of the world" and reviewed page proofs in New York with Baker's publisher, Russell Doubleday.

Equally important for someone who'd never felt important, Baker and his wife, Jessie, treated Katharine kindly and included her in social events. After Thanksgiving dinner at their home with their children and several friends, she joined the group around the fireplace, talked for hours, and sang college songs. "That's a real family," Katharine wrote in her diary. When Edith Wilson came to dinner, the Bakers invited Katharine, too. One evening, after she mentioned to Jessie Baker that she "felt blue," the couple took her out to dinner. "They are two of the nicest people in the world," Katharine decided.

She would stay with Baker for fourteen years, through all eight volumes of the work.

While Katharine Brand was documenting history in Amherst, elsewhere in Massachusetts Mary Sutton Ramsdell — the divorcee whose homosexual husband had deceived her into a false marriage — was making history. In June 1930, forty-year-old Mary became one of the first two

Massachusetts State Policewomen sent out into the field to investigate crimes. (Previously, female officers worked only in safer jobs like factory inspection.) Mary had initially put her Gibbs training to use in Boston at the Welcome House of the Florence Crittenton League home and hospital for unwed mothers. Despite its cheery name, the Welcome House was actually a private detention home that took in pregnant girls referred by the courts as well as by public and private agencies; most had been rejected by their families and had nowhere else to go. After two years, Mary saw the problem. When a young woman fell from virtue, obviously some man was involved — yet she, not he, was called to account and punished.

Issued a gun, a blackjack, and a badge and assigned to investigate crimes involving women, Officer Ramsdell was now in a position to do something about that. Not that anyone in authority cared much. No newspaper sent a reporter or photographer to cover her and Lotta Caldwell's swearing-in ceremony, and the State Police hamstrung her with sprawling responsibilities and scant resources. By herself, she had to patrol rural districts in the western half of the state that had no local police forces (Lotta got the eastern territory), and she did so in a small, broken-down rattletrap Ford that made so much noise she named it "the Racketeer."

But Mary, despite her small stature, was relentless. On duty twenty-four hours a day, seven days a week, she drove 70,000 miles in her first year. A parked car by the side of the road, lights out, an older man and an underage girl: that was a frequent scenario revealed by Mary's flashlight. As was a teenage girl seduced by the hired hand working on her father's farm. Although the girl was often charged as a sex offender, Mary always pleaded for mercy. Usually, a judge released the girl into Mary's custody, and she found a foster home where the girl could forget the past and start over.

Many other cases involved tracking down sexual predators reported to the police by teachers, ministers, district nurses, and child protection agencies. "Trying to get the man is the hardest thing I do," Mary said. "If I ever do succeed in finding him, he can usually get a clever lawyer who will find a way out." Once, she was "awfully proud" of arresting a man found with a fifteen-year-old girl. "I told myself that here was one time a man was going

to get what was coming to him. The girl in question was feeble-minded. Imagine my feelings when the case came to court and his lawyer brought up the point at once that a feeble-minded person cannot testify in court. I had forgotten there was such a law. Of course, we lost the case." Another time, she investigated twenty young men in Great Barrington for the statutory rape of two girls under sixteen. All the defendants were placed on probation and the local police department began proceedings against the two girls for being "wayward in their conduct."

Despite such infuriating outcomes, despite witnessing unending "sordidness, ignorance, squalor, and cruelty," Mary went the distance for a twenty-year career. She did get some men sent to prison on morals charges and, believing that juvenile delinquency began in bad homes, she intervened swiftly. More times than she could count, when told of young children left alone, she marched into a nearby bar and hauled their parents home. When children had been badly abused, she petitioned the court to remove them so they would have "at least a fighting chance to make a success of their lives." One twelve-year-old girl, sent out-of-state to a good school, graduated with honors. Six siblings placed in foster care all turned out well. Ron Guilmette, of the Massachusetts State Police Museum and Learning Center, called Mary a pioneer in the investigation of crimes involving women and children: "It was an all-white male force and there were many who felt there was no room for women in policing and they should be at home taking care of the children. Mary earned their respect and confidence . . . and became an advocate for women and a respected leader in the law enforcement community."

It didn't always pay to be ahead of the times. Sometimes, the consequences were heartbreaking. Helen Havergal Clark, a graduate of Gibbs in Boston in the late 1910s, discovered that the hard way.

In October 1923, twenty-six-year-old Helen stepped off a boat in Swatow, China, equipped with a pith helmet, mosquito netting, and big dreams of making a difference where it counted. The daughter of a Baptist minister, she'd invested a lot to get here. First, after Gibbs, she'd spent three years in a secretarial job at the New York office of the Woman's American

Baptist Foreign Mission Society, waiting for funding to send her overseas as a secretary. Then, as Natalie Stark would three years later, she braved a long, dangerous journey to China.

Swatow (also known as Shantou), on the east coast north of Hong Kong, had been ravaged not only by warlords but also by blithely indifferent Mother Nature, which fifteen months earlier had pummeled the area with a typhoon and tidal wave, killing an estimated 50,000 people. On the last leg of Helen's trip from Hong Kong, an armed Indian Sikh had patrolled the deck ready to shoot pirates known to prowl the waters.

Nevertheless, Helen was instantly captivated by China. "I love it and am so happy to be here," she wrote home, describing "a most beautiful pink sky," tall pine trees, and a harbor bustling with sampans. Cranking out correspondence was less enchanting. Taught at Gibbs that nobody was going to give her what she wanted unless she asked for it, she soon began lobbying for a transfer to the Industrial Mission at Shaohsing (now Shaoxing), where some 200 Chinese women and older children earned decent wages making dolls and cross-stitch embroidered linens. Children under twelve had to attend school all day, while those between twelve and nineteen could split their days between school and work — a radical policy at a time when China had no compulsory education and most poor people, especially women, were illiterate.

The mission desperately needed help. On the brink of closing, it was understaffed and the head was suffering from a life-threatening illness. Yet the work was crucial because local Chinese Christians often faced a choice between faith and survival. About one-third of Shaohsing's 300,000 residents earned their living manufacturing "spirit money," (also known as joss), elaborate fake bills that followers of Chinese folk religion burned to try to win favor with their dead ancestors, whose spirits were believed to shape the future. Amid rising Chinese nationalism, Christians also risked persecution — many were denounced as "running dogs of Western imperialism," harassed, and sometimes killed.

Her transfer approved, hoping to serve "the real China," Helen arrived in Shaohsing by the spring of 1925. Initially assigned for only three months,

she would remain there till 1934, having become superintendent of the Industrial Mission. Unlike many old-guard Protestant missionaries who viewed Chinese society as "weird and wretched" and tried to "fix" it by imposing Western standards, Helen respected the indigenous culture and aimed to win converts less by proselytizing, more by serving the needy. She could best do that, she believed, by making the mission prosperous.

With Gibbs-honed business hustle, Helen zealously pursued new customers for the mission's products. She created a special "Christmas Present Package" of assorted linens, ran ads in US Baptist publications, and badgered her friends back home to send in orders with advance payment each of $5.55 ($101 today). She planned her vacations in potential new markets, drummed up orders, set production schedules, priced goods, and oversaw billing and shipping.

Not even mortal danger could stop her. In early 1932, Helen was at the mission's business office in Shanghai, when more than five weeks of brutal warfare broke out between Chinese and Japanese troops. As machine guns fired in the distance and airplanes whirred overhead, she saw barbed wire barricades, barred shops, and thousands of refugees fleeing the city carrying suitcases and bedrolls. She stayed. Thanks to her leadership, the mission was now successful. She loved the work and, according to a visiting missionary, was "much esteemed."

In the end, though, Helen proved too modern for both the Baptists and the Chinese. Both groups were scandalized when she was seen walking the streets arm-in-arm with one "of our best Chinese men" and visiting him at his office. Gossips also chattered that she'd developed an "ardent" crush on a Chinese pastor, pledging $500 (about $12,000 today) to one of his projects when most people gave $10–$25. Although her behavior doesn't seem to have gone any further, given China's instability, this could not be tolerated.

No one took her aside and warned her. Nor did it matter that, as Baptist leaders in the United States conceded, she'd done "a valiant piece of work." They furloughed her home to Exeter, New Hampshire, in July 1934 and pressured her from various directions to resign. For a long time, she

resisted. China was the love of her life. Her mind was brimming with ideas about ways to expand sales. Recognizing that she was in "a grave crisis," Helen's parents worked slowly and gently to persuade her that returning to China was a lost cause.

"Give to courage a smiling face," Katharine Gibbs had written a few years earlier in the alumnae magazine. Helen couldn't quite manage that, but she did summon the grace to make a dignified exit, submitting a one-sentence resignation letter in December 1935. It was approved in April 1936.

Then she carried on. At thirty-nine, she still had more than half her life to live (she would die in 1991 at ninety-four). She served as treasurer for her father's church and other local organizations; she got a job as a secretary at a private school. During World War II, she chaired the local United China Relief Committee. She never married. That may have been a hope lost with one of the Chinese men she admired. And, evidently, she never returned to China.

Other stories of early pathfinding Gibbs graduates remain only in brushstrokes, and surely many more have disappeared entirely from public view. Newspapers spilled ink lavishly when a woman got engaged or married, but hardly otherwise. Women's personal papers from that era rarely survived. Still, they made their mark.

Lenna Wilson

In 1926, Lenna Wilson, from the tiny farming town of Sharon, New Hampshire, was elected to the New Hampshire State Legislature, where she served two terms and became a leading member of the House Fish and Game Committee. Two years later, her neighbors also voted her onto Sharon's board of selectmen, the executive group responsible for town government — the first woman in New Hampshire history to

EXPECT GREAT THINGS! 67

hold such an office. She served four three-year terms, and every year her male colleagues named her board chairman. Over time, she filled nearly every local post except dog catcher, including town clerk, town treasurer, library trustee, and Sharon's representative to the New Hampshire Constitution Convention.

Days after graduating from Gibbs in Boston in 1920, former music teacher Clara D. Davies landed a secretarial job at the *New England Journal of Medicine*. Rising steadily through the ranks, she eventually became executive editor.

Peg LaCentra's rich contralto voice and blond good looks were undoubtedly valuable assets, but it was after she finished at the Boston Gibbs school in 1929 that her entertainment career soared. The daughter of an Italian immigrant barber, she restyled herself as a silk and orchids sophisticate and within months landed an announcing job on Boston's WNAC radio. She went on to sing with Phil Spitalny's famous all-girl band and in 1936 joined Artie Shaw's orchestra. In the movies, she dubbed the singing voices of Susan Hayward and Ida Lupino.

While polishing the school's reputation to a high shine, this first generation of Gibbs graduates took a pickaxe to the foundation of male authority across American life. Any man who'd worked with them, if he was at all paying attention, could no longer insist that women were flighty featherbrains who belonged at home. A long road to equal opportunity lay ahead, but the quiet, groundbreaking work had started.

"Give to Courage a Smiling Face"

∾୦c๖

SUCCESS TRANSFORMED NOT ONLY her students, but Katharine Gibbs as well. The one-time girl in Victorian ankle-length skirts had become a modern woman constantly on the lookout for the new and the now. By the late 1920s, she'd moved to a twelve-room apartment in an ultra-exclusive building at 280 Park Avenue and hired three servants — a cook, a butler, and a chauffeur. Riding in the elevator, she might have met automobile manufacturer Walter P. Chrysler, *Time* magazine's 1928 man of the year, who also lived there. After aviation became a national obsession following Charles Lindbergh's historic 1927 solo flight from New York to Paris, she flew back and forth among her three schools.

Beyond school hours, the once happy housewife and mother took her own advice and embraced the world at large. She went to the theater, to the symphony, to museums, and every summer boarded a luxury liner to Europe where, in addition to exploring historical sites, she poked through bookstalls in search of the latest literature. Relentless self-improvement was "essential to her peace of mind," observed Erwin H. Schell, an MIT professor of business management who taught at the Gibbs school in Boston. "She was inherently accustomed to advance." If she enjoyed any romances, there's no record of them. The only men in her personal life seemed to be her two grown sons who, along with her sister Mary, shared her spacious apartment. That was plenty of company.

It was an enchanted life. And then it shattered.

In October 1929, the stock market crashed, throwing the economy into a tailspin. Enrollment at the Gibbs schools plunged. As millions of male breadwinners lost their jobs, as bank failures wiped out life savings, as stock portfolios nosedived, families flinched at the prospect of paying for upscale job training for their daughters — especially if they'd just finished paying for four years of college.

Seen from one angle, a Gibbs education was pointless. The Great Depression promptly put more than two million women out of work and decimated prospects for promotion. As US Senator Robert Wagner of New York commented: "Stepchildren of industry in times of sunshine, they [women workers] became the first orphans of the storm." Good jobs, when there were any, went to men with families to support. Even a fancy women's college degree meant nothing. A 1934 Barnard College graduate, for instance, felt lucky to land a job as a salesgirl at the B. Altman department store, working a forty-eight-hour week for $15.

Young single women — the profile of most Gibbs graduates — were highly vulnerable. Between 1931 and 1932, the number of homeless women seeking shelter increased by 500 percent, and many of them were newly destitute, younger "white collar" or "lace collar" workers. In October 1932 — three months after the Depression hit rock bottom — experts predicted that 30,000 unemployed single women would be homeless that winter in New York City because they had exhausted their savings after long-term joblessness. Many had deteriorated mentally; some suffered nervous breakdowns and had to be hospitalized. Joblessness induced not just poverty, but also despair, social alienation, and deep psychological damage.

With the odds stacked so high against a successful outcome and with the consequences of wasting money so dire, a Gibbs education became a hard sell.

"I believe that life requires of us all one most important thing, and that is the courage to meet it squarely . . . to meet discouragement with a mind that looks forward to the time when it shall be safely past," Katharine

wrote in December 1930. "When you give to courage a smiling face, and to strength, gayety of spirit, you have equipped yourself to meet life on any terms it offers."

Ever optimistic, she glimpsed veiled opportunity. Yes, families were in trouble — but that meant all hands were desperately needed on deck, including those of previously idle daughters. And yes, jobseekers far out-numbered available slots. But that meant employers urgently needed smart, personable, efficient workers who could do the work of two or three while collecting only one paycheck.

Part of Katharine's genius was to know when to flip conventional wis-dom on its head. Just as she had made a huge success of training women for top-flight jobs when she herself had never held a job outside the home, now — faced with crumbling revenues — she did something that didn't make sense until it made perfect sense: she doubled up on elegance and exclusivity.

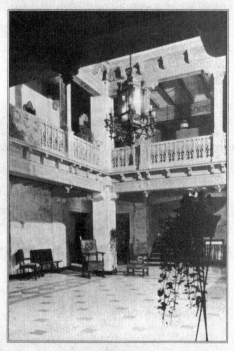

Barbizon Hotel lobby, 1930

In 1930, she took over the entire sixteenth floor of the Barbizon Hotel for Women as a residence for students at the New York school. Opened just three years earlier on sycamore-lined East 63rd Street at Lexington Avenue, the Barbizon offered glamorous respite from the mounting miseries of the Depression. Gibbs students could take a dip in the indoor swimming pool, whack balls on the squash court, attend music recitals, and sink deep into plush upholstered armchairs or play the piano in the wood-paneled twenty-second floor lounge, which was reserved exclusively for their use. From the rooftop sundeck, young women on the brink of their future could gaze out over the troubled city and still believe in its magic.

Library in a Katharine Gibbs residence in Boston
GIBBS SCHOOL BROCHURE, 1932–33. WIDENER LIBRARY, HARVARD

With similar bravado, in Boston in October 1930 Katharine bought a five-story private home at 303 Dartmouth Street and converted it into another elegant student residence.

Gibbs curriculum also got an extra dash of sparkle. Even as once-chic women were darning their stockings and making do with outdated styles,

in 1933 Katharine added a new course in high fashion because, she believed, dressing well was "one of the most important avenues to success." As visiting lecturers, she lined up a parade of top style mavens, who probably didn't come cheap. Among them were the editor-in-chief of *Vogue*; a Lord & Taylor vice president; Tobe Coller Davis, whose Tobe Fashion Service advised department stores about the latest couture trends; and designer Clare Potter, one of the inventors of American sportswear and a pioneering brand-name American designer.

Of course, Katharine didn't expect her students to swan around in Chanel or Lanvin. They needed to learn how to make, not spend, money. To prove that tasteful, well-made clothes could be had on a thrifty paycheck, a team of "Gibbs budgeteers" scanned the racks at mid-priced stores and brought back sample outfits. Their tips: polka dots were popular for business wear; patent leather purses could be easily wiped clean; a simple straw hat would accent both sturdy dimity and day-to-evening silk; dark-colored shoes were best for hiding scuffs; and hands off that all-white outfit because it would have to be laundered after every wearing.

Fine Arts lessons moved out of the classroom and, in New York, into the Metropolitan Museum of Art, where they were taught by the museum's lecturer, Grace Cornell. In Boston, *Christian Science Monitor* art critic Dorothy Adlow took Gibbs students on tours of the Museum of Fine Arts, the Fogg Museum, and the Isabella Stewart Gardner Museum.

A cyclone of energy during the Depression, Katharine kept spinning out new ideas. Two months after the stock market crash, she started an alumnae magazine, *The Gibbsonian*. Over the next few years, she launched alumnae clubs, expanded the Placement Department, and surveyed 2,000 businesses to learn which qualities they valued most in a secretary and what shortcuts her graduates could take to get ahead. In 1932 she wrote a series of career advice articles for young women. Syndicated to newspapers nationwide, they had titles like "Do You Want a Job?" "Be Careful of Appearance in Applying for a Job," and "For What Sort of a Position Are You Fitted If You Seek a Job?"

In her most daring move, as businesses shuttered nationwide and

Hooverville shantytowns sprang up in Central Park and on the Upper West Side, Katharine kept her prices high. There would be no tuition fire sale here. Between 1930 and 1933, she did slightly lower costs for residential students, but not in keeping with high rates of deflation during those years. And all Gibbs day students faced higher bills. Fees for the one-year course jumped from $375 to $400 (from $9,100 to $9,800 today). The two-year course still cost $400 for the first year, but the second-year price increased from $375 to $400. The school offered no financial aid except for one scholarship, started in 1932 and funded by alumnae contributions. (The first winner was seventeen-year-old Kathleen Michaud of Eagle Lake, Maine, whose widowed mother single-handedly ran fishing and hunting camps while raising five children.)

Admission standards remained sacrosanct. Katharine hadn't taken unqualified candidates in the early years when she'd faced a sea of empty desks, and she wasn't about to do so now. Applicants had to submit the names of two references, who were then asked to rate the young woman on criteria like "bodily health," "mental alertness," "loyalty," "self-control," "consideration of others," and "vision, disposition to grow."

Her upside-down strategy worked. By 1934 total enrollment had rebounded to the pre-crash level of 1,000, and demand from employers outran the supply of graduates, with the placement department fielding requests to fill 1,455 secretarial positions. It was an impressive accomplishment. The US economy had only started to stabilize, with full recovery years away, and the national unemployment rate remained staggeringly high at 21.7 percent.

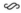

HARD TIMES BROUGHT A new woman to the Gibbs schools: one who'd seen her expectations of a leisurely future collapse. Katharine Gibbs training bridged the two worlds. Gracious surroundings and genteel manners provided a touch of the past, easing the fall, while tough-minded skills and strategy classes prepared her to tackle a harsh new reality.

Teenager Dorothy O'Shea arrived at the Boston school in the early 1930s after hitting the ground with a jolt. A decade earlier, Prohibition had outlawed her father's wholesale liquor business in Worcester, Massachusetts. Not that a little matter like the law was going to stop John J. O'Shea. Rebranding the company as a "Soda and Mineral Waters" dealership, Dorothy's father made his real money as a bootlegger and on a grand scale. Although he listed his occupation as "none" on the federal census in both 1920 and 1930, his "unemployment" funded a lavish lifestyle. During the 1920s, the family moved into a recently built, five-bedroom arts-and-crafts home on a third of an acre in one of Worcester's best neighborhoods. Servants waited on them, and young Dorothy had her own pony and a Harlequin Great Dane named Buster. When she went to the movies, driven by a chauffeur, she sported a white mink coat with a matching hat and muffler.

However, the good citizens of Worcester were none too happy about the rivers of hooch flowing through their town, nor about local law enforcement's nod-and-a-wink tolerance of the trade. After vigorous appeals to the National Prohibition Headquarters in Washington, DC, thirty-five federal agents swept into Worcester "like a thunderbolt" on January 28, 1924, and confiscated large amounts of whiskey, moonshine, and beer. Among the fifteen people arrested was Dorothy's father. It wasn't the family's first clash with authority. In 1905, in the biggest raid ever made on liquor dealers by the Massachusetts State Board of Health, Dorothy's paternal grandfather, Patrick O'Shea, had been arrested for selling beer containing potentially lethal salicylic acid (now used as a skin exfoliant).

The outcome of her father's arrest isn't known, but within a few years he was at home and listed in the city directory as a real estate investor. After the stock market crash, his business failed, and in September 1931, when Dorothy was sixteen, he died at home at age forty-six of heart disease. Those events punched a big hole in the family's life.

With no money coming in, all the servants had to be dismissed. Now, instead of "elegant meals" prepared by a cook, "we had Franco-American spaghetti out of a can, warmed with a fried egg on top of it," Dorothy would

recall. Her mother "tried to economize, but we would have the worst god-awful meals. She would say, 'I can't do it. I don't even know how to work the stove.'" Her father had also been their emotional mainstay. Blessed with a buoyant sense of humor — he'd named two of their dogs "Get Off the Rug" and "You Too" — he'd made life fun. Without him, Dorothy's mother grew despondent.

It was a terrible time to be left high and dry, especially in heavily industrialized Worcester. By the end of 1931, one-quarter of the town's workforce was unemployed (compared to 15.9 percent nationally) and many of those still on the job took home reduced wages. Her family gave up their large house and moved to an apartment.

For Dorothy, the Katharine Gibbs School offered hope. School literature promised to train women for "undreamed-of avenues of satisfaction, usefulness, and enjoyment" and listed graduates in upwardly mobile jobs such as manager of the Women's Department at Boston's Merchants National Bank; reporter at *Fortune*; advertising copywriter at BBD&O in New York; and department head at the Anglo-South American Bank in San Salvador. After scraping together tuition money to attend Gibbs in Boston, Dorothy took an early job as a secretary at a machine tool company and then set out on an adventure that rebuilt her life.

In the early 1940s, she moved to Washington, DC, and joined the Carl Byoir public relations firm where eccentric millionaire Howard Hughes became a client in 1946. The founder of Hughes Aircraft was in scalding hot water. During World War II, the War Production board had awarded him a total of $40 million to build military planes, but he had delivered just one — an unusable photo-reconnaissance plane. Particularly embarrassing was the fate of the $18 million contract Hughes received in September 1942 to build three 100-ton cargo planes from wood instead of metal, which was vitally needed elsewhere in the war effort.

Three years later when combat ended, Hughes was still hammering together the one and only wooden plane he would ever build, the behemoth Spruce Goose, a.k.a. "the flying lumberyard." It was sheer, egomaniacal folly. Vastly overweight at 300,000 pounds, the clumsy craft

had a wingspan as wide as a football field and would make only one, very brief flight near Long Beach, California. When the postwar Senate War Investigating Committee began to scrutinize contract spending, knowing that the spotlight would land on him, Hughes hired the Byoir firm to create a defense strategy.

Assigned to the Hughes team, Dorothy got swept into a vortex. Hughes summoned her to meetings and bombarded her with phone calls on business matters day and night. Although details are lost, it was highly unusual for him to include a woman in sensitive, top-level strategy sessions. All his advisors and executives were male. Yet, despite his reputation as a skirt-chasing, two-timing rake, Hughes made no play for young, trim, pretty Dorothy. Her crisp Gibbs professionalism signaled "no chance," and had he tried, one of her friends commented, "she would have punched him."

When Hughes began his Senate testimony in early August 1947, Dorothy had a ringside seat at one of the great political prizefights of the twentieth century. While Maine Senator Owen Brewster slugged at Hughes with allegations of bribing army generals and federal officials with lavish parties and free flights on his TWA airline, Hughes punched back hard. Brewster, he charged, was doing the bidding of Pan Am founder Juan Trippe, whose monopoly on trans-Atlantic routes TWA had challenged. In the end, because there was nothing illegal about Hughes's "hospitality" and, after all, he had sunk $7.5 million of his own money into the Spruce Goose, press referees held up his arm as the winner. The government stumbled away with a black eye. Dorothy had come a long way from humdrum Worcester.

In her personal life, too, she transformed herself. Mothballing the flashier fashions of her youth, she adopted the subdued, classic style taught at Gibbs, favoring cashmere, Irish tweeds, charm bracelets, and, of course, lovely hats. When she married at age thirty-two in March 1947, she replaced the shaky example set by her parents with a long, happy partnership. Unlike her father, her husband operated strictly within the law. Air Force Colonel Don Greelis was a career military officer who served

in World War II and later in the Korean War. Neither did she replicate her mother's passivity. Once when she was away on a trip, Don rearranged the kitchen for "efficiency." Dorothy didn't say a word. But first thing the next morning, she went to his office and rearranged his desk. Don laughed. Friends from later years described Dorothy as "a ray of light" — a refined, elegant sophisticate who drank single malt Scotch, subscribed to *The New Yorker*, and mingled easily in any crowd. Nobody would have guessed she was a bootlegger's daughter from a smashed-up family.

The Depression walloped Mary Goodrich's life in a different way. While her old-guard New England family held on to the fortune amassed by her grandfather, Elizur Stillman Goodrich, who'd helped develop the railroads in Connecticut, in late 1930 Mary lost her dream job as a newspaper reporter. For more than two years, she'd been a local celebrity, the *Hartford Courant*'s first aviation reporter and columnist. She'd won the position at age twenty after writing freelance articles about her flight training and earning the first woman's pilot license in Connecticut. With her stories sometimes splashed on the front page, she covered competitions, crashes, and technical developments in the field.

Just as much as she loved reporting, she loved flying. Above her parents' house, she'd temporarily throttle the engine to a low hum and shout, "I'm on my way home for supper!" Once, late for an afternoon bridge party thirty-five miles away, she hopped in a plane, zoomed over, and made a smooth landing in the hostess's backyard right by the kitchen door. In 1929, after buying a two-seat open cockpit plane, she became a charter member — along with Amelia Earhart — of the Ninety Nines, a support group of ninety-nine female pilots. Two years later, she was appointed a director of the new Betsy Ross Corps, a group of female pilots ready to assist in national defense during emergencies.

But a year after the stock market crash, with the national economy in freefall, the *Courant* let Mary go. Men needed jobs; she still had her well-off parents for support. She and a partner started a company to make exact scale models of airplanes for collectors. The business failed. At least she still had flying. Then in 1933, she lost her pilot's license after faulty depth

perception, which couldn't be corrected, caused her to try to land fifteen or twenty feet off the ground. Suddenly bereft of the two activities she loved the most, Mary had no path forward.

In the fall of 1933, shortly before her twenty-sixth birthday, she enrolled at Gibbs in New York. As it did for Dorothy O'Shea in Boston, the training put Mary back on her feet. After a brief stint at the Benton and Bowles advertising agency, she became a publicist with Pendleton Dudley, the Wall Street-based "dean of public relations," and in March 1937 moved to Dallas to supervise all publicity for the Greater Texas and Pan American Exposition. Among her adventures, she traveled to Canada to offer the three-year-old Dionne quintuplets scholarships to Southern Methodist University.

Gibbs graduates rarely worried about the next job. Their credential opened doors. So, when her Texas position ended and Mary wanted to visit California, she did. And after an undisclosed illness landed her in a Los Angeles hospital for three months, with discharge instructions to stay in the area, she found a job with one of the best employers in town, the red-hot Walt Disney Studio. *Snow White and the Seven Dwarfs* (1937), Disney's first feature-length animated movie, had just come out and was hauling in bushels of cash at the box office. The studio, located near Griffith Park on Hyperion Avenue in a two-story Spanish-style building with Mickey Mouse topping the sign on the roof, mixed the warmth of a family business with the excitement of impending expansion.

Hired in March 1938 as a secretary in the new Story Research department, within a month Mary was scouting out story ideas, writing summaries of the plot and characters, and doing background research on costumes, landscapes, and buildings. It was a once-in-a-lifetime opportunity to work directly with one of the greatest imaginative geniuses in popular culture. She didn't recognize him at first. One day, listening to music under consideration for *Fantasia* (1940), she was sitting in her office by herself. Most of the other employees were out on vacation, but she was still too new to qualify for time off. Mary recalled, "This very attractive man came in and said, 'What are you doing here all alone?' . . . So he sat down with me and

Mary Goodrich (left) in the Story Research Department
at the Walt Disney Studios, circa late 1930s

we talked about the music." After a while, "I said, 'I still don't know your name.' He said, 'I'm Walt Disney.'"

They became friends, and over the next few years, Mary contributed vitally to many Disney classics. In addition to *Fantasia,* she worked on the animated features *Pinocchio* (1940), *Dumbo* (1941), and *Bambi* (1942) as well as short cartoons of the "Fab Five" — Donald Duck, Goofy, Micky Mouse, Minnie Mouse, and Pluto. On *Dumbo,* about a flying elephant whose oversized ears serve as wings, Mary would have advised the animators on aviation, said Mindy Johnson, author of *Ink & Paint: The Women of Walt Disney's Animation* — providing information about how to dive bomb or where Dumbo's tail should be in flight. One of Mary's earliest projects, a 1938 synopsis of the Hans Christian Andersen fairy tale "The Snow Queen," would reach the screen seventy-five years later when it served as the rough basis for *Frozen* (2013).

Animated cartoons, Mary felt, magically took her back "to the years we are always trying to recapture, childhood ones." And the real-life

characters roaming the halls were just as much fun. One was the voice of Donald Duck, Clarence "Ducky" Nash, who went around trying out new words in "Duck-lingo." Some of those words, Mary noted wryly, "would never never occur to Donald who at heart is a very good boy."

This cheerful atmosphere crumbled when nearly 300 Disney animators went on strike from May 29 to July 30, 1941. At the time, the studio was under tremendous financial pressure. Encouraged by *Snow White*'s success, Disney had built a new, larger, state-of-the-art studio in Burbank, ramped up feature production, quadrupled the number of employees, and taken out hefty loans to finance the new activity. But when *Fantasia* and *Pinocchio* delivered disappointing receipts in 1940 and the war in Europe shrank foreign revenue, his bankers demanded that Walt cut costs. Facing possible bankruptcy, Disney felt he had no choice except to consider layoffs.

Meanwhile, many — but not a majority — of the studio's animators had grown discontented with arbitrary, inconsistent pay scales, lack of job security, and a class system that awarded the best privileges to those at the top. With their anger stoked by outside union activists, they demanded collective bargaining. The fight turned vicious. Picketers who demonstrated daily in front of the studio hurled insults at Walt as he drove his Packard through the studio gates; several carried a mock guillotine and used it to behead a mannequin of him. In print, they called Disney a rat, a "yellow-dog" employer, and "an exploiter of labor." He accused them of capitulating to "Communistic agitation." Not without reason, Disney felt betrayed. Over the years he and his brother Roy had made countless personal sacrifices for the company — such as selling their cars to meet payroll in 1928 and reinvesting $2.5 million in dividends instead of taking the money for themselves.

Each side believed it was right. Having worked closely with the animators, Mary faced a painful choice — her colleagues or her friend and boss? She crossed the picket line. So did 60 percent of Disney's animation workforce. Her loyalty during what Disney called "this God awful nightmare" made her a trusted family insider. When, to counteract his increasing depression, he agreed to go on a State Department–sponsored goodwill

tour of South America in mid-1941, his wife, Lillian, needed help persuading him to get the necessary shots. She phoned Mary. Walt blew up. "Oh yes," Mary recalled, "he was mad at me." Unshaken, she walked him in to the doctor. He later apologized and sent her a bracelet to make amends.

After the strike ended in late July 1941, with Disney now a union shop, the studio was never the same. Gone was the warm, casual ambiance. Now, everyone had to punch a timecard and layoffs occurred anyway, made worse by the strike's production slowdown.

Mary resigned on January, 2 1942. She was ready to leave anyway. A year and a half earlier, she'd married her Story Research colleague, Dartmouth College graduate Carl Jenson, and back East, her mother was ill. The couple moved to her hometown of Wethersfield, Connecticut, where they would raise their two children. Mary's time at Disney would always remain a prized memory. In her nineties, recalling those years, she said, "Yes, I was very lucky."

AS HER SCHOOL RECOVERED and her finances stabilized, a cascade of personal troubles assailed Katharine. Bad news came from the Midwest. In January 1931, her intellectually disabled younger sister, Cecelia Ryan, died at St. Anthony's Home in Dubuque, Iowa, of a cerebral hemorrhage at age fifty-seven. Cecelia's adult life had been grim. She'd never held a job, never been married, and under a conservatorship since 1904, had been dragged around to places she didn't want to be — made to live with her and Katharine's oldest brother, Charles, on a ranch in Denton, Montana, where she was miserable, and then in Yakima, Washington, where she was probably even more unhappy. Then in 1920, Charles abandoned his role as Cecelia's guardian. Despite hearings in 1904 and 1918 where multiple witnesses had testified that she was mentally impaired, he persuaded a Montana court that his forty-six-year-old sister had suddenly become fully competent. Poor Cecelia trudged back to Galena, Illinois, where she boarded with a widow, and after suffering a stroke in 1928, was sent to St. Anthony's

Home. She never even got possession of her meager inheritance from the family mansion — a pie slicer, a napkin ring, several nut picks, and assorted spoons and forks. Those items always remained in a bank safe deposit box.

Katharine may well have paid for Cecelia's care — she was the family member in the best position to do so. Even so, she had failed. Despite the thousands of women she'd equipped for independence, she hadn't saved her own sister from an unhappy life controlled by men.

Then came the worst blow. Around 7 a.m. on March 28, 1934, Katharine's older son, thirty-six-year-old William Howard Gibbs, jumped to his death out the window of their ninth-floor apartment at 280 Park Avenue. In his pocket, scribbled on the back of an envelope, he'd written a note addressed "To my family." It read: "Please forgive me. Either this or the madhouse. Consult those who know." As far as events could be pieced together, William had gone out the night before and upon returning had dismissed the family butler, who was the last person to see him alive. Then, for hours, fully dressed, he sat in the living room drinking beer before deciding to end his life.

Katharine, seventy-one, made no public comment. Instead her younger brother, John M. Ryan, an assistant US attorney in New York, explained to reporters that for the past four years William had suffered from a severe ear infection for which all treatments had failed.

There was more to it than that. Mentally fragile, William had never found his way in life. His troubles may have begun during World War I, when, for the last few months of fighting in 1918, he served as an ambulance driver with the US Army Ambulance Corps in Europe. Returning home, he enrolled at Columbia University, but dropped out after a year. He tried selling cars. That didn't work out either. Then he joined his mother's business as a vice president. He never did much work and in early 1929, he was evidently hospitalized. Around 1930, William resigned his position at Gibbs. In his mid-thirties, unemployed, never married, he still lived in Katharine's Park Avenue apartment.

Katharine had once advised her students "to carry your hearts high in the face of difficult things." That's what she did now. "It is an unwritten

law of the business world that you wear a calm exterior and that you smile in spite of home problems that follow you to the office. If you can be serene and cheerful and attend to office details not half so important as your own problems, you have an excellent chance to hold your job," she'd written two years earlier. A time of trial was "a time to inspire confidence and suggest strength and endurance."

Only weeks after William's death, Marie L. B. Sharp, dean of the Boston school, visited Katharine in her office in New York on a Saturday morning and found her vibrant and cheerful: "I was struck…with the great strength and precision of the short, slight figure which preceded me. The sparkle of her keen eyes and the quiet gaiety of her laugh as she turned her head were most contagious and stimulating."

But it was all too much. Katharine's health had been steadily declining. Her handwriting had become shaky, that of an old woman. By early 1934 she was no longer able to zip back and forth among her three schools.

Life finally caught up with her. She had survived so many traumatic events: her father's sudden death, which ended her carefree life in the Midwest; her husband's sudden death, which left her destitute in Rhode Island; more than two decades of unrelenting struggle to build a prosperous business out of nothing, and now, the crippling sorrow, her first-born child's suicide. Her spirit could take it, but her body couldn't. In the spring of 1934, she became critically ill and entered New York's Lenox Hill Hospital.

Katharine died there of pneumonia at age seventy-one on May 9, 1934. Two days later, a requiem mass was celebrated at St. Patrick's Cathedral on Fifth Avenue. Students, staff, and alumnae from all three schools filled the pews. News of Katharine's death appeared in papers nationwide, often in just one brief sentence — despite the fact that more than 10,000 women had graduated from her schools.

Her colleagues were stunned. Katharine had been the heart and soul of the school, the visionary leader who'd held them all together. Columbia University English professor Angus Burrell, who taught at Gibbs in New York, described Katharine as "one of those gifted and courageous

pioneer women that Willa Cather has so beautifully recorded." Elizabeth Whittemore, the Boston school's registrar, called Katharine "the most remarkable individual I have ever known" and expressed the feelings of many when she wrote, "No head of a business or school organization ever won or deserved higher respect than Mrs. Gibbs, and for none could it ever have been a greater privilege to work."

Without its charismatic founder, it seemed impossible that the Katharine Gibbs School could continue.

The Tiffany's of Secretarial Schools

∽◯C◯

CONTRARY TO FEARS, THE Katharine Gibbs School didn't implode into the black hole of its namesake's death. Instead, it entered a vibrant new phase of life under the leadership of Katharine's younger son, thirty-four-year-old James Gordon Gibbs, who took over as president. Known as Gordon, he had his mother's sixth sense about the future coupled with a bold showman's personality eager to tackle the hustle and bustle of mid-century American life. As he later explained, "They said to me in Tiffany's once, 'Ah — you head the Tiffany's of the secretarial schools.' But believe me, I wouldn't take any of that. 'On the contrary,' I said, 'it is you who are the Katie Gibbs of jewelry.'"

A strapping figure with a dapper mustache and a broad smile, Gordon entered the spotlight with surprising exuberance. During his mother's tenure, he'd been a dark horse, staying in

Gordon Gibbs strikes a debonair pose in the late 1930s

PLATEN, 1938, KATHARINE GIBBS SCHOOL
RECORDS, BROWN UNIVERSITY

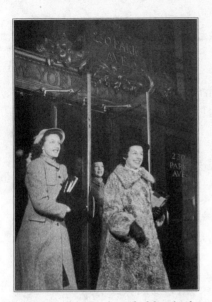

*Gibbs students at the end of the school
day at the New York Central Building*

KATHARINE GIBBS BROCHURE, 1939–40, KATHARINE
GIBBS SCHOOL RECORDS, BROWN UNIVERSITY

the shadows with a history similar to that of his troubled older brother. Both men had served with the Army Ambulance Corps in Europe during World War I; upon returning home, both had enrolled at Columbia University, but dropped out; both joined their mother's school and, unmarried, lived in her sprawling Park Avenue apartment. But by the luck of the genetic draw, where William Howard Gibbs had been brooding and pessimistic, Gordon was confident, sturdy, and, like Katharine, fearless.

Over the next few years, Gordon restyled the Katharine Gibbs School into the women's education equivalent of a tasteful Tiffany blue box tied with a white satin ribbon. In July 1935 he moved the New York school from 247 Park Avenue to larger quarters on the fourth floor of 230 Park Avenue (now the Helmsley Building), adjacent to Grand Central Station. The premises would be decorated with light green walls, plush blue carpets, and expensive upholstered furniture. That same year, he leased the two-acre Rosedon estate in Hamilton, Bermuda, complete with tennis and volleyball courts, for March and April classes as a reward for some twenty-five honor students. Although this perk was discontinued after two seasons when Rosedon was sold, Gordon made the most of it while it lasted—sending photos to newspapers of smiling, shapely students frolicking in the surf and bicycling in the sunshine. There could have been no better advertising.

He also started yearbooks at the New York and Boston schools and literary magazines that published the essays, poems, and short stories by students. Every year, a formal dance was held at a high-society location—in New York at the Ritz-Carlton, the Biltmore, or the Waldorf Astoria;

Gibbs students Dorothea Robinson (in the air) and Emily Brady in Bermuda, April 1936

in Boston, in the Louis XIV ballroom of the Hotel Somerset; and at Providence's Metacomet Country Club. Just as if they were at a debutante ball, young women in organdy and tulle gowns swirled around the dance floor with their tuxedo-clad dates while an orchestra played lilting tunes of the day. At other social events, the newly formed Gibbs Glee Club performed — strategically — with the Princeton Glee Club, whose members in the late 1930s included future celebrity pediatrician T. Berry Brazelton and network TV producer-to-be Henry Morgenthau III.

Social graces zoomed up the list of priorities. Classes were added in etiquette and voice and diction. In Boston, the school offered tickets to the Boston Symphony Orchestra, access to the swimming pool at the nearby University Club, horseback riding in Chestnut Hill, and sailing lessons on the Charles River Basin in the fall and spring. Going head-to-head with elite women's colleges, Gordon arranged for Gibbs students to compete in the MIT Nautical Association regatta on the Charles River. In 1937 two Gibbs students, sisters Carolyn and Constance Currier of Newport, Rhode Island, won fleet honors, beating their rivals from Radcliffe and Brown's Pembroke College.

In New York, a student-run Social Committee planned parties galore. There were afternoon teas three times a week, an annual mother-daughter tea at the Barbizon, and theme parties like 1936's county fair, which had

Worthwhile friendships, the Gibbs School promised, "grow out of pleasant daily associations in the school and in the residences"
KATHARINE GIBBS SCHOOL BROCHURE, 1939–40, KATHARINE GIBBS SCHOOL RECORDS, BROWN UNIVERSITY

Gibbs students enjoying the Barbizon's swimming pool
KATHARINE GIBBS SCHOOL BROCHURE, 1939–40, KATHARINE GIBBS SCHOOL RECORDS, BROWN UNIVERSITY

Plenty of outdoor recreation time, too, for resident Gibbs students
KATHARINE GIBBS SCHOOL BROCHURE 1939–40, KATHARINE GIBBS SCHOOL RECORDS, BROWN UNIVERSITY

side shows, sheriffs, and "ladies of the grange" serving hoedown style food. Some events brought all three schools together. In May 1940, Gordon Gibbs invited everyone to a picnic at the Ram Island, Massachusetts, vacation home he and his wife, Blanche, owned.

After the deaths of his mother and brother in early 1934, Gordon had wasted no time getting married. In the spring of 1934, he took a friend's suggestion and asked his pretty blond secretary, Blanche Lorraine, to a school dance. Naturally, Blanche was a Gibbs graduate, Boston class of 1930. She couldn't very well refuse, nor did she want to, even though she was already engaged to a man in her hometown of New Bedford, Massachusetts.

Blanche Lorraine Gibbs
CARBON YEARBOOK, BOSTON, 1944

"She went to this dance with Gordon Gibbs and at the dance, he proposed marriage. Imagine that! He said, will you marry me? He enjoyed his cocktail, that's how I'd put it," said their daughter, Lorrie Gibbs Button. Skeptical that he might have made one too many trips to the bar, Blanche put him off. "She said, if you're serious, call me at 7 o'clock tomorrow morning. And he did! Because my mother saw a good thing! She could get married to the president of the Katharine Gibbs School; she'd have a good thing going. She was a bit of a snob, my mother, I shouldn't say that…but he came through with his proposal. So, the New Bedford engagement was history." It worked out fine. Both loved sailing and flying and the Gibbs school, and their personalities meshed. "He was outgoing, and he loved to laugh and tell jokes," recalled Lorrie. "My mother was more reserved. But they were a team, for sure."

With the economy finally hauling itself out of the Depression, the late 1930s was an exciting time to be a Gibbs student. Together, these young women could explore the city — no need to wait for a man to call for a date, to suffer through a crashingly dull conversation, or fight off octopus arms at the end of an evening. If some people jumped to The

New York Gibbs students in a Conga line at the school's 1940 Christmas party

PLATEN. 1941. KATHARINE GIBBS SCHOOL RECORDS, BROWN UNIVERSITY

No rest for the weary among Gibbs students
PLATEN, 1937, KATHARINE GIBBS SCHOOL RECORDS, BROWN UNIVERSITY

Wrong Idea upon seeing unaccompanied, attractive young women on the street, the Gibbs-mandated hat and gloves set them straight. This was a new kind of woman, respectable and independent.

In New York, Gibbs students showed up everywhere: in the Grill Room of the Roosevelt Hotel to hear "the sweetest music this side of heaven" from house band Guy Lombardo and His Royal Canadians; at the movies, later to debate the attractiveness of Leslie Howard, Gary Cooper, Errol Flynn, Tyrone Power, and Charles Boyer; in the stands at hockey games; and sampling the fare at restaurants high and low, from scallops at Hotel Taft to White Castle hamburgers to chow mein in Chinatown.

Amid the flurry of social activity, Gibbs students still had to hit the books hard. In the late 1930s, Gordon added a raft of new first-class faculty members. Walter Pitkin, a founding member of Columbia University's School of Journalism and author of the best-selling book *Life Begins at 40*, came onboard as a practical psychology instructor. Columbia University professor Mark Van Doren, who would win the 1940 Pulitzer Prize for poetry, signed on to teach literature. Claggett Wilson, an Arizona cowboy turned World War I hero turned Broadway set and costume designer,

taught modern decoration. The former dean of Philadelphia's prestigious Curtis Institute of Music, Grace Spofford, brought every type of music into her Gibbs classroom — classical, opera, jazz, folk, atonal, be-bop, swing, East Indian, even Gregorian chants — and required students to write detailed "active listening" reports after attending a symphony at Carnegie Hall and a Metropolitan Opera performance. Remaining at Gibbs for twenty-four years until her retirement in 1959 at age seventy-two, Spofford believed that the school was preparing young women to "reconstruct" society and "build to new heights of human accomplishment."

In typing class, music sets a swift pace
KATHERINE GIBBS SCHOOL BROCHURE 1937–38,
WIDENER LIBRARY, HARVARD UNIVERSITY

Special lecturers arrived with stories of global adventure. Ruth Bryan Owen Rohde, recently retired as the American Ambassador to Denmark, had a lot to tell New York students in November 1936. Not only was she the first woman in US diplomatic history to hold the rank of minister and a former US Congresswoman, she'd also written, directed, and produced the 1922 feature film *Once upon a Time/Scheherazade*. A year and a half later, Pearl S. Buck described her experiences as the bestselling author of *The Good Earth*, about peasant life in China, which won a Pulitzer Prize in 1932. In early 1940, China's leading aviatrix and former silent movie star Lee Ya Ching — on a fundraising tour to benefit Chinese victims of her country's war with Japan — touched down on the East Coast for talks at the New York and Boston schools. A cofounder of China's first civilian flying school, where she was the only female instructor, and founder of a Red Cross hospital for wounded soldiers, twenty-four-year-old Lee told her Gibbs audience, "American business girls are the ideals of their Chinese sisters."

From the rooftop terrace of the Barbizon Hotel, Gibbs women survey
New York's renewed possibilities in the late 1930s
KATHERINE GIBBS SCHOOL BROCHURE 1937–38, WIDENER LIBRARY, HARVARD UNIVERSITY

For all their seriousness, these young women kept a sly sense of humor. An unsigned essay titled "Men," published in the Providence school's literary magazine, observed: "If you permit [a man] to make love to you, he gets tired of you in the end, and if you don't, he gets tired of you in the beginning." They poked fun at themselves too, predicting future careers as "Fashion expert/strip-tease artist," "Gun moll/Bronco buster," and "Travel/Ferry skipper to Coney Island." They gave each other nicknames like Peanuts, Toots, Skip, Squitch, and Boots.

It was a charmed life, yet it could be so easy to lose. The worst scandal in Gibbs history drove that point home. In the fall of 1936, eighteen-year-old Harriet Boyden arrived at the Gibbs school in Boston with a secret. Weeks earlier, vacationing in New York City, she'd had a fling with a man who was probably a married doctor or medical student. It ended badly, and she tried to start over again at Gibbs. But it was too late. In those days when sex education was taboo and unmarried women could not easily or discreetly obtain birth control, Harriet paid the price. She

was pregnant. Her seducer had told her she was physically incapable of bearing children.

As if blocking it out of her mind could erase the truth, Harriet told no one and sought no medical care. As months passed, hurrying away from classes and meals, she managed to hide her condition from her classmates, her teachers, and even her parents. Then, on April 3, 1937, alone in a bathroom at the 90 Marlborough dormitory where she had a private room, Harriet gave birth. The eight-month-old boy was still alive when she stuffed him in a suitcase that she hid in a closet, leaving him to die of suffocation. The truth came out when Harriet was found seriously ill with septicemia after the birth. Hospitalized under twenty-four-hour police guard, she hovered near death. Doctors said she didn't seem to want to survive.

Four days later, Harriet was charged with murder and concealing her child's birth. Refusing to name the father, she admitted all the other facts. A month later, while she was still hospitalized, a Boston grand jury dispensed mercy. Refusing to indict Harriet, they held her blameless in the baby's death. That decision seemed to recognize the futility of further punishment. Betrayed by the child's father and overwhelmed by near-suicidal guilt and despair, Harriet had lost her chance for a bright, unspoiled future. Instead of returning to Gibbs, she went home to upstate New York and disappeared. Whatever might have been, wouldn't be.

Although the case made sensational headlines nationwide, the school didn't suffer. Harriet's affair occurred before she set foot in a Gibbs classroom, and very likely school representatives had pressed for dismissal of the charges against her. They represented four out of the five witnesses who testified before the grand jury. Enrollment climbed to a new high. In the fall of 1937, the school admitted some 1,344 students from forty-one states and five foreign countries. Lesson learned, though. Gibbs now required resident students to present a health certificate signed by a doctor before the term started — or be examined by the school's physician.

The incident quickly faded and was replaced in the press by an upbeat, inspiring Gibbs success story. "One of the most envied women in America," one reporter called Jean Drewes, a 1930 Gibbs graduate, when

Jean Drewes en route to the Bahamas, December 1940
COURTESY OF MICHAEL HARDCASTLE-TAYLOR

she landed a job in late November 1940 as social secretary to the Duke and Duchess of Windsor in the balmy, vacation paradise of Nassau, the Bahamas. The royal couple, also known as Edward and Wallis, had been living there since the previous August. With war raging in Europe, Britain didn't want its former king — Edward had abdicated the throne three years earlier to marry the divorced Mrs. Simpson — rattling around the Continent at risk of being kidnapped by the Nazis and used as a political pawn. Appointed governor general of the Bahamas, then a British colony, Edward needed someone to manage the many commitments of his new goodwill and good works position.

Jean had no strings to pull to get the job. The daughter of a musical contractor for eight leading legitimate theaters in New York, she grew up in a middle-class home in Mamaroneck and attended public high school. Still, she was the perfect candidate. With a prestigious college degree from Mount Holyoke as well as top-drawer vocational training

at Gibbs, Jean had a ten-year work history assisting executives at large corporations. She easily passed a two-day audition at the New York home of Mrs. Kermit Roosevelt, the daughter-in-law of Theodore Roosevelt and Wallis's friend from their girlhood days in Baltimore, who was fielding candidates through her highbrow employment agency. No doubt it helped that tall, auburn-haired, thirty-three-year-old Jean was a career-minded professional rather than a flashy fashion plate who might have designs on handsome, debonair Edward. Wallis would have nothing to worry about.

With royal presumption, the Windsors gave Jean two days to assemble a tropical wardrobe in the dead of winter and hop on a train at Grand Central Station to begin her journey south. She made it, wearing a mink coat, a turban-style hat, and — Gibbs training in action — white gloves. Countless newspapers in big cities and small towns nationwide reported the event.

Stepping off the plane from Miami into Nassau's sultry eighty-degree heat under a "sapphire sky and billowy clouds," Jean entered a world of dazzling wealth. After a short stay in a guest house, she moved into the newly renovated, seashell-pink and white Government House, where the Windsors themselves lived. Her private rooms, complete with a veranda, overlooked flower-laden gardens and in the distance, sparkling blue waters. She often dined with the couple, traveled with them to the United States and their ranch in Alberta, Canada, and mingled with their guests at parties.

Jean Drewes in the Bahamas, 1942
COURTESY OF MICHAEL HARDCASTLE-TAYLOR

Most days, her afternoons were free, so she spent hours sunning and swimming at the private Emerald Beach Club. The royals put a car and chauffeur at her disposal and, with

prior approval, allowed her to entertain vacationing friends at Government House when they were away. For Christmas one year, they gave her a gold Cartier wristwatch.

Of course, Jean had to earn her keep. In addition to the couple's social schedules, she handled Edward's personal and confidential correspondence and served as his financial secretary, managing his private funds. Still, strict rules reminded her she was a hired hand. One of Edward's first instructions was that she must address Wallis as "Your Royal Highness." She couldn't sit unless invited to do so by the royals, and she had to curtsy to them.

But as Katharine Gibbs had taught, every work environment ran on the class system and rank had its privileges. Jean liked her employers. Yet, she also saw them up close. In their suite each morning to get her daily marching orders, she often discovered the Duke in his dressing gown and slippers, seated on a lounge chair, munching toast and marmalade while the Duchess, in a chiffon and lace jacket, sipped tea in bed. In moments like that, she saw past the public myths. The royals, she thought, were neither the greatest love story of all time — king abdicates throne for woman he loves — nor selfish sybarites who had turned their backs on duty and tradition. They were two people who had nobody except each other and who paid a high price for that.

Edward's expression often seemed to have "a weighted look, the look of a man who had weathered a great personal conflict." (Without specifically addressing allegations that the Duke and Duchess were Nazi sympathizers, in her memoir Jean dismissed negative publicity about the couple as fiction and described them as unfailingly supportive of the Allies.) Raised to become king and head of an empire on which, as yet, the sun never set, he now found himself exiled to a small, remote island — comparisons with Elba were inevitable — and tasked with busywork. "Was he frustrated? Of course, he was," Jean thought. His excess energy manifested in peculiar quirks. "[H]e was forever locking and unlocking private cases and metal trunks harboring private documents and personal papers" and he was obsessed with knowing where Wallis was every minute of the

day. Returning home from an afternoon of golf, "he came bounding up the long, spiral staircase, sometimes two or three steps at a time . . . calling, 'Wallis darling, where are you?'" He frequently phoned Jean to ask about his wife's whereabouts and when exactly she'd be home. To calm himself when anxious, he stared at the large, leather framed photo of her that he kept on his desk.

In this *pas de deux*, Wallis had to remain pretty and sparkling at all times in order to be worth all Edward had forsaken. Every time Jean saw her, the duchess was splendidly dressed in precisely tailored outfits, her makeup and hair perfectly done, and glittering in sapphires, diamonds, and topaz. The dominant note of their marriage, Jean thought, was "a lonesomeness they shared."

After three years, facing her late thirties, Jean wanted her own romance, her own home, her own family. Katharine Gibbs had advised women to keep "your eye on what you desire to accomplish." Jean took those words to heart. She found her future husband, Royal Air Force officer Brian Hardcastle-Taylor, at an RAF dance in Nassau and married him on New Year's Eve, 1943, with the Duke and Duchess as witnesses. Upon learning that she was pregnant, she gave her notice in July 1944.

Fifteen years and four children later, Jean began writing a memoir of her "wondrous years" with the Windsors. It was, she wrote, the great "unforgettable adventure" of her life.

EIGHT

"What a Job You've Done!"

∽◌∾

DESPITE ALL THE SOCIAL and political changes since the turn of the century, it was still a man's world in the late 1930s. Many men assumed that ambition and achievement belonged exclusively to them and that women existed to serve. Even the best of male bosses could be so obtuse that their actions — or lack of them — amounted to cruelty.

Katharine Brand, the Smith graduate whose subsequent Gibbs training had earned her a job with Woodrow Wilson biographer Ray Stannard Baker in 1925, didn't see that for a long time. She trusted that her loyalty would be rewarded in kind. It wasn't.

While Baker and his wife, Jessie, treated Katharine kindly and included her in social events, they also took advantage of the fact that she was a woman alone. The only child of divorced parents, she'd moved from Boston to Amherst to work in Baker's home, helping him with his multi-volume biography. She had little time to build a new network of friends because the Bakers soon piled on personal errands when — as they did very often — they went away on vacation or for health reasons. Could she get the furnace fixed? Run over to various banks to deposit his checks? Mail a necklace to South Carolina that Mrs. Baker had forgotten? Take care of his order to the seed company so he could plant corn in the back yard?

These petty tasks devoured Katharine's personal time. The Bakers never considered that she might have wanted a private life, which she did.

She wrote in her diary, "There are days . . . when I feel very much alone. I believe that too much aloneness is not good for most people." She had no boyfriend, yet envied people in love. Being around them "gives me a sort of lonely feeling." After a few years on the job, she felt her life slipping away. "Time and again I have caught myself with tears in my eyes over some mental situation — some daydream of myself!" Bouts of depression assailed her so deeply that "the thought of death comes to me so often."

She didn't dare say so. Partly because, especially during the Depression, she feared losing a decent paycheck. A Gibbs education could offset, but it couldn't completely banish, childhood insecurities. And partly — maybe mostly — she didn't speak up because she didn't want to lose the warmth of the Baker family. They meant well, she believed, and after a childhood of being caught in the middle of warring parents, getting dragged around the country, always having to be the new girl in school after school, she finally didn't hear the clock ticking toward her next departure.

Instead, Katharine buried her feelings and cheerfully did what they asked. When Baker wanted her to come to Florida in late 1929, she replied, "Of course I should enjoy going down there very much." In her diary, she wrote, "I hated Florida." Over the next few years, she made the trip several times, subletting her apartment because Baker wouldn't pay for her lodging there.

Baker often complained about being short of money. In January 1930, giving Katharine only a small raise, he explained, "Our enterprise just now is in troubled waters — I think you will understand." Although the October 1929 stock market crash had wiped out a bundle of Baker's investments, he wasn't hurting. His publisher, Doubleday, had guaranteed him $250,000 for the Wilson books (nearly $4.6 million today), plus a percentage of earnings over that amount. Additionally, at the outset of the project, multimillionaire Bernard Baruch — a friend and advisor to Wilson — had offered to give Baker a monthly allowance of $1,000 to $1,500. Baker didn't take him up on that, but if he ever got squeezed for cash, he knew there was a large bank account available to bail him out. And his finances soon improved. In February 1932, Baker received a check from Doubleday for

$12,808.13 (nearly $286,000 today). He also had money coming in from the nine popular "memoirs" he wrote as David Grayson, in which he pretended to be a bachelor transplanted from the city to the countryside.

The Bakers spent the money on themselves. They stayed at fancy hotels like the Court Inn, in Camden, South Carolina, the Seminole Hotel in Jacksonville, the Oasis in Palm Springs, and the deluxe Pioneer Hotel, in Tucson, an eleven-story Spanish Colonial revival hotel. One house where Baker stayed for the season in Winter Park, Florida, bordered on a lake and had abundant citrus trees. When he felt up to it, he sashayed over to the nearest country club to play golf.

Unconcerned about Katharine's personal life, Baker also didn't consider whether she, with her Smith College degree in English, might have wanted her own writing career. In fact, she did. Three years into the job, she felt restless. "I am 28 and I have wasted enough time. I want to write," she confided to her diary in 1928. "I want to excel — & in so many ways... I've such an urge to write." She felt lost. "Life is getting away from me and I am not doing enough about it." Between March and October 1928, she drove 1,060 miles aimlessly. "Futile, in a way. But it helps." A sure sign of her despondency, by the summer of 1930 she'd gained thirty pounds in less than a year.

In late 1931, Katharine tipped her hand to Baker, writing to him in Florida, "I have times of being very miserable. Typewriting seems to be the one thing which inevitably brings on trouble." She must have been desperately unhappy, because she suddenly took a few days off without asking in advance. Baker replied simply that he was glad she was getting away and hoped the rest would do her some good — and then he launched into a series of menial tasks for her to do. Oblivious to Katharine's pain, he added that he and his wife were leaving that afternoon for the Hacienda de la Osa, a luxury dude ranch located in the high Sonoran desert in Arizona near the Mexican border. He was "mighty glad," his letter continued, to have her in Amherst to take care of things so he could be "entirely at rest in my mind!"

Clearly, Baker wasn't going to help, so Katharine came up with her own

plan. She'd write his biography in her scant spare time. In mid-1932, she began interviewing Baker's wife, Jessie, and their daughter, Rachel. Both cooperated eagerly, sharing memories and old family photos, and one afternoon, Baker told Katharine stories about his boyhood.

She worked on the manuscript for the next six and a half years. In January 1939, she finally got up the nerve to show it to Baker. He slammed her down hard, not with words but with the devastating weapon of silence. As she wrote in her diary, "He thought what I had written was terrible! He didn't say so, but I knew." Probably Baker's reaction rang the bell of her journalist father's disapproving glare when at age seven, with pencil in hand over a blank piece of paper, she couldn't write a word for fear of disappointing his perfectionist standards. Because she revered Baker, his opinion became her opinion. She immediately abandoned the biography and evidently destroyed it. No traces remain.

All that was bad enough, but worst of all, Baker took credit for Katharine's work and profited richly from it. For the first few years, Katharine functioned as a secretary and research assistant. But in 1929, the burden of creation began to shift. That spring, fifty-nine-year-old Baker was stricken with severe eye pain, nervous strain, and a sinus infection requiring an operation in October at Johns Hopkins Hospital in Baltimore. He remained hospitalized there for more than two months and then went to Florida to recuperate. He didn't even think of doing any work till mid-February 1930 and he didn't return to Amherst till around early March 1930. For a good four or five months, he was out of commission while Katharine held down the fort.

Baker never fully recovered. In 1931, he developed heart trouble and began to suffer constant pain from angina pectoris. Over the next few years, he was in and out of hospitals.

His precarious health did, however, provide him with welcome relief from Woodrow Wilson. Baker never really wanted to write the biography but had agreed only after learning that he had been the late president's first choice. By the spring of 1929, four years into the job, he was grumbling that he wished he'd never accepted. In the summer of 1930, after his restful

sojourn in Florida, he contacted former first lady Edith Wilson to say he just plain could not continue and she ought to find someone else. She talked him into staying. It didn't stick. Over and over, Baker kept trying to resign, and over and over Edith kept persuading him to keep going.

He did, but on his own terms. Every year, Baker and his wife fled the harsh New England winters to spend three to five months at a time in sunny Florida, Arizona, Texas, and California. He did little, if any, work. Instead, he spent his time enjoying the scenery, playing golf, and, during a six week stay at the Arizona dude ranch, horseback riding "sometimes nearly all day." Even when he was back in Amherst, Baker wasn't reliably at his desk. Every day after lunch he took a nap, and some afternoons found him in the backyard tending to the bees he kept.

Constantly solicitous of Baker's health and constantly urging him to relax and set work aside, Katharine ran herself ragged. She compiled detailed chronologies of Wilson's activities, tracked down documents, corrected Baker's factual errors, and made detailed editorial suggestions — by early 1937, his work was getting sloppy, with repetitions and superficial analysis. She also continued mundane tasks like handling his personal correspondence, banking, and household business. Her self-denial likely caused the migraine headaches she suffered, and in late 1931, she narrowly avoided hospitalization for an injury to her ribs. Three years later, she did land in the hospital after collapsing when septic poisoning from untreated tonsillitis infected her blood and hit her heart. She remained there for more than a week, so ill she could sit up for only an hour a day. Instead of realizing how much she was sacrificing herself for Baker's convenience, she felt bad for being away from work for so long.

Despite all she contributed, Katharine didn't have a bullet-proof claim for credit on the six volumes of the Wilson biography that Baker published during the first twelve years she worked for him. She wasn't his only researcher. Several men also helped out, although they soon left for greener pastures. And Baker did write the books, shaping the raw material of Katharine's chronologies into thoughtful, polished narratives.

That changed in 1937. Thoroughly bored with Woodrow Wilson,

having struggled through volumes five and six, and in worse health than ever, Baker was absolutely, positively quitting — even though Wilson's life still had years to go. He told Katharine he was closing up shop. She began to hunt for another job. During the winter, Baker reversed course.

"Mr. Baker…thought up a new plan! I was to prepare the manuscript in a new way, by using as a basis the chronologies I have made during all those years. We would work out a plan together, and he would go over the manuscript with care, cutting and adding and making suggestions for changes," Katharine recalled in her diary. In other words, she would write the books and he would edit them.

And that's what happened. While Baker and his wife vacationed in Florida, Katharine dove into the task vigorously, working on it in the evenings as well as the daytime. On February 21, 1938, she sent him the whole manuscript of volume seven. Although she told him she was "scared to death!" of his response, he didn't start reading till around mid-April. Then he loved it. He wrote to her, "A tremendous affair . . . What a job you've done!" When Baker returned to Amherst in late April 1938, after five months' absence, Katharine had started on volume eight.

If Baker made substantial contributions to these two books, other than the volume seven introduction, there's no record of it — and he had no reason to. In his late sixties, in poor health, he was sick of Woodrow Wilson and he assumed the public was, too. Best of all, Katharine was willing to do all the work, probably better than he could have at that point. Although her 1939 correspondence with Baker about volume eight refers to "your manuscript," this was surely a generous fiction. Once again, just like in the previous year, Baker and his wife went to Florida for the winter. From early November 1938 through early April 1939, while Katharine slaved away on volume eight, he was sightseeing, socializing, fishing, and swimming — and complaining that he felt mentally dull and "cannot stand much pressure."

Volume seven was published in January 1939 and volume eight, which ended with the November 11, 1918 armistice, hit bookstores five months later. Both were chronologies, with day-by-day reports of Wilson's activities,

notes about political events, and often lengthy quotes from Wilson's corre-spondence. Baker's rationale for this "radical" method was that it avoided the "over-simplification" of a narrative. He took credit as the sole author. In his introduction to volume seven, he wrote that he was "under the deepest obligations to Katharine E. Brand . . . whose knowledge of the documents, as well as the collateral material relating to the Wilson period, is unequaled." Volume eight had just a brief author's note, with no mention of Katharine.

Reviews were mixed. That didn't matter so much when, in May 1940, Baker learned he'd won the Pulitzer Prize in biography for volumes seven and eight. The honor came with a $1,000 check (about $22,500 today). Baker showed no sign of contrition for having excluded Katharine from credit — at the very least, she was properly a co-author — nor did he offer her a share of the money. One person who guessed the score was Wesleyan University history professor H. C. F. Bell, who dedicated his 1945 book *Woodrow Wilson and the People* equally to Baker and Katharine.

Altogether, it was a coldhearted, self-serving scenario on Baker's part. During her 1937 job hunt, Katharine had interviewed with Gordon Gibbs at Katharine Gibbs in Boston — at the school's request — for an upcoming position as director of a new vocational department, which she would orga-nize at the Boston school. "It sounds to me like exactly the right thing," Katharine had written to Baker. If any employer was sure to appreciate her intelligence and capabilities — and to understand the career obstacles she'd faced — it was the Gibbs school. Under Gordon Gibbs's leadership, with its emphasis on social life, she might have been swept into a bright blue yonder of glamorous activities, new faces, and youthful enthusiasm. As many in the Katharine Gibbs world did, she might have met a good man and gotten married.

But Baker, knowing she was loyal to a fault, pulled "Miss Brand" (as he always called her) back into his narrow, dusty world. She didn't pursue the Katharine Gibbs job. Instead, she stayed with Baker for two more years. And now that he had his Pulitzer Prize, he had no more use either for Wilson (who had two years and four months left as president after volume eight ended) or for Katharine. Her job was over.

Katharine didn't protest Baker's taking credit for her work. It must have seemed pointless. No one would have believed that a mere, unknown secretary could have written such an esteemed work. Besides, she needed assistance from Baker in finding her next job. At thirty-nine, she was over-the-hill in the job market. Most businesses were willing to hire women only between ages eighteen and thirty, and Katharine found herself turned away time and again.

Baker did little to help. He wrote a few letters that went nowhere, made a few useless suggestions, and recommended her secretarial skills when the last thing in the world she wanted was to be somebody else's secretary. Meanwhile, he was on to better things. In October 1943 he was hired as a consultant on Darryl F. Zanuck's technicolor movie *Wilson*, based on Baker's biography and starring Alexander Knox, who would earn an Oscar nomination for his portrayal of Wilson. Baker was also writing his autobiography, which may have been the real reason he quashed Katharine's attempt at his life story. When he didn't need her any more, he felt no further obligation to her.

Katharine Brand was not unique. Her experiences stand for those of countless forgotten women before and after who silently handed their achievements over to, or had them seized by, men. Those men weren't necessarily Neanderthals. Like Ray Stannard Baker, they could be intelligent and otherwise considerate. But blinded by social standards, they didn't see what was right in front of them, what they would probably have seen had they been looking at a man: competence, skill, and potential.

Katharine Brand's story has survived because even if she didn't think the world would recognize her in her own time, and even if it never did, she refused to be erased. She kept her diaries, correspondence, childhood photos, and a memoir. Her life mattered. It was a different interpretation, but still it echoed the Katharine Gibbs principle that "the first thing of importance is to have confidence in yourself, in your abilities." After her death in 1988, her close family members and friends saved that material and found it a good home at her alma mater, Smith College.

But Katharine's fourteen years with Baker weren't entirely wasted.

Someone from that time did help. It was, no surprise, a woman, and no less a woman than former first lady Edith Wilson.

The president's widow had a practical, unpretentious side to her personality. One morning when Katharine and a friend stopped by Edith's house in Washington, DC, they found her standing on the staircase dismantling the chandelier and washing the crystals. "Oh," said Edith. "This has to be done and people don't want to do it."

Here was another job that needed doing that nobody else wanted to do — get Katharine a job. Edith donated her late husband's papers, some 1,200 boxes of them, to the Library of Congress and had Katharine named "special custodian" of the collection in September 1939. Because the Library had no extra money, Edith paid Katharine's annual salary of $2,700 (about $60,000 today) for five years. In 1944, the Library scraped together enough money to put Katharine on the payroll as a specialist in contemporary American history, and six years later she became head of the Recent Manuscripts Section.

Socially, Edith Wilson took Katharine under her wing. When Katharine arrived in Washington, DC, Edith insisted that she spend the first night at her elegant Georgian Revival mansion at 2340 S. Street — a dazzling showplace with a marble entry, Steinway piano, museum-quality paintings, and a wall-sized Gobelin tapestry. That Christmas, Edith invited her to dinner, a small family gathering of only seven people. "I will be so glad to have you join us," Edith said in her handwritten invitation. Year after year, more dinner invitations followed. One of Katharine's friends, Carol Piper, who sometimes went along, recalled that the evenings began with bourbon old-fashioneds mixed by Edith herself, followed by the meal, "a formal affair with lamps with beaded shades on each corner of the table. [Edith] was a story teller . . . just full of anecdotes. . . . It was really a pleasure." When longtime friends Katharine and Carol Piper pooled their resources to buy a house in then-rural Fairfax County, Virginia, after Katharine's retirement from the Library of Congress in 1956, Edith had her chauffeur drive her out several times to visit.

Having married a president and rubbed shoulders with world leaders,

royalty, and the Pope, Edith Wilson had keen discernment. She instantly understood what Katharine Brand's longtime male boss had never recognized. Here was a formidable woman who belonged in authority. The former first lady's nod of approval validated not only Katharine's unsung achievements, but also the Gibbs school's premise about women's hidden potential. That premise was about to knock the working world sideways.

What Are We in for Now?

∽◡↻

ON SUNDAY AFTERNOON, DECEMBER 7, 1941, eighteen-year-old Jean Haskell (later Krauklin) was at her desk in her dorm room at Katharine Gibbs in Boston, doing her homework and listening to the weekly radio broadcast of the New York Philharmonic Symphony Orchestra from Carnegie Hall. Shostakovich's Symphony No. 1, Opus 10, featuring guest pianist Artur Rubinstein, was playing. Outside, amid clear skies, the temperature hovered in the mid-thirties.

As the music paused for one of the program's regular news breaks, Jean heard the heart-stopping bulletin. "The Japanese have attacked the American naval base at Pearl Harbor, Hawaii, and our defense facilities at Manila, capital of the Philippines," said CBS announcer John Charles Daly, repeating news he'd first delivered earlier in the afternoon, news Jean had missed. Then came fast-paced snippets about outrage in Washington, DC, and orders for all US military personnel to report for duty in uniform the next day.

Jean was stunned. "What are we in for now?" she asked herself, with an awful, sinking feeling. Haskell family members back home in Berlin, New Hampshire, had been devouring articles in *Reader's Digest* about the atrocities ravaging Europe and the Far East. "With an ocean on each side, we felt safe enough, and almost everyone agreed we should stay out of war," she recalled. "People my age didn't remember World War I, but

we had certainly heard terrible things about it and seen its effects on our elders."

The next day, shortly after noon, the head of the school brought a radio into a class of about sixty students. Solemnly, they listened to President Roosevelt's historic, six-minute "Day of Infamy" speech urging Congress to declare war against Japan. Jean said, "We heard the urgency in his voice and sensed that this momentous decision was going to affect every one of us profoundly."

What were they in for? Life turned upside down. Tearful goodbyes to boyfriends, brothers, neighbors, and former classmates as young men donned uniforms and set off for distant battlefields. Heartbreak when some of them didn't return or when they did, but with lost limbs, shattered minds, and broken spirits. Blackout shades on windows after dark. Dimmed and shaded streetlights, so enemy planes wouldn't have an easy target. Rationing of food and restrictions on clothing: "Forget about luxuries, make sacrifices, don't complain," recalled Jean Haskell. "Don't you know there's a war on?"

Nylon stockings disappeared overnight from store shelves — nylon was needed for parachutes, ropes, and netting. Silk also vanished because most of it came from Japan. Skirt hems inched up to save wool for military uniforms. Forbidden to wear pants at Gibbs and finding that still-available rayon stockings sagged and drooped, Jean said, "Most of us girls painted our legs with a tan-colored goo and hoped that passed for stockings." And with leather commandeered for sturdy military boots, most shoes were now made from canvas or, seemingly, cardboard. Mercifully, Gibbs relaxed its high heels rule and allowed students to resurrect footwear from their high school and college days. A class photo in the 1943 Providence yearbook shows several wearing saddle shoes or loafers with ankle socks.

Fear was a constant companion. No one could forget Pearl Harbor or be certain that another attack wouldn't occur. One day at the Boston school, a teacher suddenly stopped class to announce that enemy planes had been sighted two hours out of New York, so everyone had to go home immediately. After an air raid drill at the New York school in January 1943,

when classes fled to the hallway, one student reflected with a note of irony, "Queer to be lined up against a solid wall and imagining how you'd feel if it suddenly caved in on you. But [typing teacher] Mrs. Williams cheered us when we got back to class. She said, and I quote verbatim, 'You went to the wrong place during the drill; one bomb would have gotten five hundred of you, instead of two hundred and fifty, as it is supposed to.'"

World War II U.S. Civil Service Commission recruiting poster

But all was not sacrifice and gloom. Young women were also in for unprecedented opportunity. As had happened during World War I, men marching off to fight overseas left empty desks at home — and this time, those desks weren't just in private industry, but also in war offices. The US government was begging for female clerical workers. "Uncle Sam does need you — badly," pleaded an Army Service Forces brochure aimed at stenographers and typists. A red, white, and blue poster of a young woman saluting behind a typewriter announced, "Victory waits on your fingers. Keep 'em flying, Miss U.S.A."

War meant paperwork. Personnel records, condolence letters to families of fallen soldiers, casualty reports, invoices, shipping tickets, specifications for military supplies, and documentation about US assistance to liberated populations. War also meant the sudden proliferation of new government agencies to do all the hidden work of fighting, everything from maintaining economic stability while massive amounts of money and materials were diverted from civilian use, to developing new weaponry, to spying on the enemy. Yet, as the Allies suffered a series of defeats in the early 1940s, more bodies were desperately needed on the battlefield. Because no one in Washington would have dreamed of sending women into combat, every available man had to gear up and head to the front. Within weeks

of the attack on Pearl Harbor, thousands of government office jobs landed in the "Help Wanted — Female" column.

This urgency was a double-edged sword. To fill positions quickly, practically anyone who could hunt and peck at a typewriter with two fingers was hired. Secretarial schools emptied out. By the fall of 1943, most had suffered a 5 to 80 percent drop in enrollment, and nearly 10 percent of them closed up shop while some stayed open with no students.

Not so at Katharine Gibbs, "the Tiffany's of secretarial schools." The Army Service Forces brochure promised "many more" vacancies at higher pay for women who could type more than forty

Boston students, 1944
CARBON YEARBOOK, BOSTON, 1944, SCHLESINGER LIBRARY, RADCLIFFE INSTITUTE FOR ADVANCED STUDY

words a minute and take dictation at a rate faster than one hundred words, with excellent opportunities for promotion. The army promised, "Plenty of room is left open for those who really strive to get ahead!" Ambitious young women everywhere knew where to go to seize that lure.

Applications to the Gibbs schools piled up so high that president Gordon Gibbs immediately launched classes three times a year instead of just once in the fall. By mid-1942 enrollment had jumped to 1,600 students, with 40 percent of them college-educated. All were virtually guaranteed not only a job, but their choice of a job, because that year the school's phones rang off the hook with more than 5,500 calls from employers. For midwestern hopefuls, in July 1943 Gordon opened a fourth Katharine Gibbs school in Chicago on the top two floors of a skyscraper at 720 North Michigan Avenue, overlooking Lake Michigan.

Skills training hewed closely to wartime demands. To serve the government's ravenous hunger for documentation, students learned to use messy mimeograph machines, which made multiple copies by forcing purple ink

through a stencil, often leaving the user with stained fingers and ruined clothing. (Xerox photocopiers weren't introduced until 1949.) Ten-part government forms had to be coaxed gently into a typewriter to preserve alignment, and then the keys struck hard enough so the ninth carbon registered on the tenth page — but not sledgehammer hard. Broken machines couldn't be replaced. During the war, Remington Rand, which manufactured the "noiseless" typewriters used in Gibbs classrooms, and other manufacturers switched their factories to making guns.

Gibbs standards aimed for the top. Uncle Sam was willing to pay extra for someone who could type more than forty words per minute? Students had to hit ninety, flawlessly. A dictation speed above one hundred words per minute to qualify for promotion? Child's play. Gibbs teachers demanded one hundred twenty words per minute. It was tedious, plodding work, achieved through two hours of shorthand and two hours of typing a day, every day, five days a week. To graduate — or "certify" in Gibbs terminology — students now had to pass a civil service exam qualifying them to work for the government.

On the academic side, instructors explained what the fight was all about. Columbia University professor Dr. John Krout, a longtime Gibbs teacher, lectured in New York about the war's global backdrop of events, US foreign and domestic policies, political leaders, and current battles, and urged students to "live our lives by a code which means freedom for all." Literature classes — with a reading list that included *Paradise Lost, Beowulf,* and Machiavelli — emphasized philosophical discussions and critical thinking about "the fiction that creeps into fact" via rumor and propaganda. Guest speaker Margaret Bondfield, who'd been Britain's first female cabinet minister when she served as minister of labor from 1929 to 1931, described the ways that British women were helping the war effort and pressed her audience to do likewise.

Channeling patriotic feeling into action, the Gibbs schools launched a War Activities Program that included war bond selling contests — during one nine-day drive, New York students raked in more than $8,400 — and blood drives that collected countless pints of blood. Young women whose

*War bond sales contests at the New York school would
raise thousands of dollars*

PLATEN, 1944, KATHARINE GIBBS SCHOOL RECORDS, BROWN UNIVERSITY

nimble fingers could race across typewriter keys spent hours making thousands of surgical dressings for the Red Cross and knitting afghan squares for blankets. Many did volunteer clerical work at hospitals, war relief agencies, the Red Cross, the USO, and other organizations suffering from labor shortages. Good listeners visited hospitals, chatting bedside with wounded servicemen, while natural-born hostesses sponsored afternoon teas through the Red Cross.

In mid-February 1944, at Halloran Hospital on Staten Island, Gibbs students brought a huge heart filled with Valentine's Day gifts donated by their classmates. For recycling as war materials, they pruned their closets of rayon garments, silks, and torn nylons, and into metal salvage barrels installed at the schools, they piled up shorthand pad spirals, orthodontic braces, and costume jewelry.

Nevertheless, war or no war, the Gibbs schools kept their magic. Formal dances continued at elegant locations. In early 1944, some 270 couples gathered in the Grand Ballroom of New York's Biltmore Hotel to hear high society's Meyer Davis Orchestra, which had played at every White House Inauguration Ball since Coolidge. Filling in for students' absent

During the war years, the Gibbs schools kept up elegant formal dances
PLATEN, 1944. KATHARINE GIBBS SCHOOL RECORDS, BROWN UNIVERSITY

beaux, some fifty midshipmen came over from. Columbia University in their dancing shoes as blind dates. There were also catered picnics at the beach, weekend getaways to the mountains, luncheons at the Ritz-Carlton in Boston, teas at the Waldorf in New York, and lavish parties at Thanksgiving, Christmas, Easter, and graduation.

Against the bleakness of the times, small moments also sparkled. Predicting what they would remember in years to come, the editors of the 1945 New York yearbook wrote, "Christmas carols being sung in the corridors when lots of us nearly cried...the loud ticking of the huge alarm clock on the desk in the library...watching the pigeons on the ledge of the building opposite the library windows...the elevator boys telling us 'It's going to be an easy day today, girls' . . ." Soon enough, a dangerous world would test these young women. Gibbs was there to arm them with not just survival skills but also an indomitable spirit.

What were they in for after Gibbs? While the lasting impact of World War II on the labor market for women is still debated, with many scholars skeptical of any real progress, this much is true: in the short term, doors to opportunity that were previously nailed shut were flung wide open. For

many women, these years would be remembered as the most exhilarating time of their life. Suddenly, they had a chance not only to play an important role on the national and even international stage, but also to step behind the curtain of male authority, see how the wheels turned, and sometimes turn those wheels themselves.

Beach excursions kept up morale against wartime gloom
PLATEN, 1943, KATHARINE GIBBS SCHOOL RECORDS, BROWN UNIVERSITY

With their gold standard credential, Gibbs women hired by the new government agencies worked close to the centers of power and helped run the vast bureaucratic machinery of war. At the Regional Office of Price Administration in Boston, Jean Haskell assisted a general contractor responsible for enforcing price ceilings in the New England lumber industry. Lumber was vulnerable to price gouging because, after curtailed production during the Depression, demand soared when wood became critical to the war effort. Meanwhile, Jean's younger sister, Ruth, who finished at Gibbs in 1943, got a job at MIT's Radiation Laboratory as a secretary to radar experts who were conducting top-secret research to adapt the technology for military use. Largely as a result of that work, radar became the most widely used and most effective new weapon of World War II.

At the League of Nations Association in New York, three days after being hired straight out of Gibbs in 1944, Marjorie Bell (later Chambers) answered the phone, grabbed her steno pad, and took down the Dumbarton Oaks Proposals — which transformed the ineffectual League of Nations into the United Nations — in shorthand from the State Department in Washington, DC. "And from then on, it was just bedlam," she recalled. Only twenty-one, she took on a whirlwind of tasks to build public and legislative support for the UN. She organized major conferences, set up interviews with radio and newspaper reporters, wrote comic books about

the UN and blanketed subways and Central Park benches with them, and ran a Fifth Avenue information store. Then she helped coordinate lobbying efforts in the US Senate that led to ratification of the UN Charter in 1945.

Although surely useful, it wasn't Marjorie's degree in British history and American political philosophy from Mount Holyoke that clinched the job for her. It was Gibbs that got the listing and arranged Marjorie's interview. At the time, women's colleges, especially the elite Seven Sisters — of which Mount Holyoke had been the first — were still regarded suspiciously as "Adamless Edens" populated by dour, frumpy, four-eyed intellectuals who, as the *Harvard Crimson* jeered at Radcliffe undergraduates, would "wander into the library like the witch of Endor and enquire if the lost volume of Kant had been returned." This didn't matter so much for women who wanted to stay in academia, and the Seven Sisters did a good job of sending graduates on for PhDs. But it was not a helpful stereotype for those looking to succeed in a man's world. By default, many women with ivory tower liberal arts degrees ended up as dependent wives who used their education to speak French at the country club.

Just as Katharine Gibbs had, Marjorie's banker father understood the dangers of marriage as a career. Men — and their money — could easily disappear. The war had magnified that possibility exponentially, as widows in their hometown of Scarsdale, New York, could testify. Marjorie's father pushed her to attend Gibbs. She recalled, "He put it in the frame of an insurance policy. He said I would always be able to eat if I was a secretary."

Marjorie's classmate at Mount Holyoke, Emily Pike, got the same advice from her mother, who after separating from Emily's father, could no longer afford life in Massachusetts and had to retreat with pre-teen Emily to her family's home in Kentucky. Although Emily was distantly related on her mother's side to Cassius Marcellus Clay, Lincoln's ambassador to Russia, the family's wealth and access to power were long gone. She'd been able to attend college only because her parents cashed in an insurance policy to pay her tuition fees. Eyeing Emily's degree in modern European history, Mother knew best. Go to Gibbs, she advised, "so you can always make some money."

Emily knew a good tip when she heard one. In the fall of 1943, months after graduating from Mount Holyoke, she signed up at Gibbs in New York and checked into a room on one of the Gibbs floors at the Barbizon Hotel. It was a heady experience for the former small-town girl. She people-watched as she walked to school along Madison or Park Avenue and spent "glorious" weekends at the theater, the opera, and concerts. At Gibbs, she transformed from a smart but starry-eyed ingenue into a polished career woman determined to get what she wanted.

After Gibbs, Emily headed for Washington, DC, armed with job leads from the placement department. First stop, the State Department, where she'd dreamed of working because of her interest in history. That was a bust. They hemmed and hawed, kept her coming back, and never made a firm offer. At the General Services Administration, she walked in, saw "about 800 people in one room" and turned around and walked out. Gibbs gradu-ates didn't wait in line. After calling on a few other prospects, she accepted a position with the newly formed Office of Strategic Services (OSS) because it offered the highest salary. Not that she knew what the OSS did, because the OSS — the forerunner of the CIA — wanted it that way.

Assigned to an OSS satellite office in Washington, Emily soon found out. The OSS managed espionage activities behind enemy lines for all branches of the US military. Within weeks, just before D-Day on June 6, 1944, she was typing reports from the French Resistance, "people who were lying down all along the railroad tracks in France counting the cars with German supplies and soldiers and where they were going." That was thrill-ing. Suffering the summer heat in a building with a corrugated tin roof and no air conditioning wasn't. Neither was getting splattered head to toe with purple ink from the mimeograph machine. "I thought, 'What am I doing here?'"

One of the hidden benefits of a Gibbs education was networking, although no one called it that back then. At the New York school, Emily had a classmate whose father was now chief of the OSS mission in Cairo. A word here and there, and it was done. Emily was transferred up to Capitol Hill to the OSS secretariat — the administrative inner sanctum — headed

by former Assistant US Attorney General William "Wild Bill" Donovan. This job was the real thing. The secretariat reviewed field agents' information and prepared reports for FDR and the joint chiefs of staff. As the top-secret control officer, Emily typed "for your eyes only" documents, locked up the files, and at the end of every day, destroyed all the trash — desk blotters, used carbon paper, even typewriter ribbons — and handed the detritus over to a security officer to be burned. "I made sure it all happened," she said. "Oh, I loved it, just loved it! Every minute of it!"

<p style="text-align:center">∾</p>

REGRETTABLY FOR EMILY PIKE, who'd hoped to be a home-team Tokyo Rose, the OSS wouldn't send women overseas during World War II. But the Red Cross did. Katharine Gibbs had always touted foreign travel as a means of self-improvement — and while the school undoubtedly had castles, museums, and stately homes in mind, bullets and bombs taught their own lessons. Gibbs graduates set out to learn those lessons while providing aid to soldiers and civilian victims of war around the globe.

World War II work would take Gibbs graduates around the world
CARBON YEARBOOK, BOSTON,
1944, SCHLESINGER LIBRARY

In northeastern India, Gertrude Pirnie, a Vassar graduate who attended Gibbs in 1942–1943, traveled for three months in a Red Cross "clubmobile" along the notoriously deadly Ledo Road through a mountainous jungle teeming with insects, leeches, and reptiles and plagued by malaria and dysentery. Built during the war by the Allies to deliver supplies to China and thwart a possible Japanese invasion of India, the 1,079-mile Ledo Road cost thousands of lives during construction. Gertrude's clubmobile — either a converted half-ton truck or a repurposed single-decker London

bus, which she operated with two other Red Cross women and a local driver — dispensed small mercies, serving light refreshments and handing out newspapers and chewing gum.

After the war broke out, Elizabeth Weigle, a Gibbs New York graduate, signed up as a civilian with the US Army Air Forces, but that felt half-hearted, like "coasting." Her younger brother was flying combat missions in Europe and, she said, "I don't want him to be ashamed of me." In mid-1944, she joined the Red Cross and was assigned to Hawaii's Camp Tarawa, the largest Marine Corps training camp in the Pacific, housing as many as 25,000 service members at a time. Officially there to organize a relief and recreation center, Elizabeth found herself with harrowing work: listening to the stories of soldiers returning from some of the war's most deadly combat in the Pacific theater. Among them were members of the Fifth Marine Division, who fought at the Battle of Iwo Jima. Elizabeth saw them ship out and she greeted the returning survivors, including the five men who'd raised the flag on Mount Surabachi. Many of the troops were exhausted, wounded, and psychologically traumatized. It was impossible to minimize the horrors they'd seen. Although that fact drove one of her Red Cross colleagues to suicide, after V-J Day, Elizabeth went home to New York, married happily, and during the Korean War rejoined the Red Cross to serve at a Marine base in Japan.

For Mary Spencer Watkins (later Ferchaud), service in Europe with the Red Cross and then the US government unveiled the moral complexities of war. A Gibbs New York graduate who had a degree in English from the University of North Carolina, Mary Spencer (she hated being called just plain "Mary") joined the Red Cross in solidarity with her brother, who was in Italy with the US Army Air Forces flying B-26 bombers, planes so

Elizabeth Weigle
COURTESY OF ST. PAUL'S CHURCH NATIONAL HISTORIC SITE, MT. VERNON, NY

difficult to handle they were called "America's flying caskets." She soon faced grim facts. While sailing to Britain in late 1943 with ninety-two other Red Cross women as part of a military transport, outfitted with a gas mask, a heavy coat, and a canteen, Mary Spencer learned that if a torpedo hit, soldiers would be first in line for the lifeboats. She resigned herself to going down with the ship.

Mary Spencer Watkins
COURTESY OF MARGUERITE MEBANE

No chivalry here, and no mercy either. After brief postings as a medical secretary at hospitals in South Wales and the English Midlands, Mary Spencer was transferred to the Red Cross's London headquarters in 1944. She arrived amid the thick of enemy bombing. In retaliation for D-Day, one week later the Germans began firing V-1 "buzz" bombs, which were twenty-five-foot-long, pilotless cruise missiles that resembled monoplanes and carried a one-ton high explosive warhead. They were more terrifying than conventional bombs, which could at least be heard in advance. Buzz bomb engines pulsed with a noise like a giant insect and then cut off, making it impossible to tell where they would land. Between June 13, 1944, and March 28, 1945, some 2,419 German buzz bombs hit London, killing 6,184 people and injuring 17,981. During the first six weeks of buzz bombing, 1.5 million Londoners fled the city.

Mary Spencer stayed. Working in the Red Cross office, she often felt the building shake and heard bombs explode nearby. More than once, co-workers left for lunch and didn't return because they'd been killed in a bombing. One day, death came almost to the doorstep of the house she shared in central London with five other women. Across the street were eight British Wrens, members of the British Royal Navy Service. She'd wave and smile and chat with them. One night, one of Mary Spencer's

housemates, who "could hear a mouse crawling ten miles away," woke up the others and rushed them all downstairs, where they heard the deafening crash of a buzz bomb. The next morning, they went outside. The Wrens' house was demolished and all eight were dead. "The only thing left was the building next to it," Mary Spencer would recall. "One of their coats was still hanging against that wall, just swinging a little bit in the breeze. Everything else was flattened."

After the war, Mary Spencer got a job in Frankfurt, Germany, with the Decartelization Unit of the US Treasury Department, which aimed to break up businesses so a horror like the Nazi party could not rise again with financing from industrial fortunes. One day, the US Military Police brought in a German man, "tall, nice looking," for an interview with her boss. While he waited, she made light conversation and offered him a cigarette. He was, she learned, one of the five scientists who had developed the buzz bombs at the start of the war. Two of them had wanted the noise to continue until the bomb hit; this ordinary man in front of her was one of the three who insisted they be silent at the end, to maximize the death toll.

Strangely, "we talked and I enjoyed it. I didn't want to say, 'You killed some of my friends,' but we talked," she would recall. He'd just been doing his job, she thought, "doing what he'd been trained for, what his country wanted him to do." Now that Germany was defeated, he was, too. "Nothing for me to do," he said. "I'd like to go to America, but they wouldn't let me in."

This, too, was part of the tragedy of war, Mary Spencer realized. Lives that might otherwise have been happy and useful were now shameful and bloodstained. She said, "And I felt sort of sorry for him, in a way. You know, you do."

TEN

"Yes, We Fight"

∽౿

FOR SOME GIBBS WOMEN, nothing less than a uniform would do — not a man in uniform, but their own uniform, complete with marching orders. Uncle Sam was ready for them. In mid-1942, President Roosevelt authorized all branches of the armed forces to start women's reserve units for non-combat jobs, and by mid-February 1943, the US Army, Navy, Marines, and Coast Guard had done so. Historically, women had served in the US military only as nurses, except during World War 1, when nearly 13,000 women enlisted to do clerical work as "Yeomanettes" in the navy or "Marinettes" in the Marines. After the Armistice, those units were disbanded.

Dire necessity drove World War II's large-scale recruitment of women. Although Congress had beefed up military spending during the year and a half before Pearl Harbor, strong isolationist winds — Jean Haskell's relatives in Maine weren't the only ones who remembered all the lives wrecked by World War 1 — kept the nation from full fighting strength. In mid-February 1942, two months after Congress declared war on Germany and Japan, President Roosevelt warned that the US military was not strong enough to thwart another attack on the country and that the enemy might "shell New York tomorrow...or bomb Detroit."

Fired up with patriotism, Gibbs women rushed to enlist. "In a world

at war, when the forces of good and evil meet on the battlefields, we know that it is action that counts.... Yes, we fight and we know the why and how," wrote a student in the 1942 New York yearbook. Many of their stories have been lost, with only a name, a branch of service, and maybe a photo in uniform remaining. The postwar years did not applaud female veterans, either in historical records or private homes. Men's exploits filled the spotlight.

Few specifics are known about the work that childhood friends Rita Keniery (later O'Keefe) and Monica Ross (later Miller) did as Navy WAVES (Women Accepted for Volunteer Emergency Service) at the top-secret Naval

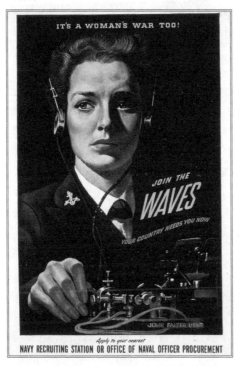

WAVES recruiting poster
LIBRARY OF CONGRESS

Rita Keniery as a member of the
World War II WAVES

Communications Annex in Washington, DC. Sworn to secrecy under penalty of death under the Espionage Act of 1917, for decades they kept their vow and refused to say a word about their wartime experiences to close family members or even each other. In 2003, when Rita's son Paul O'Keefe learned that the information had been declassified fourteen years earlier and showed Monica proof, she relented and revealed what she could recall. Because the government never notified the women that they were free to talk, Rita, who died in 1996, took her full story to the grave.

The little that is known is that for more than two years, Rita and Monica helped decrypt Japanese messages about military and commercial ship movements in the Pacific, enabling the US military to sink enemy ships, cripple Japanese industry by restricting supplies, and greatly reduce the risk of a surprise assault on Allied forces. Neither young woman ever expected to be enmeshed in international intrigue. After graduating in 1940 from Curtis High School on Staten Island, they'd set out to build comfortable, middle class lives a step above their beginnings and enrolled together at Katharine Gibbs in New York. Although both were honors students, there had been no money at home for college. Rita's father worked long shifts in a blue-collar job at Standard Oil in New Jersey, earning only enough to send her brother to Duke University. Monica's father, an income tax agent, had to support his family on a government salary. The young women took their disappointment in stride, excelled at Gibbs and, still in their late teens, landed good jobs on Wall Street — Monica with an investment counselor and Rita as a secretary to a Chase Manhattan Bank executive.

After Pearl Harbor, they knew they had to help. In order to enlist together, Rita, who was one year older, waited until Monica turned twenty

in February 1943, meeting the WAVES minimum age requirement. The Navy sent both to Cedar Falls, Iowa, for boot camp and then for Yeoman Training School — where they were taught all over again everything they'd already learned at Gibbs about typing, spelling, grammar, and punctuation. Ironically, Monica never again touched a typewriter during her Navy service.

Monica Ross, who joined the WAVES with her childhood friend Rita Keniery

FROM *WAVE SONG* BY MONICA R. MILLER. KINDLE SCRIBE, 2014

How they got high-security jobs is a mystery. Many of their coworkers at the Naval Communications Annex were recruited from elite colleges; some had PhDs. Probably, personal characteristics along with their grueling Gibbs training marked Rita and Monica as standouts. Undoubtedly, they'd scored high on the Navy's intelligence and loyalty tests. Beyond that, no one knew for sure what made a good cryptographer. Even Mount Holyoke College professor Roger Holmes, who taught a top-secret cryptology course on campus for the Navy, never figured it out. His best guess was that a few quirky traits helped. Among them — all hallmarks of a Gibbs graduate — were a "high frustration tolerance," an "ability to work for long periods without gratification," and an obsession with problem solving.

In July 1943, wearing their chic, dark blue uniforms designed by American couturier Mainbocher, Rita and Monica reported for duty at the Naval Communications Annex at Massachusetts and Nebraska Avenues, a fifteen-acre former girls' school now patrolled by Marines with submachine guns. This was the headquarters of the Naval Communications Intelligence Staff, architects of the "secret war" conducted by intercepting, decoding, and analyzing enemy naval communications. Some 4,000 Navy personnel and specially cleared civilians worked there.

Once inside, Rita and Monica went separate ways. Assigned to a traffic analysis section, Monica worked on a two-woman team poring over "stacks and stacks" of Japanese radio operators' logbooks, "line by line, all day, every day." They were looking for the word "Maru," a suffix for ship names, followed by letters and numbers that seemed like gibberish. As one of them read from the logbook, the other entered the data on a "tabulated pad." It was painstaking, monotonous work made all the more taxing by the fact that no one ever told Monica the purpose of her work and she was forbidden to ask. Upon finishing the tabulations, Monica knocked on a door, gave the papers to the hand that reached out, and never saw the rest of the person. But this was the payoff point of Gibbs's relentless perfectionism. While an error on a business letter wouldn't have brought the heavens crashing down, here one casual mistake could throw off all subsequent calculations and kill American servicemen.

Monica's raw data traveled on to Rita's "translation" section, where it was decrypted and compiled into daily intelligence summaries for Admiral Ernest J. King, the Commander in Chief of the United States Fleet, who reported directly to the president. Rita may well have done decryption. Yeoman WAVES at the Naval Annex were required to take progressively more difficult cryptography tests, and she would have picked up the skill easily. Her son Paul O'Keefe described her as "brilliant." All her life, even as the pages yellowed with age, Rita kept a blue book of Japanese alphabet characters from this time.

Late in life, watching a TV documentary about codebreakers, Rita broke her vow of silence for a few minutes. Reminiscing to Paul, she shared snippets of information about the head of the translation section, Commander Redfield Mason, and the eccentric characters who milled around the office — the bridge masters and the memory freaks who spread sniping gossip about each other and the Japanese POW who could glance at a photo once and reproduce it perfectly with pencil and paper. Why didn't she ever mention this before? Paul asked. "Suddenly, Mom stiffened. She looked me straight in the eye and said, 'Because no one has told me it's not secret anymore!' Then she shut up and never talked about it again."

Honorably discharged in November 1945, Monica and Rita remained lifelong friends. Monica went on to work for eighteen years in New York at Radio Free Europe, a CIA covert operation, and finished as secretary to the president of the parent organization, the Free Europe Committee. Marrying late in life, she had no children. Rita married soon after the war and raised five children. Although she spoke about her time in the WAVES only that once, Rita kept photos of herself and her brother in uniform on the wall of her family's home and never cashed the forty-dollar war bond she'd bought.

Military service during World War II was also a proud highlight of Lillian Lorraine's life. For nineteen months, Lillian flew planes with the Army Air Forces' WASP (Women Airforce Service Pilots) program, an elite division where women replaced men in domestic flying assignments. The road there began at Katharine Gibbs in New York, where she overcame her unhappy past.

Her father hadn't wanted her — or any of his family. No sooner had Jack Lorraine married Lillian's mother, Dorothy, in 1921 than he began cheating. It was easy for him. He was rich, the son of a prominent coffee and tea importer in New Bedford, Massachusetts, good-looking, and charming. Lillian's parents soon divorced, and her mother returned home to Halifax, Canada. The judge who decided custody acted as if it were a 50-50 property split. Dorothy got her infant daughter, also named Dorothy, while Jack got three-year-old Lillian. He promptly parked the toddler with his parents and continued to chase women.

In 1935, when Lillian was thirteen, her father married a woman who insisted that Lillian never set foot in their home. She *was* difficult, Lillian later admitted, always expecting others to wait on her. The family shipped Lillian off to the Lincoln School, an all-girls boarding school in Providence, Rhode Island, where at first, she took little interest in academics or social life.

Fortunately, her father's sister was the former Blanche Lorraine, now Mrs. Gordon Gibbs. Taking pity on the aimless, abandoned teen, Blanche and Gordon welcomed Lillian into their world. During holiday breaks, she

*Lillian Lorraine as a newly minted
pilot with the WASPs*
COURTESY OF LYNN YONALLY

often traveled with her aunt and uncle to their vacation homes in Massachusetts and Florida. Upon graduating from Lincoln in 1940, still banned from her father's house, Lillian had nowhere to go but Katharine Gibbs in New York. The ever-generous Blanche and Gordon rented her an apartment on East 77th Street, bought her clothes at Lord & Taylor, and took her out for evenings on the town. She saw the Ballet Russe at the Fifty-First Theatre, drank champagne cocktails at the 21 Club, went to Bill's Gay Nineties, a Prohibition Era speakeasy turned restaurant and piano bar, saw Ethel Barrymore in *The Corn Is Green* on Broadway, had high tea at the Waldorf, and rode the roller coaster at the New York World's Fair. She made friends, did well in her classes, and became, as one acquaintance noted, "an outstanding young lady."

Pivotally, Gordon and Blanche, who owned two airplanes, introduced Lillian to aviation. When she was fourteen, Gordon had taken her for her first plane ride, over the America's Cup races at Newport, Rhode Island. Flying was "the most wonderful feeling... [a] combination of freedom, control, and ability... beautiful in every way," she would recall. Flight lessons followed, and in September 1941 she earned her private pilot's license — three months before Pearl Harbor.

Of course, there were no women's reserves in the military then, so after Gibbs, she worked in a series of aviation jobs. The last one was the best. At Grumman Aircraft in Bethpage, New York, a leading producer of military planes, she was secretary to Bud Gillies, the head of testing and flight operations. Gillies let Lillian work part-time in one of Grumman's control towers once she got her operator's license; she was one of the first women

At Avenger Field near Sweetwater, Texas, Lillian
Lorraine quickly traded her sophisticated Katharine
Gibbs ensemble for a sturdy khaki "zoot suit"
COURTESY OF LYNN YONALLY

in the country to do so. One day, she guided in Charles Lindbergh who, astonished at having heard a female voice, came over afterward to shake her hand.

But Lillian's real excitement began on May 6, 1943, when she opened the telegram from the Army Air Forces (AAF) accepting her into its WASP training program and ordering her to report to Avenger Field just west of Sweetwater, Texas. Out of more than 25,000 women who applied, only 1,830 made the cut, and, in her case, no time had been wasted. A day earlier, she'd turned twenty-one, the WASP's minimum age requirement.

After borrowing $300 from Gillies because she'd spent all her money the night before out with friends celebrating her birthday (and there were no credit cards in those days), she threw her possessions into her suitcase, then rushed to catch two commercial flights and a train to hot, dusty

central Texas. Amid a desolate landscape dotted with mesquite bushes, she arrived looking like a Gibbs secretary in a suit, heels, hat, and gloves.

That outfit was soon replaced by khaki pants, short-sleeved white shirts, heavy shoes, and flight jumpsuits, known as "zoot suits." She had to buy all those items herself at the Sweetwater general store because the AAF provided only Army surplus mechanic's overalls, size forty-four and up. The bare-bones barracks, six bunks to each of two rooms and one bathroom in-between, and the mess hall grub contrasted sharply with Lillian's New York lifestyle. She didn't mind. She finally had a purpose, "something that I could give that I had a skill for."

The airplane had radically changed warfare. For eons, battles had been fought by soldiers and sailors on land and water. Now, instigated by the Axis powers, combat territory reached into the sky. At dawn on September 1, 1939, in the surprise attack on Poland that launched World War II, Germany unleashed its first "blitzkrieg," or lightning war, by sending nearly 900 bombers and more than 400 fighter planes along with some 2,000 tanks to batter its neighbor into submission. Two years later, Japan attacked Pearl Harbor with 353 fighter planes and bombers, killing 2,390 Americans.

Woefully under-equipped with only about 3,000 combat planes in December 1941, the US military rushed to catch up. American factories manufactured 47,800 military planes in 1942 and another 86,000 in 1943. But who was going to test all those new machines and fly them from factories to military bases? As many male pilots as possible had to be sent into combat. The obvious answer was female pilots. Thus began, in mid-1942, the Women's Auxiliary Ferrying Squadron and the Women's Flying Training Detachment, which merged in 1943 into the WASP program.

As one of fifty-nine students in the seventh women's training class at Avenger Field, Lillian lived and breathed airplanes. On the ground, she took classes in instrumentation, map navigation, signals, engines, weather, and cross country flight information. In the air, she practiced loops, spins, steep climbing turns known as chandelles, snap rolls, and slow rolls on all kinds of planes. From time to time, Mother Nature rolled tumbleweeds onto the runways, kicked up dust storms, and swarmed the air with crickets.

In her spare time, Lillian created a unique historical record, albeit illicitly. Officially, cameras were forbidden at Avenger Field — this was wartime — but her father, with whom she'd reconciled, had given her a small, boxy Argus C3 rangefinder camera and he kept her well supplied with color slide film. Surreptitiously, she snapped images of herself, her friends, the planes, and her instructors, and mailed the exposed rolls back to her father for processing. Recently introduced and considerably more expensive than black-and-white, color film was rarely used by amateur shutterbugs, and most color photos of World War II were carefully posed images shot by professionals. Lillian's work captures spontaneous emotions and experiences in vivid, you-are-there hues.

It took grit to get through the seven-month WASP training. Of the total 1,830 women who began, only 1,074 graduated. Lillian did so well she earned a spot as one of the first twenty women sent to Mather Field in Sacramento to train on Mitchell B-25 mid-range bombers, after which the army sent her to March Field near Riverside, California, to work as a tow target pilot.

Lillian Lorraine on the wing of a Douglas SBD Dauntless
naval scout plane and dive bomber, 1944
COURTESY OF LYNN YONALLY

This was no powder-puff assignment. Once she reached cruising altitude above the Mojave Desert, a tow reel operator in the stern unfurled a clear nylon fabric sleeve that trailed thirty feet behind the plane — at which, for two hours at a time, ground troops fired live ammunition for target practice. Twice, badly aimed bullets hit her plane, and once a wild shot severed the tow reel, causing her plane to jolt forward. With the unflappability of a Gibbs graduate, Lillian regained control and continued flying back and forth amid the hail of gunfire. She also did radar tracking over the Pacific and flew at nighttime "without a horizon [amid] total blackness" while "great bursts" of simulated explosions flashed at the sides of the plane. Altogether, she logged more than 1,000 hours as a WASP with no accidents, injuries, or hesitation. "I was not afraid and did not waste time on worrying. Life is to be lived!"

The WASPs had one big drawback. Unlike all the other women's wartime auxiliaries — the army WACs, the navy WAVES, the coast guard SPARs, and the Marine Corps' Women's Reserve — they were considered civilian volunteers rather than part of the military. As a result, WASPs were paid only about two-thirds as much as men doing the exact same job. If they were to die while serving — and thirty-eight WASPs did — their families would receive no life insurance payment, no survivors' benefits, no help toward burial expenses, not even a flag to drape over the coffin. Crucially, without military status, WASPs would have no access to the GI Bill that President Roosevelt signed on June 22, 1944, giving war veterans life-changing money for college, unemployment insurance, and housing benefits.

When Congress finally took up the issue in 1944, prospects looked excellent. Testifying to the House Committee on Military Affairs, AAF Commanding General Henry H. Arnold heaped praise on the WASPs for superb performance in all domestic military missions. He recommended expanding and militarizing the program, so all capable male pilots and trainees could be transferred overseas where they were desperately needed as ground troops. Other top brass, including Secretary of War Henry Stimson, supported the plan.

Never in this war had Congress rejected a measure supported by the War Department or a commanding general.

But no one had reckoned on the reaction of thousands of male Civil Aeronautics Administration instructors and pilots. Their previous exemption from military service had been revoked, so they were now staring into the crosshairs of a draft notice and possible combat duty. Why should a bunch of girls get the glamorous, relatively low-risk jobs that, they believed, were rightfully theirs? Also unhappy about the WASP program were pilots returning from battle who eyed with envy the newest, heaviest, and fastest planes that the WASPs were flying.

These disgruntled male pilots bombarded Congress and the White House with protests, prompting the House Military Affairs Committee to launch an investigation. It was a sham. No one visited the Avenger Field training school or any of the military bases where WASPs worked, and false claims by male pilots were accepted as facts. The ensuing report killed the WASP program with a hatchet chop, portraying it as a fool's errand that tried to turn "stenographers, clerks, school teachers, housewives, factory workers, and other inexperienced personnel" into pilots. On June 21, 1944, fifteen days after D-Day, Congress rejected the WASP militarization bill.

The army threw in the towel. On October 3, 1944, General Arnold announced that the WASPs would disband on December 20. They were the only women's auxiliary sent home before the end of the war.

It was an outright theft of hundreds of jobs. The *Fort Worth Star Telegram* pinpointed the swindle. "Because a predominantly male Congress could not bear to see women working when there were men wanting their jobs, and therefore denied them the status and recognition to which they were entitled, more than 900 members of the Women's Airforce Service Pilots (Wasps) are being demobilized."

Stunned, Lillian barely registered the goodbye ceremony: "I think they said thank you . . . I wasn't listening very closely." She didn't receive any discharge pay and was told to get home however she could. She packed her suitcase, caught a ride partway on a B-24 bomber, and arrived in New York

on Christmas Eve, 1944. There was no going back. Several WASPs offered to work for $1 a year. The army turned them down. Neither was there any point, after the war, in applying for a civilian pilot's job. Another WASP tried and reported, "I never heard 'no' written so many different ways in all my life."

But Gibbs had made a fighter of Lillian and the fight wasn't over yet. For years, though, she had to lie low. She may have thought when she married James M. Yonally in 1946 that they could share memories of the good old days. After all, he'd taught the ground troops firing at her tow target over the Mojave Desert. But Yonally had gone on to serve in the Korean War, a miserable, futile, massacre-laden conflict that traumatized him so badly he forbade any mention of military service to their six children and told Lillian to give her WASP uniforms to the Salvation Army. To keep the peace, she complied. Their daughter Lynn was in college before she knew Lillian had flown with the WASPs.

But silence wasn't forgetting. And being a wife didn't mean giving up her own mind. Secretly, Lillian kept in touch with other WASPs, and in the 1970s, in the wake of "second wave" feminism, the time was finally right to redress the government's wrong. Lillian pitched in to help the WASPs gain retroactive military status, which they did in 1977 — critical because it provided medical care through the Veterans Administration. More belated recognition arrived in March 2010 when eighty-seven-year-old Lillian and the other surviving WASPs went to Washington, DC, to receive the Congressional Gold Medal, the highest civilian recognition.

In her later years, Lillian traveled the country as a popular speaker about the WASPs.

Her message: "I believe women can do most anything men can, if they really want to. There is a need for that to be known."

∽

THE MILITARY DIDN'T ALWAYS delay recognition for women. One Gibbs graduate made it all the way to the top, becoming a US Marine Corps colonel — the

highest rank then available to a woman. Ironically, the Marines, the armed services branch with the most aggressively masculine image, did a better job of rewarding female competence than one of the nation's leading bastions of liberalism.

In the early 1940s, Katherine Towle was shuffling paper in an obscure corner of the UC Berkeley campus, where she'd worked years before. She'd been forced to return after having been one of the Gibbs school's early successes. Katherine was the 1923 New York graduate who six years later, at thirty-one, became headmistress of the elite Miss Ransom and Miss Bridges School for girls in Piedmont, California. During the Depression, she'd lost that job when the school, which had no rainy-day endowment, was forced to close as cash-strapped parents withdrew their daughters. She'd been financially independent, in charge, respected — "this gets under your skin." At thirty-four, unemployed and without prospects, she'd had to trudge back to her parents' home in Berkeley. For months, she moped.

It was her Gibbs-acquired typing and filing skills, not her headmistress experience or her BA in political science from UC Berkeley, that set Katherine back on her feet. She got a low-level, part-time job in Berkeley's registrar's office, and enrolled in political science graduate classes, hoping to become a professor as she'd always wanted. That looked promising. After about eighteen months, the political science department awarded her a teaching fellowship, complete with a closet-sized office under the building's third-floor rafters. She felt "very important."

But she wasn't important. Although she earned her master's degree summa cum laude in 1935, the political science department refused to accept Katherine into its doctoral program. "It wasn't because they didn't like me, or didn't think I had done good work, or was not capable of doing good work. This I'm sure of," she said. Instead, several faculty members told her point-blank that the problem was her gender. They simply wouldn't know what to do with a woman PhD.

There was no one to complain to. Gender discrimination didn't become illegal until the Civil Rights Act of 1964. Rather than return to the registrar's office, Katherine got a job as an editorial assistant at the UC

Press in a ramshackle old building where "the ivy was sort of holding the bricks together." A few years later, the publishing house moved to newer quarters and she inched up to become "editor of official publications," which meant cog-in-a-wheel production work on brochures, course catalogs, and bulletins. She was never assigned to work on any of the press's scholarly books.

For eight years, she made the best of a job far below her capabilities. Her positive attitude changed everything.

In early 1943, alarmed by recent Allied setbacks, forty-four-year-old Katherine signed up to join the navy's WAVES. Just before the date of her physical exam, a surprise tap on the shoulder turned her in another direction. The Marines wanted her as an officer.

The Marine Corps had been the last branch of the US military to form a Women's Reserve. So ingrained was its stiff-backed, "leatherneck" culture that when Marine Corps Major General Commandant Thomas Holcomb announced at an officers' bon voyage dinner on October 12, 1942 that women would soon be recruited, the room literally shook — causing a painting of the Marines' "grand old man," nineteenth-century commandant Archibald Henderson, to fall off the wall onto the buffet table. (Yes, that actually happened, an eyewitness said.) The Marine Corps Women's Reserve officially began on February 13, 1943.

World War II recruiting poster

A seemingly odd choice for leadership, Katherine had no military training or experience. Then again, neither did any other woman not already signed up elsewhere in the service. All appointments were made, she said, "by guess and by God." To fill eight officer positions right away, the Marine Corps had asked prominent college deans to recommend candidates. Berkeley's dean of women submitted

Katherine's name, and on February 24, 1943, the Marines commissioned her as a captain.

Reporting within weeks to USMC headquarters in Washington, Katherine stepped through the looking glass. Although Berkeley, where she'd met highest academic standards, considered her a nonstarter, the Marines saw potential in a novice who didn't even know how to salute. "No one could ever have been greener or less military than I in those early days," Katherine said. "I could tie the four-in-hand uniform tie for my uniform khaki shirt, but that was about all." Every day for a week, a Marine ser-

Gibbs graduate Katherine Towle soared to the top of the USMC Women's Reserve during World War II

geant major of thirty years' service took her to a quiet room "away from curious eyes" and taught her military protocol. Other officers answered her questions patiently. And on her first day as the senior female officer at the Marines' temporary women's training school at Hunter College in New York City, nearly everyone, including the male commanding officer, showed up to greet her.

Promotions came quickly. In July 1943, when the Women's Reserves transferred its training school to Camp Lejeune, North Carolina, a huge Marine Corps base that prepared men for overseas duty, Katherine went along as the senior woman officer. There, she oversaw some 3,800 female recruits who would replace men in more than 200 types of jobs. Many were bound for clerical positions, but a good 40 percent went to aviation posts as link trainers, aerologists, and parachute riggers while others became radio operators, drivers, mechanics, paymasters, and quartermasters.

In stark contrast to Berkeley, at Camp Lejeune, Katherine commanded authority and respect. "Her influence over the junior women officers, most of them in their twenties, was one of the great assets of the Marine Corps

Women's Reserve," recalled Colonel Ruth Cheney Streeter, the first director of the USMC Women's Reserve. The younger women had "a healthy awe of her. She stood for no nonsense."

Neither did Katherine fawn over or crumple up obsequiously to men on the base. A large part of her job was overcoming their hostile or derisive behavior. "We weren't wholeheartedly accepted, let's face it," she said. That was putting it mildly. Enlisted men and officers alike made obscene remarks about female recruits within their earshot. Others laughed at the sight of "girls" in uniform, and some male drill instructors let women know they detested them "more than a battalion of Japanese troops." It just had to be "brazened out," Katherine said. Eventually, "we just accepted each other as comrades and fellow Marines."

Even toward her superiors, all long-time Marine Corps officers, Katherine was respectful but unflinching. Once, when a senior officer addressed her as "Miss Towle," she calmly replied to him as "Mr." instead of "Colonel." That story gleefully made its way around base headquarters.

Her finesse won Katherine a promotion to major in February 1944 and an assignment as a staff advisor to the camp's commanding general. That fall, when the Marine Corps had reached its goal strength of 18,000 enlisted women and 1,000 women officers, she got another bump up the ladder. Promoted to lieutenant colonel, she was transferred to Washington, DC, headquarters as assistant director of the Women's Reserve, responsible for policy development and troubleshooting at posts and stations nationwide. When director Streeter resigned in December 1945, Katherine was the instant choice to replace her. Now a full colonel in charge of the whole organization, she oversaw demobilization of some 19,000 women reservists during the next six months. With that process complete in mid-1946, she put her uniform in storage and returned to UC Berkeley, bringing with her a navy commendation medal, as well as World War II and American theater medals.

Surely this wouldn't have happened to a man. UC Berkeley's version of a welcome back was to tell Katherine — good news! — that they'd held her old underling job at the UC Press office open for her. No thanks, she

said; she wanted to work with students. No chance, the university replied, and countered with a position as an administrative assistant to the male vice president and provost. It "was not what I wanted to do," she said. But for reasons she never understood, she longed to stay at Berkeley, so she accepted. A year later, her beloved alma mater finally, cautiously, gave her some responsibility and named her assistant dean of women. At forty-nine, she expected to stay in that job for the rest of her working life.

Again, the Marines came to the rescue. In 1948, Congress passed the Women's Armed Services Integration Act, giving all women in the military regular and reserve status, versus the temporary, emergency status that most had previously. Among Marine Corps top brass, there was no question who should lead the new permanent Women Marines department. Four-star General Clifton Cates, commandant of the entire Marine Corps, offered Katherine the job in person at a meeting in San Francisco.

Previously, Katherine had always taken what was handed out, done an outstanding job, and gone back to taking what was handed out. No more. Now, she realized, she had bargaining power.

Well, she wasn't so sure about this, she told General Cates. She'd just gotten started in a civilian career where she wanted to be. Did anyone ever talk to a four-star general that way, especially one who'd led the Marines at Guadalcanal and Iwo Jima? She did. She didn't mention that her assistant deanship was probably a dead end. If she was going to uproot her life at the half-century point, she was going to get something not just for herself but also for all the "quiet, uncomplaining and often gallant" military women who'd served during World War II. She was going to "put our detractors straight on a few points."

After the San Francisco meeting, her answer still up in the air, Katherine wrote to the general stating her terms. "I made it very clear" that like the heads of all the other Marine Corps departments, her position would have to report directly to the commandant. During the previous temporary setup, the women's director had reported to the director of personnel, an arrangement that made sense because they were all still learning and wartime stakes were high. Now, an extra bureaucratic

layer would not only impede clear communication, but also reinforce the second-class status that Congress had slapped on military women. The 1948 Women's Armed Services Integration Act limited the number of women in each branch to 2 percent and dictated that each branch could have only one female full colonel or navy captain, that being the highest available rank — no women generals or admirals allowed.

Marine Corps headquarters agreed to the reorganization, and Katherine moved to Washington, DC, in October 1948 as the first director of women in the regular US Marine Corps. At weekly briefings with the commandant, she was the only woman and the only colonel among generals. The symbolic value was critical because it put women on the same footing as the other departments. In charge of recruiting, in five years Katherine expanded the Women Marines from a skeleton force of 129 to more than 2,600 despite fierce competition from the other military branches and the higher-paying civilian labor market. She also traveled to bases around the country where women were stationed to ensure good living conditions, morale, and discipline. Her reports and recommendations were always taken seriously, she said.

She loved the job, "all the time, always," and stayed till the very last day, her fifty-fifth birthday on April 30, 1953, when regulations required that she retire. The Marines gave her a grand sendoff, staging a "sunset parade" in her honor, complete with a marching band and a reception afterward at a general's home. For "outstanding professional skill," she received the Legion of Merit, only the second woman Marine so honored.

When she'd resigned from UC Berkeley in 1948 to rejoin the Marines, Katherine had no intention of ever returning. They'd shown what they thought of her and so, quite differently, had the Marines. But like a sluggish student suddenly jolted awake, the university realized its mistake. In 1952, aware that she'd be retiring soon, UC Berkeley chancellor Clark Kerr asked her to return as dean of women students. This was the civilian job she wanted more than anything else, and she started there in July 1953. Eight years later, Katherine became Berkeley's first female dean of students, all students, male and female.

Four decades after attending Gibbs in New York — then a confused runaway from some West Coast trauma — Katherine Towle had become living proof of the school's strategy for success through competence, confidence, and cooperation. Her story showed a hidden side of the formula. Even if you didn't expect great things, as long as you acted as if you did, they could still happen.

ELEVEN

Civilians

∾⌒∽

BY 1944, THE GIBBS schools were posting more than 8,500 job openings per year, up from 5,500 two years earlier—against total enrollment of only 1,600. As men rushed off to war, Gibbs graduates had their pick of positions in the civilian job market.

Aviation was a particularly needy field, as firepower in the skies became crucial to victory and all available male pilots and ground crews had to be rounded up for the cause. While Lillian Lorraine and her fellow WASPs were taking over in the cockpit to fly domestic military missions, Vera Covell got behind the control tower desk for Pan Am at New York's La Guardia Airport as the first female radiophone operator for a major US airline. Giving precise instructions about direction, altitude, and wind conditions, she guided Pan Am's forty-two-ton Clipper airplanes in take-off and landing. It wasn't only her pilot's license or control tower operator's certification that led her to this groundbreaking role. It was also her Gibbs education.

Ever since childhood when she lived near an airport and awoke every morning to planes roaring over her rooftop, Vera had been fascinated by flying. Often, she went down to the airport to watch the action, and at nineteen, she started taking flying lessons. But a career as a commercial pilot was a hopeless ambition. In an era of endless bad jokes about accident-prone women drivers, it was impossible to believe

that the public would trust one to steer a huge hunk of metal through the sky with passengers aboard. Even WASP pilots, with their stellar safety records and having had the trust of the US military, were all turned away when commercial flights resumed after the war's end. Not until 1973 would a major US airline hire a woman pilot.

So, after graduating from high school in Flushing, New York, Vera went to Katharine Gibbs, which led to a short stint as a stenographer with a construction company. Heeding the school's advice to job-hop as much as necessary, Vera landed her next job as a secretary in the sales department of American Airlines and then moved over to Pan Am as a secretary. Following the Gibbs

Vera Covell on the "radiophone," guiding in a Pan Am pilot at La Guardia Airport

game plan, she raised her hand for every possible extra task. Spotting a chance to create her own job, she enrolled in air traffic control classes and earned her radio telephone operator's license in early December 1941. After the attack on Pearl Harbor sent the nation into a panicked race to assemble male fighting forces, twenty-five-year-old Vera got her job in the control tower.

Previously, Pan Am had hired women only as clerical workers and didn't even trust them to serve drinks and snacks as flight attendants.

As the war effort escalated, Pan Am joined with the US government to ferry personnel and supplies around the globe. The airline had extensive routes spanning both the Atlantic and the Pacific, and its signature Clippers — mammoth, four-engine "flying boats" with a fuselage that floated in water — were much faster than ocean travel. Much safer, too. No U-boat could shoot them down. Cargo ranged from thousands of pounds

of mail to Ireland to tons of uranium ore from the central African nation of Gabon, destined to become bomb fuel. These were the types of flights Vera guided safely to and from La Guardia Airport.

On her first call, the mere sound of her voice set off alarm bells at the Civil Aeronautics Authority, which clattered out an urgent message on the automatic telegraph printer. *Who was that on the radiophone, boy or girl?* Not quite satisfied that a woman could legitimately be doing the job, the government told Vera they'd be checking up on her. Clipper pilots also were initially taken aback and thought they'd tuned in to the wrong frequency. To overcome resistance and to prove herself beyond any doubt, Vera took courses in meteorology and navigation and studied the operation of different types of planes.

In her spare time, she flew with the Civil Air Patrol, searching twelve miles out on the Atlantic for German submarines. That was serious business. In January 1942, Nazi submarines began torpedoing merchant ships and oil tankers in American shipping lanes along the East coast, and five months later, the threat of an invasion materialized. Four Nazi saboteurs landed from U-boats on Long Island and four more on the Florida coast near Jacksonville. Armed with explosives, they planned to blow up factories, power plants, water supply systems, department stores, and railroad and bus terminals across the country. Although within weeks the FBI arrested all eight Germans before they did any damage, it had been a close call. Caught underequipped and short-staffed by the declaration of war, the US military didn't have the resources for thorough surveillance, so Vera and other volunteer "subchasers" played a vital role in national defense.

The novelty of her job, her patriotism — and, not incidentally, her photogenic appearance — caught the eye of media scouts. In 1943, Vera appeared on the cover of *This Week*, the Sunday supplement magazine that paperboys plunked down on doorsteps nationwide along with newspapers like the *Los Angeles Times* and the *Atlanta Constitution*. Woodbury Facial Soap (only 10 cents!) also came calling and hired her to tout her soap-and-water beauty routine in full-page ads that ran in *Life*, *McCall's*, *Ladies' Home Journal*, and *Cosmopolitan*.

Aviation also introduced Anita Yale to a glamorous new life. Her early years in New York had been marred by family violence. Barely old enough to walk and talk, she'd watched her father, a manager for an export company, knock her mother to the ground and hurl insults at her, calling her an "old shrew" and accusing her of eating as noisily as a horse munching oats. Her parents separated when she was three, and her mother fled to Los Angeles with Anita and her two brothers. After earning a degree at Wilson College in Pennsylvania, Anita set about distancing herself from her Guatemalan-born father and her broken past. She changed her last name from Yela to Yale and headed for Katharine Gibbs in New York to make a new start.

Her first job at a bank offered safety and respectability, but came up short on sparkle. So, when a friend who worked at an upper-crust employment agency tipped her off to a mysterious opening with a well-known public figure, Anita jumped at the chance and won the job even though countless other applicants had been rejected. Her new boss turned out to be Major Alexander de Seversky, founder of Republic Aviation and a World War I flying ace. "That crazy Russian!" her employers at the bank grimaced when she handed in her resignation. "You'll be back in two weeks."

It was true, de Seversky was a character. Born in Tiflis, Russia (now Tbilisi, Georgia), he'd been one of the most decorated pilots of the Imperial Naval Air Service during World War I. Although shot down over the Baltic Sea on his first mission by German antiaircraft guns, sustaining wounds that necessitated amputation of his right leg below the knee, he insisted on returning to combat and ultimately flew fifty-seven missions and took down thirteen — or six, accounts vary — German planes. After the 1917 Bolshevist Revolution, he came to the United States and started Seversky Aviation on Long Island. Unfortunately, his brilliance at designing and manufacturing innovative parts wasn't matched by financial acumen. He kept losing money, and after a badly timed decision to sell fighter planes to the Japanese government in the late 1930s, his board of directors seized control of the company, renamed it Republic Aviation, and fired him. But the resilient and debonair de Seversky had another life in him. He put pen

to paper and churned out a book, *Victory Through Air Power*, advocating long-range aerial bombardment to win World War II. On the day it was published in April 1942, Anita started work with him.

The book stayed in the top spot on the *New York Times* bestseller list for four weeks that summer, selling at least 350,000 copies. Those numbers perked up Hollywood's ears. By the end of the year, de Seversky had struck a deal with an unlikely screen suitor, the Walt Disney Studios, which in early 1943 departed from its bread-and-butter Mickey Mouse and Donald Duck cartoons to begin production on an animated movie version of his book. Hired as a consultant and partial narrator, her boss took Anita along to Los Angeles for the five-month duration. Celebrities galore couldn't wait to rub shoulders with a real-life hero of the skies and, along with de Seversky's movie star chic wife, former Louisiana socialite Evelyn Olliphant, Anita was often on the guest list. One lavish party in de Seversky's honor at the Beverly Hills mansion of Edgar Bergen in April 1943 drew Basil Rathbone, Alfred Hitchcock, Danny Kaye, Walt Disney, Luise Rainer, and Ira Gershwin. When film production wrapped in June, Disney threw a gala farewell dinner for 300 at the studio, with places set for Spencer Tracy, David O. Selznick, Ernst Lubitsch, and producer Hal Wallis.

Other trips had Anita packing her suitcase for getaways among business and political power brokers. In early 1944, she joined the de Severskys for a month's stay at the Fort Lauderdale home of financier and industrialist Siegfried Bechhold, who'd helped develop the Sherman tank. At an evening garden party there, she circulated among grandees like newspaper publisher and former governor of Puerto Rico Robert H. Gore and syndicated Washington, DC, newspaper columnist and radio show host Drew Pearson. Whatever went on among the rich and powerful behind closed doors, at least in public they sported their best behavior. To someone like Anita, whose parents hadn't tried to hide their fury toward each other, appearances could mean a lot. It was so alluring to live in this world that she gladly worked until 2 or 3 a.m. whenever — as he often did — the tireless de Seversky required.

Far from bailing out after only two weeks as her colleagues at the bank had predicted, Anita lasted three and a half years — and then she left only because her boss had inadvertently found her a husband. During an early 1945 trip to Europe to consult with General Carl Spaatz, commander of US Strategic Air Forces in Europe, de Seversky asked the general's personal pilot to deliver a few gifts — some silk, films, and other souvenirs — to his secretary. The personal pilot was Lieutenant Colonel Robert E. Kimmel, a veteran of fifty-five combat missions who'd earned a Legion of Merit medal, a Silver Star, and a Distinguished Flying Cross. When Kimmel showed up at Anita's desk that summer, their mutual fate was sealed. The couple married three months later in New York on November 17, 1945. With the war over now, Anita left her job and began family life. The marriage lasted till her death in 2017.

A 1938 graduate of the Gibbs school in Boston, Mary Thayer Muther had her own delightfully eccentric Russian genius boss during the World War II years — Serge Koussevitzky, music director of the Boston Symphony Orchestra. Then in his mid-sixties, Koussevitzky was renowned as a champion of modern music who had transformed Boston's ensemble from a backwater band into one of America's best orchestras. Behind him he trailed a colorful history that began at the opposite end of the social spectrum from Anita Yale's wealthy, aristocratic Alexander de Seversky. Born to a poor family in the small town of Vyshny Volochek, Koussevitzky had longed to become a conductor but reluctantly studied the double bass at the Moscow Philharmonic Institute because that was the best way to get a scholarship. Marriage in 1905 to the daughter of a wealthy Russian tea merchant changed his life, although it required him to divorce his first wife, a dancer. The new wife's money took them to Berlin, where she footed the bill for conducting lessons and hired the Berlin Philharmonic so Koussevitzky could practice his new skills. After touring Russia and Europe with symphony orchestras, he landed his job in Boston in 1924.

On the surface, Mary seemed an odd choice to assist the distinguished maestro. As a student at the University of Minnesota before she came to Katharine Gibbs, she appears to have spent most of her free time playing

golf, riding horses, and socializing with her sorority sisters. Her musical credentials, when hired by Koussevitzky, consisted of membership in the "Moments Musical" amateur music appreciation club in her hometown of Minneapolis and season tickets to the Boston Symphony Orchestra.

But Koussevitzky didn't need someone who knew a sharp from a flat. He needed someone who could put together an intelligible English sentence and type letters in a respectable form. For the last ten years, he'd relied on his wife's Russian-born niece, Olga Naumoff, who had her own whimsical way of creating correspondence. Although Olga could speak and write many languages, she found the typewriter a complete mystery and approached it like "one big jigsaw puzzle," according to Mary. "I believe she made them [her typed letters] as artistic as possible. Remember, she didn't know about spacing twice after a sentence; she never heard of an inside address." If Olga thought there were too many useless letters in a word, she simply dropped them. Koussevitzky thought the results were "pretty," but not in keeping with his stature.

So, the two women developed a system. Olga took dictation in Russian, translated it into English, and Mary smoothed off the rough edges, put back the missing pieces of words, and typed the whole thing up into a crisp and error-free document. Sometimes when Koussevitzky's reply to correspondence amounted to a simple yes or no, Mary elaborated on the reasons. When Koussevitzky nodded approval of her work, she felt "more than a little proud."

As for Olga, her job wasn't in any danger. Koussevitzky had other reasons to keep her around. She adored him and she was, Mary noted, "very charming." In 1947, five years after Koussevitzky's patroness second wife died, he married Olga. If anything improper had been going on before that, Mary didn't say. As Katharine Gibbs herself had instructed, "Don't gossip about your employer or discuss his affairs. Nothing inspires less confidence."

Besides, there was plenty of other excitement to occupy her attention. Mary met virtuoso musicians, heard world-famous cellist Gregor Piatigorsky practice in their office, and helped plan the eight-week summer academy that Koussevitzky directed at the Berkshire Music Center (now Tanglewood). A particular challenge was communicating with "B Moll,"

her boss's black cocker spaniel who understood only Russian and routinely tried to shove her off her chair.

Part high-class culture and part madcap comedy, the job was always an adventure. For helping her get there, Mary said, "I never cease to thank Katharine Gibbs."

Probably no domain of twentieth century American life was more thoroughly dominated by men than politics — at least until World War II sent so many potential candidates, and the male voters who would have supported them, off to distant battlegrounds. Meanwhile, the number of political offices didn't shrink and elections still rolled around on the same regular schedule. Hazel Thrall Sullivan — a Smith graduate who'd gone on to Katharine Gibbs in Boston — put those facts together and in 1944 decided to enter politics in her hometown of Windsor, Connecticut.

With her husband back home after serving in Iran with the army, and desperate for more intellectual stimulation than stay-at-home motherhood to their two children provided, twenty-nine-year-old Hazel accepted the Democratic party's offer to run for the state legislature. Local Republicans grinned. Windsor had never elected a woman to that position and only once before had elected a Democrat. Although Hazel considered her candidacy "a lost cause from the start," she campaigned vigorously.

Fortunately, with many of Windsor's men off at war, most voters were women. And many of them, regardless of party affiliation, admired Hazel from her volunteer work with the League of Women Voters and the YCWA, and as the only female member of the Slum Clearance Committee in New Haven, where she'd previously lived. Even Republicans and independents formed a committee to support her.

Pulling votes across party lines, more in Windsor than even FDR garnered, Hazel won the 1944 election and went on to serve two two-year terms in the General Assembly before retiring to spend more time with her family. Although she'd been a desperation candidate — the local Democratic organization hadn't been able to find anyone else to run and its chairman had never even met Hazel when he phoned to offer her a place on the 1944 ticket — she turned out to be a firebrand.

Speaking up frequently at hearings on the House floor, she didn't hesitate to lambaste either her colleagues or business fat cats for underhanded dealings. She protested indignantly when the liquor lobby wanted the state to set minimum prices for its wares, and she pushed the Connecticut Company bus line, which had a monopoly on service between Hartford and Windsor, to lower its exorbitant fares in line with comparable routes. On principle, she even acted against her family's interests. Her father and older brother ran a prosperous shade tobacco farm on land the Thralls had held since 1635 via a grant from the King of England. Yet, when the Connecticut Tobacco Growers Agricultural Association tried to stymie a bill outlawing field labor of children — statewide, about 25 percent of the industry's 10,000 workers were under sixteen — she publicly complained that "shadowy figures" had assembled ridiculous roadblocks. Child labor was wrong, she insisted. When the legislature passed only a watered-down version of the bill, she blasted it as "toothless."

However much the old boys' network might have grumbled about Hazel's upstart ways, she had a cheering section among the press. In 1947, newspaper reporters covering the state legislature voted her one of the three "most able" representatives in the House, even though she was one of its youngest and newest members.

As she stood up for society's overlooked and exploited members, Katharine Gibbs's foundational message — women must be financially self-sufficient — wasn't lost on Hazel. One of her signature achievements reflected that value. As a member of the legislature's Education Committee, Hazel helped lead a successful fight against the "dependency allowance" that gave schoolteachers hundreds more dollars per year if they had a spouse and children to support. That rankled Hazel, because almost all family breadwinners were male, so the allowance was discriminatory. "I stood for equal pay for the same amount of service," she explained years later.

Ironically, when she went to work in the early 1960s as a social studies teacher at Windsor High School, Hazel discovered that her hometown had the one school district statewide that still gave the dependency allowance. Illegally — but so what? They were getting away with it. Until Hazel

arrived. The discrepancy didn't affect her significantly because she came from a wealthy, land-owning family and her husband had a good job as a lawyer with the State Labor Department. But it wasn't fair. When the school district wouldn't budge and the all-male teachers' negotiating committee refused to back her, Hazel sued the Board of Education and the town treasurer for illegal discrimination on the basis of sex and marital status.

"It was quite a battle," she said. Viciously so. The superintendent of schools summoned Hazel to his office and after threatening reprisals if she continued, suggested what might be done for her if she dropped the lawsuit. Hazel hit back hard. "I said that I had lived too long and I never had yet accepted any kind of bribe and I was not going to." She had her day in court and won. A judge struck down the dependency allowance and even gave the town some free legal advice: don't bother appealing the decision — they'd lose. A week later, in June 1965, Windsor canceled the dependency allowance.

The school board didn't thank Hazel for a valuable civics lesson. Instead, they put a nasty letter in her file, accusing her of "being unethical, insubordinate, and some additional adjectives from which anyone could have assumed the worst," she said. The letter would have blackballed her from ever teaching anywhere else. Again, she fought back. After she hired the best lawyer she could find in Connecticut, the Board of Education rescinded its criticisms, admitted she'd had a perfect right to sue, and expunged the letter from her file. She continued to teach until 1980. Decades later, former students remembered her as "outstanding" and "a pioneer, ahead of her time and a delight." One commented, "I hope she knows how much of a difference she made!"

Wonder Woman

∽◡◠

DURING THE WAR YEARS, as women stampeded into the workforce, it was no accident that an iconic image of female power emerged in American popular culture — Wonder Woman. The only female super-hero amid a comic book battalion that included Superman, Batman, Captain America, Aquaman, and Green Lantern, the stately, shapely brunette lured millions of American children and adults alike to plunk down their dimes on the candy store counter so they could read about her latest adventures. Scantily clad in a red bustier, star-spangled blue short-shorts, gold headband, and high-heeled red boots, Wonder Woman zapped villains with knock-out punches, deflected bullets with her wide-cuff metal bracelets, time-traveled in her invisible plane, and foiled the dastardly plots of evildoers like Dr. Psycho, who wanted to send women back "to the days of the sultans and slave markets, clanking chains and abject captivity."

Joye Hummel
COURTESY OF ROBB MURCHISON

It was also no accident that a Gibbs graduate, trained at the institution that

Joye Hummel in class at Gibbs
PLATEN, 1943, KATHARINE GIBBS SCHOOL RECORDS, BROWN UNIVERSITY

turned out generations of "wonder women," helped shape the character of Wonder Woman and wrote many of her early stories. At nineteen, Joye Hummel got the job directly out of Gibbs and directly because of Gibbs.

Joye had signed up for the two-year course at Gibbs in New York in mid-1942 because her mother, crushed by the break-up of her marriage to Joye's father, needed her. As it happened, while Mrs. Hummel thought her husband was unpacking boxes and restocking shelves as manager of the A&P grocery store in their hometown of Hempstead, Long Island, he'd been seen sneaking into a hot-sheet hotel with another woman. Joye, an only child, had left home the year before for Middlebury College in Vermont. Now Middlebury was too far away and so was, three years in the distance, her earning power. Thumbing through Gibbs literature, Joye saw a quicker path to a paycheck. Here, while commuting from home, she could get a first-class education in half the time, followed by wide open doors to employment at top companies in any field she wanted.

An honors student in high school, Joye loved the rigor at Gibbs, where everything seemed pitched "to make you as perfect as you could be." During her second year, she took a course that would change her life — business psychology taught by William Moulton Marston. Even on the

Gibbs star-studded faculty roster with its Ivy Leaguers and industry leaders, fifty-year-old Marston stood out.

Over six feet tall, "built like a football player," and with a penchant for expertly tailored three-piece suits, Marston radiated the restless energy of a lifelong polymath. As an undergraduate at Harvard in the early 1910s, he'd written three screenplays that were made into short films: *The Thief,* directed by Alice Guy-Blaché; *Love in an Apartment Hotel,* directed by D. W. Griffith shortly before he made *Birth of a Nation*; and *Jack Kennard, Coward,* distributed by Thomas Edison's General Film Company. After that, Marston helped invent the lie detector test, graduated from Harvard Law School, earned a PhD in psychology at Harvard, published the influential book *Emotions of Normal People,* served as a story consultant at Universal Pictures, appeared in magazine ads for Gillette razor blades, and started writing comic books. Joye didn't know about the comic books. She didn't read them. But even if she had been among the 10 million fans of Wonder Woman, she wouldn't have connected the author with her erudite teacher. Marston wrote Wonder Woman under the pen name Charles Moulton, and in class, he never mentioned his superhero creation.

A made-to-order Gibbs professor who believed women should pursue whatever vocation they wanted, Marston taught leadership principles. "He was a brilliant teacher. I inhaled his class," Joye said. His lessons struck deep. One was that "business does not entail love . . . It's not a person with a heart" and so it required different skills than those needed in personal relationships. Another, which would speed Joye's acceptance among the quirky creative types of the Wonder Woman world, was that logical persuasion—what Marston called "inducement"—always worked better than bossiness, even when you were the boss. "It wasn't just theory," Joye said, "it was wise."

Marston's take-home final exam, consisting of eight essay questions, opened a floodgate of words for Joye. "I just wrote and wrote and wrote. I wrote in the space provided. I wrote up and down the sides of the paper," she recalled. One question asked, "Advise Miss F. how to overcome her fear of talking with the company Vice President who is in charge of her Division

and whom she has plenty of opportunities to contact if she chooses; also tell Miss F. why these contacts are to her advantage." Another described Miss A.'s brooding resentment toward her soldier fiancé, who seemed to ignore her when he came home on weekends from training camp. While trying to suppress her hurt feelings, Miss A. began to fail at secretarial school. How could she "remedy her maladjustment of personality?"

Joye's answers stunned Marston's grading assistant. Marston himself could have written them. Marston agreed. This young woman was the smartest student he'd ever had — anywhere. And he'd taught at Columbia, Tufts, and American University. (Unfortunately, Joye's paper has been lost.)

The timing was lucky. Marston needed help. Since creating Wonder Woman in 1941, he'd come under attack as a bad influence on children's impressionable minds. Frequently in his stories, Wonder Woman — and other female characters — were tied up, chained, leashed, handcuffed, bound at the ankles, whipped, spanked with a paddle, and subjected to myriad other kinds of humiliation and abuse. Some experts accused Marston of promoting bondage, sexual fetishism, and general perversion. "For heaven's sake," Marston groused to his publisher at DC Comics, Max Gaines, what a bunch of busybodies! Many other "real authorities," parents, and educators, he boasted, considered Wonder Woman "a remarkably wholesome and constructive story strip, good for kids in every way." Besides, Marston added, "women *enjoy* submission — being bound."

Despite that sexist bluster, the criticism struck home. Marston knew that he, along with all other men, had blind spots about female psychology. He'd tried male writing assistants. Useless. Now, remarkably, he'd found a young woman who understood his philosophy well enough to channel it back to him from a female point of view and who, as an added bonus, could toss in some younger generation slang. About to launch a Wonder Woman comic strip in family-friendly daily newspapers, and told by Max Gaines to cut out the saucy stuff, Marston asked the Gibbs administration for permission to contact Joye. Then, shortly before her graduation in mid-March 1944, he wrote her a letter asking her to tea.

"You can imagine how surprised I was,"she said. "Mind you, while tak-
ing the course, I never had a personal conversation with him. Never even
shook his hand or told him that I really liked his course. We didn't go in
for that sort of thing much in those days."

The interview took place at the Harvard Club in midtown Manhattan.
There, in the main lounge, a ghoulish assortment of big game heads —
originally belonging to a rhinoceros, a warthog, a cheetah, an elephant,
and an Oryx Beisa antelope, all slaughtered by safari-hunting alumni —
looked down from soaring walls. Dark leather chairs and couches dotted
the room. Unintimidated by the manly, old-money club atmosphere, Joye
held her own. How about it, Marston asked at the end of the conversation,
was she willing to have a go at writing Wonder Woman?

"Yes, I am," she replied confidently. Leaving the building, she felt her
neck redden and wondered, "What am I doing?"

That question probably echoed in Joye's mind as she studied past issues
of *Wonder Woman*. It's hard not to imagine the teenager's eyebrows rising
at the sight of provocative drawings like the one of Wonder Woman lying
on the ground, chained by an ankle to a large post, and getting whacked
across the rear with a paddle by a gleeful Martian warrior. But if she had
misgivings, she kept them to herself. After all, these pages did have over-
whelmingly positive messages. Wonder Woman always broke her chains,
liberated the oppressed, and even looked forward to a woman's running for
president (albeit not until 3004). Whatever Marston himself thought, Joye
decided she knew what he really meant: "for women to get out into the
world and *do* [something] worthy. If you had an ability, then go out and do
it, show it, make those decisions."

Marston didn't argue with that interpretation, and the job turned out
to be perfect for Joye. Growing up, because she'd moved around a lot and
made up stories to keep herself company, she'd developed "a huge imagi-
nation." Soon, she was scribbling down reams of plot ideas and discussing
them with Marston. Soon, in the Wonder Woman offices at 43rd and
Madison, she had her own office with her name on the door, "which was
quite a thrill."Marston dismissed all the other writers and from then on,

only his and Joye's stories would be published. The first female writer of superhero comics, Joye would ultimately write at least seventy-four Wonder Woman stories.

He'd hired her just in time. Shortly before 5 p.m. on August 25, 1944, Joye walked Marston, who was heartily toting his suitcase and briefcase, over to Grand Central Station where he caught a train to Boston. When he arrived a few hours later, he was racked with pain and could hardly walk. By the end of the next day he'd been hospitalized in Boston, and on August 28, an ambulance rushed him to New York's Lenox Hill Hospital. The diagnosis was polio.

It made no sense. Polio, which causes muscle weakness that can lead to withered limbs, paralysis, and death, usually targeted much younger people. No one else in Marston's family was afflicted, and the disease had struck him suddenly and violently. Yet there it was, undeniable and, as it remains today, incurable. At first Marston raged against his fate. Visiting him at Lenox Hill, Joye saw him nearly pull the rings out of the ceiling in an attempt to get out of bed. After nearly a month in the hospital, he returned home to Rye, New York, in Westchester County.

He tried to walk with braces and crutches. He became confined to a wheelchair. He sought treatment with Sister Elizabeth Kenny, a former Australian bush nurse who used a controversial method of hot compresses and passive movement to try to rehabilitate muscles. It didn't work. He exercised regularly but made no progress. He was never able to return to the Wonder Woman offices in Manhattan.

As soon as she heard the news of his illness, Joye canceled a cruise to Bermuda she'd planned with her mother, explaining that Marston had severe arthritis. She didn't dare reveal the truth. No one yet understood how polio was transmitted, and Jonas Salk's preventive vaccine wouldn't appear until the 1950s. Terrifying images were everywhere. FDR in his wheelchair was the most famous example. And if Mrs. Hummel read *Life* magazine, as millions of Americans did, only three weeks earlier she would have seen the bleak story "Infantile Paralysis," as polio was known, with photos by Alfred Eisenstaedt of rows of gaunt children flat on their backs

on thin hospital beds and a twenty-seven-year-old man in an iron lung. Joye said, "There is simply no way she would have allowed me to continue working with him a single hour if she'd known the truth."

Nevertheless, several days a week and on weekends, Joye left the apartment she shared with her mother and went to Marston's home to continue their work. The trip took hours, involving the subway, the Long Island Railroad to Grand Central Station, another train to the town of Harrison, and a taxi to Marston's home, which was a large two-story wooden house amid acres of farmland. Sometimes she didn't return home till after midnight. Sometimes she stayed overnight.

It must have been a challenge for Joye — whose mother had been so painfully two-timed — not to frown at Marston's unorthodox household. He had not only a legal wife, Elizabeth Holloway, but also a common-law wife, Olive Byrne. Both lived with him and each had two children by him. While she was told that Byrne was Marston's widowed sister-in-law, Joye spent enough time with the family to see signs otherwise. Whatever she suspected, she withheld judgment and concentrated on getting along. Publicly, she would always insist she knew nothing about Marston's private life. Gibbs graduates kept their bosses' secrets.

Her visits brought unclouded sunshine to Marston's dark days. He desperately needed that. As evidence mounted that he would never walk again, Joye said, "he just literally almost lost his mind." Sometimes, it took "so much talking" to calm him down.

They met in his parlor, he in his wheelchair. Amid a lot of laughs, she and "Doc," as Joye called Marston, batted around story ideas, the farther-flung the better. "It was great fun as our imaginations knew no boundaries," she recalled. "I guess you could say our minds went out of this world."

Joye's stories propelled Wonder Woman into lush new fantasy lands — sans the risqué elements that Marston had been inclined to include. In her story "Land of Mirrors," Wonder Woman travels to the Gobi Desert to rescue friends kidnapped by a deadly cult of sun worshippers; she fights off a blizzard of spears and magic tricks. Her Wonder Woman also ventured to the Arctic to help Eskimos (as Inuits were called then) under attack by

rampaging polar bears, to an underground world of leprechauns, and to the remote Pacific island of Wooloo, where huge angry metal robots were absconding with peace-loving natives — until, of course, Wonder Woman ended the "Siege of the Iron Giants."

One of Joye's zaniest locales was the teensy Atom Planet, ruled by the evil "Queen Atomia" and observed by Wonder Woman through her special Amazon microscope. Whatever scientists might have believed, it turned out that protons were actually women and neutrons were robotic men outfitted in blue suits of armor and wielding large sabers. Under Queen Atomia's orders, the neutrons were about to blast the earth to smithereens. Wise to this plot, Wonder Woman shrank herself "a thousand times smaller than a tiny pin point," donned an Amazon metal suit and bubble helmet, and infiltrated the Atom Planet, where she used a special cannon to shoot Queen Atomia through the stratosphere to Transformation Island. After learning "We must love, not hate!" Queen Atomia started a sanitarium where her "radio rays" healed disabled children, freeing them to throw away their crutches and bound around at play.

Joye had conjured up the idea either in 1944 or in early 1945 after reading a newspaper article about atoms and doing further study at the New York Public Library. With that happy ending, which was probably aimed at cheering up Marston, the plot seemed harmless. Not so, however, to the US government, which caught wind of the story before publication and came calling to grill Joye. Of course, neither she nor Marston knew anything about the top-secret Manhattan Project, which was developing the atom bomb to be deployed against Japan in early August 1945. Because they'd innocently gotten too close to the truth, the tale of Queen Atomia was shelved and wouldn't appear in print until late 1946.

Joye's other villains were just as wonderfully wild. In the classic "Villainy Incorporated," Joye lined up seven wittily outlandish nemeses for Wonder Woman, all female criminals she'd previously sent to Transformation Island for unsuccessful moral rehabilitation. Now, these evil geniuses banded together for revenge. They were Giganta, formerly a female gorilla; the tubby, fedora-wearing Blue Snow Man, whose real name was Byrna

*A madcap collection of unreformed female criminals cause
havoc in Joye Hummel's "Villainy Incorporated" story*
WONDER WOMAN, MARCH–APRIL 1948

Brilyant; Hypnota, sporting a turban and fake goatee; the cat-suited Cheetah; Princess Maru, a.k.a. Dr. Poison, in a black mask and green surgical gown; and two harem-costumed femmes fatales, Queen Clea of Sunken Atlantis, and Zara, Priestess of Crimson Flame. "Good — not a sissy in the lot," their brassy blonde ringleader exclaims delightedly.

Some of Joye's rogues weren't even human. In "The Brand of Madness," a red-winged fly stamped its victims with a red wing mark and turned them into homicidal maniacs — Wonder Woman to the rescue!

Coming up with such peppy yarns required all the more ingenuity because Wonder Woman's editor at DC Comics, Sheldon Mayer, had issued a typewritten list of twelve taboos for writers and artists. "We must not roast anybody alive," he instructed. Likewise, no bloody daggers, no coffins, no electric chair executions or hangings, no stabbings, no skeletons or skulls, no torture scenes, no chopping off of limbs, and especially — considering the readership — no little children dying in any way, not even from an illness. Plus, watch your language! No character could even call another a jerk. At the bottom of the page, Mayer cheekily hand-wrote, "P.S. — Now go ahead and write a good story — I dare you."

Joye's narratives colored within those lines and sailed past Mayer. Marston was well pleased. This was why he'd hired Joye, for lively, fun, and clean copy. Compared to his version of Wonder Woman, Joye's version showed more heart. When a villain called The Creeper was about to catch fire after landing on a burning car, Wonder Woman saved his life by flinging the two-ton sedan over a fence into a field "like a rubber ball."

Along with writing, Joye handled many practical tasks. Because Marston was appalled by his illness and wanted as few people as possible to know about it, he relied on her as his link to the outside world. She may have saved Wonder Woman's life. By himself, Marston couldn't have managed all the steps from idea through to the printed page. His strength was waning. Within a year of contracting polio, he'd abandoned the Wonder Woman newspaper comic strip and it's possible the next step would have been giving up on the comic books. There was no one but Joye to help. According to her, neither of Marston's wives had enough imagination for the work — very likely so, because instead of collaborating with either of them, he'd hired Joye.

After typing up both Marston's and her stories and getting them approved by editor Sheldon Mayer, Joye oversaw all production details. Working closely with Wonder Woman artist Harry G. Peter, she made sure the visuals conformed to the precise instructions in their scripts about facial expressions, costumes, actions, even furniture placement. "Every single thing that he drew had to be done by what we said, and I had to make sure that was done," Joye recalled. When correcting Peter, Joye used Marston's "inducement" strategy. "I wouldn't say to him, 'Harry that panel was wrong.' No. I would show him what I wrote and say, 'You know, I think it would be better if she were doing this or that' . . . I just never had a problem."

She also proofread all the text, supervised the lettering to make sure the placement was correct, and gave the cover a final once-over. To promote Wonder Woman, she lectured at schools. In all the places Marston couldn't be, Joye was his eyes, hands, heart, and mind.

His time was short. In September 1946, after a surgeon removed a lump

from Marston's back, a biopsy revealed incurable cancer. Fearing that the truth would plunge him into a deep depression, his family lied and told him he had a viral stomach flu. Marston died at home on May 2, 1947, a week before his fifty-fourth birthday. Right up until the end, he'd continued working with Joye on Wonder Woman.

The realization that "this brilliant man" was gone devastated Joye. "You might think it was just comics," she said, but working with Marston had been a mentorship in creativity, leadership, and human relations. She said, "I only got good out of it."

Pressing on, she became Wonder Woman's lead writer. Then life got complicated. After marrying widower David Murchison on August 17, 1947, Joye intended to keep working. One morning she changed her mind. Murchison had a four-year-old daughter, Sally, and Joye had fallen in love with her instantly. All dressed up, about to leave for the office, she went next door where her mother-in-law was babysitting Sally. The little girl looked up at her and with tears streaming down her face asked, "Are you ever coming back?"

As Joye had learned from Marston at Gibbs, business didn't have a heart. Another lesson, hammered in by shaping Wonder Woman as a force for good, was that to be worthy meant causing no harm to others. The two sides of Joye's life wouldn't fit together. Working on a story, she wrote all night, every night, giving it her all. She had to choose — either create a hero for millions of readers or be a hero to one child. No contest.

She went to the office and quit. Wonder Woman editor Sheldon Mayer couldn't believe it. "I thought he was going to have a heart attack. He told me that I was giving up a big career," she said. "He told me that I'd be sorry, but I told him that I didn't think so." To avoid leaving her colleagues high and dry, Joye turned in scripts that would be published intermittently as late as 1949.

For years afterward, Joye couldn't read any Wonder Woman comics and she didn't tell friends and neighbors about that chapter of her life. Yet, she never regretted her decision. She explained, "first comes family. Above money or anything, your family, your children, come first."

Joye and her husband moved to Hollywood, Florida, where he worked as a car salesman while she raised Sally and the two sons they had together. True to the Gibbs spirit, when she needed to go back to work, she did. With the children in high school, Joye took a correspondence course in securities, got licensed as a stockbroker, and, astutely buying Apple stock in the early days, helped pay for their college education.

After Joye left, Wonder Woman went downhill. Marston's legal wife, Elizabeth, wanted to take over, but DC Comics' new publisher Jack Liebowitz (Max Gaines had died in a boating accident in August 1947) turned thumbs down. The whole editorial staff agreed. They viewed Elizabeth as a meddlesome old lady and dived under their desks when she

Ms. Magazine cover, July 1972

entered the office. The new writer and editor, Robert Kanigher, viewed the original Wonder Woman as "grotesque" and "inhuman" and changed her into, of all things, a lonely-hearts newspaper advice columnist who, of all things, yearned to marry her former army colleague, Steve.

Although Joye had worked with Marston for only three-plus years, their version of Wonder Woman had a far-reaching effect. One reader during the mid-1940s was preteen Gloria Steinem, future leader of the 1960s women's liberation movement and a cofounder of *Ms.* magazine. Strong, independent Wonder Woman "rescued" her, Steinem wrote, saving her young self from a dreary future of "sitting around like a Technicolor clotheshorse" and waiting for some man to rescue her. The stories "had seen straight into my heart and understood the fears of violence and humiliation hidden there.... Best of all, I could stop pretending to enjoy the ridicule, bossing-around, and constant endangering of female characters."

Steinem put Wonder Woman on the cover of the July 1972 inaugural issue of *Ms.*

THIRTEEN

"Heavens to Elizabeth, Girls"

<center>∽◦∞◦∾</center>

THE POSTWAR ERA MAY have been the toughest years in the twentieth century for career-minded young women. As men returned from military service and flooded the job market, companies pulled up the drawbridge of opportunity for women. It happened swiftly. Between July and December 1945, the number of women with jobs in the US fell by nearly 3 million, to 16.71 million, an 18 percent decrease. While some had quit to head to the newly emerging suburbs and ignite the baby boom, there were still nearly half a million women looking for work at year's end. In some cities, the wages offered to them had plummeted by more than 50 percent. Anyone trying to climb the ladder would find a man's heels on her fingers. By 1947, 86 percent of all managers and administrators nationwide were male. Higher education also clamped down, narrowing the pipeline to professional success.

In the postwar years, Gibbs graduates had their choice among jobs
PLATEN, 1949. KATHARINE GIBBS SCHOOL
RECORDS, BROWN UNIVERSITY

Between 1945 and 1954, doctorates awarded to women fell from 21 percent to 9 percent.

To persuade young women that these trends were in their best interest, that they'd be happiest at home, American society mounted a full-scale campaign glorifying domesticity. Television wouldn't arrive in most American homes until the 1950s, so magazine racks led the front-line attack. Loaded with bright, cheery pictures of spotless suburban homes and well-behaved children, mass-market titles portrayed the home as a safe haven brimming with fulfilling tasks. In the April 1946 issue of *Seventeen*, Margaret Mead — of all people — published "Can Homemaking Really Be a Career?" Yes, she answered happily. Dismissing most jobs, including men's jobs, as "just ways of making enough money to live," this globe-trotting, world famous anthropologist wrote, "Homemaking, full-time homemaking into which a woman puts her whole personality, is much closer to being a career than is the average job.... you conduct complicated public relations with the grocer and the milkman; you act as a recreation director at the children's party; you nurse the sick, act as a confidante for the broken-hearted."

The following year in *Mademoiselle* — "the magazine for smart young women" — Vassar associate professor of anthropology Dorothy D. Lee joined the chorus by insisting that colleges should prepare female students for their biologically inevitable role as wives and mothers. Psychology courses, Lee wrote, should "give [a woman] some idea of how a man will act in the confusion of living: celebrating in a night club, or when his car stalls in traffic, or when he loses his job, or when his son wins a prize" and "should prepare the mother to cope with a tired four-year-old." What fun they could have "making out the family budget" and "choosing between two brands of toasters."

It was a seductive message — hide away from the cares of the world — and Katharine Gibbs couldn't always overcome it. The school had its losses. Jane Fonda's mother one of them.

Frances Ford Seymour might have soared. Highly intelligent, with a knack for numbers, she longed for adventure. In her poem "My Wish,"

published in her high school magazine, Frances wrote, "I wish I were a sailor,/O'er the whole wide world I'd go…And I would envy no man,/And I'd rove far and free…"

As she reached for that dream, she carried a heavy burden of childhood trauma. Born in 1908 in small-town Brockville, Ontario, Frances grew up in a once-glorious family that had fallen into poverty, mental illness, and social isolation. A relative on her father's side, Horatio Seymour (sometimes incorrectly named as her grandfather), had been governor of New York and won the 1868 Democratic presidential nomination but lost the election to the Republican incumbent, Civil War hero Ulysses S. Grant. Frances's father, Eugene Ford Seymour, had been a Wall Street lawyer on the staff of New York State's attorney general. Delusions cut short his promising career. In 1905, thirty-five-year-old Eugene was arrested for disorderly conduct and jailed overnight after banging on the door and ringing the doorbell repeatedly at the Manhattan apartment of a young woman he didn't know. The charges were dropped after he apologized to his victim.

Soon afterward, Eugene married nineteen-year-old small-town Canadian girl Sophie Bower. To make sure no one else got a look at her, he took her to live on a farm outside Morrisburg, New York, near the Canadian border. Life was miserable. Eugene lapsed into alcoholism, unemployment, and paranoia. Sophie sold apples and eggs to sustain the family, which grew to include seven daughters. The only outsider allowed in the house was a piano tuner, who molested eight-year-old Frances. Five years later, Eugene's wealthy niece Mary Rogers — whose father-in-law cofounded Standard Oil — rescued the Seymours by bringing them to live with her in Fairhaven, Massachusetts. Mary Rogers's glamorous daughter Millicent, six years older than Frances, took the beautiful blond teenager to high-society balls and parties at the Ritz in New York. A sort of Cinderella eager to secure her own footing, Frances enrolled at Gibbs in Boston in the late 1920s. She planned to get a job on Wall Street, find a rich man, and marry him.

Gibbs training showed her the option of self-sufficiency, and the placement office set her on a path there. In early jobs at a Fairhaven,

Massachusetts, bank and then at National City Bank in New York, Frances learned about stocks and bonds and read the *Wall Street Journal*. But then the Depression hit, choking job opportunities and threatening her with the bitterly familiar face of poverty and humiliation.

She retreated to her original plan, which seemed to work spectacularly well not once but twice. First, she threw a butterfly net over middle-aged, recently divorced millionaire George Tuttle Brokaw. After dating for six months, she bought a gold wedding band from Tiffany, tied it with a pink ribbon, and pushed it across the table at lunch, suggesting it was "about time." When they married in January 1931, she was twenty-two and he was fifty-one. Brokaw died four years later, leaving Frances a million dollars. Sixteen months later, in September 1936, she married Henry Fonda, whom she met on a movie set in London and who thought she was "bright as the beam from a follow spot." One of Hollywood's golden couples, they shared a large home in Los Angeles and had two beautiful children, Jane and her younger brother, Peter.

Behind the scenes, the story was very different. Brokaw was a violent alcoholic who died not of a heart attack, as the *New York Times* reported, but by drowning drunk in the swimming pool of the Hartford, Connecticut, retreat where he'd gone to dry out, but where he'd smuggled in bottles of liquor. Fonda was emotionally abusive. He had multiple affairs, one of which led to a paternity suit that Frances quietly paid off with her own money. In late 1949, he rewarded her loyalty by telling forty-one-year-old Frances he wanted a divorce. The bloom of youth gone, her body mutilated by several botched medical operations, she faced a crossroads.

She could have started over. The Gibbs school offered lifetime free refresher courses and lifetime placement services. A good lawyer surely could have pressed Henry, one of Hollywood's top earning stars, to pay for a sojourn in New York so Frances could brush up her skills and revive her confidence. Then she might have resumed where she left off as a single woman, perhaps becoming a stockbroker or a banker or an investment counselor.

Instead, unable to face losing everything that supposedly mattered and

having to settle for the supposedly shabby consolation prize of a career, Frances had a nervous breakdown and entered the first of three sanatoriums. At the last one in Beacon, New York, in April 1950, ten days after her forty-second birthday, she fatally slit her throat with a razor blade. The note she left for her doctor read, "Very sorry, but this is the best way out."

In ordinary life too, less drastically, women traded their potential for an apron and a vacuum cleaner and a man who didn't turn out to be what he was supposed to be. Jill DiDonato had been a star in her Princeton, New Jersey, family during the mid-1940s. "I simply adored — perhaps worshiped her would not be too strong of a description of how I felt about Jill," said Rose Nini, Jill's younger cousin. The only child of an Italian immigrant contractor and his wife, Jill had a lighthearted, vivacious personality and was a dark-haired beauty with an astute fashion sense. On Sunday mornings, she and Rose studied the fashion pages of the *New York Times*, choosing the dresses they liked best. Rose recalled, "I would always pick out the

Jill DiDonato on high school graduation day, 1946, in front of her family home in Princeton, NJ
COURTESY OF JAKKI FINK

frilliest, most ridiculous thing, as fancy as it could be. And she would say, no, no, no. And she would pick out the plainest one, like Jackie Onassis… the sleekest, most modest looking thing and it was always the right one, of course." Jill never seemed to put a foot wrong. Rose said, "I thought she was like a princess and that she had a dream life."

Having acted in plays at Princeton High School, Jill considered a theatrical career. Her strict, Old World father forbade that. Respectable girls did not go onstage. Determined to lead a bigger life, Jill talked him into sending her to Katharine Gibbs in New York. Rooming at the Barbizon,

she made friends quickly and loved the glamorous whirl of mid-century Manhattan. "Full of pep and mischief," read the caption of her first-year photo in the 1947 Gibbs yearbook. Shortly after arriving in New York, she wrote home, "The scene is just heavenly — all lit up all over."

Jill DiDonato, possibly at the Barbizon, circa 1946–47
COURTESY OF JAKKI FINK

New experiences dazzled and dazed her. She saw Tommy Dorsey in person and met Cathy O'Donnell, star of *The Best Years of Our Lives*, the highest grossing movie of 1946, who lived at the Barbizon then. She shopped at Bloomingdale's, "an awfully nice store," although all the hats were so expensive, none cheaper than $3.98. She attended the opera, the theater, the symphony — she saw Jascha Heifetz at Carnegie Hall — and the ice show at Madison Square Garden.

Academics were a different matter. Jill had signed up for the two-year program assuming that it would be more leisurely than the one-year program. She soon discovered it was the opposite, amounting to four years of college crammed into two. Piled up on her desk at the Barbizon were Thackeray's doorstopper novel *Vanity Fair,* George Eliot's *Adam Bede* and

The Mill on the Floss, and Thomas Hardy's *The Return of the Native*. One night, she had to plow through 400 pages of *David Copperfield*. She wrote home, "Never have I run up against such work as I am witnessing here. I can't explain to you how we are kept so busy every second & how we have to plan so far in advance to be able to accomplish every little thing." She failed a history exam and overall, pulled a C-minus average for the first semester.

Although one of Jill's teachers reassured her that she was one of the brightest in her class and two of Jill's classmates confided that they'd done even worse, each landing a D-minus, the most important people didn't understand. In early December 1946, Jill's parents wrote her a letter saying how disappointed they were.

She was crushed. The family was extremely close. Writing home almost daily, Jill began her cheery notes and letters with greetings like "Dearest kittens!" "Dearest dolls," and "Hi hons." She tried to explain how hard she was hitting the books, studying from 4 till 11 every night and rising at 6 a.m. "I'm just so tired I can't see straight. This past week [of exams] has been about the worst I've had as long as I lived." Four of her classmates had dropped out already. Feeling "profoundly miserable," she didn't want to come home for the full semester break because "it won't be so wonderful as I expected for Xmas vacation because of all this business."

She promised she'd keep trying. "I'll get back here next year if it's the last thing I do," she assured her parents at the start of the second semester. But as months passed, despite an occasional victory like a 98 on a short-hand test, her C minus average refused to budge. Jill didn't realize that no employer was going to look at her grades, only whether she'd graduated, and the school reassured her she would. Depressed, frustrated, homesick, worried about the widening rift with her parents, she was also unnerved by the city's dark side. One afternoon, "on the way home from school we were walking down the street and a man dropped dead. His eyes looked so queer I felt like fainting." In a movie theater, her purse was stolen by the well-dressed stranger sitting next to her. She ran out to the lobby to try to find him, but he was gone. "I was so damn mad I could have spit."

Jill didn't return to Gibbs for the second year. Instead, she transferred to four-year Rider College in Trenton, New Jersey, where she met and became engaged to handsome, outgoing World War II army veteran Robert Bomberger, an accounting major. This was her parents' dream and postwar society's exalted goal, marriage to a college graduate with bright financial prospects. In a storybook ceremony, the couple exchanged vows on November 26, 1949, in the Princeton University Chapel, with Jill wearing an ivory satin gown appliqued with seed pearls, carrying a bouquet of fleurs d'amour, and attended by bridesmaids in American Beauty gowns with matching hats.

Quickly and steeply, her life slid downhill. After the wedding, Bomberger took Jill to live with his parents in a narrow, redbrick rowhouse in a working-class neighborhood of Lebanon, Pennsylvania, a small town some ninety miles northwest of Philadelphia. The culture shock was a jolt. The new bride, who was used to the refinement of Princeton and the sophistication of Manhattan, tried to make the best of it, but Bomberger turned out to be a serial con man whom authorities suspected of having a psychiatric disorder. In 1959, convicted of swindling $13,290 from business associates, he was given twelve years' probation and ordered to make restitution. In 1968, when he'd paid back only $170, a judge sent him to prison for two to ten years. Soon after his release Bomberger stole $206,000 from ten investors, mostly elderly women, whom he'd sweet-talked into joining his Ponzi scheme "investment club"; some lost everything. Indicted on more than forty counts, in 1976 he was convicted and sentenced to six to twenty years.

Jill got out early, divorcing Bomberger in the late 1950s. But with the glorification of domesticity at its height and with three young daughters to support, she had few options. In 1960 she married her divorce lawyer, who was nineteen years older. That marriage also turned bad. Her new husband, with whom she had two more daughters, verbally and physically abused her. And then, suddenly, all the beautiful promise of Jill's life ended. In the summer of 1968, she was diagnosed with kidney disease. After two unsuccessful kidney transplants at the Hospital of the University of Pennsylvania, she died that October at age forty.

To the end, Jill kept fighting. "I remember her as being very competent, glamorous, and funny," said Jill's daughter, Jakki Fink, who was six when her mother died. "I felt very loved by her. She may have made some poor choices, but she was a huge gift to have had as a mother." In time, Jill might have found her way to a fulfilling career. But her fate underscored the reason that Gibbs training pushed young women so hard to start right away on self-reliance. As with husbands, more time couldn't always be counted on.

<p style="text-align:center">∽</p>

"HEAVENS TO ELIZABETH, GIRLS," as one Gibbs teacher said in these postwar years. It was a tough world out there.

The school's placement department felt the backlash like a gust of cold wind. Calls no longer came in for the type of woman who could hold her own with MIT radar experts or protect the security of espionage documents or test-pilot military planes. Now, bosses acted as if they were giving specifications for a custom-made Cadillac. This one wanted only a redhead. That one would consider only women who were at least five-feet-eight-inches tall. Another rejected several candidates simply because each wore a turban hat to the interview — he didn't like that style.

Even men who were supposed to know better didn't. William Du Pont insisted on a secretary who was a strong tennis player. Former US president Herbert Hoover, who remained involved in Republican politics, expected his secretary to work straight through weekends in New York. It was the start of a trend that would emerge full blown in the 1950s, the demand for an office wife.

As the past pulled backward, however, the future pushed ahead. A new generation of young women, who'd seen women's freedom during wartime, wanted the same. They weren't going to be told any longer what they could and couldn't do — not by parents, not by finances, not by social expectations, and certainly not by know-it-all men. Typical was the plucky attitude of Dorothy Guise (later Collins), who attended Gibbs

from 1947 to 1949. Although she graduated first in her high school class in Norwood, Massachusetts, her father told her that college was a waste of money for girls and that he'd pay only for her two brothers. When the school principal tried to change her father's mind by suggesting that Dorothy could get a scholarship, his best argument was that in college she'd meet the kind of man the family would want her to marry. "I can remember hearing that and thinking, if that's why I should go to college, I'm not going to go," Dorothy said. "I just decided that I wanted to be independent financially as early as possible. . . . The only place to go was Katie Gibbs."

Jane Wade, described in this Cutex nail polish as
"charming Conover model and Katharine Gibbs student"

PHOTOPLAY, MARCH 1948

Jane Wade reached the same conclusion after a year in New York that didn't turn out as expected. Leaving her hometown of Kansas City, Missouri, for New York City in the spring of 1946 with dreams of a modeling career, the tall, slender, gray-eyed brunette was exiting several dead ends. Two years' study at the University of Arizona hadn't taught her a single thing about earning a living, and her marriage at age nineteen to an Army Air Forces captain had fizzled out. Determined to make her own way, twenty-one-year-old Jane had done some modeling for local stores and the Sears catalog, and at the University of Arizona, she'd been voted the most beautiful girl on campus.

At first, all went well. Within two weeks, Jane found a job as an in-house model for Austrian-born high-fashion designer Nettie Rosenstein, who popularized the French wardrobe staple, "the little black dress," in America. Soon after, Jane signed with the famed Harry Conover agency, which specialized in wholesome-looking "real girls doing real things" instead of high-fashion sophisticates. After eight months, booked steadily at $15 an hour (about $195 today), she wrote home, "Now I am self-supporting and New York is wonderful." Among her credits was a full-page magazine ad for "Wondrous New Cutex" nail polish.

But all wasn't wonderful. Despite his self-appointed stature as the Bing Crosby of the modeling agency business, Harry Conover was a crook. In the 1950s, he would be assailed by a barrage of complaints from mothers of child models whom he never paid. In 1959, the state of New York revoked his agency license and the district attorney seized all Conover's books and records.

Unhappy with the instability of modeling, in September 1947 Jane "did the best thing I could do. I took myself to the Katharine Gibbs secretarial school." She'd planned to go into fashion administration, but a post-graduation gift of an overseas trip from her grandmother changed her mind. In the summer of 1948, traveling through Europe, visiting cultural sites and art museums, Jane discovered "the world I wanted to live in."

Upon her return, the Gibbs placement office quickly found her a spot. Only the day before, Curt Valentin had called to ask for a secretary. Owner

of the Buchholz Gallery at 32 East 57th Street, Valentin was the leading US dealer in German modern art. Admired for his impeccable taste and widely beloved by artists, clients, and colleagues for his kindly manner, Valentin boasted a globe-trotting lifestyle and friendships with art world stars like Peggy Guggenheim and Alfred H. Barr, director of New York's Museum of Modern Art.

Jane dashed over to the gallery, a smallish space with burlap-lined walls and a gray-painted cement floor. Valentin asked just one question. Did she paint? No, she replied. "That's good," he said and hired her.

So began Jane's phenomenal decades-long career, conducted step-by-step according to the Gibbs formula. To learn the art business and make contacts, she first worked for a succession of top gallerists. In Valentin's one-man shop over the next six years, she dealt with customers, went on art buying trips, and helped arrange exhibitions for Jean Arp, Georges Braque, Juan Gris, Fernand Leger, Jacques Lipchitz, Pablo Picasso, Henry Moore, Henri Matisse, Marc Chagall, Edvard Munch, and Edgar Degas. From her boss's finesse, she learned how to handle artists who were often riddled with insecurity, worried about money, and jealous of their rivals. Surrealist painter Alton Pickens praised Jane's "magnetism" and "personal warmth," which he said meant "something very great to one like myself." Valentin told friends she was the best assistant he ever had.

Unknown to Jane at the time, Valentin's charm and connoisseurship hid a dark secret. When Valentin, who was Jewish, fled his native Germany for New York in January 1937, he took with him a load of artwork from Berlin's Galerie Buchholz, works that the Nazis had looted from German museums on the grounds that they were "degenerate art." Although the Reich usually permitted Jewish emigres to take only ten reichsmarks, Valentin had gotten written permission from the German government to sell the works in the United States — which he did by opening the New York branch of the Buchholz Gallery.

That wasn't the end of his collaboration. In late June 1939, Valentin showed up at the notorious Fischer Gallery auction in Lucerne, Switzerland, where the Nazis had sent some 700 confiscated "degenerate" artworks.

Acting for New York's Museum of Modern Art, which didn't want its name dirtied by association with the auction, Valentin bought five paintings for MoMA's collection. He did nothing treasonous. World War II wouldn't start for another two months. However, money from Valentin's sales was funneled back to Germany. Some repaid the looted German museums. The rest fed the Nazi war machine.

To Jane's credit, after Valentin's death in 1954 she didn't destroy the "smoking gun" letter of September 22, 1936, from Germany's Reich Chamber of Fine Arts permitting Valentin to sell German art in the US. In 1976 she donated it among Valentin's papers to the Archives of American Art at the Smithsonian where, decades later, it became an important clue for scholars investigating the pathways of Nazi-looted art.

Gibbs training warned students that good fortune could disappear in an instant, and that happened to Jane. In August 1954, Valentin died suddenly at age fifty-one of a heart attack in Italy. She and Valentin's executor, Ralph Colin, kept the gallery going for another year, but as their artists scattered to the winds, they were forced to close. She worked next at the gallery of Otto Gerson, who operated in the same artist-friendly spirit that Valentin had. In December 1962, bad luck struck again when Gerson died. Even worse luck arrived the next year when the Gerson Gallery merged with London-based Marlborough Gallery.

It should have been good luck. Marlborough was one of the richest and most powerful art galleries in Europe, and at the newly formed Marlborough-Gerson Gallery, Jane became a director and vice president. The business had everything—a huge, splashy space at 41 E. 57th and a glittering roster of artists, among them Robert Motherwell, Larry Rivers, Mark Rothko, and the estates of Jackson Pollock, Piet Mondrian, and Kurt Schwitters—everything except a gentleman owner. Marlborough's founder was Frank Lloyd, the former Franz Kurt Levai, who'd owned a chain of gas stations in Austria. As a postwar refugee in England, Lloyd spotted a golden opportunity in the fact that many British aristocrats were broke and needed to unload their Old Masters for cash. He named his gallery to suggest a connection to the Duke of Marlborough, which it didn't have.

Lloyd terrorized artists and employees. Robert Motherwell described Lloyd as "ruthless" and said, "The degree of sadism at the gallery was unbelievable.... They were catty, bitchy, humiliating, and treated you like a schoolboy standing in a corner." Jane called Lloyd "overbearing and despotic" and envisioned him in "a Prussian general's spiked helmet." She wasn't allowed to share in the gallery's profits or make any decisions, not even about her clothing. "He told me to wear black, white, or beige so that my dress would harmonize with the visual concept of the gallery." Still, she stuck it out for two years at Marlborough, expanding her network of connections among artists and clients.

In 1965, Jane took the crowning step in the Gibbs career plan, opening her own art dealership, Jane Wade, Ltd., in her Upper East Side apartment. By appointment only, to prize-catch clients like mining and oil magnate Joseph Hirshhorn, Joseph Pulitzer Jr., and industrialist Norton Simon, she sold works by Braque, Picasso, Chagall, Matisse, and Henry Moore. A 1970 *Time* magazine round-up article about ten top private art dealers included Jane as the only woman and called her a "pioneer" in the field.

Like Jane Wade, Mary Louise Beneway (later Clifford) found that Katharine Gibbs training opened the doors to a rewarding future after other well-laid plans failed. Raised on a 125-acre fruit farm in the small town of Ontario in upstate New York, graduating at the top of her high school class, she longed to see the world and assumed that a first-class education would get her a job to do so. After her parents refused to pay for college because she was a girl — she ought to marry a farmer, they said — Mary Louise worked her way through all four years at Cornell University, first as a waitress in the student dining hall and then at the sign-out desk of her residence hall.

She remained a stellar student, majoring in government and winning election to Phi Beta Kappa. Approaching graduation in 1948, she visited Cornell's placement office. There, a vocational counselor delivered the bad news. Despite an exhaustive search, she hadn't been able to turn up any decent job opportunity for Mary Louise. This was the best option, the counselor said, pushing across the desk an application for a Katharine

Gibbs scholarship. Accepting the bitter truth, Mary Louise applied and won. That fall, she enrolled at Gibbs in Boston.

What her Ivy League degree couldn't do, Katharine Gibbs did instantly for Mary Louise. In the spring of 1949, a recruiter from the CIA — formed two years earlier as an updated version of the wartime Office of Strategic Services — visited the school offering overseas assignments. Hired right after she finished Gibbs's one-year course for college women, Mary Louise learned top-secret message coding in Washington, DC, and then asked to be sent anywhere she could use her French — except France, which didn't seem exotic enough. She was assigned to Beirut, Lebanon, a former French colony.

Arriving in October 1949, Mary Louise entered a hotbed of international intrigue. At the time, the CIA was closely monitoring construction of the $250 million Trans-Arabian Pipeline (TAPLINE), which was being built by the Arabian American Oil Company (ARAMCO) to transport oil across 1,080 miles of desert from the Persian Gulf to the Lebanese coastal city of Sidon. The installation was crucial for several reasons. It would provide oil quickly and cheaply to rebuild postwar Western Europe without depleting US supplies; ensure continued US access to Middle East oil; and shovel money into Arab nations in hopes of encouraging pro-Western attitudes. Political turmoil had plagued the project for years. Particularly unmanageable was Syria, which refused to grant a fifty-mile right of way across the Golan Heights. In March 1949 a CIA-engineered coup overthrew the Syrian government and installed the pro-American Colonel Zaim — but in August, Zaim was deposed and executed by anti-American officers. By the year's end, another CIA-friendly military coup had toppled the hostile regime and replaced it with cooperative leaders. Finally, TAPLINE could be finished.

Stationed at a converted mansion that housed the US legation in Beirut, Mary Louise became enmeshed in these schemes. Her boss's cover story was that he was the Foreign Service's "petroleum attaché." Actually, he was a CIA spy, gathering information about ongoing threats to TAPLINE. Anger about perceived American imperialism was

growing across the region. In April 1950, bombs were thrown into the US legation compounds in Beirut and in Damascus on the same day; fortunately, no one was killed.

At a desk on the second floor, Mary Louise coded and decoded intelligence messages transmitted by a radio operator in the attic. "We were watching the principal officials in the Lebanese government because they...were dealing with Syria and Iran," she recalled. Among the CIA's best sources was a leader of the Druze, an ethno-religious group living in the mountains in Lebanon. "Very often I would meet one of our contacts and smile because I knew quite a bit about him."

Amid this controversial chapter of history, Mary Louise got to see the way government actually worked, not the cleaned-up or shrouded version of events that often appeared in books. Under CIA protection, TAPLINE was completed in late 1950 and soon some 315,000 barrels of crude oil — "life-blood of the modern age" — would gush through its thirty- and thirty-one-inch steel pipes every day. When TAPLINE officially opened on December 2, 1950, she sat on a folding chair on the beach at Sidon along with about 150 dignitaries, including ambassadors, and watched as TAPLINE's president turned the valve that unleashed oil through an underground line to an offshore tanker.

She sure wasn't on the farm any more. In Beirut, known as "the Paris of the Middle East," she had her own apartment with views of the Mediterranean on one side and the mountains on the other. Some days, she went swimming in the morning and skiing in the afternoon. At social events, she circulated among diplomats, politicians, top business executives, even the head of the Sureté, Lebanon's counterpart to the CIA.

In Beirut, Mary Louise also met her future husband of fifty-four years, Robert L. Clifford, then the US Foreign Service's commercial attaché. They married in 1951 in Beirut. Because the CIA forbade married women in overseas positions, Mary Louise had to resign. But her far-flung travels continued as her husband landed jobs as a United Nations economic advisor in Niger, Pakistan, Sierra Leone, Malaysia, Burundi, and Western Samoa.

Those travels gave her a second career. After she and her husband returned to the United States, she wrote five books for Lippincott's Portrait of Nations series. The first one, *The Land and People of Afghanistan,* published in 1962, became a fixture in school libraries and sold continuously for four decades. Others described the fromerly overlooked cultures of Malaysia, Sierra Leone, Liberia, and the Arabian Peninsula.

Despite finishing first in her high school class and graduating Phi Beta Kappa from Cornell, Mary Louise said she hadn't known a thing about the English language before attending Katharine Gibbs. She'd parsed a sentence only once and had never conjugated verbs except in French. At Gibbs, her class "tore sentences apart and figured out where they belonged, what the purpose was, the whole bit." After that, Mary Louise said, "I knew everything I needed to know in order to write for public consumption. That's what Katharine Gibbs taught us."

FOURTEEN

"Greatest Show on Earth"

∽oᴄ∽

AS THE POSTWAR REVITALIZATION of American business kicked into high gear during the 1950s — that shiny, bustling decade of boat-length, two-tone cars in Sunset Coral, Seafoam Green, and Vegas Turquoise, gleaming white washers and dryers, transistor radios, portable TVs, hula hoops, Barbie dolls, and pink princess phones — the Gibbs schools entered their boom years. The gray flannel organization men who made and sold this consumerist cornucopia knew one thing. To go places, they needed a top-flight secretary. Everyone understood the symbolism: the classier the "girl" in the outer office, the more important the man.

To find that secretary, Katharine Gibbs was the place to go.

Of course, throughout their forty-year history, the Gibbs schools had always regarded their true customer as the bright, ambitious young woman eager to chart her own path. Gordon Gibbs wasn't about to change that. A photo from the 1950 New York yearbook shows him sitting beneath his late mother's portrait in the school lobby, head bowed, as if communing with her timeless wisdom. And during the 1950s, a record number of women flocked to Gibbs — women who were now better educated and more restless than ever.

Between 1900 and 1950, the number of women attending US colleges and universities surged from 85,000 to more than 800,000. Yet limited expectations still prevailed, even at elite schools. According to a 1952

Gibbs students had the perfect look for 1950s offices
PLATEN, 1950, KATHARINE GIBBS SCHOOL
RECORDS, BROWN UNIVERSITY

graduate, Smith College urged women of her generation "to marry well and raise a family and help your husband do well."

Opportunities for women at graduate and professional schools remained just as dismal as ever, with a corresponding impact on employment. In 1950, there were only about 9,500 female lawyers in the US, less than 3 percent of the total, while the percentage of female doctors still hovered around 6 percent. In business, only 13 percent of managers were female. A mere 10 percent of doctorates were awarded to women in 1956, down from one in seven in 1920.

Of course, some women needed — or, oddly, wanted — to work. That was fine, as long as they stayed in their lanes. In mid-century America, four traditional fields heartily welcomed women: teaching (74 percent female in 1950); nursing (98 percent female); librarianship (90 percent female); and secretarial/clerical work (95 percent female). But these jobs really should be done only until marriage or afterward for pin money (which was

about all their salaries usually provided) because even more loudly than the late 1940s, the fifties shouted that a woman's true calling was as a wife and mother.

Television became a leading apostle of that message. It was inescapable, as the rabbit-eared box invaded and conquered American living rooms, increasing in diffusion from 9 percent in 1950 to 90 percent by the decade's end. Programs like *The Adventures of Ozzie and Harriet*, *Father Knows Best*, *The Donna Reed Show*, *I Love Lucy*, *Make Room for Daddy*, and *Leave It to Beaver* bombarded viewers with images of contented wives and mothers in nicely furnished homes funded by faithful, reliable husbands. Women in these shows dressed in smart shirtwaists and pearls to vacuum their carpets and bake cookies for their loving, occasionally mischievous, children. No one in these shows ever suffered a serious illness, went on unemployment, had an affair, or began an argument that couldn't be resolved by the end of thirty minutes.

This wasn't just stodgy reactionary propaganda spewed by TV networks dependent on advertising dollars. When Adlai Stevenson, the Democratic nominee for president in 1952 and 1956 and a darling of the liberal set, was invited to speak at Smith College's 1955 commencement ceremony, he titled his talk "A Purpose for Modern Woman." The best use of their education, he told the graduating class, would be to protect their husbands from the "violent pressures" of the outside world that were destroying male autonomy. They'd be fighting totalitarianism and industrial dehumanization, Stevenson declared, and "you can do it in the living-room with a baby in your lap or in the kitchen with a can opener in your hand. If you're really clever, maybe you can even practice your saving arts on that unsuspecting man while he's watching television!"

Largely, the crusade worked. After collecting their high school diplomas, many young women headed for the altar. By 1959, 47 percent of American brides were under nineteen. Those who postponed marriage for college often did so to hunt for better prospects. Even at Radcliffe, the mania took hold. There, the winning entry of the 1953 school song competition cheered brainy undergraduates to "fight-fight-fight" to "trap" one

of those "rough and tough and passionate" Harvard men. By 1960, only 7 percent of American women in their early thirties had never married. By that age, society pitied them as hopeless old maids.

While some Gibbs students had marriage on their minds, others yearned for more — and they saw their restlessness not as a problem to be fixed but as the fix for a problem. This "aching longing" and "the cloudy sadness, what is it?" one student wondered. "Perhaps it is the true essence of life. For where would we go, what progress would we make, were it not for these feelings that bring discontent? . . . they whet the appetite and make us wild for adventure." They dreamed of traveling — to Paris, Rome, Rio de Janeiro, Baghdad, and Africa — and achieving something significant, even if they didn't necessarily know what. During the fifties, they crowded into Gibbs in such numbers that the school expanded its Boston location and opened another branch in a former mansion in Montclair, New Jersey. The

Located in a former mansion, the Katharine Gibbs School
opened in Montclair, NJ, in 1950
KATHARINE GIBBS SCHOOL RECORDS, BROWN UNIVERSITY

*Myrna Custis, a pioneer Black
student in the mid-1950s at
Katharine Gibbs in New York*

PLATEN, 1956, KATHARINE GIBBS SCHOOL
RECORDS, BROWN UNIVERSITY

*Mrs. Callye Horry, who joined the
New York school staff in the early 1950s*

PLATEN, 1952, KATHARINE GIBBS SCHOOL
RECORDS, BROWN UNIVERSITY

new recruits brought impressive back-
grounds. In 1950, Gibbs enrolled women
from 227 colleges.

Yet, even as the school developed an
international reputation — in the 1951–52
session, students arrived from eleven for-
eign countries — one group of Americans
remained almost entirely unrepresented.
The available Gibbs yearbooks and pro-
motional literature from the 1950s show
only one Black student, Myrna Custis,
at the New York school in 1956. What
a brave and hopeful soul she must have
been. She wasn't rich. Only six years
earlier, her family had lived in a narrow
brick rowhouse in a run-down section
of Baltimore, where her father worked
as a driver for a wallpaper store. At some
point, the family moved to New York,
where Myrna attended racially integrated
Flushing High School. There, her 1955
yearbook profile described her as, "A fine
person, a swell girl, To sum it up, a real
pearl."

At Gibbs, Myrna's classmates appear
to have welcomed her, nicknaming her
"Mickey" and noting that she liked
"watching television with Donald,"
hated wearing glasses, and often said,
"Are you kidding?" However, the 1956
Gibbs yearbook doesn't list Myrna in any
activities or show her in any of the group
photos, including photos from the spring

formal dance at the Biltmore Hotel. Likely, she couldn't afford the extras. Her family lived in a depressed area of East Elmhurst, Queens. With luck, Myrna returned for her second year at Gibbs and went on to land a good job, but neither the 1957 New York yearbook nor any career information for her is available to confirm that.

Josie Vincent, in her uniform at the New York school, early 1950s

PLATEN, 1951, KATHARINE GIBBS SCHOOL RECORDS, BROWN UNIVERSITY

Lawrence Callender, the New York school's all-around Mr. Fix-It, early 1950s

PLATEN, 1952, KATHARINE GIBBS SCHOOL RECORDS, BROWN UNIVERSITY

No last name was given in the yearbook for Ethel, who delivered messages at the New York school in the early 1950s

PLATEN, 1953, KATHARINE GIBBS SCHOOL RECORDS, BROWN UNIVERSITY

Other than Myrna Custis, the African Americans at Gibbs in New York during the fifties were four low-level employees: Josie Vincent and her successors, Callye Horry and Ethel (no last name given), apparently clerical workers who wore black uniforms and delivered messages for students, and Lawrence Callender, the stock room attendant and all-around Mr. Fix-It who did tasks like repairing broken shoe heels and running off stencils. Almost all the other students and all the teachers were white, although from a wide variety of national backgrounds. In that regard, nothing had changed since the school's earliest days, reflecting the fact that nothing had changed in American race relations.

Most Black citizens still belonged to the occupational and economic underclasses. At the outset of the fifties, they earned 48 percent less than

Fifties' Gibbs students described the school as a carnival of clever costuming that disguised their ambitions to employers

PLATEN, 1953, KATHARINE GIBBS SCHOOL RECORDS, BROWN UNIVERSITY

whites in comparable jobs, and more than 80 percent of Black families had an income below the median for white families. At Gibbs, although no application records remain, it was likely the same old story. Even if a Black family had the money, there was no point in sending their daughter to be educated for a job that didn't exist for her. Change was coming, but it wasn't here yet.

To bridge the chasm between employers' fantasies and students' ambitions, Gibbs became, as the 1953 New York yearbook announced, the "greatest show on earth." And what a show it was. Appearance was now equally important as typing and shorthand skills. Make no mistake about that, emphasized Mildred Langston, academic dean and economics lecturer at the New York school. "Business . . . is spending more money for and putting more emphasis on interior decorating than it ever has before in history. That means a girl must look as if she fits into the setting her employer has spent money on."

It was true, employers told Gibbs students at the school's social hours. At one office, female job applicants first had to pass muster with an interviewer who assessed only their looks. If they failed, out the door they went, with no chance to flaunt their skills to the second interviewer. Another boss boasted that his company, passing over more seasoned candidates, had recently promoted a "very young" woman with hardly any business experience because of her "fine personal qualifications."

Lamentable as that situation was, it had to be dealt with. Accordingly, the Gibbs schools launched a three-part program on appearance. The goal wasn't to mass produce Miss America contestants, but to instill subtle markers of sophistication. Page after page of yearbook headshots showed

the results— short or shoulder length hair neatly styled; white blouses with notched or Peter Pan collars, a string of pearls here, small button earrings there, friendly expressions everywhere. No big Hollywood smiles, no bold "statement" jewelry, no Paris couture or beatnik berets. Later generations might see that as a stifling conformity, but the fifties were an archly conformist decade and Gibbs students needed this pleasantly bland camouflage to disguise their ambitions.

Mildred Langston, Academic Department dean at the New York school, described as "a model of perfection for every Gibbs student"

PLATEN, 1953, KATHARINE GIBBS SCHOOL RECORDS, BROWN UNIVERSITY

The charm of the school's new, intensified grooming plan was that anyone could do it. "There's nothing to this beauty business except attention to details," insisted Gibbs fashion instructor Frances Church Salmon, a former opera singer who'd conducted beauty clinics and fashion shows nationwide for Elizabeth Arden.

First came good health, essential for radiance and stamina. To teach diet, exercise, good posture, and how to "coordinate mind and body as harmoniously as a wardrobe," Gibbs hired highly accomplished female physicians whose very presence sent the silent message that no barrier was unbreakable. At the New York school, they included Dr. Ruth Berkeley, one of the first female psychiatrists in the US and a clinical medicine instructor at Cornell University's Medical School; Dr. Anna L. Southam, assistant professor of obstetrics and gynecology at Columbia College of Physicians and Surgeons and a pioneering female fertility researcher; and Dr. Helen M. Ranney, raised on an upstate New York dairy farm, who did landmark research during the 1950s on sickle cell anemia and who in the mid-1980s would become the first woman president of the Association of American Physicians. These three emphasized proper diet, regular exercise, vitamins, and—ahead of their time—mental health. So that students

could submit potentially embarrassing questions anonymously, a slotted drop box was set up.

The second priority was speech because, as Gibbs vice president Marion Beck commented, "What earthly good can a girl be to an executive if he has to hide her in a closet?" To banish regional accents — fifties power brokers rivaled the English upper class in their ability to detect the "wrong sort" of speech — students recited sentences like "Betty Botta bought a bit of butter" and "Arthur the rat couldn't make up his mind, so the barn collapsed on him." The latter came from a classic nineteenth-century reading passage, "Arthur the Rat," used by phonetics researchers to identify pronunciation differences according to geography. Strictly forbidden were "popular slang terms or comic strip and radio gag lines." Students also learned how to charm office visitors and customers; how, gently, to shoo away garrulous time-wasters; and how to chat about current events and the arts at the boss's cocktail parties.

"The very necessary thing at the time was how to be diplomatic. Oh, you couldn't be anything else but," recalled Katherine Schmidt, who earned a BA in English from Wheaton College and then attended the Gibbs school in Chicago in 1949–50. She went on to work for Curtis Publishing — parent company of *The Saturday Evening Post* — the Bank of America, and the Academic Senate of the University of California, San Francisco.

Those lessons in diplomacy were the most valuable part of her Gibbs training, Katherine said. She practiced them at night in the Gibbs student residence, an elegant Edwardian house near Lake Michigan. She had to. A top student in high school and college, she was used to raising her hand and giving the right answer without sugarcoating. In a 1950s office, such forthrightness risked dismissal. Gibbs taught her how to keep her self-respect behind a show of deference.

When cringing at the boss's clumsy phrasing while taking dictation, Katherine recalled, "All you had to do was look up and bat your eyelashes, give a sweet smile, and in a very apologetic voice say, 'Do you suppose, doesn't such-and-such sound maybe a little better than that?' . . . It was fun to have them look at you startled and then as you winsomely smiled…

finally agree that it was a good idea." Oh yes, that always worked, she said. "You didn't pull it, of course, until you'd been there long enough to have his confidence in you. And it was always 'his.' There were no female executives that I was ever exposed to."

A dozen years later that strategy would horrify sixties "second wave" feminists, but at the time, for a self-supporting single woman like Katherine, it was the only way to keep a job until she was ready to leave and then find another one when and where she wanted. And that's what she did. Tiring of her job at Curtis Publishing in Philadelphia, she drove her Nile-green and cream-colored 1954 Chevrolet Bel Air to San Francisco, where her pick of employers awaited.

After health and speech, the final element in the school's campaign on appearance was "Fashion in Business," which didn't mean trendsetting *Vogue* or *Harper's Bazaar* styles but a carefully curated assortment of subdued, well-constructed suits and dresses. Yes, they could adopt the 1950s "new look" of nipped-in waists and longer, fuller skirts, but in neutral, blend-into-the background solid colors and quiet plaids. The

Practicing proper posture

PLATEN, 1950, KATHARINE GIBBS SCHOOL
RECORDS, BROWN UNIVERSITY

Promotional brochure, 1950s

KATHARINE GIBBS SCHOOL
RECORDS, BROWN UNIVERSITY

The right look for the fifties: perfect tailoring, tidy hair, gloves essential

PLATEN, 1952, KATHARINE
GIBBS SCHOOL RECORDS,
BROWN UNIVERSITY

hat-and-white-gloves mandate remained sacrosanct, and in this glistening decade of new almost-everything, the school turned up the volume in requiring neatness and cleanliness. White gloves and white blouses had to be spotless, and other clothes sent frequently to the dry cleaners. Any young woman with a run in her stocking prompted a classroom reminder to all about the importance of always keeping an extra pair at hand.

Unchanged from Depression days when the Gibbs "budgeteers" flipped through the racks at mid-priced stores hunting for stylish bargains, the school warned against frittering away one's paycheck in the designer departments of stores like Bloomingdale's and Bonwit Teller. *Fashion Digest Magazine* editor Lavinia Koelsch, who knew how to rip a garment apart for signs of quality, shared tips for finding "Lily Daché hats and Dior gowns at Macy prices." Also an instructor at New York's Traphagen School of Fashion, where graduates included haute couture designers Geoffrey Beene and James Galanos, Koelsch believed "you get what you look as though you deserve in this life."

Super-thrifty shoppers willing to negotiate uneven flooring and brave massive crowds grabbing at hangers could snag discounted designer wear at S. Klein On The Square — the square being both Union Square and the nature of the deals. Farther out in Brooklyn and the Bronx, Loehmann's (a favorite of actress Lauren Bacall) beckoned with sample garments and seasonal overstocks from designer showrooms at less-than-wholesale prices. In Boston, the magnet was Filene's, where Gibbs students might calculate the odds of clothes surviving till the next cost reduction on the store's automatic markdown schedule. Money saved on wearables could fund full-price investment in travel and cultural outings, which yielded benefits that never frayed, pilled, or went out of style.

In personal grooming, spotlessness and freshness reigned supreme at Gibbs. "Soap and water can never be used too often," dictated Mildred Langston. Keep clean, "from the top of your shiny hair to the soles of your shiny shoes." Hair had to be short and neatly styled because, the ultimate withering criticism, long or messy hair was "not in good taste."

Yet even more important than the clothes a woman wore or the cut of

her hair was the way she entered a room. In Gibbs training that meant with cheerful, outgoing enthusiasm. Frances Church Salmon taught her students to "stand upright and walk as though they were alive and glad to be alive." That was the true secret of attractiveness, she explained. "To look beautiful, one must have an interest in others. There is no room for personal problems in either the social or business worlds. Nobody wants a disagreeable whiner. Any woman can be the kind of person of whom people say, 'I don't know what she looked like, but she was wonderful to be with.'"

The big payoff moment for these head-to-toe makeovers was the school's annual formal dance. This event, a feature since the 1930s, had always aimed to show young women that even if they grew up on a farm or in a factory town, once they put on their silks and satins and Gibbs-acquired élan, they could rival any Park Avenue or Back Bay socialite. In the fifties, as big city social life exploded with glamor and ostentation, elegant self-assurance became all the more essential.

New York's spring galas took place in the nineteenth-floor ballroom of the Biltmore Hotel. Dashing out of cabs in their full-length evening

Spring formal dance, New York, 1955
KATHARINE GIBBS SCHOOL RECORDS, BROWN UNIVERSITY

gowns, escorted by their dates in tuxes and bow ties, Gibbs students rode the elevator up to a sophisticated evening of dancing and dining. In Boston, Christmas and spring dances took place in the Crystal Ballroom of the Hampshire House, a small luxury hotel in a converted Georgian-revival townhouse on Beacon Hill; in the Louis XIV ballroom of the Hotel Somerset; and at the exclusive University Club. These were the playgrounds of the bejeweled swans of the society pages and high-fashion magazines, and for one night, heralding their hoped-for future, ambitious Gibbs women also belonged there.

Hard at work with homework in the 1950s
PLATEN, 1951. KATHARINE GIBBS SCHOOL RECORDS, BROWN UNIVERSITY

Academics remained as strong as ever, taught by the usual assortment of university professors and accomplished industry professionals. Students read John Locke and Aristotle; Shakespeare and Shelley and Henrik Ibsen; the daily newspaper and *Business Week* magazine. They learned about the Cold War and the hydrogen bomb and what longtime Gibbs music appreciation teacher Grace Spofford called the "liquid architecture" of music.

In advertising class, each got a hypothetical budget of $250,000 (nearly $3 million today) to plan a campaign for a department store or jewelry manufacturer. Psychology lectures explained how to manage people by recognizing neuroses, hidden motives, and personality quirks that could derail a project. Before graduating, the prospective job-seeker had to cold-call two employers and two secretaries in different industries, arrange informational interviews, and write detailed reports about the company and what it would be like to work there.

During the 1950s, Gibbs women may have looked and sounded and smiled as if they were doubling down on the status quo, but in fact, they were preparing to join the quiet revolution of female leadership forged by previous generations of graduates. Woe to anyone who tried to stop them. In her poem "Portrait of a Gibbs Girl," 1950 New York student Lorraine Wendell wrote, "Do not annoy a Gibbs Girl, friend,/Or you will get it in the end."

FIFTEEN

Life at the Top

∽◌○◌∼

FOR 1950S EMPLOYERS, AMERICA'S campaign to send women back home with an apron and a vacuum cleaner worked a little too well. Newspaper classified ad sections swelled with listings of secretarial openings. By 1955, estimates of vacant office positions ran as high as one million.

For women facing the question of "office wife or home wife?" the choice was often easy. Many fifties bosses expected a secretary to run their personal errands, stay late on a moment's notice, and even babysit their children when the wife dropped them off so she could go shopping or out to lunch with her friends. At least as a home wife, no man was looking over your shoulder all day, urging you to work faster or blaming you for some mistake he'd made. And, with an engagement ring on her finger, a woman could dream of a devoted, considerate TV husband like Ward Cleaver or Ozzie Nelson or even a fun, show business one like Ricky Ricardo.

The "great secretary shortage" was also a function of the low Depression-era birth rate, which had resulted in fewer fresh-faced, gung-ho twenty- to twenty-four-year-olds, whom employers strongly favored over supposedly worn-out, faded flowers of thirty-five. Meanwhile, postwar prosperity meant that more families could afford to send their daughters to college — even if only to try to land a white-collar husband.

All this was good news for Katharine Gibbs graduates. In higher demand than ever, they could write their own ticket. Employers auditioned

for them, not vice-versa. On any given day, the school had 400 to 500 job openings on file.

Many Gibbs graduates landed glamorous jobs in business where they were more like the "right hand man" male secretary of the early 1900s than the "pink-collar ghetto" dwellers of the late twentieth century. They knew more company secrets than many senior executives; they could broker political intrigues with a word to the wise here, but none there; and they enjoyed unique privileges and respect because they had direct access to the boss. No, it wasn't as good as actually being the boss, but in an era that went so far out of its way to block women from becoming president of anything except the PTA, an executive secretary position was often the next best thing.

Marie Zenorini, the daughter of an Italian immigrant yarn manufacturer in New Jersey, started at the top after graduating from the New York Gibbs school in 1950. Having previously majored in Italian and French at Marymount College in Tarrytown, New York, twenty-two-year-old Marie asked the Gibbs placement office to find her a position where she could speak Italian, but one where she wouldn't have to do any translation or writing in the language. Impossible, the placement counselor said. Translating was *always* involved. But three days later, Gibbs pulled a rabbit out of a hat and sent her to an interview with Dino Olivetti, the Italian-born president of the Olivetti Corporation of America, the newly formed American subsidiary of Europe's largest manufacturer of office equipment.

The son of the company's founder, Dino needed a secretary who could welcome Italian visitors in their own language with finesse and flair; translation could surely be left to an academic in elbow-patched tweeds hidden away in a back room. To Dino, an MIT engineering graduate who spoke excellent English, sophisticated style mattered most of all. Although it made prosaic items like printing calculators and typewriters, the Olivetti company had established itself as a world leader in trendsetting modern industrial design. The Olivetti Lettera 22 portable had been designed in 1949 by architect Marcello Nizzoli and would win a number of prestigious artistic awards.

As Dino's executive secretary, Marie came aboard just as Olivetti was

planting its flag on American soil. During her first few years with the company, she helped her boss arrange two splashy design projects that made heads swivel among the nation's cognoscenti. In late 1952, quietly organized and funded by Olivetti, New York's Museum of Modern Art held a "Design in Industry" exhibition celebrating the company's products — and only the company's products. On display were Olivetti calculators and typewriters, brochures, posters, ads, photos of its stores worldwide, and even, in the museum courtyard, an eight-foot-tall, three-dimensional Olivetti billboard plucked from the side of an Italian highway. The show marked the first official acknowledgment that commercial products could also be works of art.

Topping that, in May 1954 Olivetti opened a stunning showroom at 584 Fifth Avenue between 47th and 48th Streets. "We had the biggest windows and the tallest door on Fifth Avenue, all designed by [an] Italian architect who made the complete showroom in Italy and shipped it here," Marie recalled. The sixteen-foot-high solid Italian walnut doors opened to a long room with a sky-blue ceiling, and on one side wall was a fifteen-by-seventy foot sandcast mural by architectural sculptor Constantino Nivola. Olivetti products sat on green malachite marble

Marie Zenorini in her office at Olivetti's
executive mansion in Ivrea, Italy
THE GIBBSONIAN, FALL 1959

cones. It was ridiculous as an office equipment store, grumbled *New Yorker* critic Lewis Mumford. But that was exactly the point. Olivetti wasn't just hawking its wares. It was celebrating style and vision and a beautiful peacetime future. Italian art students and style mavens from all over flocked there, and to welcome them, Marie organized cocktail parties.

Balancing the company's cool, modern aesthetic, Dino Olivetti cultivated a warm family atmosphere around the office. Returning from trips, he always had a gift for Marie in his suitcase and big boxes of candy for each department. Every summer, Dino and his wife hosted a picnic for all the employees at their Connecticut estate, with lifeguards at the pool and dining under the trees. As the company grew, he hired an assistant for Marie so she wouldn't have to work late. Could it get any better? Yes. In 1957, Dino — called back by the parent company to headquarters in Ivrea, Italy, to head manufacturing and research — asked Marie to go along. That was an instant yes.

Ivrea, at the foot of the Alps about an hour north of Turin, was then one of the world's most successful and idealistic company towns. It had artfully built, low-cost worker housing, a factory designed by two of Italy's leading architects, and amenities like health care, tennis and fencing lessons, language lessons, art exhibits, lectures, and movies, most at no charge to employees. Marie was given her own air-conditioned office in the hilltop Executive Mansion overlooking a rose garden and her own secretary to handle most of the dictation and typing. Marie greeted visitors in Italian, planned social activities, and weather permitting, spent her two-hour-plus lunch breaks playing nine holes of golf or swimming in the nearby lake.

After two and a half years, her dream job ended when Dino Olivetti delivered the news that the company wanted him to stay permanently in Italy. He wanted Marie to stay, too. But she missed the United States. She hadn't returned the whole time, instead using her vacation days to travel throughout Europe.

Back in New York, after a free skills refresher course at Gibbs, Marie set out to find her next adventure. She turned down job offers from the president of the Prentice Hall scholastic publishing company

and from the vice president of Smith Corona typewriters — not glam-
orous enough — and then interviewed with Hollywood movie director
Stanley Kubrick. Fresh off a big win with *Spartacus* (1960), starring Kirk
Douglas, over the next few years Kubrick was destined to make the box
office hits *Lolita*, *Dr. Strangelove*, and *2001: A Space Odyssey*. Marie met
him at his office in New York. "It was as big as a ballroom. And there was
nothing in it much, except way at the end there was a desk," she recalled.
"I opened the door to go in and there he was, just like in the movies, with
both his feet up on the desk, smoking a big cigar."

She'd be perfect as his secretary-assistant, Kubrick said. No, not like
that. He meant her résumé. Katharine Gibbs, Olivetti, the international
angle. He and his wife — Kubrick made sure to mention the wife — were
leaving in two weeks for Algeria where they'd stay until the rains came,
then on to Argentina, and then somewhere else. That's the way it was in
the movie business, Kubrick explained, always living in a hotel and out of
a suitcase. That was exactly what Marie *didn't* want. She'd left Olivetti in
order to stay in the US. "Thank you so much. I'll think about it," she said
and then let Gibbs deliver the bad news to Kubrick.

Soon, the placement office came up with a winning match, a job as
personal secretary to Richard Patterson, the former US Ambassador to
Yugoslavia and Guatemala who was now head of protocol for New York
City. Working most of the time at Patterson's apartment in the Waldorf
Astoria Towers on Park Avenue, Marie helped plan tickertape parades,
receptions, and private dinners for notables like the Shah of Iran, then
considered a loyal US ally, and astronaut L. Gordon Cooper. A chauffeur-
driven limousine whisked her around the city on errands and home to New
Jersey after evening parties. At events, she didn't have to carry a canapé tray
or roll up her sleeves afterward to wash dishes. She was a guest like any
other, except available to assist Patterson or his wife as needed.

Soon, though, the dazzling evenings out lost their charm. She wanted
a private life. Again, Gibbs found Marie what she asked for, a low-key
but still glittery position as assistant to the public relations manager of
Seventeen magazine, which in the 1960s was the American teenage girl's

bible of fashion, grooming, and relationship advice. She soon discovered that it was possible to be too good at one's job.

Seventeen's publisher and editor-in-chief, Enid Haupt, was looking for a new secretary and had noticed Marie. Enid had come up the easy way. Her brother, Walter Annenberg, owned the magazine. The personnel department summoned Marie and told her she had to interview with Enid, whom she'd never met. "I had heard in the meantime what a witch she was," Marie said. "That's what everybody said. They just hated her." No thanks, Marie told personnel. Maybe she didn't hear correctly. If she didn't go for the interview, she could consider herself fired because Enid's word was law.

"Well, okay, I'll go meet her," Marie recalled. "I went in and she said, 'I'd like you to start tomorrow.' I said, 'Thank you for the offer, but I'd really rather stay in public relations.' So, she just turned her back on me and said, 'Nine o'clock tomorrow.' And that was it. Turned her back and looked out the window."

It was downhill from there. Just like in the movie *The Devil Wears Prada,* Marie said. Arriving at the office, Enid would throw her mink coat on the table, put her thumb up in the air like a hitchhiker, "and that meant to bring her the Scotch and water. Regularly. No matter what time she came in. She had to have her drink. And I had to have the Scotch in my drawer in my desk."

Even tanked up, Enid was awful. Once, Marie wrote and typed a letter on expensive paper from Enid to President John F. Kennedy. Two lines: "Mr. President, Thank you so much for lighting my cigarette so quickly last night. Best regards, Enid Haupt." No, Enid didn't like the "thank you." It should be "Thanks." Marie typed it again. Now Enid didn't like "Thanks." Go think of something else — after about five tries, Enid was finally ready to sign the letter. That led to another complaint. When she picked up a ballpoint pen from the cup on her desk, the ink didn't come out right away. "For what I pay you," she screeched at Marie, "I want these pens to write the minute I pick them up. I don't want to waste my time making a scratch." After that, every morning Marie tested every pen on Enid's desk.

Enid's one redeeming feature as a boss was that she often went for two weeks to her home in Palm Beach, Florida, leaving Marie with time to watch fashion shoots, visit the magazine's test kitchen to sample recipes, and think. What she thought was that she'd seen enough of the high and mighty life . . . and Enid. It was time for something different. And Katharine Gibbs had taught her that if she could think it, she could do it. A friend was taking early childhood education classes at night. Marie joined her, earned a teaching certificate, and while Enid was off in Florida, told the personnel department she was quitting. Hired at the Montessori School in Englewood, New Jersey, Marie settled into her new career and was voted the best afternoon teacher in the country.

Like Marie, Kathleen Clair found challenge and adventure in a top tier of industry. As personal secretary for thirty-two years to Juan Trippe, founder and president of Pan Am World Airways, she worked alongside one of the great visionary industrialists of the twentieth century. The company was then leading the way in glamorizing and democratizing air travel. Kathleen's contributions, said Trippe's son Edward, were "invaluable."

Juan Trippe was a complex and controversial character. FDR called him "the most fascinating Yale gangster I ever met" after Trippe got a bill introduced in the Senate in 1945 that proposed creating an official US airline for overseas routes. The only possible choice would have been Pan Am, which had landing rights in sixty-two countries. (The measure failed and the skies remained open to competition.) Commenting on Trippe's wiliness, an industry colleague said, "If the front door was open, he would go in by the side window."

But Kathleen got along with Trippe right away. In December 1948, he hired her, a 1937 Gibbs graduate with ten years of secretarial experience, after only a fifteen-minute interview. Stationed in the anteroom just outside Trippe's office on the fifty-eighth floor of the Chrysler Building at 42nd and Lexington, she guarded access fiercely and balanced his personality. Trippe was a dreamer. Gazing at the two small globes he kept in his office, he imagined the future of flight. Kathleen turned the wheels that set his plans in motion. If, his head in the clouds, he didn't always keep track of

details, her photographic mind "remembered everything and everybody," said Edward Trippe. And if occasionally Trippe seemed aloof, she kept an unbeat mood and befriended the company's all-male inner circle, including Charles Lindbergh, whom Trippe had hired as a technical advisor in 1928 and who used Pan Am's executive offices whenever in town.

As for her boss's debatable reputation, she saw Trippe as a patriot who wanted America to rule the skies and who believed he knew best how to do that.

These were exciting times, some good, some bad, all history in the making. The good times began in the late 1940s as Pan Am spearheaded the transformation of air travel from an elite privilege into a middle-class possibility. In September 1948, three months before Kathleen joined the company, Pan Am introduced the lowest long distance fare anywhere in the world, charging a "tourist rate" of $75 one way ($960 today) between New York and San Juan, Puerto Rico.

Trippe next set his sights on affordable trans-Atlantic travel. Although Pan Am pulled in bundles of cash on its "blue ribbon" flights to London and Paris — with linen tablecloth dining and white-jacketed waiters uncorking champagne bottles — Trippe believed that the future of commercial aviation was putting more people in more planes. But the industry's price-setting cartel, the International Air Transport Association, tried to crush the idea, unwilling to disrupt a dependable, steady flow of high-priced ticket income. It took four years for Trippe to persuade his peers to adopt two classes of service, first and tourist. Kathleen fielded the phone calls, scheduled the meetings, and handled the paperwork to make that happen.

In the early afternoon of May 1, 1952, Pan Am's new "Rainbow" service took off from New York's Idlewild Airport for London, carrying tourist class travelers at a round trip rate of $486 compared to the previous deluxe-only $711 charge (today, about $5,800 and $8,500 respectively). Passengers included a Berlin-born window-washer returning to the old country to see his sick mother. Next Pan Am launched jet travel. On October 26, 1958, Pan Am's "Clipper America" plane, a new Boeing 707 with four jet engines, rose into the sky from Idlewild and headed for Paris. It was the

Kathleen Clair in Nice, France, 1950
COURTESY OF LISA CHURCHVILLE

first daily transatlantic jet flight and it slashed travel time from New York to Paris from 11 hours to 6 hours and 35 minutes. Because of the jet's greater efficiency and larger capacity, fares came down even further, starting the march toward truly accessible air travel.

Trippe also changed the New York skyline, building the massive, modernist Pan Am Building (now the MetLife Building) at 200 Park Avenue, which opened in 1963. Adjacent to Grand Central Station, it was then the world's largest and most sophisticated office building with fifty-nine floors, space for 25,000 workers, and a helipad on the roof. Always on the lookout for extra allure, the Katharine Gibbs School immediately moved in on the fourth floor. In these ebullient years, Kathleen enjoyed generous benefits.

For free, she flew on Pan Am's white and blue planes to Europe, South America, Egypt, the Middle East, Asia, and the west coast of Africa. With her room comped, she stayed in the luxurious Intercontinental Hotels, the sideline business that Trippe had started in 1946. Often, she flew down to Bermuda just for the weekend.

As closely as they worked together and for so long, Kathleen and her boss kept a formal distance, addressing each other as "Mr. Trippe" and "Miss Clair," never by first names.

Then came bad times. In the mid-1960s Trippe overestimated national prosperity and pledged $550 million for twenty-five Boeing 747 "jumbo jets." But inflation soared, the stock market tumbled, air travel declined, and TWA overtook Pan Am as the leading trans-Atlantic carrier. By May 1968, Pan Am had become "a leaking, over-loaded ship." Resigning as chairman, CEO, and president, Trippe remained only as a board member. In her late forties, Kathleen could have moved on elsewhere to an executive on the upswing. She stayed with Trippe through till the end, which came in 1981 when he died following a massive cerebral hemorrhage.

Although Kathleen resigned, she didn't quit. As a founding member and officer of the Pan Am Historical Foundation since 1977, she played a key role in saving important records and memorabilia after Pan Am filed for bankruptcy in 1991. She helped the foundation reorganize as a 501(c)(3) educational organization and drummed up contributions from high-rollers like Prescott Bush, father and grandfather of the Bush presidents; Charles Lindbergh's widow, Anne; actress Maureen O'Hara, whose third husband had been a Pan Am pilot; and best-selling novelist James Michener. Thanks to that effort, Pan Am's archives have been preserved at the University of Miami, open to researchers and aviation fans alike.

While women like Marie Zenorini and Kathleen Clair were happy working within traditional corporate structures, Muriel Wilson Scudder struck out on her own, creating a successful home-based travel book company long before self-publishing became respectable. Muriel had noticed all those planes that Pan Am and its competitors were sending off to Europe and she also noticed, preparing for a trip there with her husband

and teenage daughters, that she didn't know how to pack a suitcase any more. The fifties unleashed an explosion of clothing made from "miracle," wrinkle-resistant synthetics like Orlon, Dacron, Acrilan, and Dynel. What to take and where to wear it? This was a time before suitcases with wheels and cell phone cameras, so every extra ounce counted for travelers eager to cram as many miles and memories as possible into their vacation. Muriel looked around — no, not a published word on the subject anywhere.

"At this point, thank heavens for shorthand and typing!"commented Muriel, who'd attended Gibbs in Boston in 1926–27. On her family's trip in the early 1950s, she took detailed notes and once back home she typed them up into a ninety-three-page manuscript filled with tips not only about packing, but also about laundry, money, food, hotels, tipping, language, passports, shots, and gift buying. Traditional publishers shook their heads. Ninety-three pages was a pamphlet, not a book. Muriel published the work herself in 1955.

In the pre-Internet age, before a profusion of social media channels, marketing was a head-scratcher for the lone, rejected author. Large companies controlled book sales, and self-publishing was considered "vanity publishing," the last resort for amateurs who were doomed, at best, to arm-twist a few friends and family members into buying their work. Middle-aged Muriel was especially at a disadvantage because since her time at Gibbs, she'd been a full-time homemaker. Staring at several thousand copies of "Europe in a Suitcase" in cartons piled up in her garage in Manhasset, Long Island, she realized she had no idea how to sell them, "for who was Muriel Scudder and what had she in travel know-how?"

She decided on mail order, and pricing her booklet a $1.25 (nearly $15 today), she took out small newspaper ads in penny-saving, bottom-of-the-page positions near notices for clearance sale tires, hardwood flooring, and Saturday morning coal delivery. Word-of-mouth built gradually, then snowballed, emptying the cartons in her garage. She ordered more and more editions of "Europe in a Suitcase," wrote two more booklets ("Tourist in Russia" and "Caribbean Traveler"), and started a sideline business selling "travel essentials" like folding toothbrushes and carry-all handbags.

Orders came from as far away as Guam, Japan, and Australia and twice from prison inmates, "perplexing me considerably, as I've a feeling those gentlemen will not be traveling anywhere for a while." Once, a check was made out to Muriel's address, so "I had to pretend I was a street as I endorsed it over to that Mrs. Scudder."

By the mid-1960s, Muriel had a thriving enterprise that she ran from her kitchen table. Her ads moved uptown to magazines like *The New Yorker* and her offbeat occupation won her an appearance on TV's *To Tell the Truth* game show.

⏤

LIKE MANY WOMEN FINDING their way in a man's world, Doris Tarrant had no road map and surprised herself by ending up as New Jersey's first self-made female bank president, overseeing nearly $300 million in assets. "Shoot for the stars. There's *nothing* in between!" That's what Doris's father, who owned a small trucking company, had told her when she was growing up in Ridgefield Park. But as a teenager watching Saturday afternoon movies at the local theater, she thought it meant becoming an executive secretary, "Rosalind Russell in a business suit." So, bypassing college, she headed for Katharine Gibbs in the early 1940s.

At Gibbs, Doris learned a lesson that would guide her rise to the top. She didn't need to excel at all tasks, only those in her areas of strength. Because she liked math and did well in accounting classes, she pursued secretarial jobs in finance — working first for the treasurer of United Board and Carton, which manufactured paperboard and folding cartons, then for the treasurer of US Steel, and then as the personal assistant to long-time US Steel president Benjamin Fairless after he left in 1955 to head the American Iron and Steel Institute.

None of her bosses glimpsed her potential. Fairless, for whom she worked the longest, had always had male assistants and seemed flummoxed by Doris. "He was always reaching for a chair for me," she recalled. Well paid, she stayed until Fairless's death in January 1962. Then, after fifteen years in the

steel business, she realized she knew nothing about steel. No longer willing to stand next to power, spending her time on busywork like arranging private railroad cars and limousines, she vowed to change her life.

After a false start managing a restaurant in the Atlanta area, Doris got into banking through a side door. A friend who owned a company in the brand-new data processing field hired her to pitch computer services to banks. That led to an in-house position with People's Trust of New Jersey, the main bank in the United Jersey Banks holding company, selling its unused computer time to smaller banks. Skeptical about a traveling saleswoman, the bank hired Doris because she was the only applicant who already knew how to do the job, but gave her virtually no support, "no title, not even a business card." Nonetheless, she brought in so much money that a few years later her bosses asked her if she'd like to manage a branch. "Not for my life. No lollipops and dog biscuits for me," she replied. She wanted to be a bank president.

She didn't expect to be taken seriously, but thanks to her stellar performance the bank put her on a leadership track. Moving up steadily, in November 1973 she became president of People's Bank of Ridgewood, another of the United Jersey Banks. Four years later, she was named head of the United Jersey Bank-Northwest in Dover, where she increased assets from $60 million to nearly $300 million by the mid-1980s.

Doris was nobody's idea of a pin-striped banker in wingtip shoes. An oddball not only as a woman bank president but also as one without a college degree, she brought warmth and humor to the job. When a customer wanted to open a checking account for his dog, a four-year-old elkhound-German shepherd mix named Big Ben who earned money from personal appearances, she shrugged *why not?* Another bank had turned down Big Ben's request, but Doris showed his owners how to make it work. All they had to do was form a corporation with Ben as president and themselves as officers. She then ordered checks printed with the dog's address, phone number, and photo, and agreed to accept a rubber stamp of his paw print as an authorized signature. Doris proved what could happen when the glass ceiling shattered — more creativity, flexibility, and profit.

∽

KATHLEEN CLAIR AND DORIS Tarrant never married—and Marie Zenorini accepted a proposal only in her late fifties after winding down a decades-long career. They were all enjoying their independence too much to accept the stereotypical role of mid-century American housewife. Besides, Doris wondered, "Who'd marry a woman bank president?" No man she knew would put up with the busy hours, the social obligations, and getting pushed aside when photographers wanted a shot of her by herself at events.

After years of dodging marriage offers, Marie changed her mind at age fifty-eight when she heard from a man she'd dated during her early days at Olivetti in New York. Back then, Michael Canepa was a young Italian-born engineer and mathematician visiting the United States from Olivetti headquarters in Italy. After Marie turned down his proposal, he moved on to a long, happy marriage and the directorship of Olivetti's Electronic Research Laboratory in New Canaan, Connecticut. Widowed now, he'd started thinking about her and wondered if she was available.

No sooner did they sit down to dinner in New York than he confessed that she'd been his first love and he wanted to marry her. "The first night, after thirty-three years!" Marie recalled. "I said to him, I'm not interested, but we certainly can be friends." He kept asking her to dinner and kept proposing, unsuccessfully. Finally, she asked him not to ask anymore—it was embarrassing. Then, after about six months, she told him he could ask again. She'd fallen in love with him. They married in December 1985 and in their late nineties, remained married.

It's Showtime!

∽◦◡◦∾

DECADES LATER, TV VIEWERS would know Loretta Swit as Major Margaret "Hot Lips" Houlihan, her Emmy-winning role in the long-running CBS TV series *M*A*S*H*, but in the mid-1950s, she was a high schooler living with her parents in a working-class neighborhood of Passaic, New Jersey. Adjacent to their house was the Red and White Tavern, serving Polish food and drink, and around town were ethnic social clubs like the Polish Tatra Mountaineers, the Polish Women's Club, the Polish Youth Club, and the Polish American Citizens' Club.

Loretta Swit alongside her
*M*A*S*H costume*
PHOTO BY BILL DOW/COURTESY OF
THE HOLLYWOOD MUSEUM

Loretta's parents, both of Polish heritage, hoped she'd stay "close by, married, happy, and having babies," said Loretta.

She had other plans. For as long as she could remember, she'd longed to be an actress. It wasn't a decision, she explained. "It was my calling." She danced in recitals "as soon as I could walk," sang in the choir, choreographed and taught dance in school, was a cheerleader and majorette, acted in high school plays, and as a senior directed a freshman production of *Midge Goes to the Movies*. With her

High school classmates in Passaic, NJ, considered Loretta Swit "talent personified"

POPE PIUS XII HIGH SCHOOL, 1955 YEARBOOK

mother, who loved film, she sometimes saw two double features in one day.

Still, no one in her family had ever been in the theater, so when she hinted about her ambitions to her parents, "they just didn't believe it." Show business was a mysterious, distant universe that didn't intersect with their own. She ought to be realistic. Neither did anyone else encourage Loretta, although her yearbook described her as "talent personified" and "a model of poise." Quietly, Loretta held on to her dreams. "Becoming an actress was so in my mind all through high school, that I don't remember being conscious of other things."

For Loretta, as for other young women eager for a creative career, Katharine Gibbs offered a bridge over fear and financial worry. With first-rate office skills to fall back on, they'd never end up starving in a tenement or calling home to beg for money. And while parents might balk at the seeming foolishness of paying for acting lessons, Gibbs tuition represented a solid investment in a stable future. Loretta's parents were delighted when, months after graduating from high school in 1956, she enrolled at the Gibbs school in nearby Montclair.

She loved it there. Housed in the former Kimberley School, a converted mansion at 33 Plymouth Street in a residential neighborhood, the school exuded elegance and gave Loretta the rigorous, supportive education she hadn't found

Between classes, Loretta Swit might have relaxed in this student lounge at the Gibbs school in Montclair, NJ

KATHARINE GIBBS SCHOOL RECORDS, BROWN UNIVERSITY

in high school. At Gibbs, she said, the faculty "cared and gave guidance." Her English teacher there, Louise Brundige, made a lasting impression. "She was magnificent…an inspiration," said Loretta. "Mrs. Brundige would walk in with a pretty suit, pretty blouse, well-coiffed, with flattering makeup, not overdone, just a natural kind of look." Using her expressions as punctuation, she'd "look at us and give us a great big smile. It was like the period to the sentence, like, 'You get that, don't you?'" For fledgling actress Loretta, it was a lesson in the power of gesture, and for the teenager about to make her way in the world, a model of professional presentation.

With her Gibbs certification in hand, Loretta headed to New York and signed up at Kelly Girls, the leading temporary secretarial staffing agency. The arrangement was perfect. She could choose her assignments to accommodate acting classes, auditions, and rehearsals. She worked for the Ghanaian ambassador to the United Nations, and at a UN event, met handsome Prince Aly Khan, recently divorced from Rita Hayworth and now Pakistan's permanent representative to the United Nations. Another job, at the height of the space race between the US and Russia, took Loretta to the American Rocket Society, founded by a handful of science fiction writers who conducted rocket experiments in New York and New Jersey. The organization had pioneered the development of liquid-propelled rocket motors and by the end of the 1950s counted some 21,000 members.

Her longest assignment, lasting several years, offered glimpses of international high society. As personal secretary to syndicated newspaper columnist Elsa Maxwell, who covered the goings-on of stars, plutocrats, and royalty, Loretta worked in her own office in Maxwell's apartment at the Hotel Delmonico. She typed and, thanks to her Gibbs grammar skills and social finesse, edited Maxwell's articles and helped plan events. Although Maxwell — then in her seventies, portly, plain, and a high school dropout — boasted that she had "more friends than any other living person," including Princess Grace, Prince Rainier, and Aristotle Onassis, Loretta found her to be "homey and gracious…a very generous, very sweet lady." Loretta stayed with Maxwell until her death at eighty in 1963.

Meanwhile, Loretta built up her acting résumé. Along with studying

at places like the American Academy of Dramatic Arts, she appeared in fifteen-dollar-a-week repertory theater, off-Broadway plays, commercials, industrial films — including one for the Federal Pacific Electric Company — and on TV shows like *Captain Kangaroo* and *Car 54, Where Are You?* and the afternoon soap opera *The Doctors*. There was no guarantee that it would all add up. Talented actors with mile-long credits fell off the map every day. Still, as long as secretarial work paid the $64.70 monthly rent on her 13th Street apartment, Loretta could keep trying.

In 1967, her luck turned. Cast in a seven-month road show tour of *Mame*, she played governess-secretary Agnes Gooch alongside Celeste Holm in the title role. Loretta often stole the show. After her performance at the Texas State Fair, a reviewer wrote that among the cast members with singing parts, "only Loretta Swit really comes across well — in fact for all-round performance she tops the whole cast."

Not only the glowing notices helped. After the show closed at Chicago's Shubert Theater in early 1968, Loretta received unemployment insurance benefits — "extremely important," she said, so she could hunt full-time for her next acting job. A friend invited her to Los Angeles and at a party there, several producers asked her to do a screen test. That led to a flurry of TV guest-starring roles on *Hawaii Five-O, Mannix, Bonanza, Gunsmoke,* and *Mission Impossible*.

Then along came *M*A*S*H*. Loretta won the part of Major Houlihan on the strength of her reputation — there was no script, not even any lines to read at the audition, and she didn't submit her TV clips because she hadn't done any comedy. She was the only female series regular during the 1972–1983 run and one of only four cast members, besides Alan Alda, Jamie Farr, and William Christopher, to appear all eleven years. In 1980 and 1982, she won Emmy awards as Outstanding Supporting Actress in a Comedy or Variety or Music Series.

Even without Gibbs, Loretta was determined enough to have made it to *M*A*S*H* anyway. Yet, if instead of interesting, colorful office work she'd had to sling plates in a restaurant or slosh drinks behind a bar — standard jobs for hopeful actors — her apprentice years would surely have

*Classmates at Gibbs in New York
described future stage and movie star
Leora Dana as a dynamo, yet dreamy*
PLATEN, 1942, KATHARINE GIBBS SCHOOL
RECORDS, BROWN UNIVERSITY

been gloomier. She was always thankful for the way the school helped sustain her during the lean years. Gibbs "influenced my life, my education, my confidence certainly," said Loretta. "I think of those days with great fondness and pride."

Like Loretta Swit, Leora Dana grew up dreaming of an acting career and although she came from a family many rungs up on the economic ladder, she got similar advice from her mother who insisted she go to Katharine Gibbs first.

Leora's mother, Annie Alberta Webster Dana, knew firsthand the dangers of having no marketable skills. She was nearly left high and dry when her husband deserted her and their three young daughters in the late 1920s to run off to Reno for a divorce so he could marry another woman. The ex-husband, William Shepherd Dana, was fabulously wealthy, having inherited several large estates on Long Island and in New Jersey as well as various Manhattan properties, and he was determined to hold on to the loot. Leora's mother got such a bad deal that she fought to have the original divorce decree set aside and managed to extract a large cash settlement in exchange for ending the marriage. Mother and daughters were able to settle into a luxury apartment building at 480 Park Avenue, between 58th and 59th Streets, but it had been a close call. Annie Alberta was determined that such troubles would not befall Leora as she set out on a career that might prove just as perfidious as a man could be.

At her mother's insistence, Leora enrolled in the two-year program at Katharine Gibbs in the early 1940s. Her yearbook photos show a serious, wistful-looking young woman, and a caption described her "earnest desire to become another Katharine Cornell," a leading stage actress of the era. A poem Leora wrote at the time revealed her anxiety about the future. Titled

"That Seek to Fly," it asked, "Are dreamers out of vogue?" Leora would go on to Barnard, but it was her Gibbs certificate that reassured her and her mother that as long as dreamers could type, they could afford to keep dreaming.

It's not clear whether Leora ever had to fall back on secretarial jobs, but in addition to bolstering her courage as she knocked on producers' doors, her Gibbs training yielded a life-changing career benefit. In late 1951, she landed a part opposite Henry Fonda (less than two years after the suicide of his Gibbs graduate wife, Frances Seymour) in the Broadway play *Point of No Return*. Cast as Nancy Gray, a Westchester County housewife devoted to advancing her husband's banking career, Leora worried that she couldn't handle the part. Although secretly married to actor Kurt Kasznar since 1950 (they'd divorce in 1958), she'd never been a submissive wife or lived in the suburbs. Then, late one night, thumbing through the novel on which the play was based, she read that her character had attended Katharine Gibbs and Barnard. "I screamed with laughter," she said. She *was* Nancy Gray.

Point of No Return propelled Leora into the big leagues. Before, she'd been a promising newcomer, living in a sparsely furnished one-room apartment and worrying constantly about the next job. Now, critics singled out her performance as "splendid," praising her warmth, intelligence, and "thoroughly ingratiating style." After running in New York for nearly a year until late November 1952, the play toured nationally and made her a sought-after talent.

On Broadway, Leora went on to star opposite Melvyn Douglas in *The Best Man*, and when Hollywood came calling, she won parts alongside some of the biggest movie stars of the day. She appeared with Robert Taylor and Eleanor Parker in *Valley of the Kings* (1954); Glenn Ford in *3:10 to Yuma* (1957); Frank Sinatra, Tony Curtis, and Natalie Wood in *Kings Go Forth* (1958); Frank Sinatra, Dean Martin, and Shirley MacLaine in *Some Came Running* (1958); and Hayley Mills, Jane Wyman, and Karl Malden in Disney's *Pollyanna* (1960). By 1958, she'd left her cubicle apartment for a townhouse in the Turtle Bay section of Manhattan near Katharine Hepburn's home. When Rock Hudson came to town, she showed him around.

Behind the scenes, too, Gibbs graduates made their mark in show busi-
ness. Marie Irvine, a carpenter's daughter from the tiny Hudson Valley
village of Pawling, New York, found the secretarial classes at the New
York school dull, but the personal grooming lessons ignited her imagi-
nation. So, starting with a job giving facials at Elizabeth Arden's famed
Red Door Salon on Fifth Avenue, she built a career as one of the fashion
and beauty industry's leading make-up artists. Photographers like Richard
Avedon, Irving Penn, and Milton Greene booked her regularly for *Vogue*
and *Harper's Bazaar* shoots. And as Marilyn Monroe's favorite New York
makeup artist, Marie prepared the actress for one of the most import-
ant performances of her life — singing "Happy Birthday" to President
Kennedy at Madison Square Garden in May 1962.

Marie first met Marilyn when Avedon hired her to do the makeup
for a pictorial that ran in the December 22, 1958, issue of *Life* magazine,
with Marilyn portraying five "Fabled Enchantresses" from Lillian Russell
to Jean Harlow, with Theda Bara, Clara Bow, and Marlene Dietrich in-
between. Marilyn was then living in New York, married to *Death of a
Salesman* playwright Arthur Miller.

The assignment came with a large dose of sexism. Although Marie's
work was crucial in transforming Marilyn's face, she wasn't credited and in
an accompanying article titled "My Wife Marilyn," Arthur Miller referred
to Marie simply as "the make-up artist standing by to offer advice." Then,
in a backhanded dismissal of both Marie's and Marilyn's work, the caption
of a photo of Marilyn as herself with Miller read, "Photographer Richard
Avedon feels this is the real Marilyn, a loving wife playfully kissing her
brilliant husband, playwright Arthur Miller." Marilyn is apparently nude,
standing behind Miller who wears a suit and tie, her eyes closed, and the
side of her face pressed into his. Not responding, Miller looks directly at
the camera with a self-satisfied smile.

Over the three months it took to complete the project, Marilyn warmed
up to Marie. She encouraged Marie to bring her young daughter to the set
when she couldn't find a babysitter and, playing with the baby, confided in
Marie how much she wanted a child of her own. Later, whenever Marilyn

needed a New York makeup artist, she phoned Marie directly rather than use an intermediary. They were friends now. It came as no great surprise, then, that Marilyn asked Marie to do her make-up for that performance at the May 19, 1962, celebration of President John F. Kennedy's forty-fifth birthday (which was actually ten days later) at Madison Square Garden.

Marilyn, thirty-five, had a lot staked on this event. Divorced from Arthur Miller since January 1961, rumored to have had a one-night stand with JFK in March 1962 in Palm Springs, she'd infuriated 20th Century Fox by coming to New York in the middle of filming *Something's Got to Give*, which was already behind schedule. Whether she hoped to rekindle the flame with Kennedy or remind herself that despite the lackluster reception of her recent movies, she could still bedazzle a crowd, everything had to be perfect. On the morning of Friday, May 18, 1962, the day before the extravaganza, Marilyn was chauffeured out to Marie's home in Elmhurst, Long Island, to plan her look. The next day, at Marilyn's East 57th Street apartment, for $125 (about $1,300 today), Marie spent hours creating a dramatic, glowingly sophisticated look of precisely placed black eyeliner, winged at the outer corners; feathered eyebrows over light, frosted shadow; lipstick a shade lighter than her trademark fire-engine red; and a flawless, radiant complexion. If it was true that JFK had told Marilyn she wasn't first lady material, this face (if not her skintight, rhinestone-studded gown or platinum cotton-candy hairdo) would prove him wrong.

This would be Marilyn's last triumphant moment before her probable suicide from a barbiturate overdose less than three months later. Yet, while the other contributors to Marilyn's look that night were widely celebrated — Jean Louis for designing the gown, Kenneth Battelle for styling the uplift and side-swoop of her hair — Marie faded into anonymity before being rediscovered at age eighty-nine for a 2014 British TV documentary about Marilyn's last months.

While Marie glamorized famous faces, Martha Torge made sure they got seen. In the early 1950s, within a decade of finishing at Gibbs, Martha was the only female publicist at the RKO movie studio. Based in New York, she arranged press events for visiting stars like Jane Russell, Robert

Mitchum, Joan Crawford, John Wayne, Dick Powell, and Victor Mature, and kept a close watch to make sure they behaved themselves. In her late twenties, she earned $150 a week ($1,800 today) and sported a mink stole.

Martha's speedy rise to a coveted job masked a background of tragedy. When she arrived at the New York Gibbs school in the fall of 1940 from Buffalo, she was an eighteen-year-old orphan. Her mother had died only months earlier, and father, a department store executive, had died when she was eleven. Her only sibling, George, twelve years older, was busy building a career at a Buffalo radio station. Martha was going to have to fend for herself.

At Gibbs, Martha was no longer an oddity. None of the out-of-towners had their family close at hand, so they all had to depend on one another. Here, Martha's personality sparkled. Her 1941 yearbook photo caption read, "As witty and refreshing as one of Thurber's essays." In class, teachers provided the sort of practical life advice that good parents would have. As she built her career, Martha would cling to those lessons.

Returning after graduation to Buffalo, she started out writing fashion copy for Hengerer's department store. Gibbs had taught her not to sit around waiting to be noticed, but to drum up her own opportunities. So, about a year later, when the store decided to sponsor a new radio show, Martha pitched the winning program idea and helped audition on-air talent. When she turned thumbs-down on a prospective female announcer, the casting director grimaced, "I suppose you could do better?" Martha shot back, "Easily — even with my teeth out!" In early 1944, only twenty-one, she became one of the first two female commentators on WBEN, the NBC affiliate, giving "shopping hints and timely tips for the family" on the weekday morning program *Counter Points*. She was so popular that NBC Radio brought her to New York City to interview celebrities like Tallulah Bankhead, Gertrude Lawrence, and Richard Rodgers.

But performing was a precarious career, and with radio fading in favor of TV, Martha spent the next few years shuffling through jobs. Briefly, she worked as a secretary to Ursula Parrott, whose scandalous novel *The Ex-Wife* had been a Jazz Age bestseller, but who had now fallen into disgrace

and mental instability after helping a much younger soldier escape from a stockade in Florida. Then came publicity jobs with Decca Records and with mezzo-soprano Risë Stevens of the Metropolitan Opera Company. In 1949, when RKO needed a new star handler, she had just the right mix of experience, youthful verve, and Gibbs-honed social flair.

Amid Hollywood's Golden Age, when movie magazine readers devoured stories about larger-than-life actors supposedly living the American dream, Martha's new job kept her on her toes. She hovered around her charges, protecting them not only from overzealous fans and pushy reporters but also from themselves. If during an interview at a restaurant, the conversation derailed into a troubled part of the star's life, Martha hastily spilled her soup or tripped the waiter to create a diversion. Preparing for photo shoots with women and men used to being adorned by the studio wardrobe department, she shopped for clothes in Fifth Avenue stores and borrowed gems from Tiffany and Cartier. Lest screen idols appear friendless, she accompanied them to the theater and fancy restaurants.

Martha worked hard for these visitors from Hollywood's stratosphere, and her subdued style complemented but didn't compete with them. In appreciation, Tallulah Bankhead gave Martha a dog named Puppet. Joan Crawford, in town to promote *Sudden Fear* (1952), in which she played a successful playwright married to a murderous actor (Jack Palance), kept Martha chatting until midnight in her Hampshire House hotel room one night. When Martha suddenly realized she had to go home to feed Puppet, Joan insisted on going along. With no taxis anywhere to be seen on Central Park South, Joan suggested taking a horse and buggy from the lineup across the street. As they trotted down Fifth Avenue in the open carriage, several night owls on the sidewalk noticed Joan — but they thought she was Rosalind Russell. Truly a star, Joan stood up and boomed, "I'm Joan Crawford," drawing loud cheers and applause from the bystanders. That bright, joyful moment measured the distance Martha had traveled since her sorrow-filled childhood.

☙

AS A FIELD FOR the imagination, advertising grew sensationally during the postwar era, with annual revenues skyrocketing from $2.9 billion in 1945 to nearly $10 billion in 1956. Ironically, although women made an estimated 80 percent of consumer purchases, ad agency executives were almost all men. Not that those men necessarily knew how to address the female shopper. Martin Mayer, author of the bestseller *Madison Avenue, U.S.A.,* commented in 1958 that a great many admen with fancy titles and fat salaries relied on the brains of lower-paid, anonymous women around the office. Even as Mayer spoke, though, that was beginning to change. A cadre of determined, ambitious adwomen like Kathy McCahon (later Magnuson) had begun to insist on — and get — credit for their work.

An honors student in high school, Kathy had a quick mind and a knack for a clever turn of phrase. What she didn't have, growing up during the 1940s in a working-class neighborhood of Mount Vernon, New York, was money for college. Her Scottish-born father belonged to the letterers' union and painted images for outdoor advertising; her mother was a home-maker. "There was Katharine Gibbs when one needed it," Kathy recalled. There, she learned she could "do every bit as much as a man can do."

After a short stint at a manufacturing company, which she left after hearing male employees repeatedly refer to women as "broads," Kathy stepped into a fantasy world. As the secretary-receptionist at *Gourmet*, the self-proclaimed "magazine of good living," she rode a private elevator up to the offices in the penthouse of the Plaza Hotel. One day, she passed Cary Grant in the lobby, and among the guests at publisher Earle McAusland's on-site luncheons were actress Marlene Dietrich and boxer Gene Tunney, former heavyweight champion of the world. She made friends with then-assistant food editor Ann Seranne (real name Margaret Smith, later executive editor), who had started at *Gourmet* in Kathy's position, and chatted with the "always jolly" James Beard when he dropped off his arti-cles. Passing by the kitchen, she was likely to see a towering croquembouche in a haze of caramel spun sugar or a roast pig with a parsley stripe down its back to hide the fact that it had been cut in half to fit in the oven.

But one episode, not uncommon for the era, struck a sour note. An older, married man, a *Gourmet* ad salesman who spent many afternoons

in a bar knocking back cocktails, invited nineteen-year-old Kathy, an Audrey Hepburn lookalike, to join him and another young woman who worked elsewhere at the Plaza for a drink after work at the famed Stork Club. (The legal drinking age in New York State was then eighteen.) No trouble occurred the first few times. Then, a seemingly harmless gesture: the man—call him Howard—offered to give Kathy a ride, in the cab he'd called to take him home to Long Island, to Grand Central Station for her train back to Mount Vernon. But the car didn't turn at 42nd Street. A different route, he said. Suddenly, they were in lower Manhattan, nearing a bridge to Long Island. His wife was away, he said. *Was she being kidnapped?* Stop this car, Kathy demanded, panicking, her door halfway open before it did stop. "I'm sorry, I'm sorry," Howard sputtered, and told the cab driver to turn around. She didn't say a word all the way to Grand Central Station.

There was no point in reporting the incident because officially there was nothing to report. Sexual harassment wouldn't become illegal for several more decades. In the early 1950s, Kathy knew she'd have no chance against a company rainmaker like Howard. She didn't tell her parents, either. They'd have insisted she quit.

All she could do was avoid the ad salesman and make the most of the job's good points. And there she found her métier. Her friend Ann Seranne asked her to collaborate on the magazine's popular column, "You Asked for It!," which invited readers to request the recipes for their favorite restaurant foods. While Seranne reverse-engineered the magic, Kathy supplied witty text. When a reader asked for the ingredients in Welsh rarebit, she wrote, "There's neither hide nor hare of a rabbit in rarebit."

Gourmet also assigned Kathy to write ad copy for its cookbook, a 781-page, burgundy leatherette-bound doorstopper. Her pitches were lively and smart. One poked fun at the current marriage mania, announcing, "Enterprising young women…are husband-hunting with a will and a saucepan. And what chance does a man have against the persuasive charms of a *soufflé au gingembre*?" Despite a price tag of $10 in 1952 (about $120 today), orders rolled in and publisher McAusland — "so respectful of ladies," she said — raised Kathy's weekly salary from $50 to $75 (nearly $900 today).

Kathy McCahon kept a firm hold on the check she won in the Darling Baby Carriage slogan contest
COURTESY OF SALLY MAGNUSON

Confident she could make a career out of this, Kathy enrolled in evening classes in marketing at Pace University. There, she saw a flyer on the bulletin board announcing a slogan writing contest for the Darling Baby Carriage Company, a New York area chain of stores. Her winning words came easily. "When a marriage needs a carriage, see Darling." Presenting her with a check for the $250 prize (nearly $3,000 today), the company owner — who was married — asked her to lunch. With a firm grasp on the check, she turned him down and took the money home, where her family was so thrilled that her brother drew a trumpet on the calendar and wrote, "Kathy won!"

After only two years at *Gourmet,* barely into her twenties, Kathy left to join a small ad agency as a copywriter with her own office and a boost in salary to $100 a week (nearly $1,200 today). By 1954, she'd moved on to the William H. Weintraub agency on Madison Avenue, where she worked on one of the most daring and imaginative campaigns in advertising history, the Maidenform bra "I dreamed. . ." ad series. The concept had been hatched in 1949 by Weintraub account manager Mary Filius to tap into the postwar popularity of Freudian psychoanalysis and its fixation on dreams as unconscious wish fulfillment.

One of Kathy's ads read, "I dreamed I was an Egyptian dreamboat in my maidenform bra" and showed a Cleopatra-like figure at the front of a barge on the Nile with pyramids and palm trees in the

Kathy McCahon's ad for Dorothy Gray cosmetics, a rival to Elizabeth Arden and Helena Rubinstein

background: "Why, even the Sphinx thinks I'm a dreamboat . . ." Another showed a photo of a harem-costumed woman seated on a flying carpet, and announced, "Shades of Scheherazade! I'm soaring over the shifting sands…and the only magic word I need is Maidenform!"

The following year, McCann-Erickson, one of the top four ad agencies worldwide with more than $100 million in client billings, snapped up Kathy to work on campaigns for Talon Zippers, Dorothy Gray cosmetics (a competitor to Helena Rubinstein and Elizabeth Arden), and the International Silver Company. Her ads ran in *Life, Look, Saturday Evening Post, Ladies' Home Journal, Glamour, Mademoiselle, Woman's Day, Esquire,* and big city newspapers nationwide.

She loved advertising. The money was excellent, the people interesting, and especially at McCann-Erickson, which had named four women vice-presidents in 1949, attitudes were changing. Contrary to *Mad Men* depictions, Kathy didn't experience harassment in any of her agency jobs. The business was so high-stakes competitive, she said, that only one thing mattered. Could you move the merchandise? She could. Her ads increased sales.

"Katharine Gibbs was the reason it all worked for me, truly," she said. "They were always on your side at Katharine Gibbs."

One of Kathy McCahon's ads for the classic Maidenform "I dreamed…" campaign

COURTESY OF HANES BRANDS INC.

SEVENTEEN

The Writers

∽◯c∾

AMONG ALL THE ACADEMIC subjects taught at Gibbs, instructors hammered hardest at English. Not even a nun holding a ruler in a parochial junior high school could have done a better job of pounding usage rules into the heads of young women. It was essential to the Gibbs image. As Gordon Gibbs explained, "If you know where to put a comma, it's a sign of education; if you know where to put a semicolon, it's a sign of culture." Beginning in the postwar years, a surprising number of Gibbs graduates used their language skills to launch successful careers as authors.

Gibbs student searching for just the right word

Natalie Stark Crouter, who after finishing at Gibbs in 1923 had left her upper-class Boston-area home to marry an American in China and settle in the Philippines, had a harrowing story to tell. In late December 1941 she, her husband Jerry, and their children, twelve-year-old June and ten-year-old Frederick, were arrested as part of the expatriate community in the Philippines by the invading Japanese army. For more than three years, the family would be held captive

at internment camps, forced to live in squalid conditions, fed starvation rations, and plagued by disease.

They spent most of that time at Camp Holmes, a former police barracks in the mountains north of Manila, where the Japanese warehoused some 500 American and British citizens along with 300 Chinese nationals. Each person got only thirty-six inches of space. Dysentery broke out constantly; "millions of flies," so vicious they bit through clothing, swarmed about; "violent quarrels" erupted over the lack of privacy. Water was scarce and meals — often cornmeal and soybean residue — bordered on inedible.

Natalie Stark Crouter and children
Fred and June, late 1930s
COURTESY OF THE CROUTER FAMILY/
SCHLESINGER LIBRARY

Once the lady of the house with a staff of servants, Natalie now did mind-numbing manual labor. Every day, she lugged a petroleum can of water up the steep back steps of her barracks to scrub the muddy porch, then lugged it back down to wring out her mop at the faucet, then went back up again.

One thing saved her sanity: keeping a secret diary. In tiny letters on scraps of paper — envelope flaps, margins torn from book pages — she chronicled her daily experiences. Because the penalty for recordkeeping was death, she wrapped the paper scraps in plastic cut from an old rain-coat and hid them in food containers. Mostly, she used a can of rancid peanut butter that survived frequent inspections by the Japanese because it smelled so bad when she removed the lid.

The diary was, she wrote, "a rock through the window" of captivity and a safety valve for her "ghastly" rage. Another woman prisoner, a relative of the Kellogg cereal family, never saw Natalie's inner turmoil and described her as an inspiration. "She never complained nor talked about her hard, dirty, menial work — [she] remained every inch a dignified lady."

Natalie Stark Crouter and her family in a World War II
Japanese internment camp in the Philippines
COURTESY OF THE CROUTER FAMILY/SCHLESINGER LIBRARY

When the prisoners were finally rescued by American troops in February 1945 from their last stop, Manila's condemned, cobweb-ridden Bilibid prison, Natalie was deathly ill from malnutrition and intestinal parasites. Although doubled over in pain, she was obsessed with saving her diary. Realizing she didn't have it just as the US Army truck was about to pull away, she sent her son, Fred, racing back to the prison to retrieve the peanut butter can. Then she lost it again when army intelligence confiscated the diary as possible evidence for war crimes trials.

With their life in the Philippines destroyed, the family settled in with Natalie's older divorced sister in Cleveland Heights, Ohio. Natalie was forty-six, with an obliterated past, ruined health, a traumatized family, no US work history, and little money. US reparations for their lost property amounted to only about twenty cents on the dollar. Looking forward, Natalie resolved to make good use of her ordeal.

She'd write a book based on her camp diary.

Naturally, the army couldn't find the putrefied vat of peanut butter containing Natalie's notes. No, they hadn't lost it. It had to be . . . somewhere. Australia? The Philippines? Boston? After military bureaucrats

dithered around for months, Natalie's husband, Jerry, buttonholed Ohio congresswoman Frances Payne Bolton, who cracked the whip on the search. Found gathering dust in a Kansas City warehouse, the container was delivered to Natalie on Pearl Harbor Day, 1945, fittingly wrapped in black paper.

Her new typewriter arrived by Christmas and within days, braving the noxious fumes of the rotten gunk and straining her eyesight to read her own microscopic handwriting, she was clattering away on the keys. Painful memories left her feeling "threadbare." But after two years, she'd finished a gargantuan 5,000-page manuscript. Of course, it needed massive pruning, she knew that, but no publisher was interested. No one wanted to relive the war, they believed. It would take more than three decades for Natalie's book to reach readers.

In the meantime, an avalanche of personal troubles descended. In the summer of 1945, Natalie spent three months in a Boston hospital, where doctors said she was teeming with infections they'd never seen before under a microscope. Her husband was in worse shape. A strapping six-foot-two and 212 pounds when captured, Jerry left the camp a skeletal 145 pounds, badly crippled by beriberi and suffering from bladder disease.

Because he couldn't find a job in the United States, Jerry returned alone to the Philippines to work for the US War Shipping Administration. In August 1946, he suffered a stroke and fell into a coma in a Manila hospital. At last well enough to return to the US in 1947, Jerry found jobs with the Veterans Administration and a Cleveland stock brokerage, but in July 1951, he died at the Cleveland Clinic at age sixty of cirrhosis and cancer of the liver.

Natalie's children were badly traumatized. Teenage June, who before the war had been "full of fun…full of music," grew distant, and in her early twenties went through a rebellious phase. Fred, two years younger, suffered violent nightmares, stomach troubles, and a fear of crowds. With their mother's guidance, they made it through. Natalie's sister, Marguerite, with whom the family still lived, also leaned on her. Marguerite had been shattered when her husband of more than thirty years, *Cleveland Plain*

Dealer editor Paul Bellamy, abandoned her to marry another woman in 1941. Seven years later, Marguerite's oldest son, John, a partner in a Cleveland law firm and the father of three young children, died of polio at age thirty-seven.

Throughout all the pain and loss, Natalie held tight to her dream of publication. In 1968, after attending a meeting of the Women's International League for Peace and Freedom, she persuaded one of the speakers, Lynn Z. Bloom, who was writing the biography of Dr. Benjamin Spock, to help. Over the next dozen years, Bloom trimmed the diary by more than 90 percent and shepherded it toward publication in 1980 by the tiny Burt Franklin company, which specialized in reprinting scholarly medieval and Renaissance books.

Despite a next-to-nothing publicity budget, Natalie's *Forbidden Diary* drew nationwide acclaim. Newspaper reviewers praised it as "one of the most fascinating pieces of grassroots history to be published in years… artless, unguarded and utterly real"; "a monument to the courage of Everywoman"; and "one of the year's most important books." *Time* magazine ran a full-page story about Natalie. The Ohio House of Representatives issued a proclamation commending her "concern for humankind, commitment to human equality and equal treatment for women" and saluted her as "one of Ohio's finest citizens."

First-rate writing skills also gave Marie Lyons Killilea, who attended the New York Gibbs school in the early 1930s, a way to transform hardship and heartache into trailblazing achievement. For Marie, tragedy occurred not on the world stage but within the four walls of home. In 1941, her one-year-old daughter, Karen, was diagnosed with cerebral palsy, a neurological disorder in which damaged areas of the brain fail to communicate properly with muscles and joints, causing problems like spasticity, involuntary movement, and motor skills impairment.

Born three months prematurely, weighing less than two pounds, Karen had spent the first eight months of her life in the hospital. When she came home, Marie noticed that the baby didn't reach for her toes, roll over in her crib, or play with toys. When a specialist confirmed their

pediatrician's suspicion of cerebral palsy, twenty-eight-year-old Marie's world collapsed.

In 1941, cerebral palsy was a living death sentence. Because the condition was considered hopeless, medical schools didn't teach CP diagnosis or treatment. There was no cure, very little therapy, and general social revulsion at the sight of all severely disabled people. Children with CP were usually packed off to an institution or hidden at home, out of sight of the community.

Karen's life was useless, the specialist told Marie. She had no mental capacity and could never participate in society. For that helpful advice, he charged Marie $250 (in today's money, about $5,400).

Seeing "eloquent" intelligence in Karen's eyes, Marie refused to accept a bleak future. She already knew how to fight. After her father died when she was eleven and then the Depression hit, Marie gave up hope of attending college, enrolled at Katharine Gibbs, and went to work to help her mother and sister. Her otherwise happy marriage to Jimmy Killilea, an engineer with the New York Telephone Company, had also suffered heartbreak. A few years after the couple settled in Rye, New York, they started their family with daughter Marie, but the year before Karen was born, their second child, Katherine Anne, died at birth.

For two and a half years, Marie and her husband searched throughout the US and into Canada for help for Karen. They saw twenty-three doctors who prodded and tapped the baby with a rubber hammer, sold the family expensive and useless equipment, and delivered the same cruel verdict. Nothing to be done. One neurologist, chief of staff at a hospital, advised Marie and Jimmy to buy a large insurance policy so Karen would always be provided for. "Then take your child to an institution and leave her and forget you ever had her." Another distinguished-looking doctor said he knew of an effective treatment in China. Whatever it was, they'd do it, Jimmy exclaimed. The doctor took off his glasses, placed them carefully on his desk, and told the young parents that in China, "they take such children up on top of a mountain and leave them."

Many more blows rained down. Out in public, strangers stared at the

family "with humiliating pity or suspicious scorn." On a trip to see a doctor in a western state, at a tourist home where they hoped to stay to avoid high hotel costs, Marie and Karen were welcomed in by a kind-looking, middle-aged woman while Jimmy parked the car in the rain. Let the child run around, the woman suggested, she didn't mind. When Marie explained about Karen's condition, the landlady erupted in rage. "Get out of my house," she shrieked. "Only bad, dirty people would have a child like that."

Meanwhile, the bills piled up. They all needed new clothes, the house needed its roof replaced, the water heater was broken, their old Ford had become a wheezing jalopy. They had no money. Nearly everyone told Marie to face facts and stop fighting. Maybe the doctors were right, she thought. Was it her fault? Had she done something wrong during her pregnancy? Her heart felt "barren and chill."

The twenty-fourth doctor changed everything. Karen was "a fine healthy child," he said, and with proper help, she would sit up, use her hands, speak clearly, and even walk. And no, she was not mentally impaired. To the contrary, Karen had a normal IQ or higher. For the first time in two and a half years, Marie cried — from happiness.

Because the family had already spent "fantastic sums," and in any case there were no therapists near their home, the doctor offered to have his assistant teach Marie and Jimmy how to do physiotherapy and occupational therapy. The idea was to train another part of Karen's brain to do the work of the damaged area. With Jimmy on a leave of absence from his job, the couple spent weeks at the doctor's office in Baltimore learning how to help Karen.

For years, for four hours every day, Marie and Jimmy worked with Karen on basic skills like sitting up, eating, bathing, and dressing — all highly complicated tasks for her. When Karen got excited or spoke or used her hands, other parts of her body received impulses, so her feet would stiffen, her toes curl under, her fingers knot, and her legs shoot out rigidly. She often spilled her food on the floor. It took hours to teach her how to tie a shoe and forty-five minutes to wash her hair. With her limbs encased in heavy braces, clothes had to be bought a size larger. She needed special

furniture, special shoes, and her braces replaced as she grew. By 1947, the Killileas were spending $2,300 (some $33,000 today) a year on Karen's medical expenses. Jimmy took a second job on nights and weekends. Marie felt as if she had an iron band around her head.

Their hard work paid off. At age seven, Karen learned to walk with crutches and by eleven, she could speak clearly, read, write, and play with other children. Yet, Marie could not forget all the other CP parents she'd met in doctors' waiting rooms — hundreds of them, all looking for help they probably weren't going to find and growing ever more desperate. Fathers and mothers walked out on their family. Some CP children were hidden in attics; one was found in a box in the cellar.

One evening, after a phone call from a woman whose thirty-three-year-old brother with CP tried to commit suicide, Marie knew she had to do something. First she formed a Westchester County group, where she served as president, and in 1946 she and fifteen others created the New York State Cerebral Palsy Association, Inc., to promote awareness and provide support to families. In 1948, she became one of the five founding directors of the National Foundation for Cerebral Palsy, Inc., (later, the United Cerebral Palsy Association). She was the only woman in that group, which included Leonard H. Goldenson, then vice president of Paramount Pictures and future founder and president of ABC TV.

Traveling the state as an unpaid volunteer, Marie spoke frequently at meetings and fundraisers. In early 1949, she persuaded the New York state legislature to appropriate more than $1.1 million for aid to CP victims. By late 1950, she'd addressed some 9 million people.

Horror stories continued to pour in. In Miami, a father, worn down by his five-year-old daughter's cerebral palsy and Down syndrome, drowned her in a washtub in his jewelry store and then killed himself by taking a cyanide pellet. In Michigan, a former Detroit Symphony Orchestra musician picked up his twenty-nine-year-old CP daughter, Virginia, from the sanatorium where she'd lived for the past seven years, pulled off to the side of the road, locked all the car doors, and fired a bullet into the back of her head. Momentarily conscious, she looked at him and asked, "Why did you

shoot me?" He replied, "It's the only thing I could do," and then shot her four more times at close range in the chest. He was fifty-one and had lost his job with the orchestra. Acquitted of murder on grounds of insanity in late May 1950, he then spent two weeks in a state hospital before two psychiatrists declared him completely recovered and a judge granted him unconditional freedom. Newspaper articles deemed the killing an act of mercy. Translation: CP victims were better off dead.

Most people weren't cruel, Marie believed. They simply didn't understand that people with CP were fully human, with thoughts, feelings, and intelligence locked inside them. To spread that message, Marie wrote a book about her daughter, titled *Karen* and published by Prentice-Hall in 1952.

Reader's Digest considered Marie Lyons Killilea's Karen *on par with John Steinbeck's* East of Eden

A lengthy excerpt in *Ladies' Home Journal* in August 1952 drew the greatest reader response in the magazine's history. The book itself sold more than 100,000 copies in hardback and went through six printings in paperback as well as translation into ten other languages. *Reader's Digest* chose *Karen* as one of its four "Spring 1953 Selections," alongside John Steinbeck's *East of Eden* (and beating out Jacques Cousteau's *The Silent World*).

It was the first time anyone had opened the door and invited readers in for a close-up look at a family with a severely disabled child. Marie told her story not in gloomy or self-pitying tones but with humor, optimism, and warmth. And honesty. While she praised Karen's intelligence and spirit, she acknowledged that her daughter was often lonely and sadly aware of what she was missing. Some neighborhood children weren't allowed to play with her because of her condition. And in a deeply religious Catholic family, when Karen

wondered why God had made her this way, Marie had no satisfactory answer.

Among rank-and-file readers, the book tapped a huge, hidden current of emotion. *Karen* became one of the most widely read books of the decade and more than 27,000 letters arrived at Marie's home from as far away as Tokyo and Turkey. She answered some 14,000 personally, then decided to write a sequel. *With Love from Karen,* published in 1963, became another bestseller. Marie also wrote a children's version of Karen's story, *Wren* (1954).

Her books' success made Marie a pioneering champion of disability rights and a sought-after speaker on radio and TV shows. It also transformed the family's finances, allowing them to clear all their doctors' bills and buy a larger house. But Marie's proudest accomplishment was securing Karen's future.

Attending Catholic schools because the public system refused to accept her, Karen made it partway through the tenth grade with no special accommodations. As an adult, she worked for forty years as a receptionist at the Trinity Retreat House in Larchmont, New York, and lived independently, first in an apartment and then in her own condo. When she died in 2020 at age eighty, a lengthy *New York Times* obituary described her life as a miracle.

Joining Marie Killilea on the bestseller list in the 1950s and 1960s was Gibbs graduate Mary Slattery Stolz, who wrote an astonishing sixty-plus novels and was widely acclaimed as the best young adult author of her day. Mary believed that Katharine Gibbs, which she attended in 1938–39 in New York, made her career possible. The school's emphasis on writing skills dovetailed with her passion for literature and, she said, had she not learned to type at Gibbs, "probably I'd never have written anything that couldn't fit on a postcard."

Writing rescued—and remade—Mary. Her childhood had been scarred by frequent uprooting, her father's alcoholism, conflict with her mother, and her own self-sabotaging emotions. Her parents had barely known each other when they married in October 1918 in Newport, Rhode

Overcoming a troubled childhood, Mary Slattery Stolz became a best-selling, critically acclaimed young adult author

PHOTO BY BACHRACH, COURTESY OF THE BACHRACH ARCHIVE

Island. Mary Burgey, twenty-two, had arrived there five months earlier with her twin sister to train as overseas Red Cross nurses. Tall, handsome army sergeant Thomas F. Slattery, six years older, had just returned from the war in Europe. Weeks after the wedding, Mary and her sister shipped out for duty at veterans' hospitals in France. Upon Mary's return in April 1919, the newlyweds moved to Boston, where their daughter Mary was born the following year.

Perhaps damaged as so many were in World War I, Slattery couldn't set down roots or choose a career. After about a year, he dragged his young family off to Denver, Colorado, where, formerly an electrician, he now worked as a draftsman for the railroad and where their second child, Eileen, was born. Drinking heavily, he became frighteningly unpredictable. By 1925 the elder Mary had taken her two daughters to Manhattan, where she shared an apartment with the family of her twin, Margaret. Seeing young Mary's unhappiness, Margaret's husband consoled her with books. He bought them for her throughout her youth, everything from Keats to Emily Dickinson, from *Pride and Prejudice* to *Little Women*. She read "for sustenance, for knowledge, for inspiration, for help, for dreams."

As a famous children's author, Mary was inevitably asked about her own upbringing. Although she believed children could spot a lie at ten paces, she dissembled. Once she claimed that her father ran away to sea and never returned — another time, that he simply vanished. In fact, by 1930, Thomas Slattery was back in the picture, living with his wife and daughters in their own apartment in the Inwood neighborhood of Manhattan and working, or trying to find work amid the Depression, as an engineer.

His drinking shattered the family, which relied on his wife's income

as a district state supervisor of public health nurses. Young Mary became a lightning rod for the turmoil. Beginning at age twelve, she continually got into trouble. Quick tempered, she lied a lot and was "reckless and irresponsible." Although she had a scholarship to the elite Upper East Side private school Birch Wathen, she never studied and was expelled for her sophomore and junior years for being, she said, "disruptive, discourteous, boy-crazy, inattentive, and...an all-round undesirable." A smashed-up romance at age fifteen probably triggered her tailspin. She loved the boy; he said he loved her and then dropped her. After she did even worse at a public school, Birch Wathen took her back for her senior year. She later wrote of her childhood, "It wasn't so terrible, except to live through."

At some point during Mary's adolescence, her father either left or was thrown out. By 1940, he was living at the McAuley Water Street Mission in the Bowery, a soup kitchen and men's homeless shelter. The following year, he died at a veterans' hospital in his native Massachusetts at age fifty-one from what was politely termed "a long illness" rather than the ravages of alcoholism.

At odds with her mother, Mary was desperate to leave home. After high school, she attended Columbia University's Teacher's College "for an hour or so," and then signed up at Katharine Gibbs. In the school's elegant Park Avenue classrooms, she discovered a sophisticated new world. Despite her rebelliousness, she loved the refined glamor of "white kid gloves and hats and high heels" and in the confident, gracious female teachers, she saw a new way of behaving. One interviewer later described Mary as a young, chic Bette Davis, "warm and outgoing...witty and charming."

Gibbs also offered ample fuel for Mary's imagination. Years later she would write about, in the words of one scholar, "dynamic, intelligent, ambitious young women" — just the sort who'd tapped on the typewriter next to her in class and sipped tea with her at Gibbs social hours. During her year, other students included Park Avenue society girls. One was Eleanor Carnochan, who lived in the nineteen-story Art Deco apartment building at 740 Park, built by Jackie Kennedy Onassis's grandfather and home also to John D. Rockefeller Jr. There were also two sisters whose

family owned a fishing camp on Big Moose Lake in the Adirondacks and a Russian émigré, the daughter of a former aide-de-camp to Tsar Nicholas II. In between were young women from Staten Island, Scarsdale, Yonkers, the Bronx, Greenwich Village, and Greenwich, Connecticut. She constantly eavesdropped, Mary said, and her mind was "crammed with other people's words, thoughts, sentences, [and] rhymes."

It would take another decade, and a lot of mistakes, before she used that raw material. Only nineteen upon finishing at Gibbs, still flighty and impulsive, Mary proved hopeless as a secretary. "In one year I had perhaps six or seven jobs, quit some, got fired from others." Then, disregarding the Gibbs philosophy, she fell into the age-old trap of an escapist marriage.

Her mother found the groom, Stanley B. Stolz, a hard-working MIT graduate with a good job as a New York state sanitary engineer and the opposite of that wastrel Thomas F. Slattery. They married in January 1940, had their son, Bill, in May 1942, and after Stanley returned from wartime service cleaning up sanitation disasters in Manila (while Natalie Crouter was in Bilibid prison there), they bought a house in suburban New Rochelle, New York. Once, Mary had daydreamed about becoming a writer. Now, that fluffy cloud floated away. Like a good postwar wife, she tried to be a happy homemaker, whipping up tasty meals from her *Joy of Cooking* cookbook and volunteering as a den mother for her son's Boy Scout troop.

She was miserable. The marriage was "a disaster," she said later. Her mother-in-law, a former belle of the ball now confined to a wheelchair, resented that her son no longer paid as much attention to her, and she was "vicious" to Mary. Stanley, now City Sanitary Engineer for New Rochelle, spent most of his time inspecting restaurants for health code violations, eradicating the town's population of 30,000 rats, and giving speeches to the Kiwanis Club.

Mary fantasized about running away, knocking on just about any house door and saying, "I am a cook and a good one, and I come with my son and here I am." Instead, she let the stress grind her down so badly that, still in her early twenties, she developed severe rheumatoid arthritis. The pain nearly paralyzed her — she was afraid to cross the street for fear

she wouldn't make it to the other side before the light turned red — and filled her with rage. In 1949, her illness sent her to the hospital for three months.

It was the best thing that ever happened to her, she said. For her physical pain, her doctor prescribed the then-experimental wonder drug cortisone. For her depression, after learning that she'd enjoyed writing as a child, he advised her to get a stack of paper and crank out a novel. Back home, working on a secondhand typewriter, by August 1949 she'd completed her manuscript.

With a title adapted from a William Blake poem, *To Tell Your Love* unfolds the story of high school senior Anne Armacost who is devastated after her longtime crush, Doug, a college freshman, romances her (chastely) and then disappears. Mary drew not only on her own teenage heartbreak, but also on her conviction that at nineteen she'd married far too young. As it turns out, Doug isn't a cad. He's madly in love with Anne but realizes they're too immature for a serious relationship, so he takes up with a light-hearted girl instead.

On a whim, Mary mailed her manuscript to Harper & Brothers, where it landed on the desk of legendary children's book editor Ursula Nordstrom. In February 1950, Nordstrom invited Mary to her office for a meeting and told her she wanted to publish the book. Mary recalled, "I was stunned speechless. Walking up Park Avenue in a daze, a dream, to Grand Central, I got on the train for New Rochelle, blinked at the conductor when he asked for my ticket, and said, 'Oh! I *drove* in.'" She got off at the next station and took a taxi back to her car.

No wonder Nordstrom snapped up the book. Not only was it superbly crafted, true to the emotions and language of teenagers, but also it was bound to appeal to the postwar burgeoning market of high school librarians and aspirational parents. The counterpoint to Anne's romantic longings is the story of Nora, who marries her dreamboat boyfriend, Sam, at age seventeen, then accidentally gets pregnant, and finds herself living in a tiny, cheaply furnished fourth-floor walk-up apartment. Nora now detests her angry, resentful husband, who works in a garage. After reading that, there was no telling how many teenage girls would cancel their dates

and instead apply to college while their happy parents looked forward to buying the next Mary Stolz novel. To design the cover, Harper & Brothers hired acclaimed modern artist Ilonka Karasz, a frequent contributor to *The New Yorker*, and they paid extra to have the image reprinted as a frontispiece on an inside page, a rare outlay for any book, much less a young adult one by an unknown author.

Published on September 20, 1950, *To Tell Your Love* quickly became a bestseller. The *New York Times* reviewer called it "wise and sensitive," a model of "just how good a novel written for a teen ager can and should be," and named it one of the ten best children's books of 1950. The *Los Angeles Times* described it as "a generous store of wisdom, humor, and tenderness." Other reviewers were equally ecstatic.

Mary was off to the races. She published two more novels in 1951, and by the end of the decade had sixteen novels in print, as well as two children's books. She wrote about poor girls and rich girls, college students and student nurses, young women who asked questions like, "Who am I? What do I mean, what am I meant for?" Her characters quoted Samuel Johnson, Thomas Hardy, Gerard Manley Hopkins, and Colette. In 1955 *Saturday Review* declared, "Mary Stolz stands alone among the authors who now write fiction for the teen-age girl — alone and above."

Her meteoric rise hid a turbulent personal life. Stanley Stolz didn't want a famous author wife. He wanted the deferential helpmate he thought he'd married. In 1954, the couple separated, and two years later were divorced. Although they were close, her teenage son wanted a strong male role model in the home and asked to live with his aunt and uncle in St. Louis. Mary agreed. Lonely, she turned to the gin bottle. Still, she kept going.

Every morning, six days a week, she sat down at her typewriter and cranked out 1,400 words. Some days she threw out all 1,400 words. Often, her work remained unpublished. For every story accepted, at least one more was rejected. So, she'd start again with another idea and another blank sheet of paper, pouring out her emotions, experiences, loves, and losses. Writing was therapy. Underlying all her work, she said, was "tension, this loving and hating, this bafflement and struggle to understand."

Exemplifying the Gibbs can-do spirit, she tackled her underlying problems. After her marriage ended, money was tight. Because she couldn't afford to keep the New Rochelle house, she wrangled two advances out of Harper & Brothers and bought a small home in Pelham, New York. She joined Alcoholics Anonymous and quit drinking. And finally, she found lasting love. In 1965, she married the doctor who had saved her life back in 1949, Thomas C. Jaleski.

Over time, Mary sold more than a million books, won two Newbery Honors awards, had her work translated into more than twenty-five languages, and got fan letters from as far away as Hong Kong. The former angry teen was now a beloved author who'd found her place in the world. Mary was always grateful for the pivotal role Katharine Gibbs had played in her life. Thank goodness, she said, she'd gone there.

The Game Changers

∿⌒⌒

ALL THE WAY BACK to the early years, Gibbs women had taken part in government. Lenna Wilson served as a New Hampshire state representative in the 1920s; Natalie Stark volunteered with the Sacco and Vanzetti defense team and later, while living in the Philippines, lobbied for US aid to starving Chinese farmers. In the thirties, Mary Sutton Ramsdell racketed around half of Massachusetts in her small jalopy with a badge and a gun as one of the first two state police patrol women. During World War II, Lillian Lorraine flew domestic missions for the Army Air Forces and Katherine Towle rose to the top of the Women Marines, while Hazel Thrall Sullivan won an upset victory to become a Connecticut state representative.

In the postwar years, more Gibbs graduates reached for the official levers of power. Whatever their political bent, they understood structural authority and believed in their ability — and responsibility — to improve society. Some were otherwise unlikely candidates for power.

Without a college degree, family money, or connections, Joan M. Clark rose from an entry-level job as a government secretary in post-World War II Germany to become an ambassador and then head of the US Foreign Service. Born in Ridgefield Park, New Jersey (the childhood home also of bank president Doris Tarrant), the only child of a pharmaceutical company executive, Joan attended Katharine Gibbs in New York after finishing high school in 1939.

Described in her Gibbs yearbooks as having "a quip for any situation," "and an independent nature," she worked first at Pan Am (where Kathleen Clair would arrive in a few years), then joined the Foreign Service and shipped off to Berlin as a clerk in September 1945, four months after VE Day. Assigned to the deputy director of the Office of Political Affairs, she witnessed history as she took notes at meetings of the Allied Kommandatura, the city's postwar governing body representing the US, the UK, France, and the Soviet Union. Then, for more than three decades she steadily climbed the bureaucratic ladder with postings across Europe and in Washington, DC. Commissioned as a foreign service officer in 1957, she left the clerical ranks for mid-level administration, where she remained for twenty-plus years.

Joan M. Clark in Berlin, 1945, beginning her journey from a government clerk to head of the US Foreign Service

FOREIGN SERVICE JOURNAL, JUL.–AUG. 2007

Then history turned to face her. The sixties' "second-wave" feminist movement put intense pressure on the federal government to give more women a seat at the table. In 1961, President Kennedy established the Commission on the Status of Women to plan "the full partnership of men and women in our national life," and eight years later, President Nixon established the Equal Employment Opportunity Program. Nice gestures, but nothing to take to the bank. By the late 1970s, only 1.7 percent of women with federal government jobs had reached the GS-13 supervisory pay level for high-status professional positions. Something had to be done.

Conveniently, there was Joan, with her long years of service. In 1979 President Carter appointed her ambassador to Malta — an unusual move because ambassadorships were traditionally rewards for big campaign contributions. Admittedly, Malta wasn't Paris or Rome, but neither was

it a remote outpost or a taxpayer-funded vacation site. An island in the Mediterranean, Malta was an important naval base with diplomatic challenges. Prime Minister Dom Mintoff, miffed that neither President Carter nor Secretary of State Cyrus Vance considered him significant enough for a visit, had cozied up to Libyan dictator Muammar Gaddafi. During her two-year stint, Joan kept a lid on the potential powder keg, and Mintoff cooled toward Gaddafi.

In 1981, President Reagan promoted Joan to director general of the US Foreign Service. She wasn't the first female director general — that had been Caroline Laise, who held the job from 1975 to 1977 and was married to wealthy businessman/diplomat Ellsworth Bunker. The job was nowhere near as exciting as the title suggested. It involved no international intrigue, just the unpopular task of implementing the Foreign Service Act of 1980, which overhauled the personnel structure and sent some senior staff out to pasture.

After a difficult sixteen months, Joan won the crowning prize of her career. Named assistant secretary for consular affairs, she became one of the two highest-ranking women in the State Department. Overseeing anti-fraud measures like the $4 million transition from manually processed to machine-readable passports and visas, and monitoring immigration issues, she traveled constantly until her retirement in 1989. As she chaired meetings throughout Europe, the US, and Latin America, as well as in China, Hong Kong, Tokyo, Manila, Bangkok, New Delhi, and Cairo, rarely a month went by without at least one more stamp in her passport. In 2007, she received the American Foreign Service Association Lifetime Contributions to American Diplomacy Award.

Like Joan M. Clark, two others Gibbs graduates from the early 1940s spent decades building careers that positioned them for top-level federal jobs. Both started out as secretaries.

Ethel Bent Walsh, a 1942 Gibbs graduate, tried being a suburban Connecticut housewife. It didn't go well, possibly because her husband, a handsome former high school basketball star, seems to have spent more time playing in amateur golf tournaments than at his job as a fuel salesman. In

1950, twenty-six-year-old Ethel divorced him. Like Katharine Gibbs some forty-one years earlier, she found herself the sole supporter of two young children.

Braving the shame of an era that scowled at broken homes and working mothers, Ethel dusted off her secretarial skills and went to work as a clerk-typist at the Bridgeport Brass Company, which made metal sheets, wire, rods, and tubes. A few years later, a job at Aerosol Techniques in Bridgeport fulfilled the Katharine Gibbs promise. Hired as an assistant to the president, Ethel was promoted to vice president for operations. By the late 1960s, she was managing the Holmdel, New Jersey, plant of cosmetics giant Lanvin-Charles of the Ritz.

The need to earn a living, once a burden, now ushered her into the national spotlight. In 1969, newly inaugurated President Nixon launched a task force to bring more women into the federal government. Identified by the task force, Ethel was quickly named director of the Small Business Administration's Advisory Council. Two years later, Nixon appointed her to the Equal Employment Opportunity Commission, created in 1965 by President Johnson to enforce the job equality provision of the 1964 Civil Rights Act.

Joining the EEOC, Ethel walked into a hornets' nest. Despite a workforce of around 2,000 — including more than 300 staff lawyers, one of the largest legal departments in the federal government — and a budget of $68 million, the agency was considered "a study in scandal and mismanagement," a flat-out "disaster." Morale was so low and mutual distrust so high when she started, Ethel said, "We didn't even talk to each other unless we met in the hall." As unresolved complaints against employers piled up to create a backlog of nearly 130,000 cases by the mid-1970s, caseworkers and leaders fled with alarming frequency. Because the EEOC had to investigate each and every complaint filed, with almost no discretionary ability to reject the clearly baseless ones, most cases dragged on for years. It was no place to build a career by achieving results. One formerly idealistic staff member told the *Washington Post,* "[The EEOC] is an unbelievable morass.... I'm going to leave. I'm fed up. I can't stand it anymore."

In the outside world, the agency's reputation was equally bad. Minority and women's rights groups scorned the EEOC as slothful and ineffective, while the business community accused it of trying to handcuff profits and progress. Even the agency's general counsel was exasperated, commenting, "If I can get an investigator to do something, it's only because he wants to. Some of the district directors just tell us to go to hell."

The only woman among the five commissioners, Ethel stuck it out. In March 1975 she became the EEOC's acting chair — the first woman to lead the agency — following the forced resignation of John H. Powell, who'd been accused of mismanagement. Ironically, rather than give her a fair chance, President Ford replaced Ethel in the top slot after only two months, probably because she wasn't a lawyer or even a college graduate, and every permanent EEOC head so far had been a lawyer. Instead, Ford named Lowell W. Perry as chair in May 1975 and reappointed Ethel to another five-year term after women's rights activists praised her as "one of the outstanding women in today's public service." Perry lasted just eleven months. Bounced out under a cloud of scandal, he'd buried an auditors' report that logged sexual harassment complaints by female employees in EEOC branch offices. It was "vicious stuff," Perry allegedly railed, and not what he'd sent the auditors to find. Again, Ethel stepped in as acting chair, this time for a year until the May 1977 appointment of Yale Law School graduate Eleanor Holmes Norton.

Throughout her time at the EEOC, with the no-nonsense hustle of a single working mother, Ethel helped clear away most of the backlogged cases. She understood the urgency, commenting, "Some of these people have waited since Eve left the garden to get a fair shake and you can't leave them with nothing." Among her victories was a $700,000 settlement in 1977 (nearly $3.6 million today) with the Southern California Edison Company to end a discrimination case she'd filed five years earlier on behalf of 1,700 female and minority employees. Although passed over for leadership, before leaving the EEOC in 1981 she worked closely with Norton on a total redesign of the agency that brought it out of the dark ages. Ethel was, said Norton, "a friend whose commitment to equal opportunity Americans of every background could always count upon."

While Joan M. Clark and Ethel Bent Walsh could thank their Gibbs education for launching their government careers, at first Marjorie Bell Chambers had no such warm thoughts. In fact, she wrote, she hated every minute she spent at the school in the early 1940s. True, the training had led to her World War II job at the League of Nations Association taking down the Dumbarton Oaks Treaty over the phone from the State Department and then organizing conferences to promote the United Nations. But the idea that with her Mount Holyoke degree in history she should have to type and file—this was insufferable. Ironically, Marjorie would reach the heights of her career as a college president and advisor to four US presidents by promoting the same ideas about women's financial security that were the bedrock of a Gibbs education.

"I always wanted to be somebody. I wanted to go down in the history books," Marjorie said. "I discovered it was a very sexist world." Especially for a mid-century wife. After she married her college boyfriend, William Chambers, in August 1945, the couple went to Cornell University where he began master's studies in physics. His career came first. She'd hoped to enroll in law school, but married women weren't accepted because it was assumed that sooner or later they'd quit to start a family. Her Gibbs skills got her a job as a stenographer in the Rural Sociology department, where one of her two female professor bosses, seeing Marjorie's dynamo energy, advised her to quit and go to graduate school. The same professor came to her aid when Cornell's history department denied her financial aid, explaining that "women aren't historians." The professor arranged a research fellowship for Marjorie in the Speech and Drama department, exempting her from the $2,000 tuition fee and enabling her to earn her master's degree in British history in 1948.

For nearly two decades, acceding to the standards of the day, Marjorie focused on her husband's career and on raising their four children. After he earned his doctorate in physics at Ohio State University, they moved to Los Alamos, New Mexico, where he joined the Atomic Energy Commission. There, she did typical housewife volunteer work with the Girl Scouts, the PTA, the American Association of University Women (AAUW), and the League of Women Voters.

Not until the mid-1960s, when all her children were in school, did Marjorie revive her own goals. With a vengeance. In the space of about ten years, she earned her PhD at the University of New Mexico at Albuquerque, driving a total of 15,000 miles; won election to the Los Alamos County Council; served as national president of the 190,000-member AAUW; chaired President Ford's National Advisory Council on Women's Education Programs; and founded her own consulting firm. In July 1976, she became the first female president of Colorado Women's College in Denver.

While Marjorie was lucky to have a supportive husband and cooperative children, their attitudes were not shared by the college's board of trustees. Yes, they appreciated that she'd saved the sixty-seven-year-old school from extinction. When she arrived, it had been on the brink of financial ruin, a victim of sharply reduced individual donations, lost foundation grants, and lower enrollment as many formerly all-male colleges went co-ed. She slashed the budget by $200,000 and led a ten-day telephone fundraising campaign that miraculously brought in $500,000 and averted closing in early 1977. But no, she felt, they did not endorse her vision of a college "that dignifies, honors, respects, and yes celebrates...womanhood." According to Marjorie, the trustees wanted "a nice place to train sweet little girls to be wives of Denver's elite." Denied the customary raise after her first year, she quit in February 1978.

That experience seemed to galvanize her commitment to women's rights, propelling her onto the national stage. In November 1977 she'd attended the National Women's Conference in Houston, an event mandated by Congress to prepare recommendations to the federal government for gender equality and chaired by former congresswoman "Battling Bella" Abzug (D-NY). One of some 2,000 delegates, Marjorie helped formulate a twenty-six-point plan of action on topics ranging from abortion to education reform to the rights of elderly women.

After receiving the conference report, in mid-1978 President Carter formed the National Advisory Committee for Women, naming Marjorie as a member and Abzug and civil rights activist Carmen Delgado Votaw

as co-chairs. Proud of her combative reputation, Abzug flaunted what she thought was her power. That November, she allegedly refused to let the committee meet with Carter because he'd offered only twenty minutes. Then, before a January 12, 1979, committee meeting at the White House with Carter, an Abzug assistant illegally used a Department of Labor copying machine to run off a four-page press release criticizing the president's policies as harmful to women. At the meeting, she tore into Carter in front of some forty other people, pointing her finger at him during her harangue.

There was only so much that a president, even one who was a southern gentleman and a devout Baptist, had to take. Carter didn't fire Abzug directly. That same day, his chief of staff, Hamilton Jordan, did the honors as hatchet man. Abzug's unauthorized use of the copy machine provided an objective reason. She was furious, and so was Gloria Steinem who, while not on the committee, had come down from New York to plot strategy. Both immediately demanded that all forty committee members resign. Twenty-one, including co-chair Votaw, did.

Marjorie didn't. Appalled by Bella's rude behavior, she believed that the office of the president deserved respect and she understood that he had other priorities, like national security. Two days later, Carter named Marjorie as the committee's acting chair. Incensed by her perceived insubordination, for a long time Abzug and Steinem refused to speak to her.

But Marjorie and the president got along fine. She and the remaining committee members met with him monthly. Once, they joined him and Rosalynn for dinner in the solarium of their private quarters at the White House; the Carters, returning from a late afternoon run, wore their track suits. Faced with runaway inflation, as well as a Middle East crisis after the early 1979 overthrow of the Shah of Iran by the Ayatollah Khomeini's extremist regime, Carter said, "All right, Marjorie, the budget's got to be cut. You give me your priorities and I will hold the line for them."

Carter kept his word. The ERA topped Marjorie's agenda. Echoing Katharine Gibbs about the risks of relying on men, she told a reporter, "These little married women who feel so secure had better wake up. They don't understand that they can be left absolutely without resources under

present marital laws if they become widows or their husbands divorce them for another woman." Marjorie wanted ironclad legal protection. Aiming for approval by the thirty-eight states necessary to become law, Carter and Marjorie held a secret meeting at Blair House with officials from states that hadn't yet ratified the ERA. Discussing possible horse-trading deals, she recalled, "We were really playing hard ball politics."

They still didn't reach the target, but Marjorie believed Carter had done his best. When, after five months, he replaced her as committee chair with Lynda Johnson Robb, it was just politics. As a Republican, Marjorie had been a placeholder who gave Carter time to look around for a suitable member of his own party. Robb, a Democrat, was the daughter of former President Johnson and her husband was the lieutenant governor of Virginia. With no hard feelings, Marjorie remained as vice chair.

Ironically, Marjorie's direct influence diminished during the Reagan and Bush administrations because they didn't prioritize women's issues. While Carter had increased his appointments of women to a then-historic high of 22 percent, Reagan, she charged, rolled back the numbers to rival those of Herbert Hoover. Reagan also opposed the ERA. And when pro-choice Marjorie tried to get the platform committee for Bush's 1988 presidential campaign to moderate its position on abortion by removing language that gave greater rights to the fetus than to the mother, she was shot down. The men on Bush's campaign staff were "the most *male* men I've ever met," she seethed.

Yet, she remained a Republican. Marjorie believed financial security was the *sine qua non* of women's freedom, and the GOP touted economic prosperity as its strong suit. From their side of the equation, the two Republican presidents needed a window into the minds of women voters. In the Reagan administration, Marjorie chaired the secretary of the navy's Advisory Board on Education and Training, and for Bush, she wrote several papers on women's education.

Alongside her federal government appointments, Marjorie kept breaking barriers. In 1986, she ran in the Republican primary for state lieutenant governor, the first woman to do so, and lost narrowly. In 1985, she became

interim president of Colby-Sawyer College in New Hampshire, the first woman to lead that school. She served on commissions and committees for ten governors — nine in New Mexico, one in Colorado. She traveled the world, representing the US government and women's groups at conferences in the USSR, Eastern and Western Europe, Israel, Mexico, Japan, and even Libya, where she met Colonel Gaddafi at his home.

Over time, Marjorie grew to appreciate her Gibbs education, so much so that she agreed to give the commencement speech at a 1979 Gibbs graduation ceremony. No, she still wasn't happy that she'd had to learn typing and shorthand in order to be employable. But now, urging her audience to "make that Gibbs certificate the foundation of a life of achievement and financial success," she realized, "that's what the founder of this school had in mind."

At the grass roots level, too, Gibbs graduates made their mark — in the case of Audrey Campbell Moore, literally at the grass roots level. As a member of the Fairfax County, Virginia, board of supervisors for twenty years, she fought back against rapacious developers who were turning miles of lush parkland into a sea of housing developments, offices, and stores.

She hadn't intended to become a gadfly. She appeared to have left her rebellious days behind at the University of New Hampshire, where she'd considered herself a communist and planned to go to law school. But after her parents told her "women didn't do those things" and instead sent her to Gibbs in New York in the early 1950s, she joined the conventional crowd. In 1955 she married and the following year moved with her husband, a US Fish and Wildlife management analyst, to Annandale, Virginia. With its sprawling green spaces and endless opportunities to explore nature, the area seemed a perfect place to raise their three sons.

Only it didn't stay that way. Driving around on Sunday afternoons over the next decade, Audrey saw subdivisions "going up any old place," with no apparent planning and acres of concrete rapidly slathering over grass. As a bedroom community for Washington, DC, where well-paid federal bureaucrats were eager for suburban comforts, 400-square-mile Fairfax County was too attractive to be left alone by builders. Lobbying

for open space, Audrey joined civic groups and the Northern Virginia Conservation Council. She learned about zoning laws, land-use regulations, and state building codes. She badgered the public works department and the park authority to put the brakes on growth. She knocked on homeowners' doors and called reporters to rouse interest. All with little effect. Despite rising public protest, local officials heard only the siren songs of growth and greed. In 1966, fifteen Fairfax County supervisors, developers, bureaucrats, and lawyers were indicted by a federal grand jury on charges of offering or accepting bribes for zoning changes; eight were convicted.

Time to fight from within. Bolstered by the environmental movement — the first Earth Day took place on April 22, 1970 — in 1971, Audrey ran successfully for the nine-member Board of Supervisors as a Democrat. Her reputation as a kooky tree-hugger helped with voters, but it drew the undisguised loathing of the other board members. For most of the next sixteen years, she was a lone voice crying in the wilderness for the wilderness.

Nevertheless, she got things done. In 1982, she pushed through a zoning change that limited development on a 41,000-acre stretch of land to one house per five acres. And when the county wanted to charge ahead with construction of a condo building that had collapsed four months earlier, killing fourteen workers and injuring thirty-four others, she protested that the board hadn't seen any technical information and couldn't possibly make a good decision. The other supervisors sheepishly conceded her point and voted unanimously to defer action. "What's so appealing is that she is incorruptible," commented one of Audrey's constituents.

Appealing to some, appalling to others. Her opponents on the board ridiculed her as "Saint Audrey of Annandale" and "Mrs. No." She called them liars, cheats, and crooks.

By the mid-1980s, steam rising from their heads as they sat in their cars amid standstill traffic, a landslide of voters realized what Audrey had been talking about. Too many people packed together too tightly had not been a good idea. Since 1970, Fairfax County had gained some 200,000 new

residents as well as another 35 million square feet of office space and 130,000 more housing units. Widespread remorse turned the tide for Audrey.

In 1987, she swept to an easy victory as chair of the board of supervisors, clobbering the pro-growth Republican incumbent by 3-2. That made her the most powerful politician in Virginia's richest and most populous county. Her election shocked the local business community, which had spent hundreds of thousands of dollars on her rival's campaign. As the saying went, "Everybody hates Audrey Moore but the voters."

One developer sneered that she'd never be able to keep her campaign promise to alleviate gridlock: "She can't put an Uzi on the Beltway and shoot half the people to get rid of half the traffic." No, but she did get the board to approve $330 million in appropriation bonds (which didn't need voter approval) for road construction. And, combatting the source of the problem, she pushed the other supervisors to "downzone" thousands of acres, curtailing commercial development. When, following intense lobbying by developers, the Virginia General Assembly exempted about a quarter of that land, she commented, "Nobody ever promised me a fair world...and I don't know that it's over yet."

But in 1991, the tide turned again. Restricted development meant a stalled commercial tax base while county expenses rose, increasing the burden on individuals. Audrey overwhelmingly lost her reelection bid to a Republican challenger who portrayed her as an insensitive spendthrift. "Tonight, perhaps my independence has caught up with me," she said in her concession speech. "So be it. I wouldn't trade that independence for one more day in office."

A decade later, tempers subsided and Fairfax County recognized how much Audrey had contributed to its quality of life. In 2002, some sixteen years before her death, the community renamed the Wakefield Park Recreation Center the Audrey Moore Recreation Center. It was a fitting tribute. Audrey's involvement in the 1966 fight to save the 230-acre Wakefield Park from developers had marked her first step into environmental activism.

Behind the scenes, too, in the smoke-filled dens of political power

brokers, Gibbs women started showing up. In 1950, thirty-two-year-old Martha Cheney became a Republican ward heeler in the sixth voting district of Connecticut, responsible for preparing the party's slate of local candidates and firing up voters to go to the polls. No sooner had Martha been approved for the position by the old boys' network that ran a three-district coalition than she pulled her district out of the group and ran it by herself. "I guess they thought I was young and dumb enough to manage," said Martha, a 1937 Gibbs graduate. Walking every street, making endless phone calls, she recruited better candidates and turned the sixth district from independent to Republican. Sure, politics had its shady characters, but "I think the only way you can lick them is to get in there with them and fight for what you believe."

Across the country, former OSS headquarters worker Emily Pike reinvented herself as a "revered and feared" political power broker in northern California who ran election campaigns for Richard Nixon, Ronald Reagan, and Dianne Feinstein. She would have stayed at the Washington spy nest, except that as it morphed into the CIA, the once freewheeling organization began to feel like a deadly dull bureaucracy. It took several years and a move to San Francisco for Emily to find her niche. Along the way, as respite from unfulfilling jobs, she began volunteering in politics.

Like many other Gibbs women in the first half of the twentieth century, Emily preferred the Republican Party for what were then mostly centrist values. Through a friend in the Young Republicans Club, which then had 3,000-plus members in San Francisco, in 1955 Emily landed a job as an executive secretary at the Bechtel Corporation, the huge engineering and construction firm that had built the Hoover Dam and the Middle East's Trans-Arabian Pipeline (which Mary Louise Beneway and her CIA boss had been monitoring from Beirut). Bechtel, heavily reliant on government contracts, valued Emily's history of leadership in the Young Republicans.

Assigned to work for a mining consultant who spent most of his time on the road, she had only light office duties and lots of free time for political work. While San Francisco had a relatively small population, only 740,316 in 1960, and was becoming increasingly Democratic, it was an important

media center for northern California. And, given fabulous fortunes like those of the Hearst and Spreckels families, it was excellent fundraising territory.

At Bechtel till 1973, Emily worked on Richard Nixon's campaigns since the early days. In dismay, she watched as he changed from the genial, out-going, moderate politician of his successful 1950 bid for the US Senate to an insular, fear-driven presidential candidate surrounded by right-wing yes-men. As the San Francisco women's chair for Nixon's bid for the White House in 1968, Emily was besieged by anxious phone calls from Nixon's advisors demanding more and more people at campaign events as well as endless balloons to create a festive atmosphere. "Gosh, think of those bal-loons! It got so he liked those things: 'There weren't enough balloons.' I've heard that many times. 'There weren't enough balloons.'"

By the 1972 re-election campaign, she'd been pushed to the sidelines by "very obnoxious young men who gave orders with great authority and were thoroughly offensive, alienating the party structure completely...telling them to *do* it that way or else." Weeks before the election, seated at the head table at an event at San Francisco's Commonwealth Club, Emily unknow-ingly heard the beginning of the end. Next to her was David Packard, cofounder of Hewlett-Packard, who told her that campaign finance chair-man Maurice Stans had called him that day to ask for another million dollars. "What on earth for?" she asked. Packard didn't know, "but I guess if they need it, they need it." It went for Watergate payoffs. Even after the whole sordid episode came to light, remembering the early hopeful days, Emily mainly felt sorry for Nixon "because nothing could have been more devastating to him . . . he [had] no future."

In-between her Nixon work, Emily held leadership roles in Nelson Rockefeller's failed 1964 presidential primary campaign, Ronald Reagan's successful 1966 and 1970 races for California governor, and innumerable campaigns for lesser state and local officials. In June 1969, elected as chair of the San Francisco County Republican Central Committee, she became the first woman in the US to head a major political party in a major city.

Nevertheless, in a scenario all too typical for the era, Bechtel looked

right past Emily when it started a political section of its public relations department in the early 1970s. One day she answered her phone to hear, "I'm Bob Roarke. I'm from the Vernon office, and I'm going to be heading up the governmental affairs division here. I was told to come and see you and you'd tell me what to do."

"The more I thought about it, the angrier I got," she recalled. She quit, and with veteran campaign consultants Ron Smith and Joe Shumate formed Shumate-Smith and Associates, later Shumate/Pike and Associates. Among the firm's slate of clients were Democrat Dianne Feinstein, US Senator S. I. Hayakawa, and Governor George Deukmejian. By the time Emily retired as Republican Party chair in 1999, she was a legend in California politics — a pathfinder who proved that women could tough it out with the backroom boys and deliver top level campaign results.

Setting Sun

∽◯🙰

EVEN BEFORE PRESIDENT JOHN F. Kennedy's assassination in November 1963, the sun was setting on America's optimism and ebullience. In New York, harbinger of the future for the rest of the nation, a shocking act of violence exposed the roiling anger and hardened prejudice beneath the city's gleaming surfaces.

On the morning of Wednesday, August 28, 1963, two young women were murdered in a frenzied attack in their Upper East Side apartment. They'd been stabbed repeatedly with three kitchen knives, so fiercely that two of the blades broke off, and slashed with a broken soft-drink bottle. Bound to each other at the wrists and ankles with a ripped-up bedsheet, their bodies were wedged between a blood-soaked bed and the wall. The victims were Janice Wylie, twenty-one, an aspiring actress who'd worked on the clippings desk at *Newsweek* magazine, and Emily Hoffert, twenty-three, who was about to start teaching at a Long Island elementary school.

Newspaper headlines screamed about the "Career Girls Murders," as if the fact that the victims were young, female, ambitious, and single had made them easy prey. In fact, there was no evidence that Wylie and Hoffert were targeted. With the apartment ransacked, the slaughter appeared to be a crime of opportunity gone wrong — the killer having sneaked in to commit a burglary, expecting no one at home and panicking when he was discovered. Hammering away at their catchy label for the crime, the press implied not

exactly that the young women deserved it, but that by daring to live by them-selves in the big city, they had made themselves extraordinarily vulnerable. Was independence worth dying for?

Eight months later, under tremendous pressure to solve the crime, police arrested nineteen-year-old George Whitmore Jr., a poor Black unemployed eighth-grade dropout with a limited IQ and no criminal record. Although Whitmore soon recanted his alleged confession, saying he'd signed it after two police officers punched him sixty to seventy times, hardly anyone believed him. As he awaited trial in jail, the city breathed more easily. Then in January 1965, Wylie and Hoffert's real killer was caught — twenty-two-year-old Richard Robles, a longtime criminal who specialized in Upper East Side burglaries to support his heroin habit. A fellow addict turned him in. As later came to light, Whitmore had had an airtight alibi. On the day of the murders, he'd been at a Wildwood, New Jersey, hotel with a group of people who were watching Martin Luther King Jr.'s "I Have a Dream" speech on TV.

In a few years, the dark undercurrents of the "Career Girls Murders" — bloody violence, resentment over women's changing roles, and racial injustice — would explode and rip apart American society. Traditional foundations, many of them faulty to begin with, would cave in. The phi-losophy of gradual change that the Katharine Gibbs schools had touted, the strategy of "show, don't tell," would be tossed on the ideological trash heap. In the arena of women's rights, sign-carrying activists would literally demand change NOW, as in the "National Organization for Women."

But that was later. In the early 1960s, the Gibbs schools were still thriv-ing. There were still few other options for adventure-seeking, upwardly mobile young women. Admission rates for women at professional schools remained dismal, and newspaper classified ad sections still separated oppor-tunities into higher-status "Help Wanted Male" and lower-paid "Help Wanted Female." In 1961, the Gibbs school enrolled some 1,700 young women at its locations in New York, Boston, Providence, and Montclair, New Jersey. (The Chicago school, opened in 1943 to accommodate wartime demand, had closed in 1954.) The relatively hefty tuition cost of $935 per year

Gibbs spring formal dance, 1960
KATHARINE GIBBS SCHOOL RECORDS, BROWN UNIVERSITY

($9,800 today) paid off, with seven job openings on the books per graduate. Gibbs graduates could start at $90 a week and move up to $100–200 per week, compared to $55 weekly for the average secretary.

It was a last burst of glory for Gibbs students. They still wore hats and white gloves, still worked to grueling standards, still had formal dances at posh hotels like the Waldorf Astoria. New York students could still room at the Barbizon with their own two floors, a private lounge with a grand piano, formal teas on the mezzanine, and a separate dining room where the waitresses knew their names and remembered their meal preferences.

It was a magical experience, recalled Millie Pirko (later Triff), who attended Gibbs in New York in 1961–1962, finishing the year before the "Career Girls Murders" shook the city. After graduating from high school in Ithaca, New York, Millie took the bus down to Manhattan, accompanied by her mother and a suitcase full of new clothes she'd bought according to the school's advance specifications. Her mother left after settling Millie into a small room at the Barbizon, which was spartanly furnished

Millie Pirko (later Triff) in her Easter hat and Gibbs
white gloves at Rockefeller Center, early 1960s

with a single bed, matching bedspread and curtains, a typewriter on the desk, and a sink with a medicine cabinet above it.

The eighteen-year-old wasn't lonely for long. Over the next few days, her floor buzzed with activity as more young women arrived to unpack their belongings. She soon became best friends with a redhead named Connie Kotila from Ohio, bonding over the fact that they shared the same birthday and the same outgoing spirit. With Connie and other friends, Millie explored Chinatown, strolled through Central Park, saw *Breakfast at Tiffany's* and the Christmas show with the Rockettes at Radio City Music Hall, and ventured around the corner from the Barbizon to a favorite haunt, Malachy's bar on Third Avenue. Owned by actor Malachy McCourt, brother of future *Angela's Ashes* author Frank McCourt, Malachy's — unlike a lot of its competition — welcomed unescorted women. Millie recalled, "We spent many happy evenings in that little bar."

And, oh yes, there was school, too. On their way to Gibbs at 230 Park Avenue, passing the construction site of the Pan Am Building, they heard hardhat workers shout, "Here come the Gibblets!" Millie explained, "We were the only girls our age carrying briefcases." At

*Even shorthand class was fun with friends at Gibbs in New York
in the early 1960s; at right, Connie Kotila (later Stephan)*
PHOTO BY AND COURTESY OF MILLIE PIRKO TRIFF

first, at the end of the day, riding the bus back from school, their high heels hurt so much that they took them off as soon as they hit the sidewalk and limped in their stocking feet back to the hotel. With practice, they soon made it the whole way in their shoes.

Reaching the Barbizon's canopied entrance, where the hotel had routinely welcomed such famous and about-to-be famous guests as Greta Garbo, Lauren Bacall, Grace Kelly, and Tippi Hedren, the Gibbs women were always greeted warmly by the doorman. Decades later, Millie commented, "No one has treated me like a princess since then. Color me blessed."

LOUDELL INSLEY WAS DIRECTLY affected by fallout from the "Career Girl Murders." She had very reluctantly agreed to go to Katharine Gibbs in New York because her parents were willing to pay for an apartment there. And, after all, she had to do something with her life. At her 1963 graduation ceremony at the University of Maryland where she'd earned a BS in elementary

Just as if they were celebrities, Gibbs women staying at the Barbizon had white linen table service for meals; here, Mitzi the waitress brings their breakfast favorites. Barbara Meech (later Kelley), seated center
COURTESY OF MILLIE PIRKO TRIFF

education, with her diploma in hand she suddenly turned to her father and said, "I don't ever want to see the inside of a classroom again."

Well, what in the world was she going to do instead? asked her father, a Salisbury, Maryland, physician. She didn't know. Maybe she'd go to Atlanta and get a job as a receptionist. "No man in his right mind would hire you at a living wage," replied her father, who then asked around and was told by a hunting buddy to send Loudell to Katharine Gibbs. "No, no, no!" she protested. Secretaries were the girls in high school who didn't go to college and held dull little jobs until they married. For several months, she "kicked and screamed," mollified only by that promise of the Manhattan apartment.

Then, just as it was time for Loudell's parents to put down a deposit on the apartment, they read in horror about the "Career Girls Murders." Loudell recalled, "They turned to me and said, 'You're staying at the Barbizon Hotel.'" She called it "the Barbizon Hotel for young nuns" because of the strict 1 a.m. weekend curfew and her tiny room that looked like a monk's cell. Still, she immediately loved Katharine Gibbs.

After finishing the course in the spring of 1964, Loudell moved to Washington, DC, to work at the Pharmaceutical Manufacturers Association. But when the raise she'd been promised kept getting postponed, she thought, "Well, this is ridiculous. I don't even like this job, which is probably why I wasn't getting a raise." Her next job, in the Capitol Hill office of Massachusetts senator Ted Kennedy, came as a big surprise.

"It was the worst interview I ever had," she admitted. After answering Kennedy's first few questions with a mere, "Yes," she decided she needed to elaborate. So, when he asked what she did in her current job, she looked off to gather her thoughts. "And I see this painting, a framed painting over on the wall. It looked like finger painting of hands, but it's framed and it's got glass on it and it's big. I thought, *You don't suppose that's a Picasso?* So, while I'm thinking about it, I tune in and hear myself answer his question. I'm saying, 'I deliver the mail.' I said, 'No, no, that's

Loudell Insley, as a Maryland high school student
COURTESY OF LOUDELL INSLEY

wrong. I don't deliver the mail. The mail is delivered to me and then I distribute it to my boss and the other people in the office.' 'Oh, okay.'. . . Finally, it was over, thank the Lord." (The artwork wasn't a Picasso, but a finger painting by Kennedy's daughter.)

A month later, she got the offer. "I'm confident that they forgot who I was in thirty days. They hired the Katie Gibbs girl." The job put her up close at two events that changed history.

Starting in 1965, Loudell was assigned as the immigration caseworker for Kennedy's constituents. Then, in April 1968, on loan from the senator's staff, she joined Robert F. Kennedy on the campaign trail as he chased the Democratic presidential nomination. Euphoric excitement was shadowed by tragedy. RFK was a replacement, out front because his older brother had been killed, yet he, too, had the Kennedy charisma, that magnetic mixture of privilege and populism.

As a student at Gibbs back in November 1963, Loudell had watched TV news in the Barbizon lounge continually throughout the weekend following the JFK assassination. Now, she and countless other Americans longed for a renewal of hope from the next Kennedy in line. She didn't mind that her campaign duties were mundane — walking Kennedy's loyal traveling

*Loudell Insley, on the presidential primary campaign trail
with Robert F. Kennedy, 1968*
COURTESY OF LOUDELL INSLEY

companion, Freckles, a blue roan English cocker spaniel; typing speeches and press releases; and, along with two other secretaries, unpacking RFK's suitcase, laying out his clothes, and repacking everything the following morning. Just being there mattered.

In Columbus, Ohio, Loudell witnessed both the frenzied passion and the danger faced by "the candidate," as they called him. Typically, RFK rode in a convertible from the airport to downtown, standing either on the backseat or on the trunk, with bodyguards holding on to him so he wouldn't be pulled off. On this trip, a crush of people, eager for a touch or a souvenir, surrounded the car so tightly that his cufflinks were quickly stripped from his shirtsleeves. The next morning, Loudell saw the car, a red convertible borrowed from a local car dealer. It looked totaled. Every panel had been dented by bodies pressed against it.

After stops in Portland, Oregon, and San Francisco, the campaign arrived in Los Angeles for the June 4 California primary. That night, along

with other staffers and the candidate, Loudell watched TV news updates in RFK's suite at the Ambassador Hotel. Near midnight, CBS declared him the winner. An elated RFK dashed down to the ballroom to thank his supporters, closing with, "And now it's on to Chicago." In his suite, staff members lowered the TV's volume and chatted. Then the phone rang. Loudell answered. *Something just happened*, campaign manager Pierre Salinger told her, *find out what*. On TV, the volume restored, a reporter said Robert Kennedy had been shot.

Lacking the proper identification to enter the Ambassador Hotel's ballroom directly, taking the secret back route, Loudell found pandemonium in the hotel kitchen. On his way from the ballroom to the press room, Kennedy had been shot there multiple times at point-blank range by Jordanian citizen Sirhan Sirhan. By the time Loudell arrived, forty-two-year-old Kennedy was en route to a hospital, and five other people lay on gurneys with gunshot wounds.

The campaign was over. Everyone knew that even if he lived, RFK would be in no condition to continue. Loudell began packing up. Mid-morning on June 5, less than twelve hours after the shooting, she boarded a chartered plane headed for Washington, DC. In the windowless aircraft, which had an open area in the front passenger compartment, she and the others sat cross-legged on the floor and drank. They tried to convince themselves that Kennedy could survive. He died in the early morning of June 6.

Loudell returned to work for Ted Kennedy. Over the next year, the intense media attention on him as the last chance for another Kennedy presidency, as well as constant death threats against him, wore her down. Even she received hate mail after a story ran in a small Maryland paper quoting her about the RFK shooting. She decided to quit.

Then on the night of July 18–19, 1969, after a cookout party at a rented cottage on Chappaquiddick Island near Martha's Vineyard, thirty-seven-year-old Ted Kennedy accidentally drove his Oldsmobile Delmont 88 sedan off a narrow wooden bridge into Poucha Pond. The car landed underwater upside down. Kennedy escaped, swam to shore, and walked back fifteen minutes to the party. He left behind, trapped inside the car and dying,

twenty-eight-year-old Mary Jo Kopechne, one of the six so-called "boiler room girls" who'd worked as political advisors in Washington for Robert Kennedy's campaign. A huge scandal erupted. Why hadn't Kennedy immediately gone to one of the nearby houses and called police? Was he drunk? Was he having an affair with Mary Jo? Although his Senate career would continue for decades, Chappaquiddick ended Ted Kennedy's prospects for higher office.

Loudell, who didn't attend the party, had known Mary Jo and considered her a friend. After Chappaquiddick, more than ever she wanted to quit. Discussing the Kennedys, she'd recently told her mother, "You can always count on them to do the right thing, at least socially." Now, that clearly wasn't true. But she couldn't quit then. The press, she feared, would write that Ted Kennedy's office was falling apart with staff running for the door.

When she finally turned in her key and ID card in mid-1970, she realized how much she'd changed. After Chappaquiddick, she'd lost the stars in her eyes, having seen that the high and mighty "could be just as hurt, embarrassed…foolish and disappointing, as the average person." It was time to live her own life. After several other jobs — at the Peace Corps, the 1972 Democratic National Convention, and the Perdue chicken company working with founder Frank Perdue — she returned home to care for her ailing, widowed father and launched a successful real estate business that she loved.

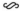

A WATERSHED YEAR IN American history, 1963 also saw the publication of Betty Friedan's book *The Feminine Mystique*, which threw a grenade into gender relationships. Based on interviews with eighty women ranging from high schoolers to middle-aged housewives, Friedan found a "schizophrenic split" between the reality of women's lives — albeit those of white, middle-class women — and "the image to which we were trying to conform… the feminine mystique." An instant success, *The Feminine Mystique* sold

several million copies and has been generally credited with launching "second-wave" feminism in the 1960s.

As Friedan became a celebrity, media companies increasingly wondered what women were really thinking rather than what they were being told to think. One way to find out was to place women in gatekeeper positions as editors and publishers, deciding which voices got heard and on what topics.

Marie Anderson was ahead of the game by the time *The Feminine Mystique* appeared. A Duke University graduate who went on to attend Gibbs in New York in 1938–39, Marie volunteered at an army training camp during World War II, then worked briefly as an ad agency receptionist in New York before accepting a job on the women's pages of the *Miami News*. There, and at the *Miami Herald* where she moved in 1949, Marie was mentored by female editors who'd started to move beyond the standard topics of "family, fashion, food, and furnishing." When her boss left for the *Detroit Free Press* in 1959, Marie took over as the *Herald*'s women's editor and accelerated the transition to serious news.

Marie's "For and About Women" section still ran fashion photos, kitchen equipment updates, and wedding announcements, but it also tackled tougher subjects. One 1960 article questioned, "Is There Life After Death?" Another that year explored female alcoholism and quoted one woman, "I drank until I passed out, even though I didn't want to drink, and I prayed to die." Days after the August 1963 "Career Girls Murders," a report about the tragedy offered twelve safety tips for young women living on their own in cities. Over the next few years, Marie ran stories about the loneliness of single women "in a world of couples," sexual activity among college co-eds, birth control, and the "black days" of PMS, then called "premenstrual tension."

Marie's pioneering approach won her four first-place awards in the JC Penney-University of Missouri Journalism competition for the best women's section in the country. Newspapers around the country rushed to copy Marie's formula and renamed their "women's pages" as "lifestyle" or "living" sections.

Over in the magazine world, Judith Glassman Daniels founded *Savvy*,

the first glossy publication for executive and professional women. A 1960 Smith College graduate with an English degree, she attended Gibbs in order to get hired at Doubleday & Co. Not that she stayed long at Doubleday — or anywhere. Job hopping every few years, Judith became the senior editor of *New York* magazine in 1968, then managing editor, then managing editor of *The Village Voice* in 1974.

To her these were drone-like jobs, "okay, but nothing, really." The content didn't speak to her. Then again, no magazine spoke to her. So, she created *Savvy*, explaining, "Other magazines, like *Cosmo*, were always saying it's OK to be excited about men. What I wanted to do was to release women and say it's OK to be excited about your work."

Publishing executives, men mostly, told her not to do it. Too risky. She went ahead anyway. A trial balloon issue included as an insert in the April 1977 issues of *New York* and *New West* magazines drew a phenomenal reader response, enabling her to raise $1.5 million for the first stand-alone issue in January 1980. Within a year, *Savvy*'s circulation zoomed to 200,000 and by the late 1980s reached 500,000. Although the magazine folded in 1991 when a business recession slashed ad revenue, *Savvy* has been credited with pushing traditional women's magazines to pay attention to career women.

*Clare Ferraro, second from right, with best-selling authors Anne Rice (*The Vampire Chronicles*), Michael Crichton (*The Andromeda Strain, Jurassic Park, etc.), and Douglas Adams (*The Hitchhiker's Guide to the Galaxy*)*
COURTESY OF CLARE FERRARO

Clare Braumann (later Ferraro, as she would be known throughout her career), who attended the Gibbs school in Montclair from 1965–66, also ran a major media company. Starting as a secretary at McGraw Hill, she became president of publishing industry giant Viking Books. Yet, when she started at Gibbs straight out of high school in Wayne, New Jersey, Clare simply wanted to get married. "I was madly in love at the time," she recalled. Her husband-to-be was in college already

and planning to attend graduate school. Although she'd done well in high school, the couple agreed that if she went to college, their romance would likely fall apart. At seventeen, she couldn't bear that thought and decided she could get more education later. What she needed now were job skills so she could support them both after the wedding.

For that kind of thinking, Betty Friedan might have conked Clare over the head with a copy of *The Feminine Mystique*. But Betty Friedan wasn't a teenager in love.

At the time, Gibbs seemed a bit old-fashioned to Clare. The school's reception area looked like "your grandmother's living room, if your grandmother had money and good taste." And those ridiculously picky typing demands, such as the one requiring the second page of a letter to start exactly six spaces down — as if anyone really cared! Carpooling to and from school every day, Clare and two Gibbs classmates wondered, was Katharine Gibbs stuck in 1952?

As it turned out, if Katharine Gibbs was stuck in 1952, so was most of corporate America.

Clare didn't stay long at McGraw Hill. She'd accepted the job because the offices were across the street from the Port Authority bus terminal in Manhattan, providing an easy commute from New Jersey. When the company moved blocks away, so did she, joining the secretarial staff of CBS News president Richard S. Salant. There, she realized that Katharine Gibbs had probably gone too easy on her. Once, she was reprimanded for having placed a staple diagonally on a document. No. There was a rule about that. The staple had to be horizontal and exactly over the "C" on the CBS letterhead. Otherwise, the boss would send it back.

Despite such corporate quirkiness, Clare considered a career in TV. But seeing no women in the highest echelon as network executive producers, she decided instead to return to book publishing, which appeared more receptive to women in power.

After a detour to the American Cyanamid chemical company in New Jersey, which paid for her to earn her BA in American Studies in 1976 at Ramapo State College, Clare took a job as secretary to the president of Pocket Books, the paperback arm of Simon & Schuster. Again, Gibbs

training had steered her right. Working for the top dog, reading all the mail and fielding the phone calls, she said, "you get a bird's eye view of what's really going on." And to get promoted, "there's no better person to have backing you than the president of the company."

She told her boss that she didn't intend to stay. He could either lose her to a competitor or lose her to someone else in the company. Clare had no fear saying that. With her Katharine Gibbs honed skills, she felt confident she could always, easily, get another good job.

Grudgingly, her boss approved her promotion to associate publicity director of Pocket Books. There, she discovered she had a "selling personality," a knack for figuring out who wanted to read what and how to fire up reviewers, TV producers, and booksellers. Abandoning one year of graduate study in literature at New York University, she soon she became full-fledged publicity director and in 1979 moved to the same position at Ballantine Books, the paperback division of Random House. After stints as editor-in-chief and then publisher of Ballantine, in 1999 she was named president of Viking Books, a division of Penguin Publishing, the largest English language publisher in the world. She held that position until retiring in 2015.

Clare Ferraro went all-out to promote Jim Davis and his six books about his cartoon character, Garfield—all became best-sellers

COURTESY OF CLARE FERRARO

Along the way, Clare worked with authors Michael Crichton, Norman Mailer, John Irving, Marilyn French, Anne Rice, Dave Barry, Douglas Adams, even Barbara Streisand, whose book *My Passion for Design* she published at Viking in 2010. A favorite achievement was the phenomenal success of six Garfield books, which she publicized for Ballantine in the early 1980s. At the time, plump, lazy, grumpy Garfield the cat was known only as a newspaper comic strip character popular here and there around the country. Garfield's creator, Jim Davis, hoped merely to get enough money from the book deal to buy a new car. Clare went all-out on promotion, sending sales sky-high. One after another, the Garfield books landed at the top of the *New York Times* best-seller list. Thanks largely to Garfield, Ballantine's income grew by 35 percent from 1980 to 1981. Far more than a new set of wheels, Jim Davis got a merchandising empire that churned out Garfield stuffed animals, coffee mugs, T-shirts, jigsaw puzzles, and countless other products.

Clare credited her professional success largely to the unrelenting rigor of her Katharine Gibbs training. "That ability to be totally focused for long periods of time — thirty and forty years after Katharine Gibbs, there were times I was working with the same intensity I worked with then. That's what they were training us for, no let-up, no break." In her entire career, she said, she never had a boss as demanding as her Gibbs teachers. "In hindsight, I have nothing but fond feelings about the place."

Some victories played out not on a public stage but in private life. One story probably stands for many. When Barbara Meech (later Kelley) first arrived at Gibbs in New York in 1961 from her hometown of Meadville, Pennsylvania, she was afraid, "very shy," and unsure of herself because she'd dropped out of college. Her home life had been unhappy. After her parents separated, her mother "just sat in a corner and drank." Cecelia Schwartz Meech had studied for a teaching career at Akron University in the 1920s, but in 1931, at twenty-four, she married patent attorney Ralph Meech and gave up her professional ambitions.

The failure of the marriage and her inability to find a new direction darkened Cecelia's relationship with her daughter. "She was not an

*Students at Katharine Gibbs, early 1960s, formal dance at the Waldorf Astoria,
from left to right: Barbara Meech (later Kelley), Connie Kotila (later Stephan),
Linda Heisel, and Millie Pirko (later Triff)*

COURTESY OF MILLIE PIRKO TRIFF

encouraging woman. She would downgrade me. She wasn't somebody
I looked up to.... It was very sad," recalled Barbara. "I [didn't] want to
ever end up like that." Her father, who traveled frequently to New York
for his job with the Talon zipper company, knew of Katharine Gibbs and
encouraged Barbara to give it a try. A year in Manhattan — *This is every
girl's dream!*, she thought.

It turned out to be just that. Arriving at the Barbizon, she found her-
self welcomed by other out-of-town Gibbs students, including Millie Pirko
from Ithaca, New York. "We were all new there, and I think that's why we
became such good friends. Because we were all there alone. Sink or swim,"
said Barbara. "That was the happiest year of my life up to then."

In the Gibbs classrooms, Barbara discovered what she'd missed at
home — positive role models among the female faculty members. They
were all kind, supportive, and encouraging. "It gave me a perspective on
how I should act as a woman. How I should act out in public, how I should

act in an office. I went in...like I knew what I was doing from the get-go," she said. "I carried that with me wherever I went."

At the end of the training, she wanted to stay in New York, but her mother had just been diagnosed with cancer and her father asked her to return to Meadville to help with her younger brother. Cecelia Meech died a year later at age fifty-six. In 1964, Barbara married a local man. It didn't work out and neither did several subsequent romances.

But with the lessons learned at Katharine Gibbs, she built a life very different from her mother's. She found work she enjoyed and at which she excelled. Early jobs took her to radio and TV stations in Pennsylvania and Texas. Later, she joined the phone company in Las Vegas, where she won employee of the year awards in different departments and one year won the company-wide president's award. Her three sons all turned out well and eventually she married happily.

Although her father died suddenly in 1969 when Barbara was twenty-six, his opinion always mattered to her. They'd been very close. What would he have thought of the way her life turned out? she wondered. Her younger brother told her: "Dad would have been so proud of what you've accomplished."

TWENTY

1968, The End

∿᧤᧥

THE SOCIAL AND CULTURAL upheavals of the mid-1960s spelled trouble for the Katharine Gibbs Schools.

Since the JFK assassination and the "Career Girls Murders" of 1963, violence and rebellion built up across America like steam in a pressure cooker. On July 13, 1966, twenty-four-year-old drifter and ex-con Richard Speck, "Born to Kill" tattooed on his arm, stabbed and strangled eight student nurses after breaking into their Chicago townhouse late at night. Two and a half weeks later, on August 1, twenty-five-year-old ex-Marine Charles Whitman took several rifles and a sawed-off shotgun to the Main Building observation tower at the University of Texas at Austin. For nearly two hours he sprayed bullets across the campus, slaughtering fifteen people.

Race riots had broken out in cities every summer since 1964. In the "long hot summer" of 1967 — which was also, paradoxically, the "summer of love" that drew some 100,000 "flower children" to San Francisco — racial violence tore apart more than 150 US cities, causing twenty-six deaths in Newark, forty-three in Detroit, and tens of millions of dollars in property losses. Opposition to US participation in the Vietnam War roiled college campuses.

In 1968, the anger and alienation exploded. On April 4, 1968, Martin Luther King Jr. was assassinated on the balcony outside his room at the Lorraine Motel in Memphis, shot by white supremacist James Earl Ray.

Over the next week, riots erupted in more than 100 cities nationwide, killing thirty-nine people, injuring more than 2,600, and leaving 21,000 under arrest.

Two days after King was killed, seven members of the Black Panther Party — holed up in a three-story apartment house in West Oakland, California, with a cache of weapons that included two military rifles and a submachine gun — exchanged fire with police for ninety minutes.

On June 5, shortly after 12:10 a.m., Robert F. Kennedy was assassinated by Sirhan Sirhan in the kitchen of the Ambassador Hotel in Los Angeles.

In the first nine months of 1968, violent crimes in the United States increased 21 percent over the same period in 1967, including a 15 percent increase in murder and a 37 percent increase in armed robbery. Nationwide, "white flight" to the suburbs left burned-out, desolate urban cores.

In the media and in average homes, cultural values turned upside down. Jeans, overalls, hippie headbands, tie-dyed T-shirts, sheepskin vests, and long hair took over fashion. Teens and young adults wore out the vinyl of 1968 best-selling record albums like the Beatles' *White Album*, Jimi Hendrix's *Electric Ladyland*, the Rolling Stones' *Beggars Banquet*, the Doors' *Waiting for the Sun*, and, with much debate over the meaning of the title, Iron Butterfly's *In-A-Gadda-Da-Vida*. New American Library published the book *High Priest*, by former Harvard psychology professor turned LSD advocate Timothy Leary, rapturously describing his and others' psychedelic drug-induced experiences. In April 1968, the musical *Hair* opened on Broadway celebrating hippie culture, with nudity, profanity, and references to sex, drugs, and anti-Vietnam War protests. It yielded a three-million-selling soundtrack album.

Gordon Gibbs understood. It was over for Katharine Gibbs. The school was as out of style as ladies' hats and white gloves. Big cities had become danger zones, young people didn't trust authority, and secretaries weren't glamorous anymore — they were now symbols of oppression. Maybe the school could have been revamped, but neither of his daughters wanted to take over, and the old-guard staff staunchly resisted change. One New York Gibbs school employee, responding to a query from etiquette columnist

Amy Vanderbilt, scoffed at the use of "Ms." as an honorific, calling it "contrived and meaningless."

At sixty-eight, Gordon Gibbs was ready to leave anyway. He'd been running the school for exactly half his life since his mother's death in 1934. That effort, and his active lifestyle of sailing, flying, and skiing, had worn him down physically. Taking a tumble on the slopes of the Laurentian Mountains in Canada, he'd ripped a shoulder, cracked his head, and injured one arm so badly, he said, it was "all full of wires and bolts." He and his wife, Blanche, still had good years left and the means to enjoy them.

It was best to step aside and let someone else try to steer the ship into safe waters. In late July 1968, Gordon agreed to sell the Katharine Gibbs Schools to Crowell Collier and Macmillan, Inc., for a parcel of stock worth an estimated $5 million (about $45 million today).

His timing was prescient. Feminist rebellion against traditional roles escalated. On September 7, 1968, nearly one hundred women marched on the Boardwalk in Atlantic City to protest the Miss America Pageant in progress there at Convention Hall. Carrying signs that read "Can make-up cover the wounds of our oppression?" and "Welcome to the Miss America Cattle Auction," and "If you want meat — go to the butcher," they sang anti-Miss America songs. Into a "freedom trash can" they threw girdles, bras, hair curlers, high heels, and a ripped-up *Playboy* magazine. (Contrary to popular lore, no actual bra-burning took place because Atlantic City's mayor had warned about fire damage.)

After the sale to Crowell Collier and Macmillan in 1968, the Katharine Gibbs schools slid downhill steadily, done in as much by corporate greed and incompetence as by social upheaval. Founder Katharine Gibbs and her son Gordon had always operated on the principle that vision would generate profit. A parade of new owners flipped that formula, prioritizing a rapacious desire for profit.

For a while, the school's stellar reputation carried it along. But the new owner's eagerness to wring every possible dollar out of the Katharine Gibbs name led to a near-tripling of the number of locations and started a slow death march. By 1984, there were eleven Katharine Gibbs schools, with

less-than-Park Avenue addresses in places like Valley Forge, Pennsylvania; Tyson's Corner, Maryland; and Piscataway, New Jersey. Then, beginning in 1988, the schools got tossed around like a hot potato. First, they went to British media magnate Robert Maxwell (father of future Jeffrey Epstein sex trafficking collaborator Ghislaine Maxwell) as part of the package when he bought Macmillan for its robust publishing operation. Maxwell didn't want the Gibbs schools. He closed two of them right away and unloaded the rest in 1989 on Phillips Colleges, a shady for-profit network of business schools based in Gulfport, Mississippi.

Slapped with a $155 million repayment demand in 1993 by the US Department of Education for fraudulently obtaining federal student loans, Phillips punted the Gibbs schools over to the K-III Communications Corp., which in turn sold them to Career Education Corporation in 1997. None of the new owners could make a go of the business. They tried everything—from admitting male students from 1971 onward to offering a wildly incongruous menu of classes that included criminal justice, graphic design, hotel and restaurant management, fashion design, even disaster recovery and digital filmmaking.

Finally, in January 2005, the Grim Reaper came calling for the Katharine Gibbs Schools. That month, the oldest and most successful news show in TV history, CBS's *60 Minutes*, ran an expose about aggressive and deceptive tactics at the New York school, where a recruiter told an undercover producer that the graduation rate was 89 percent when it was actually a dismal 29 percent. The following year, Career Education hung a "for sale" sign around the neck of the Gibbs schools. In 2008, having found no takers, Career Education announced that all locations would close, a process completed in 2011.

EPILOGUE

～ஓ～

IN MID-1970, SOME FIFTY women's liberationists, including at least one from the National Organization for Women (NOW), which had formed in 1966 to fight sexism through political, social, and cultural confrontation, arrived at New York's Pan Am Building. Eluding security guards, they stomped up to Gibbs's fourth-floor reception desk. When the school's director, Alan Baker, came out to meet them, they bombarded him with angry rhetorical questions like, "Do you train people to be office wives?" and accusations that the school's ads were "fortifying" an oppressive, sexist system. When Baker acknowledged that some "girls" had complained about the ads, several of the group shouted back, "Women!"

They didn't know and didn't want to know history. Although Baker pointed out that in 1911, "women couldn't get responsible jobs at all" and that Katharine Gibbs's mission had been to change that, the women's group ignored him. Instead, they peppered him with more verbal assaults. Finally, the *Village Voice* reported, "the group grew weary of challenging Baker" and left.

But history did matter. For much of the twentieth century, the name "Katharine Gibbs" had been synonymous with women's empowerment. The school had tapped a large, hidden reservoir of female ambition that had nowhere else to go, blocked as it was by minuscule quotas or male-only admissions policies at professional schools and hemmed in by social

norms that demanded marriage and motherhood. Gibbs students weren't defiant, fire-breathing feminists nor, generally, had they burned with one clear ambition since childhood. They were finding themselves and their direction in the world. Without Katharine Gibbs, they might easily have disappeared into other people's expectations.

Over and over Gibbs graduates said the same thing. The school told them they were valued and valuable, competent, professional, and capable of rising as high in the world as they could dream. It told them that not just in words, but also through elegant surroundings, top caliber teachers, sophisticated social events, and those exasperatingly high achievement standards that they were always glad afterward they'd suffered through.

By the time Gordon Gibbs signed the 1968 sale contract to Crowell Collier and Macmillan, Inc., some 50,000 young women had graduated from the Katharine Gibbs schools. They had fanned out to all facets of American public life, to work in business, government, the military, education, entertainment, and the media. Some chose to remain secretaries because they liked that work and it gave them the freedom to step in and out of the labor market — perhaps to raise a family, perhaps to travel — secure in the knowledge that whenever they wanted, they could find another interesting position at a good salary.

Other Gibbs graduates used their skills and strategic knowledge to achieve pioneering heights in their chosen careers in fields dominated by men virtually everywhere. If these women worked their way up step-by-step rather than by kicking down doors, it was largely because in their era, kicking down doors would have failed. They had to confront circumstances as they were, not as they wished them to be.

What those feminists who pilloried Alan Baker at the New York Gibbs school in 1970 didn't appreciate was that Gibbs graduates had helped lay the foundation for their theoretical arguments. Women were equal? As an idea alone, that wasn't going to sell, not to men who were used to dealing only with men in authority. But Gibbs women showed they could run everything from an executive office to an entire company or government agency. They infiltrated. They worked hard. They earned respect. Part of a

great, subversive revolutionary force operating on the inside, they opened minds and changed attitudes among all but the most hardened so-called male chauvinist pigs.

And so, Gibbs graduates gave the second-wave women's liberation movement living proof for its slogans, posters, picket signs, and T-shirt maxims.

The school is gone, but its legacy runs deep. They didn't do it alone, of course, but thousands of Katharine Gibbs graduates fighting in the trenches for decades against gender bias paved the way for future generations. Unlike her counterpart in the 1950s — that young woman on the Manhattan sidewalk adjusting her ladylike hat and raising a white-gloved hand to hail a cab on her way to a secretarial job interview — today's ambitious female needn't disguise her ambitions by starting her career as the perfect helpmate to a male boss. Yet, in the twenty-first century, when a woman's place is every place, it is easy to forget that a mere seventy-five years ago, possession of a Katharine Gibbs certificate, lightning-fast typing skills, and a great hat and suit were weapons that would help radically change the working world.

ACKNOWLEDGMENTS

I'm deeply grateful to everyone whose kind help made this book not only possible, but also enjoyable and illuminating to work on. Especially, I am thankful to all the Katharine Gibbs graduates and their family members and friends who generously shared memories of their time at the school and its impact on their lives.

At the outset, Millie Pirko Triff provided vivid recollections and snapshots and helped connect me with the world of midcentury Gibbs life, as did her Gibbs classmate Barb Kelley. Loudell Insley was a fountain of good cheer and lively stories. Kathy McCahon Magnuson's vivid descriptions of glamorous 1950s New York brought those scenes to life, while Marie Zenorini Canepa shared the excitement and adventure of working in Italy as well as in New York's elite circles. Describing her rise from an upstate New York farm to CIA intrigue in Beirut and her subsequent career as an author, Mary Louise Beneway Clifford helped me understand the immense barriers once faced by intelligent, educated, ambitious young women. Katherine Schmidt, in her nineties, cheerfully recalled details of her adventures seventy years earlier. Thanks also go to Clare Ferraro — no surprise that she rose to the very top of book publishing — and the always amazing Loretta Swit, who has followed her Emmy-winning acting career with animal rights activism through her nonprofit SwitHeart Animal Alliance. All these Gibbs graduates were unfailingly generous with their

time and so warm and friendly during our interviews. All reinforced to me what a special place the Gibbs school must have been if one could have met such people there.

Family members and friends were also invaluable in putting together the stories of barrier-breaking Gibbs graduates who so often were overlooked in their own time or whose accomplishments were later pushed aside by history as just "women's work." I'm indebted to Jakki Fink (and to Paulina Bren, who connected us) for sharing a trove of letters home from Gibbs written by her smart, beautiful mother, Jill DiDonato. Jakki and Jill's cousin Rose Nini filled in background information that made Jill's memory sparkle. Bill Stolz was delightful to speak with about his best-selling author mother, Mary Stolz. Fred Crouter and Jerry Crouter offered valuable insights about globe-roaming Natalie Stark Crouter and kindly gave permission to use family photos. Lynn Yonally helped immensely with recollections about her World War II high-flying mother, Lillian Lorraine. Likewise, I greatly appreciated material provided by Michael Hardcastle-Taylor about his mother, Jean Drewes. Also indispensable were conversations and correspondence with Vicki Croke about her friend Dorothy Greelis; Kristin Viltz about her mother, Marie Lyons Killilea; Andy Sutton and Porter Sutton about Mary Sutton Ramsdell; Robb Murchison and Sally Murchison Boyd about Joye Hummel Murchison Kelly; Lisa Churchville about Kathleen Clair; Paul O'Keefe and Claire O'Keefe about Rita Keniery O'Keefe and Monica Ross; Marguerite Mebane about Mary Spencer Watkins Ferchaud; and Lorrie Gibbs Button about her parents, Gordon and Blanche Gibbs.

Many thanks as well to these libraries and archives: the John Hay Library at Brown University; the Arthur and Elizabeth Schlesinger Library at Radcliffe; Harvard's Widener Library; Smith College; the Providence, Rhode Island, Public Library; the Smithsonian (especially, Lilla Vekerdy); Manhattanville University Special Collections (especially, Lauren Ziarko). Very kindly, Susan Camp loaned me a rare copy of an early Gibbs New York yearbook.

Behind the scenes, the book owes a great deal to my writer friends:

Cathy Curtis, who first suggested the idea of a Katharine Gibbs book; Diane Kiesel, who read nearly every word and provided incisive comments; Arnold Mann, for his superb sense of structure; and Heath Hardage Lee for enthusiasm and introductions to several Gibbs graduates. Great appreciation also goes to my wonderful agent, Isabelle Bleecker, and to the team at Algonquin Books: my terrific editor Amy Gash for wise guidance, perfect edits, and ever-availability; the super-efficient and helpful Jovanna Brinck; resourceful publicist Marisol Salaman; and the design staff who captured the spirit of the book visually.

NOTES

∽

ABBREVIATIONS

Newspapers and Magazines

- *BG:* *Boston Globe*
- *BTU:* *Brooklyn Times Union*
- *CSM:* *Christian Science Monitor*
- *CT:* *Chicago Tribune*
- *FREN:* *Fall River Evening News* (Fall River, MA)
- *GDG:* *Galena Daily Gazette* (Galena, IL)
- *HC:* *Hartford Courant*
- *KCS:* *Kansas City Star*
- *LAT:* *Los Angeles Times*
- *LHJ:* *Ladies' Home Journal*
- *NYDN:* *New York Daily News*
- *NYT:* *New York Times*
- *PDJ:* *Providence Daily Journal*
- *PET:* *Providence Evening Tribune*
- *SEP:* *Saturday Evening Post*
- *TG:* *The Gibbsonian*, alumnae publication of the Katharine Gibbs School
- *WP:* *Washington Post*

Archival Collections

- *ABHS:* American Baptist Historical Society
- *EP-OH:* "Emily Pike, Republican Party Campaign Organizer: From Volunteer to

Professional," interview by Miriam Feingold Stein, 1977 (Berkeley, CA: Regents of the University of California, 1983)

FLG: Frank and Lillian Gilbreth papers, Purdue University

HL: Hagley Library, Wilmington, DE

KAT-OH: Katherine Towle, interview by Harriet Nathan, *Katherine A. Towle, Administration and Leadership* (Berkeley: University of California Regional Oral History Office, 1970)

KEB-SC: Katharine E. Brand Papers, Smith College

KGSB: Katharine Gibbs School, Boston, Pamphlet Box, Widener Library, Harvard University

KGSR: Katharine Gibbs School Records, Brown University

MBC: Marjorie Bell Chambers Papers, Schlesinger Library, Radcliffe Institute

MSP-UM: Mary Stolz Papers, University of Minnesota

MSP-USM: Mary Stolz Papers, University of Southern Mississippi

MUSC: Manhattanville University Special Collections

MSWF-OH: Mary Spencer Watkins Ferchaud, interview by Beth Ann Koelsch, Nov. 26, 2019, Oral History Collection, University of North Carolina at Greensboro

PSF: Papers of the Stark family, Schlesinger Library, Radcliffe Institute

ONE: APRIL 4, 1909, CRANSTON, RHODE ISLAND

two-mast craft...Katherine: "A Presentation," *PDJ*, Oct. 11, 1904, 12; "Yacht Club House Burned," *FREN*, Apr. 14, 1908, 5.

watchmaker at Tilden-Thurber...died there: "Mast Breaks, Falls on Owner," *PDJ*, Apr. 5, 1909, 1; Yachtsman Did Not Survive Injuries," *PET*, Apr. 20, 1909; William Gibbs, "Return of a Death," City of Providence, Apr. 22, 1909, familysearch.org.

Nothing except her clothes...indentured laborers: Estate of William Gibbs, Petition for Allowance of Furniture, and Decree, May 28, 1909; Schedule B, Jul. 5, 1910; Application for Liberty to Sell Articles named in Inventory at Private Sale, May 28, 1909, Probate Court of the Town of Cranston; Chapter 321, Sec. 5, General Laws of Rhode Island: Revision of 1909. Providence, E.L. Freeman Co., Printers to the State, 1170; Chapter 248, Sec. 1–3, General Laws of Rhode Island: Revision of 1909. Providence, E.L. Freeman Co., Printers to the State.

TWO: CATHERINE/KATHARINE

Galena, Illinois: Esther E. Eby, "Once-Glorious Galena," *Journal of the Illinois State Historical Society*, Jul. 1937, 172, 174; "The New Galena," *The Inter Ocean* (Chicago), Dec. 29, 1886, 12.

James M. Ryan...Katharine's mother: "Commencement of the Packing Season," *GDG*, Oct. 28, 1870, 3; "The Northwest," *CT*, Nov. 16, 1882, 2; "A Packing House," *The Daily Journal* (Freeport, IL), Nov. 22, 1888, 4; "The New Galena," *The Inter Ocean* (Chicago), Dec. 29, 1886, 12; "Death Descended Swiftly," *GDG*, Oct. 10, 1892, 3; "In Brief," *GDG*, Dec. 16, 1873; "House-Warming," *GDG*, Sep. 27, 1882, 3.

allowed to run wild: "In Brief," *GDG*, Oct. 30, 1871, 3.

Academy of the Sacred Heart: "Convent of the Sacred Heart," *The World*, Feb. 4, 1894, 14; "Misses Minnie & Kate Ryan," 1882 Ledger, 560, Manhattanville University Special Collections; *Manhattanville Yesterday and Today*. Purchase, NY, 1953, 4. MUSC;

Margaret Williams, *Second Sowing: The Life of Mary Aloysia Hardey* (New York: Sheed & Ward, 1942), 338; Mary Ryan letter, Dec. 1952, in *Manhattanville Yesterday and Today*. Purchase, NY, 1953, 23. MUSC.

"accompanies spinsterism": Edward H. Clarke, M.D., *Sex in Education; or, A Fair Chance for the Girls.* Boston: James R. Osgood and Company, 1873, 47–8, 14, 154–7.

only a few thousand women: Linda K. Kerber, "'Why Should Girls Be Learn'd and Wise?': Two Centuries of Higher Education for Women as Seen Through the Unfinished Work of Alice Mary Baldwin," in *Women and Higher Education in American History,* edited by John Mack Faragher and Florence Howe (New York: W.W. Norton, 1988), 35.

In 1890, only 19 percent: Sophonisba P. Breckinridge, *Women in the Twentieth Century: A Study of Their Political, Social and Economic Activities* (New York and London: McGraw-Hill, 1933), 108.

"natural and proper": Sophie Douglass Pfeiffer, "Women Lawyers in Rhode Island," *American Bar Association Journal,* Jun. 1975, 740.

median age for a woman to marry…follow his instructions: Marriages Trends and Characteristics (Rockville, MD: US Department of Health, Education, and Welfare, 1971), 5; Ruby Maloni, "Dissonance Between Norms and Behaviour: Early 20th Century America's 'New Woman,'" *Proceedings of the Indian History Congress,* 2009–2010, 883; Sara L. Zeigler, "Uniformity and Conformity: Regionalism and the Adjudication of the Married Women's Property Acts," *Polity,* Summer 1996, 478.

died of heart failure…dismantled the house: "Death Descended Swiftly," 3; "The Business for Sale," *GDG,* Nov. 3, 1892, 3; "Administrators' Notice," *GDG,* Nov. 10, 1892, 2; "The Old and the New," *GDG,* Jan. 4, 1893, 2; "Notice of Delinquent Sale," *The Independent-Record* (Helena, MT), Mar. 24, 1893, 2; "A Brilliant Bridal," *GDG,* Jan. 2, 1895, 3; "City Chat," *Galena Daily Gazette,* Apr. 30, 1895; "Short City News Items," *GDG,* Sep. 4, 1897, 3; "History of a Year," *GDG,* Dec. 31, 1897; "Personal Mention," *GDG,* Oct. 28, 1897, 3.

estimated value of $500,000 to $1 million: "Death Descended Swiftly," 3.

agreed to settle with Charles: William Rippin, Jo Daviess County Judge, re Petition of John J. Jones, Conservator of Cecelia M. Ryan, for power to adjust claim of his ward against Charles L. Ryan, July Term, 1904, 3. Jo Daviess County, IL.

Cecelia Ryan: Email from archives@sinsinawa.org to author, Apr. 28, 2022; Petition for appointment of a Conservator for Cecelia M. Ryan, Feeble minded, Witnesses Testimony, Jul. 26, 1904. Jo Daviess County, IL.

"all grades of idiocy": Amos G. Warner, *American Charities.* New York: Thomas Y. Crowell, 1908, 336.

awarded amounts varying: John J. Jones, Conservators Report, Feb. 21, 1906, Jo Daviess County, IL.

THREE: A NEW IDEA IN EDUCATION

"Take sides and get mad": "Formula for Youth," *Newark Star-Ledger,* Dec. 6, 1949, 33.

borrowed $1,000: R. Magruder Dobie, "How to Educate a Secretary," *SEP,* Feb. 12, 1949, 117.

opium dens…Providence police: "A 'New China' Here Too," *Providence Sunday Journal,* Feb. 16, 1913, Section 5, 5, 10.

only a desk: "In Appreciation of Mrs. Katharine M. Gibbs," *TG,* 1934; "How to Educate a Secretary."

"Do the best you can": Katharine Gibbs, "Human Problem Enters into Holding One's Job, Educator Informs Girls," *The Morning Herald*, (Uniontown, PA), Oct. 28, 1932, 14.

"good for something": Sarah Louise Arnold, "Simmons College for Women," *The Journal of Education*, Aug. 21, 1902, 119–20; Sarah Louise Arnold, "Vocational Training for Women," *Proceedings of the Academy of Political Science in the City of New York*, Oct. 1910, 139.

female students skyrocketed: William H. Chafe, *The Paradox of Change: American Women in the 20th Century* (New York: Oxford University Press, 1991), 99.

US medical schools: Stephen Cole, "Sex Discrimination and Admission to Medical School, 1929–1984," *American Journal of Sociology*, Nov. 1986, 555, 557; Regina Markell Morantz, "Women in the Medical Profession: Why Were There so Few?" review of *Doctors Wanted — No Women Need Apply*, by Mary Roth Walsh, in *Reviews in American History*, Jun. 1978, 164; Bruce A. Kimball and Brian S. Shull, "The Ironical Exclusion of Women from Harvard Law School, 1870–1900," *Journal of Legal Education*, Mar. 2008, 15.

US law and business schools: Donna Fossum, "Women in the Legal Profession: A Progress Report," *American Bar Association Journal*, May 1981, 579; Deborah L. Rhode, "Perspectives on Professional Women," *Stanford Law Review*, May 1988, 1174; Kimball and Shull, "Ironical Exclusion of Women," 8; https://celebratewomen.yale.edu/history/timeline-women-yale, accessed Sep. 26, 2022; https://www.wharton.upenn.edu/history/, accessed Sep. 24, 2022.

barred from 60 percent: Chafe, *Paradox of Change*, 66–67; Sharon Hartman Strom, "'Light Manufacturing': The Feminization of American Office Work, 1900–1930," *ILR Review*, Oct. 1989, 56. Esther E. Lape, "Women in Industry," *The New Republic*, Jan. 26, 1921, 252.

"I had a new idea": Katharine M. Gibbs, "Housekeeper vs. Businesswoman," *Brooklyn Daily Eagle*, Apr. 8, 1928, 14.

"Accomplishment comes only": "85 Years of Excellence Brochure," 1950s–1960s pages. Box 4, KGSR.

"the ability to distinguish": Katharine M. Gibbs, "Beginnings," *TG*, Dec. 1929.

"Believe you can accomplish": Katharine M. Gibbs, "Believe in Life," *TG*, May 1931.

"She was irresistible: John C. Dunning, "In Appreciation of Mrs. Katharine M. Gibbs," *TG*, 1934, 6.

"protection against the future": "Katharine Gibbs School of Secretarial and Executive Training for Educated Women," 1922–1923, 4. Box 4, KGSR.

FOUR: "EXPECT GREAT THINGS!"

"I can wish nothing better": Gibbs, "Beginnings."

"calmly and confidently": "In Appreciation of Mrs. Katharine M. Gibbs," 3, 5.

"an adventure — an education": Loring A. Schuler, "Experience," *LHJ*, Feb. 1929, 30.

"even more profound influence": Editorial, *McCall's*, Oct. 1928.

"unexpectedly large increase"…female dentists: Mary V. Dempsey, "The Occupational Progress of Women, 1910 to 1930," *Bulletin of the Women's Bureau*, No. 104, US Department of Labor (Washington, DC: Government Printing Office, 1933), 3, 34, 2, 7, 29, 28, 34, 25, 70, 71; Chafe, *The Paradox of Change*, 100.

a full 60 percent: Paul Philip Marthers, "Sweeping Out Home Economics: Curriculum Reform at Connecticut College for Women, 1952–1962," *History of Education Quarterly*, Aug. 2011, 363.

women lawyers... osteopaths: William H. Chafe, *The American Woman* (New York: Oxford University Press, 1972), 58; Dempsey, "Occupational Progress of Women," 23.

Ada Kepley: Karen Berger Morello, *The Invisible Bar* (New York: Random House, 1986), 49.

"Expect great things!": Katharine Gibbs, "Expect Great Things" ad, *Harper's Bazaar*, Nov. 1922, 35.

an average of $631...window washers: "Higher Salaries for Teachers," *Evening Journal* (Wilmington, DE), Jun. 27, 1919, 4; "Housemaids Get More Pay Than Do Teachers," *Falls City Journal* (Falls City, NE), Jan. 1, 1920, 2; "Women to Ask Teachers' Pay Bill Be Passed," *New York Tribune*, Mar. 23, 1920, 13.

Natalie Corona Stark: Marguerite Stark Bellamy to Natalie Stark, undated, 2. Box 50, Folder 3, PSF; Lynn Z. Bloom, "Introduction," *Forbidden Diary* (New York: Burt Franklin & Co., 1980); Natalie Stark Crouter, handwritten note, PSF; Natalie Stark, "Thought Book," 1913, 1. Box 40, Folder 9, PSF.

Katherine Towle: Katherine Towle, interview by Harriet Nathan, *Katherine A. Towle, Administration and Leadership* (Berkeley: University of California Regional Oral History Office, 1970), 62–63.

Clara D. Davies: "Record Class Graduated," *Boston Globe*, Jun. 24, 1914, 4; "Clara D. Davies, 88," *BG*, Jun. 16, 1981, 23; 1920 Federal Census.

Katharine Brand: Katharine E. Brand, "I was born..." and "My father was..." Box 1, Folder 5; Katharine E. Brand, "Book I," 56. Box 7, Folder 3; Katharine E. Brand, résumé, Box 1, Folder 3. All KEB.

Mary Sutton Ramsdell: "Woman Presides," *Boston Post*, Jul. 21, 1896, 4; "Condensed Telegrams," *FRDEN*, Mar. 27, 1895, 1; "Woman Chosen Mill President," *BG*, Jul. 19, 1896, 16; "Police Long Wanted Him," *BG*, Dec. 8, 1905, 19; "Out of Jail and In Again," *Boston Evening Transcript*, Aug. 5, 1907, 1; "Held in $300 Bail," *BG*, Jan. 31, 1908, 8; Bishop Moulton, "On the Way to the Uinta Reservation," in *The Spirit of Missions*, Sep. 1921, 567; "Fort Duchesne Sends Liberally to Flood Relief," *Vernal Express* (Vernal, UT), Aug. 31, 1923, 1; "Myton," *Duchesne Courier*, Sep. 21, 1923, 4; Crimson Rambler, Rowland Hall 1924 yearbook, 12.

Leland Stanford Ramsdell: 1880 Federal Census; Andy Sutton email to author, Dec. 14, 2021; "Leland S. Ramsdell Sues for Divorce," *Daily News Leader* (San Mateo, CA), Jul. 5, 1917, 5; Cholly Francisco, "Golf to Be Theme of Dinner Dance," *San Francisco Examiner*, Jun. 2, 1916, 9; Untitled item, *Concord Transcript* (Concord, CA), Feb. 7, 1918, 2.

Kay Francis: Harry T. Brundidge, "Kay Francis, The New Toast of Hollywood, Tells How She Got That Way," *St. Louis Star*, Dec. 3, 1929, 3; Katharine Gibbs brochure, 1922–23, 1. Box 5, Folder 44, KGSR.

few, if any, Black women: Katharine Gibbs School brochure, circa 1927, 21. HL; Theodore Kornweibel Jr., "Black Life in the Twenties," *Journal of Black Studies*, Jun. 1976, 311; Gunnar Myrdal, *The American Dilemma*, Vol. 1 (New York: Harper & Brothers, 1944), 380–381.

finance this expansion: Gibbs, "Housekeeper vs. Businesswoman," 14.

"[S]ocial development": Katharine Gibbs School brochure, 1927, 9. HL.

"that was really a mistake!": Author phone interview with Katherine Schmidt, Dec. 3, 2021.

"first thing of importance": Gibbs, "Believe in Life."
"Every business office": Gibbs, "Human Problem Enters," 14.
"keep human relations": Gibbs, "Housekeeper vs. Businesswoman," 14.
qualities most valued by employers: W.W. Charters and Isadore B. Whitley, *Analysis of Sec-*
 retarial Duties and Traits (Baltimore, MD: Williams & Wilkins Company for The
 National Junior Personnel Service, Inc., 1924), 174, 136, 178.
"Nothing pleases an employer more": Katharine Gibbs, "Exceptional Job Requires Ability and
 Hard Work, Says Writer Pointing Way," *Washington C.H. Herald,* Nov. 4, 1932, 11.
Katharine poached heavily: "Katharine Gibbs School Opens in Five Buildings," *BG,* Oct. 3,
 1929; "Katharine Gibbs School" brochure, 1927, 5. HL.
a special lecturer she wanted: Elizabeth Whittemore, "In Appreciation of Mrs. Katharine M.
 Gibbs," *TG,* 1934, 6.
Lillian Gilbreth: Lillian Gilbreth to Katharine Gibbs, Mar. 19, 1928, 2–3; Katharine Gibbs
 to Lillian Gilbreth, Mar. 21, 1928, 2. FLG.
"opportunities and responsibilities": Katharine Gibbs School brochure, circa late 1920s, 9–10.
 FLG.
"Read, study, think": Katharine Gibbs, "Big Job Never All Ready Made," *BTU,* Oct. 30, 1932,
 11; Katharine Gibbs, "Women Find It Harder to Win," *BTU,* Oct. 31, 1932, 4A.
simple, well-cut dresses: Katharine Gibbs, "Must Look Well to Get the Job," *BTU,* Oct. 28,
 1932, 4A.
hat edict was borrowed: Deirdre Clemente, "'Prettier Than They Used to Be,' Femininity,
 Fashion, and the Recasting of Radcliffe's Reputation, 1900–1950," *The New England
 Quarterly,* Dec. 2009, 659.
"Make contacts": Katharine Gibbs, "Businesswoman Finds Way to Successful Career Harder
 Than Man Does, Writer Says," *Washington C.H. Herald,* Nov. 17, 1932, 12.
"Many young girls": Gibbs, "Human Problem Enters," 28.
"You apply for a promotion": Lillian Gilbreth, "Questions to be asked next time," FLG.
"No race has": Lillian Gilbreth, "Heredity and Environment or Education," FLG.
"A group objects": Gilbreth, "Questions to be asked."
"That so tiny": Whittemore, "In Appreciation."
"so sweet and motherly": "About the Author," Michael Hardcastle-Taylor email to author,
 Apr. 9, 2021.
"Hit by a Fifth Avenue bus"... "rare modesty": Dobie, "How to Educate a Secretary," 118; "In
 Appreciation of Mrs. Katharine M. Gibbs," 5, 6.
"School. Dazed"... "One of 4": Natalie Stark, 1921–1923 diary, Box 41, Folder 1. PSF.

FIVE: WHERE DO ALL THE GIRLS COME FROM?

totaled nearly 1,000: "Katharine Gibbs School Opens in Five Buildings," *BG,* Oct. 3, 1929.
"I can't help wondering": Erwin H. Schell, "In Appreciation of Mrs. Katharine M. Gibbs,"
 TG, 1934, 5.
"smoothness and suavity": Natalie Crouter, *Forbidden Diary,* 85.
Since the 1911 Revolution... back of the head: Matthew R. Portwood and John P. Dunn, "A
 Tale of Two Warlords," *Education About ASIA,* Winter 2014, 17–8; J.A.G. Roberts,
 "Warlordism in China," *Review of African Political Economy,* 1989, 27.
Japanese military either destroyed: Nym Wales, "China's New Line of Industrial Defense,"
 Pacific Affairs, Sep. 1939, 285.

While thwarting Japanese: Edgar Snow, *The Battle for Asia* (New York: Random House, 1941), 96–97.

Chinese government promised: Wales, "China's New Line," 286–87; Ida Pruitt, "Six Years of Indusco," *Far Eastern Survey*, Feb. 28, 1945, 50.

Natalie chaired... "Chinese characters": "Mrs. Sayre Asks P.I. Industrial Co-Operatives Group to Lecture," *The Tribune* (Philippines), Aug. 28, 1940, 5; *Forbidden Diary*, 206; xvi; Mrs. E.E. Crouter to Dr. H.H. Kung, Jul. 31, 1940, Helen Foster Snow Papers, Box 28, Folder 9. Brigham Young University; Edgar Snow, *Journey to the Beginning* (New York: Random House, 1958), 210; Natalie Stark Crouter to Richard Bellamy, April 24, 1941 PSF.

At its peak: Pruitt, "Six Years of Indusco," 48; S. Bernard Thomas, *Season of High Adventure: Edgar Snow in China* (Berkeley: University of California Press, 1996), 199.

Katherine Towle: KAT-OH, 64–7; Eric C. Bellquist, Introduction to KAT-OH, vi.

Katharine Brand: Katharine E. Brand, "The Woodrow Wilson Collection," *Quarterly Journal of Current Acquisitions*, Feb. 1945, 3–4; Ray Stannard Baker to Katharine Brand, Oct. 5, 1925, Box 4, Folder 10, KEB; Katharine Brand notebook, 1925–39, 89, 31–32, 73, 47. Box 7, Folder 3, KEB; Katharine E. Brand, "Writing Biography," *TG*, Feb. 1938, Box 7, Folder 6, KEB.

Mary Sutton Ramsdell: Shirley Mulliken, "Elderly Masher Special Prey of this State Policewoman," *BG*, Nov. 25, 1934, B3; "Bay State Leader in Type of Service Started Last Year," *Springfield Republican* (Springfield, MA), May 31, 1931, 1-E; "Great Barrington Morals Defendants on Probation," *North Adams Transcript* (North Adams, MA), Jul. 21, 1938, 8; Laura Haddock, "Ex-Policewoman Urges Proper Trust in Courts," *CSM*, May 8, 1950.

Helen Havergal Clark: "Former Fairfield Girl Writes of Work in China," *Daily Kennebec Journal* (Augusta, ME), Apr. 12, 1924, 13; Virginia M. Lesher memo, "Death Notice — Miss Helen Havergal Clark," International Ministries, ABC, Mar. 20, 1991; Joseph Tse-Hei Lee, "Christianity and State-Building in Republican Chaozhou, South China," in *From Early Tang Court Debates to China's Peaceful Rise*, Amsterdam University Press, 78; Helen H. Clark, various correspondence in Helen Clark 1923–1929 file, Helen Clark bio file, and Helen Clark 1930–1939 file, all ABHS.

"running dogs," "weird and wretched": Xiaoqun Xu, "The Dilemma of Accommodation: Reconciling Christianity and Chinese Culture in the 1920s," *The Historian*, Fall 1997, 25, 51.

Lenna Wilson: New Hampshire Women Legislators (New Hampshire: Evans Printing Company 1971); "62 Women Nominated to Serve in 1955 Legislature," *Nashua Telegraph* (Nashua, NH), Sep. 24, 1954, 6: Untitled item, *The Brattleboro Reformer* (Brattleboro, VT), Mar. 17, 1928, 2.

Peg LaCentra: "We Hear from the Alumnae," *TG*, Dec. 1929, 5.

SIX: "GIVE TO COURAGE A SMILING FACE"

"essential to her": Schell, "In Appreciation of," 5.

2 million women... "orphans of the storm": "Study Your Government, First Lady Urges Women," *NYDN*, Mar. 29, 1935.

1934 Barnard College: Miron Straf and Ingram Olkin, "A Conversation with Margaret Martin," *Statistical Science*, Feb. 1994, 129.

homeless women seeking: Elaine S. Abelson, "Women Who Have No Men," *Feminist Studies,* Spring 2003, 115.
30,000 unemployed...hospitalized: "30,000 Women Seen in Need of Winter Shelter," *New York Herald Tribune,* Oct. 23, 1932, 2.
"I believe that life": Katharine M. Gibbs, "Meeting Life," *TG,* Dec. 1930.
"important avenues to success"...Clare Potter: "School Plans Style Course," *Mount Vernon Argus* (White Plains, NY), Aug. 28, 1933, 6.
"Gibbs budgeteers": "Here's What Fashion Dictates the Well-Dressed Secretary Will Wear," *Helena Daily Independent,* Jul. 3, 1932, 11.
no tuition fire sale: Katharine Gibbs booklet, 1930, 48–49; Katharine Gibbs booklet, 1932–33, 44–45, Katharine Gibbs School, Boston: Pamphlet Box, Widener Library.
Applicants had to submit: "Application" and "Valence Card," Katharine Gibbs booklet, 1930, Katharine Gibbs School, Boston: Pamphlet Box, Widener Library.
1,455 secretarial positions: "Positions for College Women," Katharine Gibbs ad, *Wellesley College News,* Apr. 25, 1935, 2.
Dorothy O'Shea Greelis: Worcester, MA Business Directory, 1923, 1057; Author interview with Vicki Croke, Jan. 7, 2022 and Mar. 15, 2023; Tom Long, "Dorothy Greelis, 88; "gentle touch made her dogs champions," *BG,* Feb. 11, 2003, 24; Worcester Gets Jolt from Drys," *BG,* Jan. 29, 1924, 13; "Biggest Roundup Yet," *BG,* Aug. 10, 1905, 7; "Learning from a leaner time: The cooking lessons of the Depression," *BG,* Feb. 19, 1992, 34; Andrea Dormady email to author, Mar. 13, 2023.
upwardly mobile jobs: "Results" brochure, Katharine Gibbs School, circa 1932. Alida Perreault Papers, Special Collections and University Archives, UMass Amherst.
three 100-ton cargo planes...Spruce Goose: Mark S. Foster, "The Flying Lumber Yard," *Aerospace Historian,* Jun. 1986, 101; Don E. McIlvenna, "The Hughes Superplane and the Second Front Clamor During World War II," *Southern California Quarterly,* Winter 1975, 371.
Mary Goodrich: "Woman Flyer Joins Model Plane Firm," *HC,* Dec. 27, 1930, 16; "Girl Pilot Makes First Solo Flight," *HC,* Oct. 9, 1928, 1; Doug Maine, "Neighbors," *Wethersfield Life,* Nov. 1, 2001, 13; "Plane Helps Girl To Keep Appointment," *HC,* Jul. 29, 1927, 1; "Woman Flyer Joins Model Plane Firm," *HC,* Dec. 27, 1930, 16; Mary Scribner, "Mary Goodrich Jenson," *The Ninety-Nine News,* Dec. 1977, 15; "Society," *HC,* Nov. 19, 1933, 22; Adele Allerhand, "With the Women," *Radio Daily,* Apr. 2, 1937, 5; "Mary Goodrich Quits Agency," *Motion Picture Daily,* Mar. 24, 1937, 13; Maine, "Neighbors," 13; J.B. Kaufman email to author, Mar. 8, 2022; Mindy Johnson, *Ink & Paint* (Glendale, CA: Disney Editions, 2017), 91; Mindy Johnson phone interview with author, Mar. 13, 2022; Charles Solomon, *The Art of Frozen* (San Francisco: Chronicle Books, 2013), 10–11; M. Oakley Christoph, "For Your Information," *HC,* Jul. 28, 1939, 6.
Disney strike: Neal Gabler, *Walt Disney* (New York: Alfred A. Knopf, 2006), 350, 365, 371; Steven Watts, "Walt Disney: Art and Politics in the American Century," *Journal of American History,* June 1995, 103; Paul Prescod, "80 Years Ago Today, Disney Animation Workers Went on Strike," May 29, 2021. https://jacobin.com/2021/05/disney-workers-animators-cartoonists-artists-strike-picket-1941-guild-scg-sorrell-babbitt, accessed Jun. 23, 2024; Bob Thomas, *Walt Disney: An American Original* (New York: Simon & Schuster, 1976), 170, 169, 167, 168, 170–71; "Publicists Guild Votes in N.Y.: No Disney Peace," *Motion Picture Herald,* Jul. 12, 1941, 49; Maine, "Neighbors," 21.

Mary resigned: Author interview with Mindy Johnson, Mar. 13, 2022.

"I was very lucky": Maine, "Neighbors," 21.

Cecelia Ryan: "Standard Certificate of Death," State of Iowa, Department of Health Division of Vital Statistics, Jan. 13, 1931; Statement by Edward Clark, Conservator of Cecelia M. Ryan, Sep. 28, 1910, File 1, Jo Daviess, IL, County Court.

William H. Gibbs: "Gibbs Killed in Fall From Ninth Floor," *Lowell Sun,* Mar. 28, 1934, 2; "William Gibbs Dies in 6-Story Fall in Park Av.," *NY Herald Tribune,* Mar. 29, 1934, 10; "Headquarters Port of Embarkation, Hoboken, New Jersey, Passenger List of Organizations and Casuals," Section 604, United States Army Ambulance Service; Columbia University Office of the Registrar email to the author, Apr. 6, 2022; Lillian Moller Gilbreth to Mrs. Katherine [sic] Gibbs, Mar. 11, 1929, 2. FLG.

"carry your hearts high": Katharine M. Gibbs, "Meeting Life," *TG,* Dec. 1930.

"serene and cheerful": Katharine Gibbs, "Must Look Well to Get the Job," *BTU,* Oct. 28, 1932, 4A.

"a time to inspire": Katharine Gibbs, "For What Sort of a Position Are You Fitted If You Seek Job?" *Washington C.H. Herald,* Oct. 25, 1932, 5.

"I was struck"... no longer able: Marie L.B. Sharp, "In Appreciation of Mrs. Katharine M. Gibbs," *TG,* 1934, 6.

more than 10,000 women: "Katharine Gibbs, School Head, Dies," *Transcript-Telegram* (Holyoke, MA), May 10, 1934, 7.

gifted and courageous pioneer: Angus Burrell, "In Appreciation of Mrs. Katharine M. Gibbs," *TG,* 1934, 5.

most remarkable... privilege to work: Whittemore, "In Appreciation."

SEVEN: THE TIFFANY'S OF SECRETARIAL SCHOOLS

"They said to me in Tiffany's": Phyllis Meras, "45,000 girls are glad Katie sold her jewels,'" *Providence Sunday Journal Magazine,* Mar. 23, 1969.

fourth floor of 230 Park Avenue: McMullan, "Fifty Years," 6; R. Magruder Dobie, "How to Educate a Secretary," *SEP,* Feb. 12, 1949, 116, 31.

leased the two-acre Rosedon estate: "Pupils Go to Bermuda," *Evening Star* (Washington, DC), Feb. 24, 1935, G-12; "A Glimpse at Gibbs," 3. Box 4, KGSR.

T. Berry Brazelton... Henry Morgenthau III: Glee Club Concert, Katharine Gibbs School and Princeton University, program, Feb. 25, 1938.

Boston Symphony... sailing lessons on the Charles: Katharine Gibbs School, 1939–1940 brochure, 17. Box 4, KGSR.

"She went to this dance": Lorrie Gibbs Button phone interview with author, Dec. 15, 2021.

Gibbs students showed up everywhere: 1939 *Platen,* 18, 30, 16. Box 1, KGSR.

Grace Spofford brought every type: Grace Spofford exam questions, Grace Harriet Spofford Papers, Sophia Smith Collection, MS 00150, Smith College Special Collections.

Ruth Bryan Owen Rohde: "Activities," 1937 *Platen,* 76. Box 1, KGSR.

Pearl S. Buck: "The Calendar," 1938 *Platen,* 75. Box 1, KGSR.

Lee Ya Ching: "Chinese Woman Flyer Plans Trip to South America," *BG,* Mar. 8, 1940, 32; "Dear Mary," 1940 *Platen,* 62. Box 1, KGSR; Rebecca Maksel, "China's First Lady of Flight," *Smithsonian Magazine,* Jul. 23, 2008, https://www.smithsonianmag.com/air -space-magazine/chinas-first-lady-of-flight-1725176/, accessed Jul. 16, 2024.

essay titled "Men": "Men," *Crest* magazine, 1937, Providence school, 47. Box 4, KGSR.

Harriet Boyden: "Girl, 18, Held as Baby Born in School Dies," *NYDN,* Apr. 8, 1937, 4; "Father Sought in Baby Killing," *BG,* Apr. 8, 1937, 8; Julia McCarthy, "Schoolmate Bares How Slain Baby's Mother Hid Fears," *NYDN,* Apr. 9, 1937, 4; "Girl Faces Charge of Murdering and Concealing Baby," *Modesto Bee and News-Herald* (Modesto, CA), Apr. 8, 1937, 11; "Girl Held Blameless for Death of Her Child," *Baltimore Sun,* May 6, 1937, 7; Julia McCarthy, "Tells How Girl, 20 Hid Motherhood in Swank School," *NYDN,* Apr. 9, 1937, 4. "Marathon Girl, Facing Murder Charge, Gains," *Press and Sun-Bulletin* (Binghamton, NY), Apr. 9, 1937, 15; "Girl Charged with Murder," *Barre Daily Times* (Barre, VT), Apr. 7, 1937, 1; "Find Baby Dead, Girl, 18, Held," *Reading Times* (Reading, PA), Apr. 8, 1937, 12; "Hold Girl Blameless in Her Child's Death," *Billings Gazette* (Billings, MT), May 6, 1937, 14.

present a health certificate: "General Information," Katharine Gibbs 1939–1940 brochure, 51. Box 4, KGSR.

Jean Drewes: Cynthia Lowry, "Mount Vernon Girl Named Secretary to Duke, Duchess of Windsor — Reaches Nassau Today," *Daily Argus* (White Plains, NY), Nov. 30, 1940, 1; Jean D. Hardcastle-Taylor, *The Windsors I Knew* (Michael Hardcastle-Taylor, Second edition, 2018); Cynthia Lowry, "Mount Vernon Girl Named Secretary to Duke, Duchess of Windsor — Reaches Nassau Today," *Daily Argus* (White Plains, NY), Nov. 30, 1940, 1; Michael Hardcastle-Taylor, "About the Author," email to author, Apr. 9, 2021; Michael Hardcastle-Taylor, "About the Author," *The Windsors I Knew,* 137.

"your eye on what you desire": Katharine Gibbs, "Human Problem Enters into Holding One's Job, Educator Informs Girls," *Calgary Daily Herald,* Nov. 12, 1932, 22.

EIGHT: "WHAT A JOB YOU'VE DONE!"

piled on personal errands: Katharine Brand to Mrs. Ray Stannard Baker, Dec. 10, 1938, 1. Box 5, Folder 1, KEB; Katharine Brand to Ray Stannard Baker, Dec. 5, 1928, Dec. 10, 1928. Box 4, Folder 10, KEB.

"There are days", "lonely feeling", "Time and again", "thought of death": Katharine Brand notebook, 1925–39, early 1932, 113, 116, 61, 81. Box 7, Folder 3. KEB.

"I should enjoy": Katharine Brand to Ray Stannard Baker, Dec. 11, 1929, 2. Box 4, Folder 10, KEB.

"I hated Florida": Katharine Brand, "My father was," 4. Box 1, Folder 5, KEB.

"our enterprise just now": Ray Stannard Baker to Katharine Brand, Jan. 31, 1930, Box 4, Folder 11, KEB.

guaranteed him $250,000: Robert C. Bannister Jr., *Ray Stannard Baker, the Mind and Thought of a Progressive* (New Haven: Yale University Press, 1966), 253.

Bernard Baruch: Ray Stannard Baker, *American Chronicle* (New York: Charles Scribner's Sons, 1945), 513.

February 1932, Baker received: Katharine Brand to Ray Stannard Baker, Feb. 22, 1932, Box 4, Folder 13, KEB.

stayed at fancy hotels: Jessie Baker to Katharine Brand, Feb. 23, 1928. Box 4, Folder 10; Ray Stannard Baker to Katharine Brand, Jan. 4, 1930, Box 4, Folder 11; Ray Stannard Baker to Katharine Brand, Feb. 2, 1932 Box 4, Folder 13. All KEB.

"I am 28", "gained 30 pounds": Katharine Brand notebook, 1925–39, 99, 91, 94, 101. Box 7, Folder 3, KEB.

"being very miserable"...Baker replied simply: Katharine Brand to Ray Stannard Baker, Dec. 5, 1931, 1–2. Box 4, Folder 12, KEB; Ray Stannard Baker to Katharine Brand, Dec. 10, 1931. Box 4, Folder 12, KEB.

"had written was terrible!": Katharine Brand notebook, 1925–39, Jan. 23, 1939, 121. Box 7, Folder 3. KEB.

stricken with severe...Edith kept persuading: Bannister, Jr., *Ray Stannard Baker,* 283–84.

horseback riding: Ray Stannard Baker to Katharine Brand, Jan. 13, 1932, 1. Box 4, Folder 13, KEB.

took a nap...bees he kept: Katharine Brand notebook, 1925–39, Aug. 11, 1932, 118–20. Box 7, Folder 3, KEB.

injury to her ribs...she felt bad: Katharine Brand to Ray Stannard Baker, Dec. 28, 1931, 2. Box 4, Folder 12; Edith Churchill to Ray Stannard Baker, Fri., no date, 1934, Dec. 11, 19344, Dec. 3, 1934, Box 4, Folder 14, KEB.

struggled through Volumes: Bannister Jr., *Ray Stannard Baker,* 302.

"a new plan!": Katharine Brand notebook, 1925–39, Jan. 23, 1939, 123. Box 7, Folder 3. KEB.

"scared to death!": Katharine Brand to Ray Stannard Baker, Mar. 17, 1938, Box 5, Folder 1, KEB.

"A tremendous affair": Ray Stannard Baker to Katharine Brand, Apr. 16, 1938. Box 5, Folder 1, KEB.

mentally dull: Ray Stannard Baker to Katharine Brand, Mar. 3, 1939, 2. Box 5, Folder 2, KEB.

"cannot stand much pressure": Ray Stannard Baker to Katharine Brand, Mar. 1, 1939, 2. Box 5, Folder 2, KEB.

only between ages 18 and 30: Katharine Gibbs, "Women Find It Harder to Win," *BTU,* Oct. 31, 1932, 4A.

"first thing of importance": Katharine M. Gibbs, "Believe in Life," *TG,* May 1931.

dismantling the chandelier, Edith insisted: Carol Piper: audiotape and transcript, 1987–88, 17–18, 16. Box 1, Folder 7, KEB.

"I will be so glad": Edith Bolling Wilson to Katharine Brand, Dec. 21, 1939. Box 7, Folder 3, KEB.

"a formal affair": Piper: audiotape and transcript, 17.

NINE: WHAT ARE WE IN FOR NOW?

Jean Haskell: Jean L. Krauklin, "Girlhood Memories of World War II," Single Folder Collections–2006 Box 1, Folder 1, Florida State University Special Collections & Archives.

As the music paused: Elizabeth McLeod and David Schecter emails to author, Nov. 8, 2024.

enemy planes had been sighted: "Class Acts," *Middlebury Magazine,* Spring 2014, 58.

"Queer to be lined up": Marilyn Feldsten, "Diary of a Gibbs Girl," 1943 *Platen,* 43.

"Uncle Sam does need": "Stenographers and Typists...Uncle Sam Needs You," Army Service Forces, 1943, 2–4. books.google.com, accessed Jun. 27, 2023.

thousands of government office jobs: "Uncle Sam Needs Stenographers," *Healdsburg Tribune and Enterprise* (Healdsburg, CA), Jan. 22, 1942, 2.

Secretarial schools emptied: "School for Super Secretaries," *Newsweek,* Oct. 4, 1942, 104.

"many more" vacancies... "plenty of room": "Stenographers and Typists..." 4.

1,600 students: "How a Secretary Trains," *Good Housekeeping,* Aug. 1942, 28.

5,500 calls from employers: Katharine Gibbs ad, *The Port Weekly* (Port Washington, NY), May 14, 1943, 4.

couldn't be replaced: Remington Rand ad, *Platen* 1944, 56.

had to hit 90...100...120: "EP-OH, 15; "Stenographers and Typists..." 4.

"the fiction that creeps": Dedication page, 1943 *Platen.*

more than $8,400...costume jewelry: "War Activities," 1944 *Platen*, 38–39; 1945 *Carbon*, 38.

"Christmas carols being sung": Class of '46, "We Will Always Remember..." 1945 *Platen* 5, 52.

most effective new weapon: Massachusetts Institute of Technology Bulletin, President's Report, October 1945 (Cambridge, MA: MIT), 6.

Marjorie Bell: Lois Rich-McCoy, *Late Bloomer* (New York: Harper & Row, 1980), 49; "Résumé of the first 30 or so years in the life of Marjorie Bell Chambers, PhD.," 3. Box 1–3, Folder 1, MBC.

Adamless Edens: Deborah M. Olsen, "Remaking the Image: Promotional Literature of Mount Holyoke, Smith, and Wellesley Colleges in the Mid-to-Late 1940s," *History of Education Quarterly*, Winter 2000, 425.

"like the witch of Endor": Clemente, "'Prettier Than,'" 639–640.

"He put it in the frame": Rich-McCoy, *Late Bloomer*, 49.

Emily Pike, got the same advice: EP-OH, 6–7, 14, 16–19.

Gertrude Pirnie: "New York Girl and New Castle Man Betrothed," *Morning News* (Wilmington, DE), Jul. 21, 1945, 7; "The Ledo Road Today," *The Military Engineer Today*, Jan.–Feb. 1956, 30; "World War II and the American Red Cross," https://www.redcross .org/content/dam/redcross/National/history-wwii.pdf, 9. accessed Aug. 1, 2023.

Elizabeth Weigle: "Elizabeth Weigle: Serving with the Red Cross, and the Marines, in World War II," https://www.nps.gov/articles/elizabeth-weigle-serving-with-the-red -cross-and-the-marines-in-world-war-ii.htm, accessed Aug. 3, 2023.

Mary Spencer Watkins: "Lands in England," *Greensboro Daily News* (Greensboro, NC), Mar. 15, 1944, 3; MSWF-OH, 8, 6; "Not Strictly News," *Greensboro Record* (Greensboro, NC), Jan. 23, 1947, 8; Marguerite Mebane email to author, Sep. 10, 2024.

"buzz" bombs...1.5 million Londoners: Robert W. Stanley, "Attacking the Mobile Ballistic Missile Threat in the Post–Cold War Environment," *Air University Press*, 2006, 6; Julian Palmore, "Theater Missile Defense: Origins and Expectations," *Phalanx*, Sep. 1997, 6; "Deaths and Injuries, 1939–45," https://web.archive.org/web/20030918043234/http:// myweb.tiscali.co.uk/homefront/arp/arp4a.html#, accessed Aug. 11, 2024.

Working in the Red Cross office... "You know, you do": Marguerite Mebane email to author, Sep. 10, 2024.MSWF-OH, 19–22.

TEN: "YES, WE FIGHT"

"shell New York tomorrow": "Possible for Axis to Shell New York, President Declares," *Tucson Citizen*, Feb. 17, 1942, 1.

"In a world at war": Jean Weston, "Our Best," 1942 *Platen*, 53. Box 1, KGSR.

enabling the US military...risk of a surprise assault: "The Role of Communication Intelligence in Submarine Warfare in the Pacific," *Radio Intelligence Publication Number* 340, Nov. 19, 1945, ii–iii; "The Role of Radio Intelligence in the American-Japanese Naval War, Vol. 1," Sep. 1, 1942, ii. National Archives.

Monica Ross and Rita Keniery: Monica R. Miller, *Wave Song* (Kindle: Monica R. Miller, 2014); Paul O'Keefe emails to author, Aug. 11 and 13, 2023; Paul O'Keefe interview with author, Sep. 18, 2023.

a few quirky traits: "Phone call from Roger Holmes, [illegible] March 1975 re Cryptography courses taught by him at MHC during WWII (and after)," Box 1, Philosophy Department records, College Archives and Special Collections, Mount Holyoke College.

with submachine guns… 4,000 Navy personnel: Stephen Budiansky, "The Code War," *American Heritage of Invention & Technology,* Summer 2000, 36.

Lillian Lorraine: Lynn Yonally phone interview with author, Jan. 25, 2022; Cherry & Co. to Matlin Cloak & Suit, Nov. 9, 1940. Lillian Lorraine scrapbook, scans sent by Lynn Yonally to author; "Lillian Lorraine Yonally," *Lighting the Way, Historic Women of the Southcoast,* https://historicwomensouthcoast.org/lillian-lorraine-yonally/, accessed Sep. 26, 2023; Julia Lauria-Blum, "Lillian Yonally—A Life in Color," *Metropolitan Airport News,* Jan. 11, 2022, https://metroairportnews.com/lillian-yonally-a-life-in-color/, accessed Oct. 5, 2023; "Lillian Lorraine Yonally, Veteran," interview by Wayne Clarke, New York State Military Museum, Aug. 27, 2009. https://museum.dmna.ny.gov/application/files/3215/9464/6639/Yonally_Lillian_Lorraine.pdf, accessed Feb. 23, 2022; Doug Snyder, "Honoring Lillian Yonally, WWII Pilot," https://guideposts.org/positive-living/health-and-wellness/life-advice/finding-life-purpose/honoring-lillian-yonally-wwii-pilot/ accessed Sep. 26, 2023.

only 1,830 made the cut: Jacqueline Cochran, "Final Report on Women Pilot Program" memo to Commanding General, Army Air Forces, Jun. 1, 1945, 1.

surplus mechanic's overalls: Shelia Henderson, "Zoot Suits, Parachutes, and Wings of Silver, Too," in *Code One,* General Dynamics Fort Worth Division, Oct. 1988. http://www.wingsacrossamerica.us/wasp/resources/henderson.htm, accessed Oct. 8, 2023.

only 3,000 combat planes: Molly Merryman, *Clipped Wings: The Rise and Fall of the Women Airforce Service Pilots (WASPs) of World War II* (New York: New York University Press, 1998), 9.

only 1,074 graduated: Cochran, "Final Report," 1.

only about two-thirds…not even a flag: "University Women to Hear Woman Pilot in WWII," *Morning Call* (Allentown, PA), Jan. 9, 2003, 21; Merryman, *Clipped Wings,* 8.

Arnold heaped praise…eyed with envy: Merryman, *Clipped Wings,* 77–78, 80–82.

disgruntled male pilots: Joseph H. Baird, "Protests over WASPS Make Report to Congress Likely," *Evening Star* (Washington, DC), Apr. 16, 1944, 5.

No one visited… "stenographers, clerks": Merryman, *Clipped Wings,* 82–83.

rejected the WASP militarization: Sarah Byrn Rickman, *Nancy Love and the WASP Ferry Pilots of World War II,* (Denton: University of North Texas Press, 2008), 197.

WASPs would disband: "Wasp to Disband Dec. 20, Arnold Says; 1,000 Women Pilots to Get Certificates," *NYT,* Oct. 4, 1944, 7.

"Because a predominantly": "Keep 'Em Flying," *Fort Worth Star Telegram,* Dec. 20, 1944, 6.

$1 a year: "WASPS Are Inactivated; Local Chief May House Hunt," *Cincinnati Post,* Dec. 21, 1944, 6.

"I never heard 'no'": Graham Rayman, "Flying Their Way to History," *Newsday,* Sep. 1, 2006, 17.

the room literally shook: Colonel Mary V. Stremlow, *Free a Marine to Fight: Women Marines in World War II* (Washington, DC: US Marine Corps Historical Center, 1994), 1.

Katherine Towle: KAT-OH; Stremlow, *Free a Marine,* 5, 9–10; "Women Writers Visit
Marine Base," *News and Record* (Greensboro, NC), May 2, 1944, 9; Ruth Cheney
Streeter, "Katherine A. Towle, Dean of Students," KAT-OH, xiii.

limited the number of women: Agnes Gereben Schaefer, Jennie W. Wenger, Jennifer Kava-
nagh, Jonathan P. Wong, Gillian S. Oak, Thomas E. Trail, and Todd Nichols, "History
of Integrating Women into the U.S. Military," in *Implications of Integrating Women
into the Marine Corps Infantry* (Rand Corporation, 2015), 8.

ELEVEN: CIVILIANS

8,500 job openings… 5,500: Katharine Gibbs ads, *Mount Vernon Argus* (Mount Vernon, NY),
May 18, 1945, 5; *The Port Weekly* (Port Washington, NY), May 14, 1943, 4.

Vera Covell… only as clerical workers: "She's Only One of Her Kind," *Spokane Chronicle,*
Jan. 3, 1942, 9. "Airline Girls," *This Week, Cincinnati Enquirer,* Aug. 23, 1942; Ruth
Arell, "Behind the Scenes at P.A.A.," *The Gregg Writer,* May 1942, 439–442; Marion
Dietrich, "Sacramentan Will Leave for Air Force," *Sacramento Bee,* Jan. 15, 1951, 12;
"Clipper to Ireland," *NYDN,* Aug. 13, 1945; Steve Weintz, "How America's Airline
Went to War," https://www.panam.org/war-years/400-how-america-s-airline-went-
to-war-2, accessed Mar. 4, 2024; "Member of Airline 'Flight Watch,'" *Decatur Herald*
(Decatur, IL), Jan. 30, 1942, 14.

Nazi submarines began… Nazi saboteurs: Steve Cox, "Civil Air Patrol: A Story of Unique
Service and Selfless Sacrifice," https://www.maxwell.af.mil/News/Features/Display
/Article/1024853/civil-air-patrol-a-story-of-unique-service-and-selfless-sacrifice/,
accessed Mar. 4, 2024; Leon O. Prior, "Nazi Invasion of Florida!" *The Florida Historical
Quarterly,* Oct. 1970, 129–30.

Anita Yale: Passport application, and 1920 Federal Census., familysearch.org, accessed Mar.
5, 2024; "When His Wife Ate, She Made Loud Noise like a Horse Eating Oats," *Fall
River Globe* (Fall River, MA), Jul. 28, 1923; Pat Gray, "Girls: This Boss Found His Sec-
retary a Husband," *Tampa Tribune,* Jul. 10, 1952, 18; "Air Pioneer De Seversky Dies;
Hailed for Role in World War II," *LAT,* Aug. 26, 1974, A1; Russell E. Lee, "Impact of
'Victory Through Air Power' Part I: The Army Air Forces' Reaction," *Air Power History,*
Summer 1993, 3; "Filmland Party Fetes Seversky," *LAT,* Apr. 28, 1943, A5; "Women's
Activities," *LAT,* Jun. 27, 1943, D2; Hedda Hopper, "Hedda Hopper Looking at Holly-
wood," *LAT,* Jun. 21, 1943, 15; "Major De Seversky En Route to City," *Fort Lauderdale
News,* Feb. 11, 1944, 1; "Lauderdalians Invited to Meet Major Seversky and Mrs. Sev-
ersky," *Fort Lauderdale News,* Mar. 2, 1944, 5; "Yale-Kimmel," *NYT,* Nov. 11, 1945, 38.

Mary Thayer Muther: "Moments Musical Club," *Star Tribune* (Minneapolis, MN), Mar. 3,
1940, 54; Mary Thayer Muther, "Words and Music," *TG,* undated, 10.

Hazel Thrall Sullivan: "Hazel Thrall Sullivan," interview by Joyce Pendery (University of
Connecticut, Center for Oral History, Women's Studies Program, 1981), 18–20, 28, 23,
24, 9, 25; "Democrats Pick Woman for House," *HC,* Oct. 7, 1944, 12; "When Tobacco
Growers Are the Law," *The American Child,* Jan. 1946, 1; "Legislative Notes," *HC,*
May 17, 1947, 4; "Windsor Legislator Finds Little to Her Liking in Results," *Meridien
Daily Journal* (Meridien, CT), Jun. 5, 1947, 2; "Marsh, House Named in Legislative
Poll," *HC,* May 1, 1947, 4; "Legal Action Is Instituted to Halt Dependency Payments to
Teachers," *HC,* May 21, 1965, 28; "Town Hall Referendum Scheduled for June 29," *HC,*
Jun. 23, 1965, 26.

TWELVE: WONDER WOMAN

Works consulted:

- *Alter Ego, Mar. 2019:* Richard J. Arndt, "The First Amazon"; "Sidebar #2: From San Diego Comic-Con Panel, July 2018"; "Sidebar #4, From San Diego Comic-Con Panel, July 2018, continued"; Sheldon Mayer, "Note to Writers and Artists."
- Lepore, Jill, *The Secret History of Wonder Woman*, (New York: Knopf, 2014).

while Mrs. Hummel: "More Evidence Asked by Court," *Nassau Daily Review-Star*, Apr. 20, 1945.

One question asked: Dr. Marston, "Psychology Examination, January 25, 1944," Joye Murchison Kelly Papers, MSS 1818 B, Special Collections, Smithsonian Libraries and Archives.

"Yes, I am": Joye Hummel Murchison Kelly interview by Mark Evanier, https://www.newsfromme.com/2018/08/20/todays-audio-link-51/, accessed March 19, 2022.

nearly pull the rings out...canceled a cruise: Joye Hummel Murchison Kelly, interview by Evanier and Robbins; Kathy Leigh Berkowitz, "Bringing Wonder Woman to Life," *Haven Magazine*, Jan. 1, 2018. https://www.havenmagazines.com/haven_lakeland /cover_story/bringing-wonder-woman-to-life/article_b3359532-ebde-11e7-b487-5ff ddc803de4.html, accessed Mar. 22, 2022.

"Infantile Paralysis": "Infantile Paralysis," *Life*, Jul. 31, 1944, 25–28.

"almost lost his mind": Hummel Murchison Kelly interview by Evanier.

"our imaginations": Berkowitz, "Bringing Wonder Woman."

incurable cancer: Berkowitz, "Bringing Wonder Woman"; Elizabeth O'Brien, "A Real Life Wonder Woman Adventure," *Connect* (Smithsonian Libraries), Summer 2015, 15.

"this brilliant man": O'Brien, "A Real Life."

all night, every night: Berkowitz, "Bringing Wonder Woman."

"Technicolor clotheshorse": Gloria Steinem, "Wonder Woman," in Gilbert H. Muller and Melissa E. Whiting, *Language and Composition, The Art of Voice* (New York: McGraw Hill, 2014), 313–14.

THIRTEEN: "HEAVENS TO ELIZABETH, GIRLS"

fell by nearly 3 million...more than 50 percent: "Facts on Women Workers," Women's Bureau, US Department of Labor, Feb. 8, 1946, 1–2.

86 percent: Linda Keller Brown, "Women and Business Management," *Signs*, Winter 1979, 267.

fell from 21 percent: M. Elizabeth Tidball and Vera Kistiakowsky, "Baccalaureate Origins of American Scientists and Scholars," *Science*, Aug. 20, 1976, 647.

Margaret Mead: Margaret Mead, "Can Homemaking Really Be a Career?" *Seventeen*, Apr. 1946, 117.

Dorothy D. Lee...toasters: Dorothy D. Lee, "What Shall We Teach Women?" *Mademoiselle*, Aug. 1947; reprinted in *Vassar Alumnae Magazine*, Feb. 1948, 15.

"My wish": "My Wish," *Huddlestonian* (Fairhaven High School, Fairhaven, MA), Fall 1924, 16.

Eugene Ford Seymour: "Had the Visitor Arrested," *NYT*, Apr. 23, 1905, 1; "Intruder Apologizes and Is Freed," *NYT*, Apr. 24, 1905, 5.

Life was miserable...marry him: Patricia Bosworth, *Jane Fonda: The Private Life of a Public Woman* (New York: Houghton Mifflin Harcourt, 2011), 20–21; Jane Fonda, *My Life So Far* (New York: Random House, 2005), 28.

In early jobs: Nancy Randolph, "Fonda's Fair Fiancée Fit for Film Fame," *NYDN*, Aug. 26, 1936, 51; Bosworth, *Jane Fonda*, 22.

bought a gold wedding band... "bright as the beam": Bosworth, *Jane Fonda*, 22; Fonda, *My Life*, 29.

paternity suit... divorce: Fonda, *My Life*, 50; "Actor Fonda's Wife Kills Self with a Razor," *NYDN*, Apr. 15, 1950, 3.

three sanatoriums... "best way out": "Actor Fonda's Wife," *NYDN*, 3, 13.

Jill DiDonato: Rose Nini email to author, Jun. 4, 2022 and phone interview with author, Jun. 22, 2022; Jill DiDonato letters home, 1946–47, Jakki Fink private collection; "Local Man Takes Bride Today in Princeton Chapel," *Lebanon Daily Times* (Lebanon, PA), Nov. 26, 1949, 7; "Money Scheme Ends," *Philadelphia Daily News*, Mar. 5, 1976, 8; "Suspect Held in the Bilking of $206,000," *Philadelphia Inquirer*, Nov. 15, 1975, 10; Morton C. Paulson, "Beware of investment club ripoffs," *Times Herald Record* Middletown, NY), Jul. 9, 1976, 60; "very competent, glamorous": Jakki Fink email to author, April 24, 2022.

only a redhead... straight through weekends: Dobie, "How to Educate a Secretary," 116, 31.

Dorothy Collins: Dorothy G. Collins, interview by Laura Smail, Nov. 1982 and Mar. 1983. Interview #244, University of Wisconsin-Madison Archives Oral History Project.

Jane Wade: "Career of Kansas City Girl Takes a Cinderella Turn," *KCS* (Kansas City, MO), Sep. 5, 1948, 50; Item, *KCS*, Sep. 18, 1944, 4; Joseph Kaye, "Sparkles in a Fabulous World of Art," *Kansas City Star*, (Kansas City, MO), Nov. 17, 1963, 18A; "Now a Conover Model," *Kansas City Star* (Kansas City, MO), Aug. 4, 1946, 44; Carl Edwin Varney, "Glamor Isn't Everything," *Dayton Daily News* (Dayton, OH), Feb. 27, 1944, 8; "Career of Kansas City Girl"; Celestine Sibley, "Harry Conover, Atlanta Visitor, Says You Need 'An Inner Glow,'" *Atlanta Constitution*, Jul. 4, 1944, 6; Arthur Mulligan, "Conover Loses License and DA Seizes His Books," *NYDN*, May 27, 1959, 5.

Alton Pickens praised... Valentin told friends: Alton Pickens to Jane Wade, May 11, 1955, 1. Jane Wade Papers Regarding Curt Valentin, Box 1, Folder 15. Archives of American Art, Smithsonian; Illegible signature, letter to Jane Wade, Sep. 20, 1954, 2. Jane Wade Papers Regarding Curt Valentin, Box 1, Folder 14. Archives of American Art, Smithsonian.

Fischer Gallery auction... "smoking gun" letter: Alice Goldfarb Marquis to the Editor, "Nazi Art Loot Found Its Way to New York's Modern Museum," *NYT*, Oct. 9, 1994, 14E; Jonathan Petropoulos, "Five Uncomfortable and Difficult Topics Relating to the Restitution of Nazi-Looted Art," *New German Critique*, Feb. 2017, 138; Jane Wade papers, Archives of American Art, Smithsonian, microfilm reel 2322, frame 929.

Marlborough-Gerson Gallery: Elsye W. Allison, "Dealer Works to Keep Area Artists in Picture," *KCS*, Feb. 12, 1978, 82; Walter Barker, "Curt Valentin Tribute at New Gallery," *St. Louis Post-Dispatch*, Dec. 1, 1963, 32; Lee Seldes, *The Legacy of Mark* Rothko (New York: Penguin, 1979), 53–4, 67.

"overbearing and despotic": David L. Shirey, "Frank Lloyd and the Marlborough: Art and Success," *NYT*, May 21, 1973; Seldes, *The Legacy*, 58.

her own art dealership... "pioneer": "Live Auction 1230, Impressionist and Modern Art (Day Sale) and Impressionist," https://www.christies.com/en/lot/lot-4092669, accessed April 5, 2022; Joseph Kaye, "Gains Success as Art Dealer," *KCS*, Mar. 27, 1966, 16A; "By Appointment Only," *Time*, Aug. 3, 1970, 59.

Mary Louise Beneway: "Salutatorian Honor Goes to Class Treasurer," *Democrat and Chronicle* (Rochester, NY), June 5, 1944, 23; Mary Louise Beneway Clifford interviews with author, Sep. 13, 16, 17, 2021 and Jan. 13, 2022.

$250 million Trans-Arabian Pipeline: "Big Tapline Stimulates Mid-East Oil Production," *Corpus Christi Times*, Dec. 24, 1950, 9-B; "Arabian Oil Piped to Mediterranean," *NYT*, Dec. 3, 1950, 1; "Tapline Completed," *Evansville Press* (Evansville, IN), Dec. 12, 1950, 32; Douglas Little, "Pipeline Politics: America, TAPLINE, and the Arabs," *The Business History Review*, Summer 1990, 256–57, 278, 280; Douglas Little, "Cold War and Covert Action: The United States and Syria, 1945–1958," *Middle East Journal*, Winter 1990, 55.

US legation in Beirut: Little, "Pipeline Politics," 280; Fred Zusy, "Bombs Hurled in U.S. Legations," *Charlotte News* (Charlotte, NC), Apr. 19, 1950, 1.

"We were watching": Beneway Clifford interviews with author.

315,000 barrels: "TAPline Completed for Mid East Oil," *Odessa American*, Dec. 5, 1950, 8; "Big Tapline Stimulates Mid-East Oil Production," *Corpus Christi Times*, Dec. 24, 1950, 9-B; "Little, "Pipeline Politics," 255.

FOURTEEN: "GREATEST SHOW ON EARTH"

surged from 85,000: Clemente, "'Prettier Than,'" 637.

9,500 female lawyers... doctorates: Michael H. Cardozo, "Women Not in the Law Schools, 1950 to 1963," *Journal of Legal Education*, Dec. 1992, 594; Carl N. Degler, "Revolution without Ideology: The Changing Place of Women in America," *Daedalus*, Spring 1964, 661; David A. Cotter, Joan M. Hermsen, and Reeve Vanneman, "Women's Work and Working Women: The Demand for Female Labor," *Gender and Society*, Vol. 15, No. 3 (Jun. 2001), 437; Frank Stricker, "Cookbooks and Law Books: The Hidden History of Career Women in Twentieth Century America," *Journal of Social History*, Autumn 1976, 2.

"violent pressures": Adlai Stevenson, "A Purpose for Modern Woman," in *Images of Women in American Popular Culture* (New York: Harcourt Brace Jovanovich, 1985), 113–14.

47 percent... "rough and tough": Beth L. Bailey, *From Front Porch to the Back Seat* (Baltimore: Johns Hopkins Press, 1988), 43, 45.

only 7 percent: "The Family: Woman's World," *Time*, June 14, 1963.

"aching longing": Janet Meseroll, "Burned Toast and Honey," 1950 *Platen*, 39.

227 colleges... 11 foreign countries: Katharine Gibbs ad, *Daily Illini*, May 7, 1950, 4; *Gibbs Girls at Work*, 1951–2, 14. Box 4, KGSR.

Myrna Custis: 1950 Federal Census; 1956 *Platen*, 31, 50, Box 1, KGSR.

earned 48 percent less... more than 80 percent: Mary S. Bedell, "Employment and Income of Negro Workers — 1940–52," *Monthly Labor Review*, Jun. 1953, 600–601.

"spending more money"... "personal qualifications": "Girl Who Wants A Career Must Fit into the Office as Well as into the Job," *Columbia Record* (Columbia, SC), Jul. 21, 1950, 10-A.

"this beauty business": N.O., "'Fashion, Beauty Can Be Fun,' Says Suncoast Expert," *St. Petersburg Times*, Aug. 7, 1956, 20.

"What earthly good": "'Katie' Gibbs grads are secretarial elite," *Business Week*, Sep. 2, 1961, 44.

"very necessary thing": Katherine Schmidt, phone interview with author, Dec. 3, 1921.

Lavinia Koelsch: "Kenoshan Earns Fashion Acclaim," *Kenosha Evening News,* Aug. 26, 1944, 3; 1950 *Platen,* 11. Box 1, KGSR.

"Soap and water": Phyllis Battelle, "Well-Groomed Look Puts Employers in Hiring Mood," *Atlanta Daily World,* Jul. 1, 1954, 8.

"glad to be alive": N.O., "Fashion, Beauty," 20.

"Portrait of a Gibbs Girl": Lorraine Wendell, "Portrait of a Gibbs Girl," 1950 *Platen* yearbook, 39. Box 1, KGSR.

FIFTEEN: LIFE AT THE TOP

as high as 1 million: Lisa Parks, "Watching the 'Working Gals': Fifties Sitcoms and the Repositioning of Women in Postwar American Culture," *Critical Matrix,* Jun. 30, 1999.

20- to 24-year-olds: "Everything for the Girls," *Newsweek,* Jul. 13, 1953, 76.

400 to 500 job openings: Gay Pauley, "Secretary Can Type Her Own Ticket," *LAT,* May 1, 1957, A7.

Marie Zenorini: Marie Zenorini, "A Career in Two Cities," *TG,* Fall 1959, 3; Marie Zenorini Canepa, phone interview with author, Jun. 17, 2022.

"Yale gangster"... "if the front door": Marylin Bender and Selig Altschul, *The Chosen Instrument* (New York: Simon and Schuster, 1982), 13, 15.

"remembered everything": Ed Trippe, "Kathleen Clair, 1919–2019," https://www.panam. org/global-era/719-remembering-kathleen-clair, accessed Apr. 13, 2024.

generous benefits: "System Spotlight," *Clipper,* Jan. 1964, 13; Lisa Churchville phone interview with author, Mar. 6, 2024.

"leaking, over-loaded ship": Najeeb E. Halaby, *Crosswinds: An Airman's Memoir* (Garden City, NY: Doubleday, 1978), 252.

Muriel Wilson Scudder: Muriel Wilson Scudder, "Europe in a Suitcase," *TG,* undated; Roberta Roesch, "Book of Practical Travel Hints," *The Record* (Hackensack, NJ), July 2, 1962, 26; "Europe in a Suitcase" ad, *Democrat and Chronicle* (Rochester, NY), Feb. 5, 1956, 26; "Tips for Travelers" ad, *Philadelphia Inquirer,* Jan. 29, 1956, 75; "Europe in a Suitcase" ad, *Democrat and Chronicle* (Rochester, NY), Feb. 5, 1956, 26; "Secretarial Bookshelf," *Today's Secretary,* Mar. 1958, 12.

Doris Tarrant: Bill Lohmann, "Secretaries no longer 'office wives,'" *Daily Register* (Harrisburg, IL), Apr. 22, 1986, 9; Terry Wetherby, *Conversations* (Millbrae, CA: Les Femmes Publishing, 1977), 234; Robert Cooper, "Women at the top," *The Record* (Hackensack, NJ), Aug. 17, 1975; Mark Finston, "Libbers get low credit rating from woman bank president," *Newark Star-Ledger,* Jan. 7, 1974; Vivian Waixel, "Here's one commercial bank that doesn't take tokens," *The Record* (Hackensack, NJ), Nov. 23, 1973, D-14; "Secretary," *Flint Journal* (Flint, MI), Apr. 20, 1986, 23; "Doris Tarrant heads new bank," *Ridgewood News* (Ridgewood, NJ), Jul. 31, 1977, 12; Paul Carlsen, "Ben thinks his car's just grrreat," *Morning Star* (Rockford, IL), May 7, 1977, 10; Lew Head, "She Figured on Bank Presidency," *Springfield Union* (Springfield, MA), Jan. 27. 1974, 50.

SIXTEEN: IT'S SHOWTIME!

Loretta Swit: Loretta Swit phone interview with author, Apr. 24, 2024; Tom Malone, "This Bears Mention," *Morning News* (Wilmington, DE), Feb. 18, 1965, 13; Michael C. Pollak, "To be young and dreaming of stardom in Passaic," *The Record* (Hackensack, NJ),

Feb. 27, 1983, 20; "Elsa Maxwell Dies at Age 80," *Brownsville Herald* (Brownsville, TX), Nov. 3, 1963, 16-A; Peggy Herz, *All About M*A*S*H* (Scholastic Book Services, 1975), 60–61; Robert Douglass, "Miss Holm Barrels Through 'Mame,'" *Fort Worth Star-Telegram*, Oct. 9, 1967, 5-C; Loretta Swit interview by Gary Rutkowski, May 10, 2005, Television Academy Foundation, https://interviews.televisionacademy.com/interviews/loretta-swit?clip=59319#show-clips, accessed Apr. 29, 2024.

Leora Dana: "Ask Court to Revoke Dana Will Probate," *Brooklyn Daily Eagle,* Jul. 21, 1914, 6; "Junior Leaguer and Millionaire Reno Grads, Wed," *NYDN*, Aug. 1, 1929; Jean Dietrich, "Her Tobacco Road Leads to Louisville," *Courier-Journal* (Louisville, KY), Feb. 20, 1970, E4; 1942 *Platen*, Box 1, 18, 54, KGSR; Richard L. Coe, "These Two Figured Out a New Rule," *WP*, Dec. 7, 1952, L1, L5; Robert Wahls, "Her Role on Stage Draws Interest of Bankers," *NYDN*, Feb. 24, 1952, 26; Radie Harris, "Exclusively Yours," *Photoplay*, Apr. 1958, 60.

Marie Irvine: 1925 New York State Census, ancestry.com; Penelope Green, "Marie Irvine, Makeup Artist to Marilyn Monroe, Dies at 99," *NYT*, Jan. 21, 2024; Arthur Miller, "My Wife Marilyn," *Life*, Dec. 22, 1958; Laura Collins, "Marilyn Monroe's desperation to get close to JFK," May 19, 2014, https://www.dailymail.co.uk/news/article-2632931/Marilyn-Monroes-desperate-plan-close-JFK-panic-forgotten-earrings-craved-baby-Monroes-friend-breaks-52-year-silence-reveal-true-story-Happy-Birthday-Mr-President-performance.html, Accessed Apr. 21, 2024; Keith Badman, *The Final Years of Marilyn Monroe* (New York: St. Martin's Press, 2012).

Martha Torge: Alice Hughes, "'Kon-Tiki Author Has More Glamour Than Dream Stars," *Fort Worth Telegram*, Apr. 23, 1951, 12; Janet Mevi, "Billion-Dollar Baby Sitter," *Cosmopolitan*, Jul. 1951, 10; 27; Frances Rosser Brown, "Society," *Muskogee Daily Phoenix* (Muskogee, OK), May 15, 1946, 7; Alice Hughes, "FPA's Book of Quotations Is as Interesting as Novel," *Fort Worth Star-Telegram*, Jun. 9, 1952, 8.

$2.9 billion in 1945: Stephen Fox, *The Mirror Makers*, (New York: William Morrow, 1984), 172.

$10 billion in 1956: Daniel Seligman, "The Amazing Advertising Business," *Fortune*, Sep. 1956, 107.

80 percent of consumer purchases: Fox, *Mirror Makers*, 284.

relied on the brains: "Author Mayer Says Admen Have Titles; Gals Have Know-How," *Advertising Age*, Apr. 21, 1958, 32.

Kathy McCahon Magnuson: Kathy McCahon Magnuson phone interview with author, Jul. 12, 2022.

more than $100 million in client billings: Fox, *Mirror Makers*, 173.

SEVENTEEN: THE WRITERS

"where to put a comma": "'Katie' Gibbs grads are secretarial elite," *Business Week,* Sep. 2, 1961, 44. Box 5, Folder 47, KGSR.

Natalie Stark Crouter: Natalie Crouter, *Forbidden Diary* (New York: Burt Franklin & Co., 1980); 40, 42, 15, 130, 96, 69, 433, 390, 484, 524, 523, 525; Excerpt from Mrs. Van Schaick letter, May 1945. Box 96, Folder 2, PSF; Fred Crouter phone interview with author, Aug. 25, 2022; Natalie Crouter to Richard and Sally Bellamy, Dec. 27, 1945, 1. Box 51, Folder 13, PSF; Helen Henley, *CSM*, May 17, 1945; Natalie Crouter to Richard and Sally Bellamy, Aug. 10, 1946. Box 51, PSF; John Tucker, MD, to Dr. E.S. Grossman, Aug. 7, 1951.

Box 45, Folder 1, PSF; J.S.B, "From one of John's letters from Baguio," undated, PSF; Crouter, *Forbidden Diary*, 525.

violent nightmares…fear of crowds: Crouter, *Forbidden Diary*, 525; Eric Englund, "Crouter talks, folks listen," *Shopper News* (Paramus, NJ), Jun. 11, 1980, 30.

Forbidden Diary reviews: Henry Kisor, "Internment diary captivates," *Green Bay Press-Gazette* (Green Bay, WI), May 18, 1980; Mary Taylor-Previte, "A testament to humanity at its best," *Courier-Post* (Camden, NJ), July 13, 1980, 5-D; Roy Katz, "Book Review," *New Beacon and Dispatch* (Fair Lawn, NJ), Jun. 27, 1980, 4. "Americans in Captivity," *Time*, Mar. 24, 1980, 55.

Marie Lyons Killilea: Marie Lyons Killilea, *Karen* (Englewood Cliffs, NJ: Prentice-Hall, 1952; New York: Dell, 1960); "Mom Persisted, So Karen Walks," *NYDN*, May 11, 1952, W2; Katharine Q. Seelye, "Karen Killilea, was keystone of family that pushed for disability rights," *BG*, Dec. 20, 2020, A28; Maureen McKernan, "Killilea Story of Palsy Fight Is Published," *Daily Argus* (White Plains, NY), Jul. 30, 1952, 8; "Palsey [sic] Aid Unit Leader to Open National Drive," *Standard-Star* (New Rochelle, NY), Jun. 30, 1948, 8; "Palsy Group Incorporated," *Daily News* (Tarrytown, NY), Jan. 13, 1950, 3; "Parents of Cerebral Palsied Children Hear Words of Hope," *Montreal Daily Star*, Oct. 19, 1950, 14; "Literary Success Transforms Suburban Housewife into High-Powered Executive," *Tampa Bay Times*, Mar. 15, 1953; Katharine Q. Seelye, "Karen Killilea, was keystone of family that pushed for disability rights," *BG*, Dec. 20, 2020, A28.

drowned her in a washtub: "Dad Kills Palsied Girl and Himself," *NYDN*, Feb. 25, 1950, 3.

In Michigan, a former Detroit: "Swinging Bottle Wins Parking Spot," *Detroit Free Press*, Apr. 19, 1948, 19; "Symphony Member Shoots Self," *Detroit Free Press*, May 22, 1949, 1; Calvin Mayne, "Barred Spastic Victim Watches Mercy Trial," *Detroit Free Press*, May 10, 1950, 4; "Father Slays His Crippled Daughter, 29," *Lansing State Journal*, May 21, 1949, 1; Calvin Mayne, "Braunsdorf on Bond Pending Sanity Hearing," *Detroit Free Press*, May 24, 1950, 4; "Braunsdorf Gets His Freedom," *Detroit Free Press*, Jun. 7, 1950, 14.

Mary Stolz: Mary Stolz, "Speech for Uni of Minnesota," 7. MSP-UM; Mary D. Burgey, WWI card, ancestry.com; 1922 Denver City Directory, 1945; "Mary Stolz," *Something About the Author Autobiography Series*, Vol. 3, 281; Untitled speech draft, Box 3, Folder 2, 3. MSP-USM; Mary Stolz, "Choosing Women Friends," 1. Box 14, Folder 18, MSP-USM; "Mary Stolz," *Something About*, 287; 1930 Federal Census; Ruth Pember, "First Book of New Rochelle Author Makes Best Seller List," *Reporter Dispatch* (White Plains, NY), Feb. 3, 1951, 5; Mary Stolz, "Children's Books, According to an Ex-Child Who Not Only Remembers but Writes Them," Box 3, Folder 2, 7. MSP-USM; Stolz, "Choosing Women Friends," 4; "Mary Stolz," *Something About*, 282–3; Lee Bennett Hopkins, *More Books by More People* (New York: Citation Press, 1974), 349; Amanda K. Allen, "Mary Stolz," *Dictionary of Literary Biography*, Vol. 389, 257; "Captain Stolz Helps Organize Sanitation Section in Manila," *Middletown Times Herald* (Middletown, NY), Jun. 14, 1945, 8; William Stolz email to author, Feb. 16, 2024; William Stolz phone interview with author, Feb. 12 and 17, 2024; "All About Kids!" Mary Stolz interview by Lois Ringquist, Minneapolis Public Library, https://cdm17208.contentdm.oclc.org/digital/collection/p17208coll5/id/65525, accessed Feb. 10, 2024; Mary Stolz, "On Reading and Writing," *The Writer*, Nov. 1960, 18.

McAuley Water Street Mission…Veterans Hospital: 1940 Federal Census; "Thomas F. Slattery," *Transcript-Telegram* (Holyoke, MA), Aug. 1, 1941, 14.

Mary Stolz reviews: Ellen Lewis Buell, "For Younger Readers," *NYT,* Oct. 8, 1950, BR18; Ellen Lewis Buell, "There's Fact and Fancy — and the Horse Is Still King," *NYT,* Nov. 12, 1950; Ellen Lewis Buell, "Ten Best Children's Books, 1950," *NYT,* Dec. 3, 1950, BR31; Helene Lewis Coffer, "First Love Sours Girl on Universe," *LAT,* Oct. 29, 1950, IV-5; L.M., Review of *Rosemary* by Mary Stolz. *Saturday Review,* Nov. 12, 1955, 82.

"Who am I?": Mary Stolz, *Hospital Zone* (New York: Harper & Row, 1956), 74.

more than a million books: Mary Stolz full-page ad, *NYT,* Oct. 20, 1968, Q39.

more than 25 languages: Allen, "Mary Stolz," 257.

Thank goodness: Bennett Hopkins, *More Books,* 344.

EIGHTEEN: THE GAME CHANGERS

Joan M. Clark: "Nomination of Joan M. Clark to Be Director General of the Foreign Service," Ronald Reagan Presidential Library & Museum, https://www.reaganlibrary .gov/archives/speech/nomination-joan-m-clark-be-director-general-foreign-service, accessed May 10, 2024; Steven Alan Honley, "A Career of Management Excellence: Joan M. Clark," *Foreign Service Journal,* Jul.-Aug. 2007, 49.

only 1.7 percent of women: Homer L. Calkin, *Women in the Department of State: Their Role in American Foreign Affairs* (Washington, DC: Department of State, 1978), 10.

highest ranking women: Joan Plaisted, "Getting to the top: Is it lonely up there?" *State,* Aug.-Sep. 1988, 20.

Ethel Bent Walsh: "Stranahan, Ward and Chapman Among Victors in North-South Amateur Golf," *NYT,* Apr. 21, 1949, 33; "Golf Star Divorced," *HC,* Apr. 30, 1950, 63; "Walsh Gains Crown, 3 and 1," *NYT,* Aug. 1, 1948, S6; Marcia Saft, "Voicing Concerns of Manufacturers," *NYT,* Apr. 28, 1985, CN4; "Nomination Hearing Before the Committee on Labor and Public Welfare United States Senate" (Washington, DC: US Government Printing Office, 1971), 2; Saft, "Voicing Concerns"; "Senate to Act on Mrs. Walsh for EEOC Post," *Bridgeport Telegram* (Bridgeport, CT), Apr. 28, 1971, 3; "Equal Employment Opportunity Commission," *Weekly Compilation of Presidential Documents,* Oct. 13, 1975, 1122.

EEOC: Dorothy Rabinowitz, "The Bias in the Government's Anti-Bias Agency," *Fortune,* Dec. 1976, 138; Ernest Holsendolph, "New Powers Urged for Job Rights Agency," *NYT,* Mar. 25, 1975, 29; Jack Nelson, "Rights Panel Defended Despite Backlog," *LAT,* Apr. 21, 1977, B18; William Chapman, "An Agency in Shambles," *WP,* Feb. 5, 1977.

"outstanding women": Blanche Corbman, New Jersey Women's Equity Action League, to President Gerald Ford, Jun. 15, 1975. https://www.fordlibrarymuseum.gov/library/document/0019/23914117.pdf, accessed May 12, 2024.

cloud of scandal: Norma Langley, "Jobs-for-sex girl heard bosses discuss who would love her first," *San Antonio Star,* May 9, 1976, 3.

"waited since Eve": Chapman, "An Agency."

"a friend whose commitment": "Ethel B. Walsh; EEOC Commissioner, Rights Activist," *WP,* May 29, 2004, B7.

Marjorie Bell Chambers: "Resume of the first 30 or so years in the life of Marjorie Bell Chambers, Ph.D.," 1998, 2. Box 2, Folder 1, MBC; Rich-McCoy, *Late Bloomer,* 55–6, 50 Marjorie Bell Chambers, notes for "This Is a Time for Women" speech to Katharine Gibbs School, 1979. Box 12, Folder 4, Card 29d MBC.

brink of financial ruin...averted closing: Wallace B. Turner, *Colorado Women's College, 1888–1982: the story of a dream* (Marceline, MO: Walsworth Publishing Co., 1982), 252, 257; K.C. Mason, "She Fights for All-Girl College's Life," *Indianapolis Star,* Jan. 23, 1977.

"dignifies, honors, respects": Turner, *Colorado Women's College,* 251.

"sweet little girls": Carol Edmonds, "Women's college head won't give up ship," *Daily Sentinel,* (Grand Junction, CO), Jan. 18, 1977, 7.

offered only 20 minutes: Marjorie Bell Chambers interview by Cullom Davis, Jun. 21, 1985, *Marjorie Bell Chambers Memoir* (Springfield, IL: University of Illinois at Springfield, 1985), 4.

Bella Abzug: Chambers interview by Davis, 9, 6, 7, 8 12; Martin Schram, "The Story Behind Bella's Departure," *WP,* Jan. 16, 1979; "Carter fires Bella Abzug from committee," *Detroit Free Press,* Jan. 13, 1979, 13A; Alice Bonner, "Abzug Colleagues Resign to Protest Ouster by Carter," *WP,* Jan. 14, 1979.

dinner in the solarium... "All right, Marjorie": Chambers interview by Davis, 11, 8.

"These little married women": Eileen C. Spraker, "Bella's Replacement Doesn't Shout, But She Knows How to Get Things Done," *Evening Journal* (Wilmington, DE), Mar. 9, 1979, 45.

then-historic high of 22 percent: Marjorie Bell Chambers, "A Political Diary of an Assertive Women," in Meg McGavran Murray, *Face to Face* (Westport, CT: Greenwood Press, 1983), 240.

"the most male men": Patt Morrison and Elizabeth Mehren, "Closing Gender Gap Considered by Many to be Crucial for Bush," *LAT,* Ag. 17, 1988, 4.

"make that Gibbs certificate": Marjorie Bell Chambers, "This Is a Time for Women," June 11, 1979. Box 12, folder 4, Card 25. MBC.

Audrey Moore: Mary Jordan, "The Fixed Resolve of Audrey Moore," *WP,* Jan. 12, 1988; Antonio Olivo, "Audrey Moore, Fairfax County supervisor and environmentalist, dies at 89," *WP,* Dec. 19, 2018; Audrey Moore interview by Laura McDowall, May 19, 2005, 1. https://web.archive.org/web/20110725100521/http://braddockheritage.org/content/vault/Moore_Audrey_01b88d7e52.pdf, accessed Oct. 29, 2021; Mary Jordan, "Gadfly Vies for Leadership," *WP,* Oct. 26, 1987; Christine Neuberger, "Audrey Moore, Fairfax Crusader," *Richmond Times-Dispatch,* Apr. 29, 1990, H-1.

15 Fairfax County supervisors...convicted: "Two Washington Builders Indicted by Jury Probing Fairfax Zoning Cases," *Danville Register* (Danville, VA), Sep. 21, 1966, 3; Jordan, "Gadfly Vies"; Olivo, "Audrey Moore, Fairfax County."

killing 14 workers: "Fairfax Board Defers Action on Condominium," *Daily News-Record* (Harrisonburg, VA), Jul. 24, 1973, 7.

"What's so appealing": Christine Neuberger, "Vision for city formed as child," *Richmond Times-Dispatch,* Apr. 29, 1990, H-2.

liars, cheats, and crooks: Jordan, "Fixed Resolve"; Olivo, "Audrey Moore, Fairfax County."

"Everybody hates": Jordan, "Gadfly Vies."

"can't put an Uzi": Jordan, "Fixed Resolve."

Martha Cheney: "Girl in the Back Room," *LHJ,* May 1952, 205, 54.

Emily Pike: Ronald L. Smith, "Introduction," EP-OH, vi; Almena Lomax, "GOP's Emily Refuses to Skirt the Issues," *San Francisco Examiner,* Jun. 3, 1972, 7; EP-OH, 74, 282,

291, 21; John Koopman, "Emily Pike dies — longtime GOP leader in S.F.," *SF Gate*, June 7, 2008. https://www.sfgate.com/bayarea/article/Emily-Pike-dies-longtime-GOP -leader-in-S-F-3210058.php, accessed Aug. 31, 2023.

NINETEEN: SETTING SUN

"Career Girls Murders": "2 Girls Murdered in E. 88th St. Flat," *NYT*, Aug. 29, 1963, 1; Thomas Buckley, "Youth Is Accused in Wylie Slaying," *NYT*, Apr. 28, 1964, 1; Peter Kihss, "Parolee Booked in Wylie Slaying," *NYT*, Jan. 27, 1965, 1; "Drifter Accused of Career Girls Murders," *Galion Inquirer* (Galion, OH), Apr. 1964, 1.

enrolled some 1,700...$55 weekly: "'Katie' Gibbs grads are secretarial elite," *Business Week*, Sept. 2, 1961, 44, 46, 43.

Millie Pirko Triff: Millie Pirko Triff phone interview with author, Oct. 8, 2021; Millie Pirko Triff, "What It Was Like to Attend the Best Secretarial School in 1960s America," *Reader's Digest*, Jan. 20, 2017, https://www.rd.com/article/secretarial-school/, accessed Oct. 7, 2021.

Loudell Insley: Loudell Insley phone interview with author, Feb. 10 and 11, 2022; Loudell Insley, *Life on a Road Less Traveled*, Kindle edition (Bloomington, IN: iUniverse, 2011).

"the image to which": Betty Friedan, "Preface and Acknowledgments," *The Feminine Mystique* (New York: Dell Publishing, 1963), 7.

Marie Anderson: Beatrice Washburn, "Is There Life After Death?" *Miami Herald*, Jan. 16, 1960, 8A; Eleanor Hart, "Women Alcoholics Find an Answer to Despair," *Miami Herald*, Jan. 27, 1960, 1-C; Gay Pauley, "Just How Secure Are Career Girls in a Big City?" *Miami Herald*, Sep. 4, 1963, 1-D; Nancy Jackson, "Divorcee: Work, Wondering, Self-Pity," *Miami Herald*, Oct. 24, 1963; Theodore Berland, "Smart Swingers at College Are Taking the Pill, Too," *Miami Herald*, Sep. 25, 1965, 5-AW; Eve Edstrom, "U.S. Ready to Expand Family Planning Role," *Miami Herald*, Sep. 13, 1965, 1-C; "Premenstrual Tension Means 'Black Days' for Women," *Miami Herald*, Sep. 8, 1965, 1-C; "Marie Anderson Papers (C4074)," State Historical Society of Missouri, https://files.shsmo .org/manuscripts/columbia/C4074.pdf, accessed Apr. 9, 2021.

Judith Daniels: Marian Christy, "Bold Judith Daniels Launching 'Savvy,'" *Times-Tribune* (Scranton, PA), Jun. 23, 1977, 20; Ellen Stern, "Savvy cashes in on women who aim for the top," *Chicago Tribune*, Mar. 29, 1981; raise $1.5 million: Judith Daniels, "A Cliff-Hanging Saga," *Harvard Business School Bulletin*, Nov./Dec. 1980, 102; Judith Daniels Papers, Smith College.

Clare Ferraro: Clare Ferraro phone interview with author, Jan. 27, 2022.

Ballantine's income grew: Stephen Rubin," "Paperbacks break the snob barrier as holiday gifts," *Chicago Tribune*, Nov. 29, 1981.

Barbara Meech Kelley: Barbara Meech Kelley phone interview with author, Oct. 12, 2021; "Co-op Classes for Women Successful," *Akron Beacon Journal*, Dec. 16, 1924, 21.

TWENTY: 1968, THE END

scoffed at the use: Amy Vanderbilt, "Your etiquette, *Newark Star-Ledger*, Feb. 14, 1967, 12.

worth an estimated $5 million: Clare M. Reckert, "Publisher in Bid for Gibbs School," *NYT*, Jul. 30, 1968, 51.

sang anti-Miss America: Charlotte Curtis, "Miss America Pageant Is Picketed by 100 Women," *NYT*, Sep. 8, 1968.

eleven Katharine Gibbs schools: Katharine Gibbs ad, *News and Observer* (Raleigh, NC), Mar. 22, 1984, 10.

Maxwell didn't want: "Phillips Colleges Buys New York Schools," *Sun Herald* (Biloxi, MS), May 16, 1989, C-2.

$155 million repayment demand: US Department of Education, Office of Inspector General, "Semiannual Report to Congress," Oct. 1, 1992–Mar. 31, 1993, 4; Sharon Fitzhugh, "New president of Phillips College off the job," *Sun Herald* (Biloxi, MS), Sep. 4, 1993, C-1.

K-III Communications Corp.: "Katharine Gibbs Schools Sold," *Putnam Reporter Dispatch* (White Plains, NY), Mar. 9, 1994, 2E.

wildly incongruous menu: Katharine Gibbs ad, *Newsday*, Nov. 10, 2008; Katharine Gibbs ad, *NYDN*, Feb. 10, 2008; Lore Croghan, "Doors are closing at Katharine Gibbs," *NYDN*, Feb. 16, 2008; Katharine Gibbs ad, *NYDN*, Feb. 11, 2008; "Train for a New Career," *NYDN*, Jan. 13, 2008.

60 Minutes, ran an expose: "Career Education Corporation," https://www.help.senate.gov /imo/media/for_profit_report/PartII/CEC.pdf, accessed Jun. 11, 2024.

EPILOGUE

some 50 women's liberationists: Mary Breasted, "Women on the March: 'We're a Movement Now!'" *Village* Voice, Sept. 3, 1970.

some 50,000 young women: Reckert, "Publisher in Bid."